Photography
Theory

University College Cork
Coláiste na hOllscoile Corcaigh

The Art Seminar

VOLUME 1
ART HISTORY VERSUS AESTHETICS

VOLUME 2
PHOTOGRAPHY THEORY

VOLUME 3
IS ART HISTORY GLOBAL?

VOLUME 4
THE STATE OF ART CRITICISM

VOLUME 5
THE RENAISSANCE

VOLUME 6
LANDSCAPE THEORY

VOLUME 7
RE-ENCHANTMENT

Sponsored by the University College Cork, Ireland; the Burren College of Art, Ballyvaughan, Oreland; and the School of the Art Institute, Chicago.

Photography Theory

EDITED BY
JAMES ELKINS

University College Cork
Coláiste na hOllscoile Corcaigh

Routledge
Taylor & Francis Group
New York London

Routledge is an imprint of the
Taylor & Francis Group, an informa business

Routledge
Taylor & Francis Group
270 Madison Avenue
New York, NY 10016

Routledge
Taylor & Francis Group
2 Park Square
Milton Park, Abingdon
Oxon OX14 4RN

© 2007 by Taylor & Francis Group, LLC
Routledge is an imprint of Taylor & Francis Group, an Informa business

Printed in the United States of America on acid-free paper
10 9 8 7 6 5 4 3 2

International Standard Book Number-10: 0-415-97783-5 (Softcover) 0-415-97782-7 (Hardcover)
International Standard Book Number-13: 978-0-415-97783-8 (Softcover) 978-0-415-97782-1 (Hardcover)

Visit the Taylor & Francis Web site at
http://www.taylorandfrancis.com

and the Routledge Web site at
http://www.routledge-ny.com

TABLE OF CONTENTS

SERIES PREFACE

It has been said and said that there is too much theorizing in the visual arts. Contemporary writing seems like a trackless thicket, tangled with unanswered questions. Yet it is not a wilderness; in fact, it is well-posted with signs and directions. Want to find Lacan? Read him through Macey, Silverman, Borch-Jakobsen, Žižek, Nancy, Leclaire, Derrida, Laplanche, Lecercle, or even Klossowski, but not—so it might be said—through Abraham, Miller, Pontalis, Rosaloto, Safouan, Roudinesco, Schneiderman, or Mounin, and of course never through Dalí.

People who would rather avoid problems of interpretation, at least in their more difficult forms, have sometimes hoped that "theory" would prove to be a passing fad. A simple test shows that is not the case. Figure 1 shows the number of art historical essays that have terms like "psychoanalysis" as keywords, according to the *Bibliography of the History of Art*. The increase is steep after 1980, and in three cases—the gaze, psychoanalysis, and feminism—the rise is exponential.

Figure 2 shows that citations of some of the more influential art historians of the mid-twentieth century, writers who came before the current proliferation of theories, are waning. In this second figure, there is a slight rise in the number of references to Warburg and Riegl, reflecting the interest they have had for the

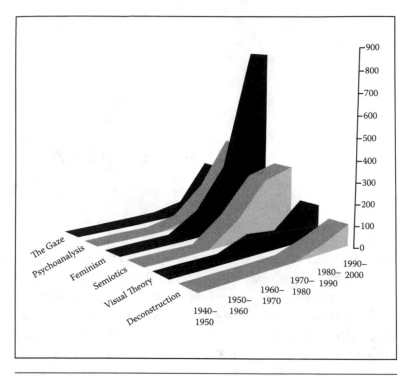

Figure 1 Theory in art history, 1940–2000.

current generation of art historians; but the figure's surprise is the precipitous decline in citations of Panofsky and Gombrich.

Most of art history is not driven by named theories or individual historians, and these graphs are also limited by the terms that can be meaningfully searched in the *Bibliography of the History of Art*. Even so, Figures 1 and 2 suggest that the landscape of interpretive strategies is changing rapidly. Many subjects crucial to the interpretation of art are too new, ill-theorized, or unfocused to be addressed in monographs or textbooks. The purpose of *The Art Seminar* is to address some of the most challenging subjects in current writing on art: those that are not unencompassably large (such as the state of painting), or not yet adequately posed (such as the space between the aesthetic and the antiaesthetic), or so well known that they can be written up in critical dictionaries (the

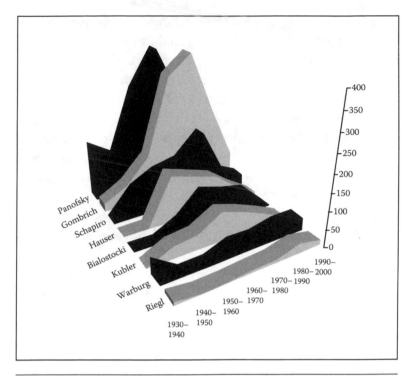

Figure 2 Rise and fall of an older art history, 1930–2000: Citations of selected writers.

theory of deconstruction). The subjects chosen for *The Art Seminar* are poised, ready to be articulated and argued.

Each volume in the series began as a roundtable conversation, held in front of an audience at one of the three sponsoring institutions—the University College Cork, the Burren College of Art (both in Ireland), and the School of the Art Institute of Chicago. The conversations were then transcribed, and edited by the participants. The idea was to edit in such a way as to minimize the correctable faults of grammar, repetitions, and lapses that mark any conversation, while preserving the momentary disagreements, confusions, and dead ends that could be attributed to the articulation of the subject itself.

In each volume of *The Art Seminar*, the conversation itself is preceded by a general introduction to the subject and several

"Starting Points," essays that were read by the participants before the roundtable. Together, the "Introductions" and "Starting Points" are meant to provide the essential background for the conversation. A number of scholars who did not attend the events were then asked to write "Assessments"; their brief was to consider the conversation from a distance, noting its strengths and its blind spots. The "Assessments" vary widely in style and length: some are highly structured, and others are impressionistic; some are under a page, and others the length of a commissioned essay. Contributors were just asked to let their form fit their content, with no limitations. Each volume then concludes with one or more "Afterwords," longer critical essays written by scholars who had access to all the material, including the "Assessments."

In that way, *The Art Seminar* attempts to cast as wide, as fine, and as strong a net as possible, to capture the limit of theorizing on each subject at the particular moment represented by each book. Perhaps in the future the subjects treated here will be colonized, and become part of the standard pedagogy of art: but by that time they may be on the downward slide, away from the centers of conversation and into the history of disciplines.

1
INTRODUCTION

Theories of Photography

A Short History

Sabine T. Kriebel

What is a photograph? What is photography? The answer to these apparently simple questions—what *is* the medium—would seem to be a necessary basis for its theorization. A *theory of* something purports to offer up a set of overarching, generalizable qualities and functions—how something operates and why. But to respond to the query "What is a photograph?" is not merely to describe a familiar, omnipresent item—a "transparent envelope," as Roland Barthes[1] has called it—a thing that we often *see through* in order to get information about the world. It is to describe a series of histor-ically contingent processes that, at one time or another, comprised a photograph and the practice of photography. How do we speak in one breath of photography, and unproblematically incorporate the range of objects and practices that includes daguerreotypes, calotypes, 35-millimeter prints, Polaroids, and digital photo-graphs into a convincing theoretical model?

Consider their fundamental material differences:[2] the shiny, easily damaged daguerreotype, the product of a direct and unre-peatable process, is pressed between a glass sheet and metal mat

for protection, becoming integral to its physical life. Its subject matter was originally a laterally reversed image; later, this reversal was corrected by placing a mirror at an angle before the lens and photographing the subject in that mirror, in turn resulting not in a direct image of the subject, but an image of its reflection. We cannot speak of this particular photograph as an index (to invoke a term that is fiercely contested throughout the volume) of the world-out-there, that is, contiguous with the object it represents, unless we make clear that that contiguity is with a mirror reflection. Nor can we speak of mass reproduction (another key term in photography theory), as the daguerreotype was a single, original, and unrepeatable image. Contrast William Henry Fox Talbot's nearly contemporaneous calotype, which introduced the negative–positive process on paper (a paper negative and a paper positive), as well as instantaneity, resistance to deterioration, and reproducibility, not to mention affordability. However, the paper fibers often showed through to the proof, blurring details and hazing tones and making it a less-than-precise record, distancing the empirical world rather than revealing details invisible to the naked eye. The twentieth century witnessed lighter cameras, perforated 35-millimeter film, and an efficient negative-positive process that resulted in an endlessly reproducible, mobile image. Though this modern photographic model might seem to be normative—a widespread enough phenomenon upon which to base a generalizable photographic theory—contrast the equally modern Polaroid, which is a direct process, with no negative, no mass reproduction possible (except via auxiliary processes such as rotogravure), and an unparalleled immediacy of imagery. That immediacy is perhaps only rivaled today by the digital image, where medium itself becomes virtual.

Therefore, a clear definition of intrinsic, universal qualities of a photograph would be, at the very outset, hampered by its dependence on technological change. To speak of "the photograph" would be to speak of its multiplicity and malleability. As Richard

Bolton has rightly noted, perhaps "photography has no governing characteristics at all save adaptability."[3] Moreover, is it correct to say that it is the *object*—the photograph—that we theorize, or is it photographic *practice*, which would incorporate the psychologically and ideologically informed act of taking photographs and the processes of developing, reproducing, and circulating them in society? Or do we theorize their *function*? Some writers argue that the photograph's role in discourse, its actual purpose, is wholly the rightful object of photography's theorization. Just as the apparatus itself is historically bound, making it impossible to declare a kind of photographic unity, so too are its various social functions. How do we understand how photography operates in society—ideologically, politically, psychologically? Which photography, exactly? Art photography? Advertising photography? Photojournalism? Documentary? Erotica? Photography is a manifold phenomenon, taking hold in discourses ranging from fine art to journalism, criminal investigation to optics. As the British photographer and critic Victor Burgin writes, it seems "reasonable to assume that the object of photography theory is, at base, a photograph. But what *is* a photograph?"[4] He continues, listing not its various incarnations as an apparatus, but its various *social* understandings: "When photography first emerged into the context of nineteenth-century aesthetics, it was initially taken to be an automatic record of reality; then it was contested that it was the expression of an individual; then it was considered to be 'a record of a reality refracted through a sensibility.'"[5] Just as the physical composition of the photograph changes, so too does the cultural *perception* of photography, which Burgin suggests is imbricated in its theorization.

Theory too is historically conditioned, of course; photographic theories themselves are not immune from discursive trends. In this introduction, I will provide a short history of the theories of photography, beginning from some of the first public utterances to the present day, framing them in their respective historical contexts. These theories were articulated in response to a set of

particular conditions—political, commercial, cultural, and tech-
nological—and sought to provide some overarching observations
and predictions about the medium in a certain moment in time
and place. Covering a span from the 1830s until the twenty-first
century, the introduction will by necessity be summary, offer-
ing an overview of a dispersed and contested theoretical field.
Most of the writers discussed in this essay could be treated in a
lengthy introduction of their own; their writings—their texture,
their implications—exceed the summaries I can offer here. Cer-
tain writers who have received extensive treatment elsewhere, for
example Walter Benjamin or Roland Barthes, have been distilled
to a few key points. I have highlighted the elements of texts that
emphasize continuities of concern over the century and a half of
photography theory that further develop a particular strand of
thought, or that challenge an argument. My aim is to illuminate
the key issues addressed in photo theory, pointing out similarities,
contested differences, moments of aggravation, points of repres-
sion, and insistent returns to a theme. These theorizations move
from a few isolated writers searching to explain a novel phenome-
non and its impacts on society to a full-blown academic discourse
that becomes more substantive, pluralist, strident, and contentious
as the twentieth century draws to a close and the ramifications of
the digital age confront us.

1

During photography's beginnings (which, as Geoffrey Batchen
demonstrates, was a pluralism of events and coincidences, not a
decisive historical moment),[6] the medium was hailed by promi-
nent writers of the day as "the most important and perhaps the
most extraordinary triumph of modern science" (Edgar Allan Poe
in 1840)[7] or linked to "a form of lunacy," tied to "the stupidity of
the masses" (Charles Baudelaire in 1859).[8] Given that both writ-
ers were devoted to the dark power of the imagination and the

exploration of enigmatic, subjective states—Baudelaire was an admirer of Poe—the discrepancy between their two evaluations could not be starker. Importantly, the divergence is rooted in the different assessments of the daguerreotype's social functions. The first account, written just a year after Daguerre's public presentation of the invention he named after himself, is enthralled by the daguerreotype's nearly divine representation of "absolute truth," which is "*infinitely* more accurate than any painting by human hands."[9] According to Poe, science not only was the source of the imagination, but also would *exceed* "the wildest expectations of the most imaginative."[10] For Poe, the power of science was in the unforeseen, the yet-to-be-known, and therein lay its promise and its lure. Not coincidentally, Poe took pleasure in the fact that the daguerreotype could capture inaccessible heights and lunar charts, ciphers of his own imaginative sensibility.

The second response, written fifteen years later, is searingly apprehensive about photography's encroachments on art and the imagination. Unlike Poe, who was dreaming of photography's potential, Baudelaire witnessed the mass commercial appeal and celebration of the mechanical replication of the physical world. Photography, in Baudelaire's estimation, contributed to the impoverishment of the artistic imagination, only fueling the popular notion that art and truth lie in the exact replication of the visual world rather than the world of the imagination, dream, and fantasy. "An avenging God has heard the prayers of this multitude," wrote Baudelaire in mock biblical prose; "Daguerre was his messiah. And then they said to themselves: 'Since photography provides us with every desirable guarantee of exactitude' (they believe that, poor madmen!) 'art is photography.'"[11] For Baudelaire, photography could at best be a tool of memory, a record keeper, an archive, but never a fine art. In his words, "Poetry and progress are two ambitious men that hate each other."[12]

Art, science, and commerce: these are the terms around which early photographic theories turned. On the one hand,

the replicated image was the product of a mechanical process, the effect of a technical device that, through the infiltration of light on a light-sensitive surface, could record the world before it. The camera was a picture-machine: objective, mechanical, technological. On the other hand, there was a language surrounding nineteenth-century photography that was based in nature, not technology. Photographs were also called "sun pictures" and said to be "impressed by nature's hand." The title of William Henry Fox Talbot's photographically illustrated book of 1844, *The Pencil of Nature*, correlates the photograph with a sketch of nature. Photographs were "obtained," or "taken," the way natural history specimens were found in the wild.[13] Both the conception and the reception of the photographic image remained bifurcated.

Significant technological advances in the early twentieth century shifted the terms of discourse from the aesthetic and commercial merits and demerits of photography to the aesthetic politics of mass reproduction. Rapid developments in photographic technology, including the invention of the lightweight 35 millimeter Leica camera in 1924, the use of perforated film rather than ungainly light-sensitive plates, the heightened photosensitivity of film and photographic paper, the development of the wide aperture lens, and the flashbulb, allowed photographers to work at higher speeds and previously impossible light conditions. In addition, the refinement of the photogravure technique in the early 1900s enabled text and high-quality images to be printed simultaneously on a single page. A new publishing industry emerged that centered on the picture magazine, soon rivaling text-only newspapers. The mass-reproduced photograph had become an integral part of a new consciousness industry.

Intellectuals recognized that the new postwar age was indelibly marked by the mechanically reproduced photograph. While many critics considered the mass-reproduced photograph to be symptomatic of social decline, Siegfried Kracauer, writing for his bourgeois *feuilleton* audience in the *Frankfurter Allgemeine Zeitung*

in 1927, invested the omnipresent photograph with redemptive potential. Although Kracauer's dialectical perspective is equally mired in social disenchantment, he holds onto the notion that decline (represented in part by the illustrated magazine) is a vital, though negative, step toward enlightenment. In his essay "Photography," Kracauer argued that the sheer accumulation—what he variously called "blizzard," "the flood," and the "assault"—of photographs in the press catapults this photographic archive of modern life into the realm of allegory.[14] The multitude of photographs displayed in the press, according to Kracauer, forces the beholder to confront the truth of capitalist society: its mechanical superficiality, its banality, its spiritual meaninglessness. Photography, in Kracauer's estimation, "is a secretion of the capitalist mode of production."[15] Only through a raw encounter with the surface nature of photography, in its accumulated emptiness, can the process of disenchantment and, importantly, change begin. At the heart of Kracauer's thesis is a paradox: "In the illustrated magazines, people see the very world that the illustrated magazines prevent them from perceiving," he writes, suggesting that seeing is not the same as being critically conscious of what one sees.[16] Siegfried Kracauer believed that the abundance of photographs, archived in the multiplicity of picture magazines, appearing on newsstands month after month, year after year, could potentially catapult consumers into unflinching recognition of, and revolt against, a vapid, overrationalized society. Until that moment, however, the sheer accumulation of photographs offers an eternal, ever-renewable photographic present, repressing the lurking presence of transience and death by ever reproducing more, new pictures.

Kracauer's friend Walter Benjamin too vested the mass-reproduced photograph with revolutionary potential, most famously in his 1936 essay "The Work of Art in the Age of Mechanical Reproduction." Written from a Marxist perspective and in the context of the spread of fascism in Europe, Benjamin asserted that photography "shatters" capitalist, bourgeois tradition by

destroying the "aura" of the sacred, authentic, and original art object. The aura, which he defines as "an experience of distance, however close the object may be," is an extension of the object's "cult value," once rooted in the origins of art in magic and religious ritual and now manifest in a secularized cult value, which valorizes the singularity, physical authenticity, and tradition of the art object.[17] A reproduction "as offered by picture magazines and newsreels," destroys the art object's "aura," bringing the distant object closer and making it accessible to a mass public, at simultaneous moments, in multiple locations.[18] This aspect of Benjamin's argument is summarized in the often-quoted assertion "[T]hat which withers in the age of mechanical reproduction is the aura of the work of art."[19] At issue here is the plurality of copies versus a unique existence, for, as Benjamin observes, "to ask for the 'authentic' print makes no sense."[20] With the destruction of aura, art is not based on ritual but on politics, argues Benjamin, capitalizing on the mass function of the reproduction; in 1936, he saw fascism to be aestheticizing politics and communism to be politicizing art.

"The Work of Art in the Age of Mechanical Reproduction" elaborates on the ideas that Benjamin first expressed two years earlier in his 1934 essay "The Author as Producer," which argued for the rapprochement between technological innovation and radical politics. Benjamin insisted that the cultural agent must function within and transform the production relations of the time, utilizing photographic production and reproduction for the purposes of social change.[21] It is here, in this marriage of material form and engaged content, that Benjamin offers his response to Baudelaire's antithesis of aesthetic meaning and technology. Baudelaire's ambitious poet, in Europe of 1934, needed to embrace modern technology in an aesthetics of struggle, to *intervene* using modern material.

One form of modern imagery that in Benjamin's opinion supplied the productive apparatus without changing it was

photographic reportage (framed by the Soviet-derived aesthetic of the New Objectivity, a trend of 1920s German photography that employed dramatic camera angles, seriality, extreme close-ups, and stark light-dark contrasts). In Benjamin's estimation, reportage reproduces the values of capitalist society, bringing things from far away—foreign lands, springtime, celebrities—up close, all in the service of novel effects, entertainment, and modishness. Nothing is inaccessible; even poverty and suffering are aestheticized by elegant camera angles or glossy reproductions. Photography now transfigures the world by aestheticizing it, reporting on surfaces, not struggle. Benjamin argues that the way to rescue photography from its replication of capitalist modishness is to mobilize language, by way of the caption, to direct the meaning of the photograph to revolutionary ends. As he phrases it, text rescues the image from "modish commerce" in order to give it "revolutionary use value."[22]

Benjamin's first formulation of the symbiotic relation between photography and language can be found in "A Little History of Photography," published in *Die literarische Welt*, September–October 1931, during mounting political and economic instability in Germany.[23] There he argues that inscription anchors photographic meaning, offering it a constructed depth that rescues it from surface meaninglessness. To aid in his argument about photographic superficiality, Benjamin mobilizes Bertolt Brecht's now-often-quoted remark:

> [L]ess than ever does the mere reflection of reality reveal anything about reality. A photograph of the Krupp works or the A.E.G. reveals almost nothing about these institutions. Actual reality has slipped into the functional. The reification of human relations—the factory say—means that they are no longer explicit. So something must in fact be *built up*, something artificial, posed.[24]

That artificial, posed "something" adds up to Surrealist photography for Benjamin, who places his stakes in photographic imagery that offers a visibly constructed meaning.[25] Siegfried Kracauer too urged that the "surface coherence of the photograph must be destroyed" in order for history, substance, the idea to present itself, otherwise the "image idea" drives away the idea.[26]

Benjamin bases his understanding of photographic meaning in a technological determinism, proposing that photographic matter and process determine the meaning of an image. The silent, restful, quiet concentration of the early daguerreotype, he argues, is rooted in the material facts of the procedure such as prolonged exposure time and the need to be in a separate, closed-off space away from distractions (Benjamin reveled in the fact that David Octavius Hill photographed his subjects in a cemetery). "The procedure itself caused the subject to focus his life in the moment rather than hurrying on past it; during the considerable period of the exposure, the subject … grew into the picture."[27] For Benjamin, these early daguerreotypes had an aura, produced by "the way light struggles out of darkness," which lent qualities such as fullness and security to the subject's gaze.[28] "Everything about these early pictures was built to last."[29]

In stark contrast to the gravitas of the daguerreotype was the "split-second of exposure" of the 1920s snapshot, which Benjamin considers to be in keeping with the instability and flux of contemporary life: "[A]s Kracauer has aptly noted, the split second of the exposure determines 'whether a sportsman becomes so famous that photographers start taking his picture for the illustrated papers.'"[30] While its immediacy and speed suggest that the snapshot cannot summon an aura, it would also promise to be more powerful in destroying the bourgeois artwork's aura, as he advanced in his later "Work of Art" essay. But the loss of the photographic aura preceded the modern-day snapshot; in Benjamin's mind, it was already initiated by the gum print, or gum bichromate print, which was introduced in 1894 and remained popular

into the 1920s.[31] The procedure allowed the photographer to cre-
ate atmospheric effects by dissolving the pigmented gum arabic
surface with a stream of water or a brush.[32] For Benjamin, these
effects of depth and moody lighting preferred by the imperialist
bourgeoisie were artificial and whims of fashion.

While the bourgeoisie sought spiritual effects in tampered
pictures, the photograph itself summoned an enchanting presence
that Benjamin called the "optical unconscious," things visible to the
camera eye and the unconscious eye but invisible to the waking eye.
"[P]hotography reveals ... physiognomic aspects, image worlds,
which dwell in the smallest things—meaningful yet covert enough
to find a hiding place in waking dreams, but which, enlarged and
capable of formulation, make the difference between technology
and magic visible as a thoroughly historical variable."[33] Photogra-
phy, like the talking cure, reveals associations and presences not
immediately available to the conscious mind.

Photography's role in shaping mass public consciousness (or
unconsciousness) only intensified after World War II and peaked
during the Vietnam War. Mass media—primarily photography
but also television—were the means by which the public received
horrific images of the war atrocities.[34] Between 1954 and 1956,
the French semiotician Roland Barthes wrote a series of essays—
one each month for about two years—for a mass public on current
events. Several essays on the role of photography appeared in the
left-wing *Les Lettres nouvelles*. Barthes was less invested in the rela-
tion of photography to art, and focused instead on its construction
of cultural myths on a mass scale. His key assertion in *Mytholo-
gies* is that photography is not nature (in contrast to the previous
century's claims that photography is its coextension), not a "uni-
versal language" (a notion that he roundly attacks in his "Fam-
ily of Man" essay), but a form of coded, historically contingent,
ideological speech, amenable to scientific study, semiotic analysis
in particular, which he defines as the "science of forms."[35] The
result, insists Barthes, will not be an ahistorical formalist study

but one that enables a deepening of historical criticism, noting, "A little formalism turns one away from History, but a lot brings one back to it."[36] In "Myth Today," Barthes links photography with modern mythological speech, which is historical form parading as natural knowledge, as a kind of enduring truth. As the first term of a mythical system, the photograph distorts, alters, and disintegrates meaning, reproducing forms and relations of production as needed to maintain the power of the dominant ideology. Photography is constitutive of structures of power—history transformed to look natural. Above all, photography is malleable. As he notes in a later essay of 1961, "The Photographic Message," "[A] photograph can change its meaning as it passes from the very conservative L'Aurore to the communist L'Humanité."[37]

In two essays written during the early 1960s, "The Photographic Message" (1961) and "The Rhetoric of the Image" (1964), Barthes deepens his ideas on photography and semiotics first articulated in Mythologies.[38] Elaborating on the observations first offered by Walter Benjamin on the guiding role of text in photography, Barthes asserts that one way of anchoring that floating chain of signifieds, to "counter the terror of uncertain signs," is to root it with a "linguistic message."[39] While Benjamin sees text as offering depth and structure, Barthes ultimately considers text as a repressive form of ideological control: text helps the viewer to "choose" the correct level of understanding, leading the viewer to attend to some signifieds in the image and avoid others.[40] "[B]y means of an often subtle dispatching, it remote-controls him towards a meaning chosen in advance."[41] (In "The Photographic Message," he calls text "parasitic."[42]) The photograph generally exceeds the language assigned to it, however, since two signifying systems cannot duplicate one another, suggesting a level of redemption for photographic meaning.

Barthes insists that the photograph has an Edenic state, in which it is cleared, in a utopian fashion, of all connotations, becoming a "non-coded iconic message"; it is innocent, by virtue

of what he declares is its "absolutely analogical nature."[43] In this utopian state, the photographic message is what Barthes calls "a message without a code."[44] However, as soon as a photograph leaves Eden, so to speak, and enters into circulation, it becomes culturally coded, transforming the image and putting it into the realm of connotation. Barthes maintains that this connotation is not, strictly speaking, part of the analogic photographic structure, but dependent on a context, often an ideological one.[45] For Barthes, the photograph always oscillates between the naturalized image and the ideological sign, the denoted and the connoted message. His famous interpretation of the Panzani advertisement in "The Rhetoric of the Image" deconstructs a "naturalized" image of what he calls Italianicity, or transmitted clichés about Italian culture, in a photo-based advertisement for packaged pasta products to demonstrate how the photographic image is ideologically constructed in terms of codes and secondary systems. Barthes observes, "[T]he more technology develops the diffusion of information (and most notably of images), the more it provides the means of masking the constructed meaning under the appearance of the given meaning."[46]

2

The 1960s mark photography's decisive entry into the institutions of the fine arts, from museums to the art market. This shift was in large part engineered by the curators of American museums who sought to plead the case of photography as high art, excavating photography's essential properties so as to determine its difference from painting and sculpture and justify its place in the museum. As Douglas Crimp has noted, "[I]f photography was invented in 1839, it was only discovered in the 1960s and 1970s—photography, that is, as an essence, photography *itself*."[47] But Christopher Phillips observes that this cultural repackaging of photography in the 1960s shifts the emphasis from photography's (potentially

revolutionary) role as a mass medium to its "cult value" status, consequently inverting Walter Benjamin's terms.[48] This would be the appropriate context in which to consider the writings of John Szarkowski, curator of Photographs at the Museum of Modern Art from 1962 to 1991. Szarkowski is the bête noire of postmodern critics who condemn his sheer disregard of political, social, and cultural context in the quest for essential photographic meaning. Szarkowski's project was to assert the aesthetic value of the photograph against the mass culture of journals and magazines in which many photographers earned their daily bread. Apparently when Szarkowski arrived in New York in 1962, no gallery showed fine art photography. His 1966 publication *The Photographer's Eye* seeks to systematize photography and insert it into a Greenbergian modernist discourse, isolating the formal elements specific to photography and thereby giving it an authoritative aesthetic language of its own.[49]

In his own words, *The Photographer's Eye* "is an investigation of what photographs look like, and of why they look that way. It is concerned with photographic style and with photographic tradition."[50] The book asserts that there is indeed such a thing as a shared vocabulary of photography, some sort of common denominator, that belongs to photography alone. He proposes that the following five interdependent qualities are inherent in the medium: (1) "The Thing Itself," because photography deals with "actual"; (2) "The Detail"; (3) "The Frame," because "The photographer's picture is not conceived but selected"; (4) "Time," because "There is in fact no such thing as an instantaneous photograph"; and (5) "Vantage point," by which he means the various perspectives from which "the thing itself" can be framed, such as bird's- and worm's-eye views or foreshortening. While Szarkowski mobilized Clement Greenberg's critical strategy for the purposes of his photographic aestheticization, he stops short, as Christopher Phillips insightfully points out, of a materialist account of the photograph and the move to abstraction. "The formal characteristics he acknowledged

were all modes of photographic *description:* instead of stressing (as had Clement Greenberg in his formalist essays on painting) the necessary role of the material support in determining the essential nature of the medium, Szarkowski wished to reserve unexamined for photography that classical system of representation that depends on the assumed transparency of the picture surface. Thus the delimitation of formal elements could prove no end in itself, but only set the stage for a move to the iconographic level."[51]

André Bazin, the film critic for the French journal *Le Parisien libère,* is another writer in search of photography's essence in the 1960s. His purpose, however, is not to aestheticize photography for institutional purposes but to excavate the core qualities of the still photographic image in order to develop critical methods for the moving picture. Like Barthes, Bazin is interested in photography's role as a mass medium of culture, seeking differences between photography and film and finding them anchored in temporality. The ontology of the photographic image is moored in the psychological aspects of the invention, in particular, as a defense against the passage of time, a protection against death, whose primordial origins Bazin locates in Egyptian tombs. Bazin argues that in the modern world, the image is about the creation of an ideal world in the likeness of the real, with its own temporal destiny. Photography, he writes, "does not create eternity, as art does, it embalms time, rescuing it simply from its proper corruption."[52] In contrast to photography, which Bazin likens to long-dead insects preserved in amber, film cannot enshroud the instant, delivering mummified duration instead. An important aspect of photography's ontology is to be found in its objective access to the real: "No matter how fuzzy, distorted or discolored, no matter how lacking in documentary value the image may be, it shares, by virtue of the very process of its becoming, the being of the model of which it is the reproduction; it *is* the model."[53] Indeed, realism and its historical discourses are a primary preoccupation in Bazin's essay. Yet at the same time, Bazin notes, photography delivers

hallucination while it delivers fact—what Roland Barthes[54] would later call photography's "madness"—offering us an image of the real, of something that was, that we can hold in our hands, paste in an album, or put in a frame, but that does not physically exist in our time and space.

The social, cultural, and political caesurae of the late 1960s radicalized much (but not all) critical thinking about photography, turning the terms of discourse away from its core properties—be they formal, temporal, or structural—to a concern with the subject in politics and ideology. While the preoccupations of these writers are similar to those of the 1930s, the sheer scale of mass media—their omnipresence—necessitated different dimensions of discourse since the medium, as Barthes observed, had shifted from novel to naturalized. Roland Barthes chose not to change or update *Mythologies* in the wake of May 1968, for he noted that the need for ideological criticism was made "brutally evident" by these events.[55] As he writes in his 1970s preface, *Mythologies* is an ideological critique bearing on the language of mass culture. The series of essays written by the American philosopher Susan Sontag, first published in the *New York Review of Books* from 1973 to 1977 and subsequently collected in a volume called *On Photography*, are similarly invested in the political ideology of photography. Sontag is primarily interested in the ethical and moral problems raised by the sheer mass of photographs in capitalist society. Accordingly, much of her language frames photography in terms of consumption, acquisition, and power, offered up in a language that anticipates quotation. In her essay "In Plato's Cave," for instance, she offers aphoristically, "[T]he camera is the ideal arm of consciousness in its acquisitive mode," for "[t]o collect photographs is to collect the world."[56] And, "Photographs, which package the world, seem to invite packaging."[57]

Photography's primary social role, she argues, is not as an art form but as a mass form, continuing, "It is mainly a social rite, a defense against anxiety, and a tool of power."[58] Taking

photographs is a way of limiting experience of the world and making it safe by transferring it into a photogenic image, a souvenir. Both the act of photographing and the photograph itself become apotropaic devices, managing and taming difficult experience, numbing shock, not unlike a fetish—the word she uses herself is "talismanic."[59] In contrast to Kracauer, who hopes that the sheer mass of photographs will shock the viewer into some understanding of the surfaceness of the capitalist mode of production, Sontag ultimately offers up a Brechtian argument, which asserts that photographs only show the surface, not the complex relations below the surface:

> Photography implies that we know about the world if we accept it as the camera records it. But this is the opposite of understanding, which starts from *not* accepting the world as it looks.... The knowledge gained through still photographs will always be some kind of sentimentalism, whether cynical or humanist. It will be a knowledge at bargain prices—a semblance of knowledge, a semblance of wisdom; as the act of taking pictures is a semblance of appropriation, a semblance of rape.[60]

This language of superficial understanding, appropriation, and rape conjures leftist politics in post-1960s United States, produced in the crosscurrent of widespread anticapitalist, anti-imperialist, and pacifist sentiment at home and the American military intervention abroad in Vietnam.

Perhaps it was because Roland Barthes felt that he had said everything he needed to say about photography and ideology in *Mythologies* that he elected not to load his book *Camera Lucida* of 1980 with an overt politics. Or perhaps his concerns were more urgently personal at this moment in the late 1970s. Written in the wake of his mother's death and published shortly before his own untimely end, Roland Barthes's *Camera Lucida* is, among other things, a meditation on the memory work of photographs and

the privacy of photographic experience within the mass of public images. With the exception of Walter Benjamin, no other writer on photography is more often quoted and quibbled with than Roland Barthes in *Camera Lucida*. Moving away from the structuralist concerns of his earlier works, *Camera Lucida* invests more in the subjectivity and hallucinatory mystery of photographic experience. Although photography's material base is a mechanical and chemical process, the medium offers a melancholy poetics—traces of things and places that-have-been, a capturing of time lost, a specter of our imminent death—imparting an element of romantic mourning to this very banal object. Admitting that he is "concerned with the impulses of an overready subjectivity," Barthes's language is personal, full of parenthetical remarks, elliptical observations, and allusive conclusions, which infuriates some of his readers and charms others.[61] That allusive and multilayered form of writing links Barthes and Benjamin, charging their work with a suggestiveness that makes it fecund for generations of thinkers after them. Or, for others, useless. Many writers argue that Barthes's *Camera Lucida* is not useful for building up a functional theory of photography.

Possibly because of its maddening idiosyncrasy and ellipticality, there is a tendency in the interpretation of *Camera Lucida* to distill the text to the notions of the *punctum* and *studium* as the irreducible keys to interpreting a photograph. Like the work of Kracauer, Benjamin, and Sontag, Barthes's work addresses the mass of images in society, if primarily to dismiss them (he does not like all of them, experiencing indifference to most). This multitude of images he calls the *studium*, which are coded, cultural, and ideological, an experience of polite interest in photographs that he contrasts with the *punctum*, a noncoded detail in a photograph that unexpectedly pricks or wounds the viewer. It is a "subtle kind of *beyond*" that the image permits us to see.[62] Importantly, the *punctum*, which disturbs the *studium*, is private and personal.

While *punctum* and *studium* are certainly significant aspects of the essay and perhaps the most exportable ones, the book is an intricate investigation of and riff on the experience of photography. This is a project that is obliquely in alliance with that of other 1960s writings on the subject, as he speaks of an ontological desire to "learn at all costs what Photography was 'in itself.'"[63] I say "obliquely" because just as soon as he declares this intention, he fails to deliver on its so-called essence, offering instead an account that is contradictory, elusive, contingent, and subjective. While the photograph is Edenic in his earlier writings, here Barthes aims to be primeval: "I wanted to be a primitive, without culture," he writes, proposing to suspend his set of scientific apparatus in order to get at what photographs are in themselves.

The first "essential" element that Barthes proposes is that the photograph is never separated from its referent: "it is the absolute Particular, the sovereign Contingency, matte and somehow stupid, the *This* (this photograph and not Photography), in short, what Lacan calls the *Tuché*, the Occasion, the Encounter, the Real, in its indefatigable expression."[64] "The photograph," writes Barthes, "belongs to a class of laminated objects whose two leaves cannot be separated without destroying them both—referent and photo."[65] Our tendency to point, to conflate representation with the thing itself, brings Barthes to say, "Whatever it grants to vision and whatever its manner, a photograph is always invisible: it is not it that we see."[66] As much as Barthes insists that the "stubbornness of the Referent"[67] is part of the essence of photography (a notion that will be roundly attacked by subsequent theorists of photography), he also asserts its opposite:

> First of all, I did not escape, or try to escape, from a paradox: on the one hand the desire to give a name to Photography's essence and then to sketch an eidetic science of the Photograph; and on the other the intractable feeling that Photography is essentially (a contradiction in terms) only contingency,

singularity, risk: my photographs would always participate, as Lyotard says, in "something or other": is it not the very weakness of Photography, this difficulty in existing which we call banality?[68]

At the heart of his analysis, it seems, is not so much photography's referential nature, but its temporal nature, an idea first explored in "The Photographic Message" and developed considerably in *Camera Lucida:* "To ask whether a photograph is analogical or coded is not a good means of analysis. The important thing is that the photograph possesses an evidential force, and *that its testimony bears not on the object but on time*"[69] (italics mine). The presence of an object deferred is as central to Barthes's argument as the stickiness of the referent. Is it the "that" or the "has-been" that is the intractable element of Barthes's "that-has-been"? "[I]nterfuit: what I see has been here, in this place which extends between infinity and the subject; it has been here, and yet immediately separated; it has been absolutely, irrefutably present and yet already deferred. It is all this which the verb *intersum* means."[70]

Declaring that every photograph is an analogue or a certificate of presence past, as Barthes does, is not the same as insisting that it offers a one-to-one, undistorted (indexical) relationship to the world, as later commentators would have Barthes do. Barthes asserts, "[N]othing can prevent the photograph from being analogical."[71] An analogue, according to the *Concise Oxford Dictionary*, is "a person or thing seen as comparable to one another."[72] Deriving from the Greek word *analogos,* or "proportionate," an analogue is something that can be likened or is similar; it does not connote exactitude. Be that as it may, Barthes concludes, "Photography's *noeme* has nothing to do with analogy."[73] Rather, it is "an emanation of *past* reality: a magic, not an art."[74] And with that, we are returned to Barthes's primitivist imaginary.

3

Roland Barthes's richly suggestive *Camera Lucida* is one of a plurality of analyses that enters photography theory in the 1980s. Art historians also weigh in on the field, motivated by the significant methodological shifts in the art historical discipline that widened the field of study. Except for Szarkowski, the other prominent writers on photography theory thus far have not been art historians, but poets and novelists, journalists and philosophers, a film theorist and a semiotician. Ranging from the so-called new art history[75] to the incorporation of film theory, feminist theory, the psychoanalytical models of Sigmund Freud and Jacques Lacan, Michel Foucault's writing on power and control, and Louis Althusser's analysis of ideology, to name just a few, critical writings of the 1980s offer up an unprecedented complexity of theoretical approaches to photography. They were accompanied by a new prominence of photography in the art market and the increased prestige of photography within postmodernist art production.[76]

Many of these key texts on photography theory have been assembled in Richard Bolton's *The Contest of Meaning: Critical Histories of Photography* (MIT Press, 1989), which offers a significant cross-section of writings on photography in the early to mid-1980s in American scholarship. Bolton's own assessment of the status of photography in 1987 reads,

> We no longer need to argue for photography's acceptance as a form of art.... We no longer need to argue for the establishment of a distinct history of photography ... [but] the social function of photography and the social role of the photographic artist have been ignored.... By analyzing the material, institutional, and ideological influences on photographic practice, these writers create a new understanding of the dynamics of modernist photography and, more importantly, of the role of the photograph within *modernity*, within the modernization that has transformed twentieth-century life. These essays describe

not only the politics of photographic representation, but also the politics of meaning itself.[77]

While Roland Barthes emphasized that photographs are constituted by and constitutive of a contextually driven social language, the use of *discourse* as a key term in photography theory came about in the 1980s with the widespread influence of Michel Foucault's work, which demonstrated that discourse, not universal essences, constitutes the object. For example, in "Photography's Discursive Spaces" (1982), American art critic and professor of art history Rosalind Krauss investigates photography's shift from a wider scientific and empirical discourse in the nineteenth century to an aesthetic discourse in the twentieth century.[78]

In the nineteenth century, she argues, photography was often in the service of science and knowledge, integral to discourses of topography, geography, exploration, and survey, but those practices have been retrospectively inserted into aesthetic discourses by members of the museum institution who are invested in legitimating photography as an art. They assess the medium according to imposed (modernist) terms, such as flatness, composition and atmospheric effects, as well as aesthetic genres such as landscape, or notions of *oeuvre* and style. "The object here," as MoMA photography curator Peter Galassi famously wrote in the catalogue of his show *Before Photography*, "is to show that photography was not a bastard left by science on the doorstep of art, but a legitimate child of the Western pictorial tradition."[79] Krauss argues that this discursive shift, engineered by powerful arts institutions, takes these objects out of their original contexts, canceling their initial meanings and assigning them new ones. "Everywhere at present," Krauss notes, "there is an attempt to dismantle the photographic archive—the set of practices, institutions, and relationships to which nineteenth century photography originally belonged—and to reassemble it within categories previously constituted by art and its history."[80]

Douglas Crimp and Christopher Phillips also investigate the interpenetration of discourse and photographic meaning, examining two specific institutional models: the New York Public Library and the New York Museum of Modern Art, respectively. Crimp's "The Museum's Old/The Library's New Subject," published in 1981 (a year before Krauss's essay) and then revised in Bolton's *The Contest of Meaning*, considers the then-recent recategorization of photographs in the New York Public Library from their various dispersed archival locations into a singular department of Arts, Prints and Photographs.[81] Crimp argues that photography effectively has been transferred from an informational category to an aesthetic one—from the library to the museum—reassigning its plural functions in information, documentation, illustration, and so on into a singular category of autonomous modernist art. He considers the change to be indicative of a paradigm shift. For Crimp, Szarkowski's interpretation of the photograph according to its formal qualities is a perversion of the modernist project, "[f]or photography is not autonomous, and it is not, in the modernist sense, an art. When modernism was a fully operative paradigm of artistic practice, photography was necessarily seen as too contingent—too constrained by the world that was photographed, too dependent upon the discursive structures in which it was embedded—to achieve the self-reflexive, entirely conventionalized form of modernist art."[82] Szarkowski's retrospective recategorization of photography as art isolates photography within a single discursive practice, denying its earlier functions, and, for Crimp, setting in motion modernism's calcification and demise.

In "The Judgment Seat of Photography" (1982), Christopher Phillips, an American photography critic and editor, examines how the New York Museum of Modern Art's Department of Photography shapes public discourse on the medium. As Phillips notes, MoMA, "through its influential exhibitions and publications, has with increasing authority set our general 'horizon of expectations' with respect to photography," by which he means

the set of cultural, ethical, and historical expectations we hold in relation to photography.[83] Museums not only are taste makers but also determine understanding on a mass scale. Although this essay is focused on an American example, its observations hold for many instances of museums and their treatment of photography. The museum (as embodied by the MoMA Department of Photography) has effectively turned the photograph into an auratic art object, offering what Phillips calls "an ironic postscript" to Walter Benjamin's 1936 thesis in "The Work of Art in the Age of Mechanical Reproduction."[84] Photography, which Benjamin believed had overturned what he called the "judgment seat" of traditional art, has been in turn absorbed by the art establishment and transformed into an auratic cult object. Phillips observes, for example, the shift from the archival mode of Marville's documentary photos of Paris to what the curator Beaumont Newhall called "personal expressions" principally by virtue of Marville's "subtle lighting and careful rendition of detail."[85] We have ended up with an institutional framework at NY MoMA (currently in the person of Peter Galassi) that emphasizes photography's lineage from painting and an inherent nature that is modernist. Photography is now in its own aesthetic realm, consequently suppressing the medium's multiple determinations and functions.

In contrast to many writers on photography from the 1980s onward, Krauss is compelled by the referential status of photography. The term *index* figures prominently in her writings[86] and denotes the terminology proposed by the semiotician Charles Peirce, who theorizes the differences among signs according to a set of nine nonexclusive categories that includes symbol, icon, and index.[87] An "index" is a sign connected to its referent along a physical axis, such as a thumbprint or a footprint, offering a one-to-one correspondence with the thing it represents. Importantly, Peirce signals the complexity of photographic meaning, noting that the photograph is both an index *and* an icon, which establishes meaning through the effect of resemblance. In Krauss's

formulation, "The photograph is thus a type of icon or visual likeness, which bears an indexical relationship to its object."[88] Krauss uses the notion of the index—she also uses the terms *trace, imprint, transfer,* and *clue* to indicate the multiple ways of getting at this relation between photographic image and referent—to point out that photographs are first and foremost bound to the world itself rather than to cultural systems.[89] Krauss draws on Roland Barthes's assertion that a photograph in its Edenic, purely analogical state is a "message without a code," to emphasize that photographs, at base, are empty signs. She likens them to what linguist Roman Jakobson calls "shifters" (like the words "this" or "I" or "you"), which are filled with meaning only when juxtaposed with an external referent, with supplemental discourse.[90] Although Krauss ultimately argues that discourse, context, and supplemental meaning are what supply the empty indexicality of the photograph with meaning, its referentiality (and its basic meaninglessness) remains at the core of her analysis. Indexicality and displaced meaning are continually in play with one another in this theoretical framework.

The twentieth-century photograph's reproducibility is another key aspect of its identity that Krauss grapples with in "A Note on Photography and the Simulacral," an essay that draws on the theories of French sociologists Pierre Bourdieu and Jean Baudrillard. Bourdieu argues that the difference between art photography and popular photography (such as the tourist's snapshot) is a sociological effect rather a qualitative condition, because he believes that photography has no aesthetic norms proper to itself, instead borrowing them from other arts and movements. Because a photograph can be replicated endlessly from its celluloid negative, its condition conflicts with the values of originality and singularity that are the underpinnings of the fine arts discourse that seeks to emphasize photography's "cult value," to invoke Benjamin's term. Instead, the photograph can "partake of sheer repetition," as Krauss phrases it, breaking down the difference between original

and copy, singular object and multiple.[91] With the "total collapse of difference," Krauss asserts, the photograph enters the realm of the simulacrum and the theoretical territory of Jean Baudrillard, in which the possibility of differentiating between the real and the simulation is refused. Instead, what the mind experiences is a world full of copies, of resemblances. We are surrounded by the reality effect, Krauss observes, a labyrinth of resemblances of the real. Although the photograph is a trace of the world-out-there, it is nevertheless a mechanical representation of that world, a copy, a resemblant object, and not the thing itself. Herein lies what Krauss believes to be the discourse proper to photography; it is not an aesthetic discourse but one of "deconstruction in which art is distanced and separated from itself."[92]

As Rosalind Krauss observes, Alan Sekula is one theorist of photography who consistently condemns the aestheticization of photography.[93] He looks instead to its functions in the system of capitalist commodity exchange. An American Marxist critic and practicing photographer, Alan Sekula examines how the discourses of power and class relations within capitalism construct photographic meaning. "It goes almost without saying," Sekula writes in his 1981 essay "The Traffic in Photographs," "that photography emerged and proliferated as a mode of communication within the larger context of a developing capitalist *world order*," thus decimating any notion of photography as a universal or independent signifying system.[94] Indeed, Sekula takes issue with Barthes's division between photography's primitive, denotative core of meaning and its connotative, cultural meaning. For Sekula, photography is an incomplete utterance that always depends on external conditions in order to signify. Turning Barthes's language of mythology back on him, Sekula asserts that this notion of pure denotation is powerful "folklore," elevating photography to the legal status of document and lending it a "mythic aura of neutrality."[95] Instead, Sekula continually links photographic meaning to a task: "A photographic discourse is a system within

which the culture harnesses photographs to various representa-
tional tasks…. Every photographic image is a sign, above all, of
someone's investment in the sending of a message."[96] That task is
always trapped between the two animating tensions of capitalist
photographic discourse, which is at once objective and "scientific"
as well as subjective and "aesthetic," haunted, as he suggests, by
the "chattering ghosts" of bourgeois science and bourgeois art,
caught in "an incessant oscillation between what Lukács termed
the 'antinomies of bourgeois thought.'"[97]

I take Sekula's "The Body and the Archive" (originally
published in 1986)[98] to be indicative of these concerns. Sekula
argues that photography is "a double system," functioning "*hon-
orifically* and *repressively*."[99] On the one hand, the photographic
portrait (in this instance, a daguerreotype) provides "ceremonial
representation of the bourgeois *self*," reaffirming steadfastly held
notions of identity within a particular class; on the other hand,
the photographic portrait in the guise of the criminal identi-
fication photo operates repressively, establishing and delim-
iting the terrain of the other, of the criminal, the deviant, of
social pathology—that is, *not* the upstanding bourgeois citizen.
"[E]very proper portrait has its lurking, objectifying inverse in
the files of the police."[100] Sekula's context-driven account, based
on discourses of phrenology and criminology in nineteenth-cen-
tury society, demonstrates how the photograph is part of a com-
plicated social discourse, linked to historically bound notions
of scientific "truth" and policing at the same time that it is
allied with bourgeois notions of self through portraiture. For
Sekula, the materiality or physical quality of the photograph is
less significant than how the photograph functions to serve and
reinforce capitalist power structures. The contingency and inde-
terminacy of the photographic message that Barthes and Benja-
min anchored with the "caption" or "linguistic message" are now
simultaneously broadened and fastened by Sekula with the more
expansive notion of *discourse*.

Like Sekula, John Tagg argues that without a specific historical context, the photograph is meaningless in his *The Burden of Representation: Essays on Photographies and Histories,* a set of essays begun in the 1970s and published as a book in 1988.[101] The plurals indicated in his title—photograph*ies* and histor*ies*—suggest the multiple discursive practices he excavates in his book, drawing on Michel Foucault's theories of discipline and power and Louis Althusser's analysis of ideology and political control. While the formalist position of American museum professionals was a central point of contention among American postmodern theorists, it is the realist position of Roland Barthes that Tagg assails in his writings. Tagg rejects what he insists is Barthes's central claim in *Camera Lucida* that "every photograph is somehow co-natural with its referent."[102] Tagg vehemently contests the notion that a photograph guarantees a corresponding pre-photographic existent and a particular level of meaning, arguing instead (using a universal claim of his own) that "*every* photograph is a result of specific and, in every sense, significant distortions which render its relation to any prior reality deeply problematic."[103] His description of the unstable and distortional photographic process is as follows:

> Reflected light is gathered by a static, monocular lens of particular construction, set at a particular distance from the objects in its field of view. The projected image of these objects is focused, cropped and distorted by the flat, rectangular plate of the camera which owes its structure not to the model of the eye, but to a particular theoretical conception of the problems of representing space in two dimensions. Upon this plane, the multicoloured play of light is then fixed as a granular, chemical discolouration on a translucent support which, by a comparable method, may be made to yield a positive paper print.

How could all this be reduced to a phenomenological guarantee? At every stage, chance effects, purposeful interventions, choices, and variations produce meaning, whatever skill is applied

and whatever division of labor the process is subject to. This is not the inflection of a prior (though irretrievable) reality, as Barthes would have us believe, but the production of a new and specific reality, the photograph, which becomes meaningful in certain transactions and has real effects, but which cannot refer or be referred to a pre-photographic reality as truth.[104]

Tagg believes that the photographic distortions are meaningful enough to counter any sort of evidential force. The discourses of photography that center on its truth value—such as the legal record or criminal evidence—Tagg asserts are validated by not by its "natural" relation to fact, but by institutional and social practices. It is precisely these social practices that historians of photography need to examine in order to understand the functions of the medium. With Tagg, photographic meaning is ever deferred and displaced to institutional practice and power structures. "It is this field we must study, not photography as such."[105]

The referential status of photography is again interrogated by American photography historian and practicing photographer Joel Snyder in "Picturing Vision," an essay that seeks to debunk the notion that the photograph produces "a natural or privileged relation between picture and world," and that rejects the idea that it is a "condition of pictorial significance."[106] "If I hit the wall with a hammer," Snyder writes, "there is no reason to conclude that the dent *must* bear a resemblance to the head of the hammer."[107] Drawing on the writings of the philosopher Nelson Goodman and the art historian Ernst Gombrich, Snyder argues that the so-called nature of photography is not at all natural, that it does not replicate vision, but that it was constructed according to habits of vision established during the Renaissance. Emphasizing that the invention of the camera itself originated in conventions of vision based on painting, Snyder provides a brief history of the camera to demonstrate that its conception and manufacture were predicated on handmade pictures. "The problem for post-Renaissance painters was not how to make a picture that looked like the image

produced by the camera, it was how to make a machine that pro-
duced an image like the ones they painted."[108] "Photography," he
points out, "did not sidestep the standards of picture production,
it incorporated them."[109] Snyder suggests that we adopt a model
of vision itself as pictorial, based on various standardized customs
of seeing, thus "picturing vision"—and photographic vision—as
cultural, habitual, and, in fact, distorted, not a natural one-to-one
correspondence with the material world.

If the previous accounts of photography theory relate its
meaning to institutional and academic structures, the next two
accounts look for its meaning in unconscious habits, drawing on
psychoanalytic theory.[110] In his alliteratively titled "Photography,
Phantasy, Function" (1982), Victor Burgin theorizes photography
by means of theorizing *looking at* photography—the act of visu-
ally consuming the still image.[111] Combining Sigmund Freud's
theory of the fetish with Jacques Lacan's writings on the gaze and
the formation of the subject, Burgin provides a psychoanalytic
interpretation of the act of looking at photos as constitutive of the
beholder's ideological subject position. Vision is never a question
of just looking, insists Burgin: "the look always-already includes
the history of the subject."[112] His analysis hinges on the notion
of *suture*, first theorized by a student of Lacan and later adapted
into film theory, which is concerned with how (visual) utterances
both incorporate and activate the subject within a particular dis-
course.[113] Suture operates in all discourse and names the complex
processes by which the subject is interpellated by discourse, rec-
ognizing him or herself within it. The primary suturing instance
in photography, Burgin argues, is the subject's identification with
the camera position. That ego-identification with the camera-eye
will oscillate between voyeurism and narcissism, that is, between
a controlling gaze over the object represented and identification
with that object.

Burgin proposes a "structural homology" between the look
at the photograph and the look of the fetishist.[114] The fetishist,

according to Freud, has found some inanimate object to serve in place of the penis that he has traumatically found to be lacking in his mother; he (the fetishist in Freud's formulation is always male) looks at the fetish in order to look away from the site of trauma, displacing the look onto another thing in order to disavow the lack he knows is there but does not want to acknowledge.[115] The structure of fetishistic looking is a structure of "yes I know, but" or a separation of knowledge from belief that Burgin finds echoed in looking at photographs. "To look at a photograph for a while is to become frustrated," because looking at first gives scopophilic pleasure but then that pleasure is frustrated, because we still cannot access the reality that it represents.[116] "The look belongs to the camera."[117] Instead, the beholder experiences a constant to-and-fro between authority over the image and alienation from that image, desire and disassociation, causing a disruption in the imaginary relationship with the visual field before us, not unlike the fetishist who looks and then looks away from the site of sexual trauma. Offering a psychoanalytic take on what Siegfried Kracauer considered to be the surface nature of the photograph and the sheer excess of them in circulation, Burgin observes that we look and then look away, noting that photographs are deployed so that we need not look at them for very long; there is always another photograph in its place to receive the displaced look.[118] Burgin's theory of photography suggests, then, that we look and then look away from the photograph to understand it. As Geoffrey Batchen has already observed, Burgin's theory "displaces attention from the photograph itself (a category that Burgin has in any case already abandoned as antithetical to the semiotics of meaning production)" to operations outside, in another place.[119] Although Burgin argues elsewhere that there is no singular, unique system of signification upon which all photographs depend, he seems to undermine this claim by arguing for the homology between photographic structures of looking and the fetish.[120] That is, all photographic looking is figured by the operations of the fetish. Yet because fetishistic

looking is not *unique* to photography alone, since it also describes the fetish, Burgin's analysis eludes the essentialism he deplores.

In contrast to Burgin, Christian Metz's "Photography and Fetish" of 1985 emphasizes the relation between the material functions of the photograph and the fetish as a protection against death, rather than a source for displaced gratification. A fetish, like a photograph, signifies loss (symbolic castration) at the same time that it offers protection against loss. The authority of the photograph, which Metz calls "a silent rectangle of paper," rests in its motionlessness and muteness. It also operates as a figuration for death: "Immobility and silence are not only two objective aspects of death, they are also its main symbols, they *figure* it."[121] Metz notes that others insistently return to this parallel between photography and death, citing Philippe Dubois, who writes of photography as "thanatography," and of course Roland Barthes. In common parlance, photography is compared with shooting; the camera becomes a gun. The practice of displaying photographs of the deceased beloved keeps them in a live stasis, while at the same time, a photograph of ourselves witnesses our own aging, capturing a moment in our finite time that is always-already past and anticipates our own passing. The snapshot, too, is like death, states Metz. It is "an instantaneous abduction of the object out of the world into another world, into another kind of time…. The photographic take is immediate and definitive, like death and like the constitution of the fetish in the unconscious, fixed by a glance in childhood, unchanged and always active later."[122] While film returns the dead to an appearance of life, restoring bodies into time, photography by virtue of its stillness "maintains the memory of the dead *as being dead.*"[123]

The fragment, which Szarkowski argues is a photographic essence, is differently theorized in Metz, who bestows it with the psychoanalytic weight of the fetishistic part-object. Cutting off the subject matter from its context in space and time figures castration and is figured by the camera's "click."[124] Cutting off also intimates

an off-frame, something absent from view but close by.[125] This is precisely the operative structure of the fetish, according to Freud, which receives the traumatized glance of the boy-child who looks away from his mother's lack, displacing the gaze onto something close by, off-frame, just adjacent to the primal glance. Fetishism, like photography, is a constant process of framing and deframing. Metonymically, the fetish alludes to the adjacent place of lack; metaphorically, the fetish is the equivalent of a penis, replacing the absence with a presence, a thing, a part-object.[126] Metz observes how the fetish in everyday language combines a double and contradictory function: on the side of metaphor, an inciting and encouraging one, it brings luck, it is a pocket phallus (or like a photo in the wallet); and on the side of metonymy, an apotropaic one, averting danger, warding off bad luck.[127] Metz's interpretation of the "yes I know, but" structure of the fetish is opposite that of Burgin; for him, it points not to the permanent frustration of looking at a distant object, but to its proximity: "[S]he or he knows what a *representation* is but nevertheless has a strange feeling of reality (a denial of the signifier)."[128]

That these conventions associated with photography and looking are also determined by patriarchal power structures (treated as normative in most accounts—so commonplace so as not to bear scrutiny), in addition to historical, class, and institutional discourses, is taken up by American photography critic and feminist scholar Abigail Solomon-Godeau. As Solomon-Godeau observes, a feminist analysis of photography is not a localized appendage of, or a supplement to, other discursive studies of photography theory, but is, in her words, "an epistemological shift that involves nothing less than a restructuration, a reconstitution of knowledge."[129] The supposedly transparent and naturalistic medium of photography "has been an especially potent purveyor of cultural ideology—particularly the ideology of gender."[130] Solomon-Godeau critically examines the visual and discursive apparatuses through which the terms "masculine" and "feminine," "man" and "woman," have been and

continue to be constructed as subject positions, both in making and looking at photographs. Her work interrogates the ways in which photographs reproduce and also challenge tropes of male as viewer/female as viewed or male as active subject/female as passive object of the gaze. Solomon-Godeau observes that the binary structure of this male/female, subject/object split also works to repress homosexuality, often presuming a heterosexual spectator. "[F]eminism alerts us to the falsity—as well as the concomitant oppression—of presuming a universal male spectator."[131] In several essays, Solomon-Godeau foregrounds the sexual economy of looking at erotic and pornographic photography, which arguably represents the pinnacle of heterosexual male viewing.[132] In analyzing their pictorial strategies, Solomon-Godeau demonstrates their artificiality as opposed to their universality; when this analysis is directed at male nudes, which posits different potential viewers, both male and female, the alienation engendered by culturally normative categories becomes all the more evident. Similarly, Solomon-Godeau takes psychoanalytically informed terms such as *scopophilia, voyeurism,* and the *fetish,* which are theoretically structured around a male viewer and his pleasure and/or trauma, and examines them vis-à-vis female photographers and viewers, examining how they can be complicit with, subversive of, or ambiguous about patriarchal norms.[133]

Like most theorists of photography in the 1980s, Solomon-Godeau too rejects the notion that photography is a thing in itself, but rather believes it is something dynamically produced in the act of representation and reception and is always-already framed by preexisting discourses. Solomon-Godeau writes eloquently about institutional structures and discursive formations, but, importantly, the photograph itself never goes missing as it often does in other accounts of photography and its theories. She scrutinizes how a photograph produces meaning by attending to, in her words, "the syntax, the rhetoric, the formal strategies by which their meanings are constructed and communicated."[134] Her writing addresses both discursive codes and the material facts of

the photograph, noting, for example, how the "grainless and pre-
ternaturally sharp" quality of the daguerreotype works to articu-
late every freckle and blemish of a (viewed) woman's skin, thereby
heightening the picture's erotic and realist effects and solidifying
her argument. In her work, the photograph as a historical object
and as a visual imperative is always present, not displaced else-
where. Solomon-Godeau discusses the ramifications of matter,
aesthetics, and desire as integral, not contradictory, to a politi-
cized art historical project.

Geoffrey Batchen's *Burning with Desire: The Conception of Pho-
tography* (MIT Press, 1997) grapples with the opposing trends in
photography theory that have emerged since the 1960s, arguing
that they are not as diametrically opposed as they initially appear.
On the one hand, "postmodern critics," as Batchen identifies
them (though noting that they are by no means theoretically uni-
fied), argue that photographic meaning is determined by context
and deny that there is such a thing as "photography as such"; on
the other hand, the formalist critics seek to identify fundamental
characteristics of the photographic medium. Batchen, who admits
having been trained and influenced by the former category, what
he calls "the dominant way of thinking about the medium,"
argues that both positions are guilty of looking for some kind
of essence.[135] "In postmodern criticism, the photograph still has
an essence, but now it is found in the mutability of culture rather
than in its presumed other—an immutable nature."[136] In the end,
both camps believe that "photography's identity can be deter-
mined as a consequence of *either* nature *or* culture," and precisely
that binarism is troubling for Batchen.[137] In staking these binary
claims, Batchen argues that both postmodern and formalist posi-
tions "avoid coming to grips with the historical and ontological
complexity of the very thing they claim to analyze."[138]

Taking his cue from Michel Foucault's archaeological project
and Jacques Derrida's critique of opposition in the notion of *dif-
férance,* Batchen excavates the moment of photography's discursive

origin—not the disputed moment of photography's invention, but the moment of its *conception*, the *desire* to photograph—as a strategy to get at the problem of photography's complex identity. Photography's earliest proponents, he demonstrates, "offer far more equivocal articulations that incorporates but declines to rest at either pole."[139] Batchen's response to this either/or dichotomy is a both/and response, which is eloquently summarized in his reading of Hippolyte Bayard's *Self-Portrait as a Drowned Man* of October 18, 1840, a photograph that was made just over a year after the medium was made public. In Bayard's staged self-portrait, Batchen points out, photography is understood as both performative *and* documentary, nature *and* culture, demonstrating that during its early beginnings, photography's ontological status was understood as unstable, complex, and multiple, shuttling self-consciously between representation and the phenomenological real. "We can no longer afford to leave the battlefield of essence in the hands of a vacuous art-historical formalism," declares Batchen, because it is in the very matter of every photograph *and* photography's discursive spaces in which the operations of power and oppression reside.[140] "[P]ower inhabits the very grain of photography's existence as a modern Western event."[141]

4

The new millennium witnessed the widespread dissemination of another technology of photography, digital photography, which many consider to be a radical break from analogue photography. In contrast to the film-based and chemically transformed analogue photograph, the digitally encoded, computer-processable image first exists as mathematical data.[142] While light-sensitive silver salts on film in a camera produce an analogue photograph, in a digital photograph, a grid of light-sensitive picture cells, or pixels, emit electrical signals proportional to the intensity of light they receive. The gridded pattern is sequentially scanned and the

signals are converted to numbers proportionate to their strength, then electromagnetically stored. They can be altered (or not) by computer, and then transmitted onto a screen (television, computer) or onto paper. In contrast to analogue photography, which is tonally continuous, digital photography is broken up into discrete steps, subdividing the visual field into a grid.[143]

One of the predominant qualities of digital technology, it is argued, is its ability to produce imagery that has no immediate relation to the material world. Until it is printed, made material, the image is immaterial and ephemeral. This means that the image matter itself is infinitely malleable, freed from the restrictions of the analogue world and inserted into the exploratory, experimental, and potentially infinite digital realm. The image becomes "information" in the computer. As Peter Weibel, the director of the new media museum Zentrum für Kunst und Medien (ZKM) in Karlsruhe, once noted, "For the first time in history, the image is a dynamic system."[144] Discussions of the simulacrum intensify as the virtual world increasingly intersects with our lived, material world. French cultural theorist Paul Virilio prognosticates, "There will be no simulation but substitution."[145]

William J. Mitchell, professor of architecture and media arts, has written a methodical account of the ruptures between analogue and digital photography in *The Reconfigured Eye: Visual Truth in the Post-photographic Era* (MIT Press, 1992). His analysis rejects the notion that the digital photograph is infinite; instead, it is the traditional photograph that offers indefinite amounts of information. When enlarged, he argues, the analogue photograph reveals more detail, though a fuzzier and grainier picture.[146] A digital image, by contrast, "has precisely limited and tonal resolution and contains a fixed amount of information."[147] When a digital image is blown up to reveal its gridded microstructure, enlargement reveals nothing new but only lays bare the discrete square shapes of the pixel. However, to rework or tamper with the analogue photograph's fragile and recalcitrant emulsion-coated

surface, concealing all traces of recombination, is a labor-intensive and time-consuming process. To rework a digital image is effortless and even integral to it. Mutability and manipulation are inherent to the digital medium, Mitchell argues: "Computational tools for transforming, combining, altering, and analyzing images are as essential to the digital artist as brushes and pigments are to a painter, and an understanding of them is the foundation of the craft of digital imaging."[148] Because manipulation in digital imagery is so easy, however, its evidentiary force—its truth value—as an authentic record is put into question. "Increasingly, digital image manipulation was defined as a transgressive practice, a deviation from the established regime of photographic truth."[149] "We are faced not with conflation of signifier and signified, but with a new uncertainty about the status and interpretation of the visual signifier."[150] Even the mass replication of digital versus traditional photographs is different, Mitchell argues. While analogue photographs cannot be replicated without degradation, that is, without the loss of visual information, digital images can be copied ad infinitum, without loss of quality. "A digital copy is not a debased descendent but is absolutely indistinguishable from the original."[151]

Lev Manovich, formerly a graphic designer and now a professor of new media, is Mitchell's most vocal critic and the most prominent proponent of digital media's continuities, not breaks, with analogue technologies.[152] His essay "The Paradoxes of Digital Photography" argues that the digital photograph might break with aspects of older modes of representation but also reinforces them.[153] Manovich criticizes Mitchell's analysis for focusing entirely on the "abstract principles of digital imaging."[154] In practice, he argues, Mitchell's key points do not hold, adding provocatively, "Digital photography simply does not exist."[155] Manovich concedes, for example, that in theory, Mitchell is right that a digital image offers finite information and therefore limited detail. In reality, though, high-resolution images now make it possible to record more infor-

mation, in finer detail, than ever possible with analogue photography.[156] "Current technology has already reached the point where a digital image can easily contain much more information than anybody would ever want."[157] Moreover, Manovich notes, new technologies have bypassed the pixel grid such that "the pixel is no longer the 'final frontier'; as far as the user is concerned, it simply does not exist."[158] Manovich also takes issue with Mitchell's association of montage with digital photography and the tradition of realism with the essence of analogue photography. "What Mitchell takes to be the essence of photographic and digital imaging are two traditions of visual culture. Both existed before photography and both span different visual technologies and mediums."[159]

Manovich also considers Mitchell's notion of "normal" unmanipulated photography to be problematic, arguing that unmanipulated straight photography does not dominate modern uses of photography. Rather, straight photography was but one tradition of photography that coexisted with others. "Digital technology does not subvert 'normal' photography because 'normal' photography never existed."[160] Manovich equally disagrees with Mitchell's assertion that digital reproduction avoids pictorial degradation. While this may be true in theory, in practice, the considerable size of a single digital image requires a significant amount of computer storage space and makes it time-consuming to transmit over a network. Current software (the most widespread technique is JPEG) relies on lossy compression, which makes image files smaller by deleting information. Each time a compressed file is saved, he notes, more information is lost and therefore subject to even more degradation. Nor does Manovich see this trend reversing in the future. "[L]ossy compression is increasingly becoming the very foundation of digital visual culture."[161] Consequently, the theoretical differences between traditional photography and digital photography appear to be negligible enough in practice that significant physical differences between the two do not exist for Manovich.

It was Roland Barthes who wrote that photography is an uncertain art.[162] He noted its disorder—that all of its practices and subjects were mixed up together.[163] Much the same can be said of photography theory. It remains a messy and unsettled field, vehemently debated but with little consensus, and strong positions held on all fronts. Therein lay its appeal and its potential. The primary points of contention revolve around several key themes that continue to be revisited in the essays in this volume: the nature of its relation to the world-out-there, that is, its referentiality or indexicality, and whether this is significant; quarrels about photography's uniqueness or if it is always-already determined by its histories and contexts; and if it is an object or a function. While there has been a great deal of focus on the social, political, cultural, and psychological resonances of the photographic medium, it does seem that the actual physical characteristics of the medium and how they signify have gotten short shrift. In the 1980 introduction to *Classic Essays on Photography*, Alan Trachtenberg observed, "There has been little notable effort to address the medium itself, to examine its evolving character, its social and cultural properties, its complex relations with other media, and the great variety of roles it performs. Partly, although historians especially should know better, the cause of such neglect lies in the assumption that photography is unitary, a single method of making pictures, a unique visual language."[164]

Since that introduction was written in 1980, writing on photography theory has done much to address the social and cultural ramifications of photography, its relations with other media (most commonly advertising, film, and painting), and its multiple functions. Of course, there is still more to be said on all of these fronts—as various and multiple as the histories and contexts in which photographs operate. With a few notable exceptions, however, what is still missing from many accounts is how the medium and its various evolving incarnations signify in its particular contexts. That is, how does matter mean? How do the material and

physical processes of different photographic practices contribute to the meaning of the image represented? How are politics and culture imbricated in its very form? How does the photographic object circulate in a public sphere or a private one, and how does its physicality transform into meaning? Benjamin's "A Little History of Photography" is a compelling and useful model, integrating photographic technology with its social, political, and psychological meanings to arrive at a subtle and nuanced analysis. The photograph emerges as something that we not only look through but also look at. Given the increasing authority and omnipresence of digitality and virtuality, these questions about photography and its materiality seem all the more urgent and productive.

Acknowledgment

My thanks to Abigail Solomon-Godeau for her bibliographic recommendations for this essay.

Notes

1. Roland Barthes, *Camera Lucida* (New York: Hill & Wang, 1981), 5 (hereafter, *CL*).
2. Useful descriptions of these various processes can be found in Gordon Baldwin, *Looking at Photographs: A Guide to Technical Terms* (Los Angeles: J. Paul Getty Museum and the British Museum Press, 1991); and *A History of Photography*, edited by Jean-Claude Lemagny and André Rouillé (Cambridge: Cambridge University Press, 1987).
3. *The Contest of Meaning: Critical Histories of Photography*, edited by Richard Bolton (Cambridge, MA: MIT Press, 1989), xi.
4. Victor Burgin, "Something about Photography Theory," *The New Art History*, edited by A. L. Rees and Frances Borzello (Atlantic Highlands, NJ: Humanities Press International, 1986), 46.
5. Burgin, "Something about Photography Theory," 46.
6. Geoffrey Batchen, *Burning with Desire: The Conception of Photography* (Cambridge, MA: MIT Press, 1999).
7. Edgar Allan Poe, "The Daguerreotype," *Alexander's Weekly Messenger*, January 15, 1840, reprinted in *Classic Essays on Photography*, edited by Alan Trachtenberg (New Haven, CT: Leete's Island Books, 1981), 37–38.
8. Charles Baudelaire, "The Modern Public and Photography," in *Classic Essays on Photography*, 83–89.
9. Poe, "The Daguerreotype," 38.
10. Poe, "The Daguerreotype," 38.

11. Baudelaire, "The Modern Public and Photography," 86.
12. Baudelaire, "The Modern Public and Photography," 88.
13. Ian Jeffrey, *Photography: A Concise History* (Oxford: Oxford University Press, 1981), 10.
14. Kracauer hereby reinvigorated the debate between symbol and allegory within the terms of modern technological representation just a few years after his good friend Walter Benjamin investigated the role of symbol and allegory in the German baroque *Trauerspiel*. Kracauer wrote a review of Walter Benjamin's *Origin of German Tragic Drama* (1928; reprint, London: Verso, 1998) in the *Frankfurter Allgemeine Zeitung*, July 15, 1928. Reprinted in Siegfried Kracauer, *The Mass Ornament*, edited and translated by Thomas Y. Levin (Cambridge, MA: Harvard University Press, 1995), 259–64.
15. Kracauer, "Photography," in *The Mass Ornament*, 61.
16. Kracauer, "Photography," 58.
17. Walter Benjamin, "The Work of Art in the Age of Mechanical Reproduction," translated by Harry Zohn, in *Illuminations* (New York: Schocken, 1969), 222.
18. Benjamin, "The Work of Art," 223.
19. Benjamin, "The Work of Art," 223.
20. Benjamin, "The Work of Art," 224.
21. Walter Benjamin, "The Author as Producer," presented at the Institute for the Study of Fascism, Paris, on April 27, 1934. Reprinted in *Walter Benjamin: Selected Writings, Volume II, 1927–1934* (Cambridge, MA: Belknap Press of Harvard University Press, 1996), 768–82.
22. Benjamin, "The Author as Producer," 775.
23. Benjamin, "Little History of Photography," in *Walter Benjamin: Selected Writings, Volume II, 1927–1934*, 507–30.
24. Walter Benjamin, "Little History of Photography," 526. Rosalind Krauss's essay "The Photographic Conditions of Surrealism," in her *The Originality of the Avant-Garde and Other Modernist Myths* (Cambridge, MA: MIT Press, 1986), 87–118, compellingly pursues this line of thought.
25. Benjamin, "Little History of Photography," 526.
26. Kracauer, "Photography," 52, 58.
27. Benjamin, "Little History of Photography," 514.
28. Benjamin, "Little History of Photography," 517.
29. Benjamin, "Little History of Photography," 514.
30. Benjamin, "Little History of Photography," 514.
31. Baldwin, *Looking at Photographs*, 51.
32. Baldwin, *Looking at Photographs*, 51.
33. Benjamin, "Little History of Photography," 512.
34. According to Mary Warner Marien, in spite of increased sales of television sets in the mid-1960s, television news did not surpass newspapers and picture magazines as a major source of information until the early 1970s. Mary Warner Marien, *Photography: A Cultural History* (London: Laurence King Publishing, 2002), 364.
35. Barthes, "Myth Today," in his *Mythologies* (New York: Noonday Press, 1972), 112.
36. Barthes, "Myth Today," 112.

37. Barthes, "The Photographic Message," in *Image, Music, Text*, edited by Stephen Heath (London: Fontana, 1977), 15.
38. "The Photographic Message" (1961) and "The Rhetoric of the Image" (1964) were originally published in the journal *Communications* and later translated and compiled by Stephen Heath in *Image, Music, Text*.
39. Barthes, "The Rhetoric of the Image," 9.
40. Barthes, "The Rhetoric of the Image," 39.
41. Barthes, "The Rhetoric of the Image," 40.
42. Barthes, "The Photographic Message," 25.
43. Barthes, "The Rhetoric of the Image," 42–43.
44. Barthes, "The Rhetoric of the Image," 43. With photography, Barthes argues later in the essay, humanity encounters for the first time in history a message without a code. "Hence the photograph is not the last (improved) term of the great family of images; it corresponds to a decisive mutation of informational economies" (45).
45. Barthes, "The Rhetoric of the Image," 49.
46. Barthes, "The Rhetoric of the Image," 46.
47. Douglas Crimp, "The Museum's Old/The Library's New Subject," in Bolton, *The Contest of Meaning*, 7.
48. Christopher Phillips, "The Judgment Seat of Photography," in *October: The First Decade*, edited by Annette Michelson, Rosalind Krauss, Douglas Crimp, and Joan Copjec (Cambridge, MA: MIT Press, 1989), 283. Originally published in *October* 22 (Fall 1982), and also republished in Bolton, *The Contest of Meaning*.
49. John Szarkowski, *The Photographer's Eye* (New York: Museum of Modern Art, 1966).
50. Szarkowski, *The Photographer's Eye*.
51. Phillips, "The Judgment Seat of Photography," 287.
52. André Bazin, "The Ontology of the Photographic Image" (1967), in Trachtenberg, *Classic Essays on Photography*, 242.
53. Bazin, "The Ontology of the Photographic Image" (1967), 241.
54. Barthes, *CL*, 115–19.
55. Barthes, *Mythologies*, February 1970 preface, 9.
56. Susan Sontag, "In Plato's Cave," in her *On Photography* (New York: Farrar, Straus & Giroux, 1977), quotations taken from 4 and 3 respectively.
57. Sontag, "In Plato's Cave," 4.
58. Sontag, "In Plato's Cave," 8.
59. Sontag, "In Plato's Cave," 20.
60. Sontag, "In Plato's Cave," 24.
61. Barthes, *CL*, 18. Some have interpreted that personal language as a bid to write fiction, not an academic study. Margaret Iversen understands *CL* to be a "kind of fable about photography," while Margaret Olin distinguishes between Barthes the author versus "Barthes" the narrator of the book in order to separate two writerly strategies. See Margaret Iversen, "What Is a Photograph?" *Art History* 17, no. 3 (September 1994): 450–64; and Margaret Olin, "Touching Photographs: Roland Barthes's 'Mistaken' Identification," *Representations* 80 (Fall 2002): 99–118.
62. Barthes, *CL*, 59.
63. Barthes, *CL*, 3.
64. Barthes, *CL*, 4.

65. Barthes, *CL*, 6.
66. Barthes, *CL*, 6.
67. Barthes, *CL*, 6.
68. Barthes, *CL*, 20.
69. Barthes, *CL*, 88–89.
70. Barthes, *CL*, 77.
71. Barthes, *CL*, 88.
72. *Concise Oxford English Dictionary*, 11th ed., 46
73. Barthes, *CL*, 88.
74. Barthes, *CL*, 88.
75. Victor Burgin, in his essay "Something about Photography Theory" (1986), argues that the "new art history" has had no consequences for the study of photography as the new art history wants to avoid isolating works from the broader social circumstances of production and reception, which is impossible to do with photography. Art historians have succeeded in doing just that, as we shall see, but Burgin's statement reiterates his theoretical position against those very formalist accounts in order to assert the radical mobility and contingency of the photograph.
76. Abigail Solomon-Godeau, *Photography at the Dock: Essays on Photographic History, Institutions, and Practices* (Minneapolis: University of Minnesota Press, 1991), xxi.
77. Bolton, "Introduction," in *The Contest of Meaning*, ix–x.
78. Rosalind Krauss, "Photography's Discursive Spaces," in her *The Originality of the Avant-Garde*. Originally published in *Art Journal* 42, no. 4 (Winter 1982): 311–19; and also republished in Bolton, *The Contest of Meaning*, 287–302. Andrew E. Herschberger has recently published a critique of Krauss's Foucaultian method in "Photography's Discursive Spaces," arguing that she dichotomized and misused Foucault by nominating two categories—art and science—to which nineteenth-century photography was assigned. Herschberger notes that Krauss fixes these divisions, in turn making normative, coherent, and unified categories, while Foucault asserted that discursive formations are dispersive and illogical. He also argues that Krauss misuses the notion of the archive in precisely the way that Foucault was critiquing it, namely, as an institutional repository for documents and records. Foucault, according to Herschberger, imagines the archive as a system that is never fully completed. How, then, can it be dismantled and reassembled, as Krauss claims, when for Foucault it is beyond our grasp and never completed? Herschberger asserts that Krauss has set a precedent for misunderstanding in subsequent Foucaultian interpretations of photography. See Andrew E. Herschberger, "Krauss's Foucault and the Foundations of Postmodern History of Photography," *History of Photography* 30, no. 1 (Spring 2006): 55–67.
79. Krauss, "Photography's Discursive Spaces," 135, originally published in Peter Galassi, *Before Photography* (New York: Museum of Modern Art, 1981), 12.
80. Krauss, "Photography's Discursive Spaces," 150.
81. Douglas Crimp's essay, "The Museum's Old/The Library's New Subject," was originally published in *Parachute* 22 (Spring 1981). All citations refer to Bolton, *The Contest of Meaning*.
82. Crimp, "The Museum's Old/The Library's New Subject," 8.

83. Phillips, "The Judgment Seat of Photography," 258.
84. Phillips, "The Judgment Seat of Photography," 258.
85. Phillips, "The Judgment Seat of Photography," 265; taken from Beaumont Newhall, *Photography: 1839–1937,* exhibition catalogue (New York: Museum of Modern Art, 1937), 48.
86. See for example Rosalind Krauss, "Notes on the Index: Part 1," "Notes on the Index: Part II," and "The Photographic Conditions of Surrealism," all in Krauss, *The Originality of the Avant-Garde.*
87. See C. S. Peirce, "Logic as Semiotic: The Theory of Signs," in *Philosophical Writings of Peirce,* edited by Justus Buchler (New York: Dover Publications, 1955). As many writers have pointed out and as the roundtable discussion amplifies, Peirce's complex argument is often oversimplified and misused in discussions of the index in photography. It nevertheless remains a key term in the debates of photography theory.
88. Krauss, "Notes on the Index: Part 1," 203.
89. Krauss, "Notes on the Index: Part 2," 212.
90. Krauss investigates shifters and photographic meaning in both Parts 1 and 2 of "Notes on the Index."
91. Rosalind Krauss, "Photography and the Simulacral," *October* 31 (Winter 1984): 49–68, esp. 59.
92. Krauss, "Photography and the Simulacral," 63.
93. Krauss, "Photography's Discursive Spaces," 150 n. 27.
94. Alan Sekula, "The Traffic in Photographs," in *Photography against the Grain: Essays and Photo Works 1973–1983* (Halifax: Press of the Nova Scotia College of Art and Design, 1984), 8.
95. Alan Sekula, "The Invention of Photographic Meaning," in *Photography against the Grain,* 5.
96. Sekula, "The Invention of Photographic Meaning," 5–6.
97. Sekula, *Photography against the Grain,* xv.
98. Alan Sekula's "The Body and the Archive" was originally published in *October 39* (Winter 1986): 3–64; and was revised in Bolton, *The Contest of Meaning,* 343–88. All citations refer to the Bolton version.
99. Sekula, "The Body and the Archive," 345.
100. Sekula, "The Body and the Archive," 346.
101. John Tagg, *The Burden of Representation: Essays on Photographies and Histories* (Amherst: University of Massachusetts Press, 1988).
102. Tagg, *The Burden of Representation,* 1.
103. Tagg, *The Burden of Representation,* 2.
104. Tagg, *The Burden of Representation,* 3.
105. Tagg, *The Burden of Representation,* 63.
106. Joel Snyder, "Picturing Vision," *Critical Inquiry* 6 (Spring 1980): 500.
107. Snyder, "Picturing Vision," 507.
108. Snyder, "Picturing Vision," 512.
109. Snyder, "Picturing Vision," 514.
110. See also Margaret Iversen's compelling rereading of Roland Barthes's *CL* through a Lacanian perspective, which further explores the structures of traumatic looking in photographs. Iversen, "What Is a Photograph?"
111. Victor Burgin, "Photography, Phantasy, Function," in *Thinking Photography,* edited by Victor Burgin (London: Macmillan, 1982).
112. Burgin, "Photography, Phantasy, Function," 188.

113. The notion of *suture* was first articulated by the French Lacanian psycho-analyst Jacques-Alain Miller; see Jacques-Alain Miller, "Suture (elements of the logic of the signifier)," *Screen* 18, no. 4 (1977–1978): 24–34. In film theory, suture is used to describe the way in which the construction of various shot-to-shot relationships structures the viewer as an ideological subject. See Kaja Silverman, *The Subject of Semiotics* (Oxford: Oxford University Press, 1983), 194–236; and Stephen Heath, *Questions of Cinema* (Bloomington: Indiana University Press, 1981), for semiotic analyses of suture in cinema.
114. Burgin, "Photography, Phantasy, Function," 190.
115. Sigmund Freud, "Fetishism" (1928), in *Standard Edition of the Complete Psychological Works of Sigmund Freud*, vol. 21 (New York: Vintage, 1999).
116. Burgin, "Photography, Phantasy, Function," 191.
117. Burgin, "Photography, Phantasy, Function," 191.
118. Burgin, "Photography, Phantasy, Function," 191.
119. Geoffrey Batchen, *Burning with Desire: The Conception of Photography* (Cambridge, MA: MIT Press, 1997), 11.
120. Burgin, "Something about Photography Theory," 49.
121. Christian, Metz, "Photography and Fetish," *October* 34 (1985): 83.
122. Metz, "Photography and Fetish," 84.
123. Metz, "Photography and Fetish," 84.
124. Metz, "Photography and Fetish," 87.
125. Metz links the off-frame to Barthes's *punctum:* "For Barthes, the only part of a photograph which entails the feeling of an off-frame space is what he calls the *punctum,* the point of sudden and strong emotion, of small trauma; it can be a tiny detail. This *punctum* depends more on the reader than on the photograph itself, and the corresponding off-frame it calls up is also generally subjective; it is the 'metonymic expansion of the punctum'"; Metz, "Photography and Fetish," 87.
126. Metz, "Photography and Fetish," 86.
127. Metz, "Photography and Fetish," 86.
128. Metz, "Photography and Fetish," 88.
129. Solomon-Godeau, *Photography at the Dock*, xxxi.
130. Solomon-Godeau, *Photography at the Dock*, 257.
131. Solomon-Godeau, *Photography at the Dock*, 257.
132. See, for example, Abigail Solomon-Godeau, "Reconsidering Erotic Photography: Notes for a Project of Historical Salvage," and "Sexual Difference: Both Sides of the Camera," both in *Photography at the Dock.*
133. See in particular Abigail Solomon-Godeau, "Just like a Woman," in *Photography at the Dock;* and Abigail Solomon-Godeau, "The Legs of the Countess," *October* 39 (Winter 1986): 65–108.
134. Solomon-Godeau, *Photography at the Dock*, 225.
135. Batchen, *Burning with Desire*, 5.
136. Batchen, *Burning with Desire*, 20.
137. Batchen, *Burning with Desire*, 21.
138. Batchen, *Burning with Desire*, 21.
139. Batchen, *Burning with Desire*, x.
140. Batchen, *Burning with Desire*, 202.
141. Batchen, *Burning with Desire*, 202.
142. See Baldwin, *Looking at Photographs*, 37–38.

143. William J. Mitchell, *The Reconfigured Eye: Visual Truth in the Post-photographic Era* (Cambridge, MA: MIT Press, 1992), 4–5.

144. Michael Rush, *New Media in Late 20th-Century Art* (London: Thames & Hudson, 1999), 170.

145. Rush, *New Media,* 170.

146. Mitchell, *The Reconfigured Eye,* 6.

147. Mitchell, *The Reconfigured Eye,* 6.

148. Mitchell, *The Reconfigured Eye,* 7.

149. Mitchell, *The Reconfigured Eye,* 16.

150. Mitchell, *The Reconfigured Eye,* 17.

151. Mitchell, *The Reconfigured Eye,* 6.

152. See Lev Manovich, *The Language of New Media* (Cambridge MA: MIT Press, 2001), which, among other things, plots the connections between new media arts and traditional cinema.

153. Lev Manovich, "The Paradoxes of Digital Photography," in *The Photography Reader,* edited by Liz Wells (New York: Routledge, 2003), 240–49.

154. Manovich, "The Paradoxes of Digital Photography," 242.

155. Manovich, "The Paradoxes of Digital Photography," 242.

156. Manovich, "The Paradoxes of Digital Photography," 243.

157. Manovich, "The Paradoxes of Digital Photography," 244.

158. Manovich, "The Paradoxes of Digital Photography," 244.

159. Manovich, "The Paradoxes of Digital Photography," 245.

160. Manovich, "The Paradoxes of Digital Photography," 245.

161. Manovich, "The Paradoxes of Digital Photography," 243.

162. Barthes, *CL,* 18.

163. Barthes, *CL,* 16.

164. Alan Trachtenberg, "Introduction," in *Classic Essays on Photography* (New Haven, CT: Leete's Island Books, 1980), vii.

2

STARTING POINTS

CONCEPTUAL LIMITATIONS OF OUR REFLECTION ON PHOTOGRAPHY

THE QUESTION OF "INTERDISCIPLINARITY"

Jan Baetens

In these remarks on the limits of conceptualization of photography, I would first like to focus on what is generally considered the main limit of photography itself: *time*. In our doxical views on photography, we still stick indeed to the "snapshot" idea of photography, apparently left untouched by all possible paradigm shifts since 1839 (and of course before, but that is not the problem at stake here). Yet, my interest in time in photography is not just an interest in the limits of the medium; it is also a rather direct way to tackle the specificity and thus, I argue, the conceptualization of the medium itself. Although such an interest in medium specificity is no longer taken for granted today,[1] I still believe that it is not only valuable, but also necessary, in discussions on limits, borders, transgressions, and the like. So please excuse my old-fashioned obsession with photographic time and medium specificity, and try

to see it as a shortcut to my ideas on the conceptualization of limits of photography, which will appear to have close links with a rather different matter, that of interdisciplinarity.

Why has it become so difficult to think about photography?[2] There are of course many reasons, but two of them deserve to be foregrounded. First there is our difficulty with limiting "meaning" to itself, that is, with keeping "meaning" safe from "context." We are no longer able to speak of meaning in itself, and our unavoidable taking into account of the "context" opens a door, which becomes a deadlock, which becomes an abyss: "meaning is context bound, but context is boundless" (Jonathan Culler).[3] At a more general level, one might even ascertain a certain influence of contemporary thinking stressing the "impossibility" to fix meaning, to delineate a certain subject matter, to come to terms with a problem (this is an almost existential issue, to which I shall come back later). Second, there is also the fact that we no longer believe that photography is one single medium. Photographs change through time, and it is not possible to reduce all types of photography to one model.[4] Our current fascination with hybridization is probably one possible consequence of this shattered vision of photography. More: we are losing the very traces of photography once we start paying attention to, as every serious contact with photography should do today, practices of looking, on the one hand,[5] and practices of image making, on the other hand.[6] In the former case, photography becomes part of a longer history of technology-driven ways of manipulating and disciplining the imperfect, anarchic, chaotic human eye (photography, here, is not the absolute turning point in modern visual history, but one of the technologies that were developed after the acknowledgment, situated by Jonathan Crary at the late eighteenth century, of the fundamental discovery of the "embodiment" of the eye); in the latter case, photography as we tend to conceptualize it, that is, a technique of image making, loses also its privileged position in order to become part of a larger series of techniques of

surface markings between which the boundaries are rapidly being blurred; in both cases, the result is similar: photography can no longer be distinguished from other ways of knowledge production by visual means.

Yet at the same time, this picture is much too dark. Even if photography as a compact, monolithic, one-dimensional medium may seem to have vanished into the air, there are also many discursive, methodological, and theoretical innovations that help us conceptualize its object. Sometimes these innovations contradict the already mentioned tendencies and doubts, but this is utterly normal in periods of open discussion and radical transformations. For symmetry's sake, I will also limit myself here to three major changes. What they have in common is their ability to make us think more clearly about what photography is and what pictures mean. First, I would like to stress the rediscovery and fine-tuning of historicization, which is no longer reduced to art historical schemes and categories (the "artist," his or her "style," and so on) but enlarged to the study of interpretive frames and models for instance ("discourses," in a loose sense of the word) and to the whole field of photography (industrial, scientific, and vernacular photography, and so on). Second, one should mention a renewed interest in questions of medium specificity, whether they are determined by new visions of what specificity means (no longer an eternal essence, but a permanently shifting effort to "link" signs, supports, and contents)[7] or by a politically inspired resistance to the spread of hybrid forms in contemporary visual culture.[8] And, third, how could one ignore the rise of interdisciplinarity as the universal answer, not to say the wonder drug, to all our interrogations and perplexities? Interdisciplinarity is seen as the panacea we need in order to escape the limits of disciplinary and narrowing methods, and its usefulness is hardly contested.

But what exactly do we mean here, that is, in the field of photography, by "interdisciplinarity"? And does interdisciplinarity really offer us the profit we are expecting from it? Does it not

reintroduce, albeit unnoticed, new forms of limits? And, if this is the case, is this an inherent danger, or should we try to define other types of interdisciplinary that give us new looks on the problem of the limits of conceptualization? These four questions will form the thread of my argument.

1

Interdisciplinarity is not a decontextualized and dehistoricized phenomenon. In the field of photographic discourse, it can certainly not be reduced to one single phenomenon. Interdisciplinarity implies first of all "disciplinarity," and in the case of the discourse on photography, such a disciplinarity implies a previous phenomenon of "professionalization." In order to become a real discipline, photographic discourse had to become the discourse of a certain type of specialists, and very often, I will argue, those specialists appeared to be no photographers at all. In other words, if interdisciplinarity supposes professionalization, then the discourse on photography becomes a kind of "language game" that is played for and by academic peers, in an arena that is no longer either that of the photographic practice itself or that of social life and social action (and this is, of course, what is really at stake in the recent discussions on professionalism).[9]

If in the first decades, and even the first century, of photography, the discourse on photography was held by photographers (the difference between professionals and enlightened amateurs does not play a fundamental role here), its professionalization has produced a radical shift in the profile of those speaking on photography: it is no longer the photographers themselves who are socially recognized as having the key to what they do; it is academics, that is, people having no direct relationship with artistic practice (unless as critics and theoreticians).[10] Those specialists acquire the privilege of "talking art" in a serious matter, and they have hardly any competition when "theory" is involved. Such a shift is rather

common in contemporary society: the same can be observed in literature, for instance, where theory is no longer produced by the writers themselves (this was still a perfectly common stance in the nineteenth century; it may suffice to think of Flaubert). It is, however, not a fatality: in film studies, for instance, filmmakers are not excluded from the professional debate: Eisenstein, Hitchcock (or should we say his ghostwriter, Truffaut?), Bresson, Godard, Tarkovsky, and many others are not disqualified by the fact that they are not scholars in the classic sense of the word. For photography, the situation is slightly bizarre. On the one hand, one observes an increasing tendency toward "professionalism" (and thus away from practice). On the other hand, the professionals under question have a very particular background: they are not sociologists, art historians, or, why not, photography scholars, but writers, often with an important personal creative practice in literature. Think for instance of the five major names in the socially and professionally legitimized discourse on photography: Walter Benjamin, André Malraux, Susan Sontag, John Berger, and Roland Barthes, who have in common the fact that they are in the first and the last place... writers (yet not all of them in the same way: some of these authors are not "fiction writers," and even if they are, or are not, their relation to fiction cannot be reduced to one simple model; Malraux for instance moved away from fiction to theory, whereas Barthes's work evolved the other way around, without therefore ever attaining the border of "real" fiction). Nevertheless, all of these writers have been more or less sensitive to the seduction of the literary in their texts on photography. The case of Roland Barthes is of course the most explicit, since it is not impossible to argue that his later work on photography was a way of coping with the impossibility to write the novel he was dreaming of. The case of Susan Sontag, who was not confronted with this problem of the impossible novel and whose writing on photography is much more turned outwards, may represent the opposite pole in the range of possible attitudes toward the relationship of literature

and writing on photography.[11] Are we then to be surprised that in a recent book on the cultural history of photography, the author opens with a simple sentence that sounds like a manifesto: "C'est la littérature qui donne du sens à la photographie."[12] Even if today things have become a little different (one might suppose, for instance, that the role of the writers has now been taken over by philosophers and art historians, and the names of Jean Baudrillard and Geoffrey Batchen come here easily to mind), this strange concentration of photographic discourse in the hands of people with a literary background is not a simple detail or a mere coincidence. Before asking some questions on the pros and cons of such a situation, always from the perspective of the limits of conceptualization, one should start wondering if one can really speak of interdisciplinarity when the professional discourse on an object is detained almost monopolistically by one type of scholars, despite their paramount contributions to the field and whatever may be the importance of the "visual turn" in their thinking. One may indeed suppose that a certain type of monodisciplinary discourse has simply taken over the position of a former monodisciplinary one. In other words: the discourse on photography presents itself in a very interdisciplinary manner, but its reality may resemble also a disguised new monodisciplinarity (of course, I know I am exaggerating).

2

What are the advantages of this (supposedly) literary approach of photography? Provided one accepts my idea that the discourse on photography has been a literary discourse for many years, that is, a discourse secretly or overtly haunted by the prestige of literary fiction, how then has literature reshaped our vision of photography? In what follows, I would like to stress four ideas: antitechnofetishism, antiessentialism, antiformalism, and antilogocentrism.

A major achievement of the literary discourse on photography has obviously been the fading of technological fetishism. Contrary to many ancient discourses on photography, the discussions on technical aspects of photography cease here to be rather vague and general (the more technical discussions have survived more easily in the socially delegitimized circles of photo amateurs). Of course, literary discourse pays a lot of attention to the impact of photography as a new technique of image making, but this interest is often so general that one has the impression that the "idea" of photography matters more than the formerly more widespread discussions on lenses, cameras, lightning techniques, photographic papers and chemicals, and so on. I consider this an achievement (with many losses also, of course), since it has freed the discourse on photography from its narrow technical bases and opened it to the broader field of cultural history and critique. This innovation does not imply, however, that the new discourse on photography is no longer hindered or hampered by technological determinism.[13] The clearly exaggerated ways in which the digital evolution has been overinterpreted as an absolute watershed is a good symptom that the refusal of technofetishism can perfectly go along with an obvious technological determinism.[14] The most interesting aspect of literary discussions on technological determinism in photography, however, has less to do with photography itself then with the *mediation* of photography. André Malraux's ideas on the photographic revolution on art, for instance, cannot be separated from his reflection on the encounter between the medium of photography and the medium of the book.[15] In this sense, the technological determinism introduced by literary scholarship on photography seems to be very nuanced.

A second innovation, probably the most important one of those enumerated here, is the attack on essentialism. The interdisciplinary reading of photography has made possible that the basic assumption of a photograph as mainly pictorial, that is, spatial and thus nontemporal or nonsequential, has been radically con-

tested. Step by step, literary-minded scholarship has brought in an analysis that stresses the photograph's vulnerability to the characteristics of its seemingly opposite pole: the text and, more broadly speaking, the time-based arts. This larger scope can be described in three phases: first, a picture is seen as situated in *time;* then, a picture is seen as telling a *story;* and, finally, a picture is seen as capable of narrating a *fiction* (literature being, as Thélôt, reminds us, radically different from the purely denotational language of the "paper," be it the newspaper or the research paper). It will come as no surprise that my examples here are in the first place Mieke Bal and Jacques Derrida. The narratological bias of Mieke Bal's feminist readings of the image not only aims at exceeding the word and image divide, but also tends most of all at developing (inventing) alternative (fictional) stories to oppose patriarchal rule in art (and) history. The interest of Jacques Derrida in the photonovellas by Marie-Françoise Plissart, for example, has an even more narrative and fictional bias, which illustrates his vision on the impossibility to fix meaning.[16]

Time, story, fiction: these three inextricably linked elements contradict rather bluntly the traditional vision on photography as a realist slice of space. The motivations of this "despatialization" of photography are utterly diverse, but its impact on the essentialist vision of photography is very direct. Photography is no longer concerned by the Lessing-Greenberg paradigm opposing the *nebeneinander* of the picture and the *nacheinander* of the text. Or to put it in a more cautious way: the "natural" link between photography and space is at least interrupted by the literary scholarship on photography. This idea has been replaced by a much more temporal, narrative, and even fictional vision, which has now become "natural" in its turn, but which, contrary to the "realist slice of space" theory, is not thought of in terms of "essence."

A third shift created by the literary discourse has been, I think, the insistence on photography as a meaning-producing device. In this sense, one might say that there has been a clear

break with the more formalist approach of photography. Indeed, the meaning under analysis is never seen as simply the meaning of the "thing" and its formal parameters, but as the meaning produced by a spectator, who tends to project on the image his or her own stories, which may very well be fictions or phantasms. This antiformalism is also an antinaturalism, and it explains why the reading of photographs has been an easy candidate for all types of methods and disciplines obeying cognitive turn, with its well-known emphasis on memory, intertextuality, framing, pattern recognition, scenarios, and... narrative in general.

A fourth and maybe more paradoxical contribution of the literary orientation of interdisciplinarity is finally the antilogocentrism of the new discourse on photography. The construction of meaning in and through language is wrapped nowadays in a fundamental distrust of the representative possibilities of language, which seem "inherently" (such a vision is also, of course, essentialist) incapable of bridging the gap between sign and referent and of stopping the infinite deferral of meaning due to the stream of free-floating signifiers. These views on language have become a new doxa, that of the postmodern sublime,[17] and it should be clear that this theoretical and philosophical input dramatically increases the importance of the above-mentioned phenomena of antitechnofetishism, antiessentialism, and antiformalism.

3

The benefits of an interdisciplinary opening of the discourse on photography are undeniable. Yet this methodological broadening is not without danger. I am not discussing here the fact that the professionalism of this new discourse has put between brackets many achievements and insights linked to the practical knowledge of the nonprofessionals, that is, the nonacademics, the artists, the amateurs, and so on, which is a serious problem to which

I will have to return later. What I am discussing here is the fact that interdisciplinarity itself bears certain risks.

Let us start for instance with the very success of the literary discourse on photography. As in Orwell's tale, one might say that in discussions on interdisciplinarity, all disciplines are equal, but some are more equal than others. This is undoubtedly the case: the literary approach does not simply add itself to an existing range of discourses on photography, but also tends to be "the" leading discourse in the field (in the way linguistics were to become the "pilot science" in the humanities of the early 1960s), and this dominant position explains that other disciplines are less well placed when entering the game of interdisciplinarity. This is a general problem: the idea that there is a kind of ecumenia in matters of interdisciplinarity is an utopia, and each time we speculate about the virtues of interdisciplinarity, we often fall prey to the fashion of the day (even if the interest of the fashion is beyond question): we do nothing more than replace an outdated form of disciplinary approach with a newer one. In that sense, one can safely put that interdisciplinarity narrows as much as it opens.[18]

But all this probably sounds too general. Things become stickier when one takes a closer look at what is probably the bottom line of literature's concern with photography: time. What is at stake here is, I think, the fact that a very specific conception of time is transplanted from the medium of the text to that of the photograph. Heavily relying on Lessing's idea of time as *nacheinander*, literary scholarship on photography tends to disclose in the image something that resembles the notion of sequence or sequentiality. Hence the insistence on, for instance, the presence of several successive moments within a single frame (the photographic enunciated), the traces of the temporality of the picture's taking and deciphering (the photographic enunciation, both at the side of its production and at the side of its reception), the material transformations of the picture through time (the photographic history), the fascination with sequential arrangement of pictures,

photonovellas, chronophotography, and so on. However valuable such an approach may be, it nevertheless promotes a conception of time as *nacheinander* that should not be uncritically received as universal truth. The conceptual limitations of this textual and literary scholarship become very clear when issues of time in photography are raised from a different perspective. A good example is given by a recent article of the French philosopher Georges Didi-Huberman, who denounces the illusions of Marey's chronophotography (a type of photography always heavily emphasized by literary scholars, who see in it a major step toward the deconstruction of the space-time opposition). Quoting Bergson's ideas on vital *durée*, he proposes that chronophotography is on the contrary a devitalizing reduction of time, which is never a sequence of autonomous moments.[19] Bergson's ideas and their afterlife in many contemporary texts on time[20] may represent a very useful (and critical) complement to a literary and art-historical vision of time that tends sometimes to confound time with action and storytelling.

Third, and this problem is the logical consequence of the previous issue, the literary turn of photographic discourse also has implications for the way the visual corpus is processed. By turning away the essential opposition between the temporality of the text and the spatiality of the image, the interdisciplinary reading of photography has created an internal subdivision between two types of pictures: on the one hand, pictures capable of being read within a temporal (or even narrative and fictional) prospective, and on the other hand, pictures where this temporal dimension is simply not relevant. And although the frontiers between both categories are of course always shifting, the mere acceptance of this difference is hazardous, since it sneakily reintroduces a kind of essential difference between time and space that the interdisciplinarity approach of photography should question more radically. Moreover, such a splicing of the corpus can reinforce the (rather discouraging) ideal that the interdisciplinary encounter of

two disciplines does not produce two views on the same object, but that each of these disciplines produces its own view on its own subject, and that interdisciplinary dialogue does occur less easily than we would like.

A fourth problem is that internal discussions within a certain discipline tend to be pushed to the background when that discipline is welcomed into existing discussions in a certain field and on a certain object. Seen from the outside, as we unavoidably tend to do when we are not specialists in the field, disciplines seem always much more monolithic than they really are for those working within a monodisciplinary spirit. Until now, for instance, I have established a seamless connection between textuality and time, for I think this is the way the "specificity" of literary discourse on photography is generally perceived. However, in literary theory the issue of time is far from being uncontested. In high-modernist criticism, there has always been a very strong inclination to support the "spatial," explicitly antitemporal structure of literary works (it may suffice here to quote Joseph Frank's ideas on "spatial form"[21] and the controversy on the ideological underpinnings of this spatialization launched by Frank Kermode).[22] And in avant-garde criticism, illustrated for instance by the work of the French author Jean Ricardou (who likes to quote Mallarmé's introduction to the 1894 version of *Un coup de dés ...:* "le récit s'évite"), the disgust of temporal structures is turned into a disgust of story and fiction, both harshly accused of being "agents of idealism": the very temporal, narrative, and fictional reading of an object is identified as a negation of this object's materiality.[23] In all these areas, the plea against temporality is not made from the viewpoint of the image, but, more astonishingly, from that of the text. However, this type of disciplinary dissent does often vanish when one starts doing interdisciplinarity, and the case of photography is not an exception to this rule.

Fifth and last, there is another difficulty that one may consider the trickiest in terms of interdisciplinary intercourse: the fact that

disciplinary approaches engaged in interdisciplinary discussions are often not interdisciplinary themselves. In theory, the existence of a neutral metainterdisciplinary viewpoint might help solve this problem, but things being as they are, such a viewpoint does not exist and one always falls in with the problem of the power relations between disciplines.

4

It is thus important to be aware of the conceptual, methodological, and theoretical limitations of our use of interdisciplinarity. However, this awareness should not turn into an *a priori* skepticism toward the very use or usefulness of interdisciplinarity. The very fact that I quoted approvingly Didi-Huberman's confrontational vision on chronophotography indicates well enough that interdisciplinarity is for me too an absolute necessity.

Therefore, what should matter, I believe, is the attempt at redefining, in a very modest and practical way, some of its aspects. Rather than solving the limitations of interdisciplinarity by creating "more of the same" by adding always more disciplines to the interdisciplinary concert, I would like to make a plea for a "different" interdisciplinarity, or at least try to make some suggestions capable of reducing, albeit in a symbolic manner, some of the above-mentioned problems.

A major issue in each form of interdisciplinarity should be a critical attitude toward professionalism, in the Fishean sense I have mentioned above. I think we will have a serious problem in redefining or reshaping interdisciplinarity if we exclude nonprofessional forms of discourse. Certainly in the case of discourses on art, such an exclusion would be counterproductive. But how can one imagine this reunion of professional and nonprofessional discourses? To begin, photographic discourse should make room for research by artists, since they are, in a certain sense, the real specialists in the field and those who are most committed to its

knowledge. This broadening of professionalism (I prefer this description to the alternative view of "de-academization" or "de-professionalization") supposes of course that the artist's research is acknowledged and legitimized as such, that is, as a theoretical practice that does not simply increase personal skills but also produces intersubjective knowledge. Moreover, this inclusion of formerly nonacademic speech and practices might take also a directly interdisciplinary form. Artists and scholars, to use the traditional vocabulary, should have the opportunity to work, think, and write together, and to do so in such a way that new, interdisciplinary forms of producing knowledge may become possible. Globally speaking, the collaboration of scholar and artist in the field of photography would then become a supplementary illustration of one of the most promising aspects of interdisciplinarity in the broader field of science: the razing of the barriers between the humanities (the "alpha" sciences) and the sciences of nature (the "beta" sciences). Given the fact that photography is a less institutionalized field than other artistic disciplines, and given also the fact that most scholars do not feel too reluctant to discuss technical matters regarding photography, the field may very well play a pilot role in this regard. For this reason, it is urgent for scholarly discussions to tie in with what has been explored or achieved in the field of, how shall I put it, "visual writing," that is, certain forms of visual compositions aiming at establishing cognitive networks the way texts do. How to write visually is not a new question (one may think here of the ideas of Eisenstein on ideographic montage, to quote just one example, even if it is a rather outdated one), but it is a question that has now become very crucial. Visual artists not only "think," but also their work often proposes illustrations of thought-provoking devices, whose structure and content have effects that can be compared to that of language. If we follow Barbara Stafford, for instance, we know that scientific thinking from at least the eighteenth century on has become increasingly "visual,"[24] and many contemporary

photographers present their work as real cognitive statements (a good example, it seems to me, is the work by Louise Lawler).[25] In some cases, the difference between scholarly and creative appears to be very thin (a still stimulating example is Joseph Lesy's *Wisconsin Death Trip*).[26] At a more modest, but therefore no less necessary, level, one might think here of new forms of illustration in scholarly work. The neglect of the impact of the visual material included in a book, to put it negatively first, is always harmful to the argumentation developed by the author.[27] On the other hand, the intelligent and audacious use of images can not only help the reading of a text, but also become part of thinking itself. All this is easy to realize. One can therefore only regret that it is so rarely effectively done.

However, all these innovations are still based upon a series of simple oppositions (the scholarly versus the artistic, the word versus the image, and so on). A more radical interpretation of interdisciplinarity is possible, which puts into question the very autonomy of each of these terms. Here, the recently redefined notion of *intermediality* may be very useful. Contrary to the traditional conception of intermediality as the relationship between two arts, two practices, two objects, or even two discourses, newer forms of "interart comparison" have emphasized the implications of the prefix "inter" in a way of thinking that is not alien to the spirit of deconstruction. As both Eric Méchoulan and Henk Oosterling put it in two seminal articles of the first issue of *Intermédialités:* a clear distinction has to be made between the interart spirit of the *Gesamtkunstwerk* and the more deconstructive spirit of the new intermediality, where the focus is on the "difference" of the "inter."[28] This vision opens many opportunities to new forms of interdisciplinarity, which can so become less monolithical, and therefore more interdisciplinary themselves. The contemporary philosophy of the intermediate is thus not an alibi to turn away from disciplines in favor of a kind of generalized "antidisciplinarity" that cultural studies is sometimes dreaming of;[29] it is a way

to make the various disciplinary approaches more aware of their impossible purity. Here, too, these general reflections should not be separated from their practical counterparts, which are always much more than just "counterparts." The already mentioned use of new techniques of illustrations can for instance make room, not for a dehierarchization of word and image, but for a more tactical use of hierarchical shifts between the verbal and the visual.[30]

Finally, and this may seem, from our current ideological perspectives, a mere provocation, interdisciplinary research on photography may suggest new ways of going against the contemporary myth of the unspeakable. Referring to the pre-Romantic theory of the sublime, postmodern criticism is haunted by the defaults of representation and the shattering impact of this representative failure on the construction of the subject. I do not have the ambition to turn this page, but neither do I believe that this way of thinking is still very useful nowadays. If the increased use of interdisciplinary voices on photography only tends to increase our awareness of the limits of any representation—if interdisciplinarity, in other words, reinforces the myth of the unutterable—I think we are losing a crucial opportunity to think against the grain.

Of course, interdisciplinarity confirms that it is not possible to exhaust the meaning of a photograph. Each new occurrence of interdisciplinary research crudely reveals the limits of all other language. And of course taking into account the image itself as a thought- and knowledge-producing device can only intensify our attention toward everything that escapes or exceeds verbal language. Visual thinking is definitely not the solution to the failure of words. But this is not the only lesson one can draw from the contact of words and images in photographic research. Why not turn the argument around and observe that, whatever the obstacles may be, images do manage *to say* something, whereas words *do not necessarily fail* to do the same? Would it not be refreshing to make a plea for "clear and distinct" ideas, not as something given that is to be dismissed because it can never be attained, but as a

possible horizon for our efforts (after all, Descartes never said clear and distinct ideas were immediately available, without any effort: they are not simply to be *found*, they are to be *made*)? The very fact that the interdisciplinary intermingling of words and images in our discourses on photography only seems to enhance our faith in the impossibility of representation may be seen as a paradoxical invitation to go beyond this difficulty and to search for clarity, simplicity, transparence, *en connaissance de cause,* that is, knowing that it is a difficult and probably impossible job. This is not a way of instrumentalizing art, of using art to the benefit of mere concept: such an idea is typical of "professionals" with little practical knowledge; practicing artists or craftsmen know very well how difficult and relative and fragile each communicative success in this field remains.[31] Nor is this the easy way; on the contrary. The paradox of the whole thing is that, if the way of the researcher is the *lectio difficilior,* not the *lecto facilior,* this hardest thing to do now is taken for simplicity and straightforwardness, whereas the search for infinite deconstructive *jouissance* has become the easiest way. Just as in the case of a text, it should be stressed that producing infinite meaning in photography is much easier than trying to suggest just one single meaning, and neutralizing all the others that will inevitably pop up in the mind of the reader:

> Contrairement à ce que l'on pourrait penser, tout écart... tend, une fois accepté et pris en charge par le lecteur, non pas à enrayer la lecture mais à l'activer.... La participation du lecteur étant inversement proportionnelle au degré d'élaboration séman-tique des poèmes... la difficulté n'est pas de produire du sens mais de produire un sens, ou un non-sens... il faut donc être prudent, ou du moins conscient de ce qui se passe à la lecture, car à la limite, la prolifération du sens est contrairement aux idées reçues, la marque d'une certaine faiblesse du système.[32]

Why not consider our new commitment to interdisciplinarity and the new relationships between words and images an attempt

to speak *nevertheless?* How to define and implement such an interdisciplinarity can only be sketched here in very general terms, but its major features will have to be at least threefold: (1) it must be really plural, and not just the opening of the interdisciplinary field to the fashion of the day (yesterday narrative and fiction, today deconstruction, and tomorrow something else: the ideal is not to fight narrative or fiction or deconstruction or whatever in the name of something new, but to combine them in a way that does not produces a kind of synthesis, for synthesis is often the name one gives to the dominant position of just one discipline in the interdisciplinary debate); (2) it must be very corpus-focused, since this offers the best guarantees of precise discussions on specific aspects and dimensions of photography; and (3) it should be itself as "interartistic" and "intermedial" as possible (words and images, scholarship and creation, and alpha and beta should intermingle, but here too in a dialectical spirit that leaves room for contradiction).[33]

Notes

1. The big theme now is hybridization, to which the journal *History of Photography* will devote a special issue in 2006.
2. Or so easy, since photography is clearly a booming business: the difficulty of speaking on a subject has never prevented anyone from speaking of it. As I will try to argue later in this paper, the relationship between "easiness" and "difficulty" is more paradoxical than one may think.
3. Quoted from Jonathan Culler, *A Very Short Introduction to Literary Theory* (Oxford: Oxford University Press, 1997).
4. Although there are of course exceptions to this view. See for instance Alain Buisine's book *Atget* (Nîmes: éd. Chambon, 1994), which makes a strong claim for the radical ahistoricity of the medium, and thus for its conceptual unity.
5. I am thinking here of work by Jonathan Crary, for instance *Techniques of the Observer* (Cambridge MA: MIT Press, 1991).
6. One may think here, but not exclusively, of the work by Patrick Maynard, *The Engine of Visualization: Thinking through Photography* (Ithaca, NY: Cornell University Press, 1997).

7. The unfortunately less well-known works by the Belgian semiotician Henri Van Lier provide a good example of this approach: *Philosophie de la photographie* and *Histoire photographique de la photographie* (both books, which are from the 1980s, have been republished [Paris: Les Impressions Nouvelles, 2005]; the Lieven Gevaert Centre of the University of Leuven plans also an English translation). *Mutatis mutandis,* his views on photographic "specificity" are not very different from those held by Stanley Cavell in his first book on film, *The World Viewed* (Cambridge MA: Harvard University Press, 1971; enlarged ed., 1979).

8. Here of course the first reference coming to mind is Rosalind Krauss's study on Marcel Broodthaers's, *"A Voyage on the North Sea": Art in the Age of the Post-medium Condition* (London: Thames & Hudson, 1999).

9. I am following here the arguments developed by Stanley Fish in his attack on the political utopia of cultural studies' craving for "anti-disciplinarity" in his book *Professional Correctness;* Stanley Fish, *Professional Correctness: Literary Studies and Political Change* (Oxford: Clarendon, 1995), xxx. In my article "Cultural Studies after the Cultural Studies Paradigm," I try to analyze some of the consequences of this discussion in the institutional terms emphasized by Fish; Jan Baetens, "Cultural Studies after the Cultural Studies Paradigm," *Cultural Studies* 19, no. 1 (January 2005): 1–13.

10. In that sense, Henri Van Lier's *Philosophie de la photographie* can be considered the last link in a long chain of "preprofessional" discourses on photography. This book, moreover, not only pays a well-merited tribute to the photographic practitioners but has also, despite its slightly misleading title, a strong antiprofessional bias. As the blurb (manifestly written by the author himself) puts it, "A la fois très artificielle et très naturelle, elle (= la photographie—J.B.) invite à des considérations cosmologiques et anthropologiques radicales. C'est sans doute pourquoi, depuis un siècle et demi qu'existe la photographie, les philosophes se sont curieusement tus à son égard, ayant sans doute pressenti à quel point elle ébranlait leur discours prestigieux."

11. If I am to develop a little on this improvised typology, I would be tempted to stress the closeness of Malraux and Barthes in this regard: Malraux's writing on art seems to me a clear "compensation" (and, given the baroque aspects of his style, even an overcompensation) of his farewell to fiction. Berger, on the contrary, can be put aside of Sontag, whereas Benjamin seems to occupy an intermediate position.

12. Jérôme Thélot, *Les inventions littéraires de la photographie* (Paris: Presses Universitaires de France, 2003). This book is very different from those existing on the interart relationships between photography and literature, such as Jane Rabb's *Literature & Photography: Interactions 1840–1990: A Critical Anthology* (Albuquerque: University of New Mexico Press, 1995), since it establishes a clear but challenging hierarchy between both practices. In this sense, it goes much farther than the comparable book by Philippe Ortel, *La littérature à l'ère de la photographie* (Nîmes: éd. Chambon, 2002).

13. I make a distinction between technological determinism in the broad sense of the word and technofetishism, the latter being the all too exclusive focus on single technical aspects that become almost context independent. As Van Lier puts it nicely in *Histoire photographique de la photographie* (although in a slightly different context), what is missing in technofetishism is the "logy" of techno-logy (Van Lier, *Philosophie de la photographie*, 74).

14. It should be clearly remembered here that such a determinism is not a general feature of the discourse on photography. Notable exceptions are, for instance, Henri Van Lier, *Philosophie de la photographie*, 20; and Geoffrey Baetchen, *Each Wild Idea* (Cambridge, MA: MIT Press, 2001), ch. 7.

15. Similar ideas can be advanced on the analysis of, for instance, the "slide," where the importance of contextual and cultural aspects is paramount: slides not only alter the materiality of the image but also reinforce the notion of intertextuality (slides are never isolated items; they are part of slide shows); the projection of slides is always a show, a performance; and the impact of slides on the selection of the subject is dramatically high (the same goes for the material that is now being digitalized); see, for instance, Horst Bredekamp: "A Neglected Tradition? Art History as *Bildwissenschaft*," *Critical Inquiry* 29–30 (2003): 418–28; and Jan Baetens, "Quelles pratiques pour quels enjeux?" *Protée* 32, no. 2 (Fall 2004): 59–66.

16. See Jacques Derrida's untitled "Lecture" printed as an "afterword" (?) in Marie-Françoise Plissart, *Droit de regards* (Paris: Minuit, 1985), which starts this way: "Tu ne sauras jamais, vous non plus, toutes les histoires que j'ai pu encore me raconter en regardant ces images."

17. In France, the conceptualization of the representative limits of language as a form of "postmodern sublime" is often linked with the publication of some basic "poststructuralist" works on the philosophy of art such as Philippe Lacoue-Labarthe's and Jean-Luc Nancy's *L'absolu littéraire. Théorie du romantisme allemande* (Paris: Seuil, 1978); or Louis Marin's *Des pouvoirs de l'image* (Paris: Seuil, 1993).

18. I would like to link this "narrowing" effect of interdisciplinarity to what Reed Way Dasenbrock calls the "illusion" of interdisciplinarity of the very scholars who consider themselves the champions of interdisciplinarity in today's humanities: the fact that we (literary scholars) are relying on works from other disciplines (for instance philosophy, sociology, and psychology) while reading also nonliterary texts (since we read Marx, Bourdieu, Freud, and so on) does not prevent us from "still doing what we do best: reading a text in a commentary tradition" (Reed Way Dasenbrock, "Toward a Common Market: Arenas of Cooperation in Literary Study," *ADFL Bulletin* 36, no. 1 [Fall 2004]: 20-26).

19. Georges Didi-Huberman, "L'image est le mouvant," *Intermédialités*, no. 3 (2004): 11–30. Once again, this tension between "real time" and "successivity" had been very well understood by Van Lier, *Philosophie de la photographie*, 18.

20. A more in-depth analysis of this problem will have to take into account the notion of time-image in Deleuze, who opposes the temporal sequence of the "image-mouvement" to the ideal montage of the "image-temps."

21. Joseph Frank, *The Idea of Spatial Form* (1945; reprint, New Brunswick NJ: Rutgers University Press, 1991).

22. Frank Kermode, *The Sense of an Ending* (1966; reprint, Oxford: Oxford University Press, 2000). If W. J. T. Mitchell's theory of the "diagram" (see W. J. T. Mitchell, "Spatial Form in Literature: Toward a General Theory," *Critical Inquiry* 7 [1980]: 539–67; and W. J. T. Mitchell, "Diagrammatology," *Critical Inquiry* 8 [1981]: 622–33) has picked up Frank's heritage, this was largely due to the fact that his work tried to go beyond the very divide between word and image, space and time, that was the uncontested starting point of both Frank and Kermode.

23. Among other books, see Jean Ricardou, *Nouveaux problèmes du roman* (Paris: Seuil, 1978).

24. Among other publications: Barbara Stafford, *Good Looking: Essays on the Virtue of Images* (Cambridge MA: MIT Press, 1998).

25. See Louise Lawler, *An Arrangement of Pictures* (New York: Assouline, 2000); extracts of this work had appeared in the journal *October.*

26. Joseph Lesy, *Wisconsin Death Trip* (New York: Pantheon Books, 1973; 2nd reprint ed., Albuquerque: University of New Mexico Press, 2000). In the foreword to this book, it is quoted that Lesy's work was the first work of this type to be accepted as a Ph.D. (in history).

27. A good, but in my eyes painful, example is the book by Daniel L. Schacter, *Searching for Memory* (New York: Basic Books, 1996), where the treatment of the visual material is so naïve that it, completely unwillingly I suppose, undermines the sophistications of the text (the problem here, however, is not only the illustrations, but also the analyses of the images themselves).

28. Eric Méchoulan, "Intermédialités: le temps des illusions perdues," *Intermédialités* 1 (2003): 9–28; and Henk Oosterling, "Sens(a)ble Intermediality and Interesse: Towards an Ontology of the In-Between," *Intermédialités* 1 (2003): 29–46.

29. I subscribe on the contrary the plea, made by Reed Way Dasenbrock (see n. 18), for a new kind of initial "anti-anti-disciplinarity" as a necessary attitude in order to achieve interdisciplinarity.

30. I borrow, of course, this notion from Michel de Certeau.

31. See Tufte, who often comments on failures, not in order to mock his competitors, but in order to stress the inescapable gap between what "is" and what "should be."

32. Mireille Ribière, "Alphabets," *Cahiers Georges Perec* 1 (1985): 143–44. I know the context of this quotation is totally different of what I am discussing here (Ribière is analyzing the Oulipian poetic production of Georges Perec), yet I believe that the stakes are comparable: a contestation of the stereotypical overevaluation of infinite polysemy.

33. In order to finish with a positive and concrete opening, I would like to quote, as a possible example of what I am here thinking of, the (creative as well as theoretical) work made by David Tomas, whose very innovative ideas on photography (which he defines as a process rather than as a product) emerge from the active dialogue between his double scholarly and artistic research projects. See his book *A Blindness of Light: Photography between Disciplines and Media* (Montreal: Dazibao, 2004).

AFTER MEDIUM SPECIFICITY *CHEZ* FRIED

JEFF WALL AS A PAINTER; GERHARD RICHTER AS A PHOTOGRAPHER[1]

Diarmuid Costello

According to Michael Fried, circa 1966–1967, art aspires to great-ness—that is, to exemplarity in its medium—to the extent that it seeks to rival the highest achievements of past work in its medium, the quality of which is beyond doubt.[2] But consider the following possibility: if a photograph should succeed in rivaling the highest achievements of past painting, would that make it a great *painting* on Fried's account? Conversely: were a painter to rival the high-est achievements of photography, would that make them a great *photographer*, again on Fried's account? You would think clearly not, if what counts as an exemplary work in a given medium is one that "compels conviction" that it can stand comparison to the past achievements of *that* medium, for this would seem to preclude in advance a painting, say, being compared to past photography, or vice versa, since they are—allegedly—in distinct media. But, in

concert with Stanley Cavell,[3] early Fried also maintains that we are unable to say a priori what may count as an instance of a given medium—other than that it bear a "perspicuous relation" to the past practice of the medium in question—it being a function of the ongoing development of the medium to bring this out. Given this, if it should turn out that a photograph *can* be made to stand comparison to past painting or vice versa in the relevant sense, what happens to "medium specificity" as a category in Fried's aesthetics? If a photographer can make paintings using the technical means of photography, or a painter can make photographs by painting, is it still possible to distinguish between artistic media in principle?

This is the question I want to address here, and I shall do so by briefly considering the practices of Jeff Wall and Gerhard Richter. I want to suggest that, on a strong reading of Fried's early criticism, particularly those passages that address the very idea of an artistic medium, the photographer Jeff Wall emerges, albeit with certain important qualifications, as a "painter" who paints photographically, and the painter Gerhard Richter emerges as a "photographer" who makes photographs with the means of painting.[4] This is significant today because Fried is currently working on a book on large-scale color photography since the Bechers. One of the most controversial moves of that book is likely to be the claim that much of this photography has inherited the scale, mode of address, and destination of painting, in particular *modernist* painting—which is to say that it is large, frequently frontal or facing in orientation, and intended for the museum or gallery wall, where it can address more than a single beholder at once.[5] Fried has already put this claim on the record for Jeff Wall's *Morning Cleaning, Mies van der Rohe Foundation, Barcelona* (1999), for example, in relation to Morris Louis's *Alpha Pi* (1960).[6]

There are two reasons why claims like this are likely to be controversial, the first external, and the second internal, to Fried's project. The external reason is that approaching photography in

this way arguably fails to regard photography as photography, preferring to present photography as a kind of painting by other means; the internal reason is that, given Fried's earlier defense of medium specificity, it looks inconsistent for Fried—of all people, as it were—now to approach photography through the optic of painting.[7] Recall the infamous lines from "Art and Objecthood": "*The concepts of quality and value*—and to the extent that these are central to art, the concept of art itself—are meaningful or wholly meaningful, only within *the individual arts. What lies* between *the arts is theatre*"—in which theater has already been glossed as not simply the nemesis of modernist painting and sculpture, but also the antithesis of art as such.[8] Claiming that today photography inherits the scale, mode of address, and destination of modernist painting looks like an attempt to reclaim something of this "in-between" space, and *that* looks like, if not quite a volte-face, then, at the very least, a stepping back from the stridency of those earlier claims.[9] I want to concentrate on this latter, internal, worry here. Since both presuppose some prior conception of what an artistic medium is, it makes sense to consider Fried's own, if one intends to explore a possible internal problem, rather than—as is more often the case—present what amounts to a statement of incommensurable starting points.

Now it could simply be the case that Fried has changed his mind. There would be no dishonor in that; more than a little water has flowed under the bridge since his epic stand against minimalism in 1967. But I want to propose what I hope is a more thought-provoking interpretation. For though it might be objected that it is anachronistic to interpret his early criticism through the optic of later art, I want to suggest that my claim vis-à-vis Wall and Richter brings out an intrinsic, which is to say conceptual, possibility of Fried and Cavell's *early* conception of an artistic medium itself, even if it arguably took subsequent artistic developments to make this fact apparent. Thus, contrary to what many will no doubt think, I want to suggest that Fried's "photographic turn" is *not* the

volte-face it may initially seem. Or, to put the point more force-fully: it is nothing if not a logical extension of the terms of his early work. Given *how* Fried understands an artistic medium—that is, as a structure of intention on the part of artists to elicit a certain conviction in their audience vis-à-vis the standing of their work in relation to the achievement of past art—it follows that if a given artist seeks to rival the achievements of one medium through the means of another, their work will count as an example, and if great an exemplar, of the former. So far, so good—but there is a sting in the tail. For if this is correct, it threatens to dissolve the very idea of an artistic medium as something with *any* substantive empirical constraints from within, such that it is no longer clear what is meant by something being "in," "between," or "across" an artistic medium or media.

There is a second possible objection to my claim that can only be addressed by turning to examples, namely, that it is at best coun-terintuitive, and at worse downright willful, to describe Wall as a painter and Richter as a photographer, even on such an avowedly anti-essentialist, historicized conception of an artistic medium as Fried's: hence, to suggest that Fried's conception of medium speci-ficity contains the seeds of its own dissolution, by adverting to the examples of Richter and Wall, is simply implausible. But consider the evidence. Wall has repeatedly described his own practice as reviving the project, marginalized by modernist painting's stress on autonomy, of the "painting of modern life." Here is Wall describing his involvement with this idea in conversation with T.J. Clark:

> Some of the problems set in motion in culture not only in the 1920s, but in the 1820s and even in the 1750s, are still being played out, are still unresolved… that's why I felt that a return to the idea of *la peinture de la vie moderne* was legiti-mate. Between the moment of Baudelaire's positioning this as a programme and now, there is a continuity which is that of capitalism itself.[10]

And again, from the same interview:

> [W]hen the concept of a painting of modern life emerged with
> particular clarity in the nineteenth century, it changed the way
> the history of art could be seen.... Manet's art could be seen
> as the last of the long tradition of Western figuration, and of
> course at the same time, as the beginning of avant-gardism....
> So it seems to me that the general programme of the painting
> of modern life (*which doesn't have to be painting, but could be*)
> is somehow the most significant evolutionary development in
> Western modern art.[11]

Wall, a photographic artist trained in art history and steeped in the
history of painting in particular, has taken on one genre of painting
after another in his work, the scale of which is explicitly keyed to
painting, rather than that of the photographic plate, print, or album,
as traditionally conceived—Wall's recent protestations to the con-
trary notwithstanding.[12] But above all, he has sought to rival the
pictorial ambition, scale, and mode of address of the highest genre
of painting, history painting, often deriving the compositional
strategies of his most ambitious works from this tradition, such as
*Dead Troops Talk (A Vision after an Ambush by a Red Army Patrol
near Moqor, Afghanistan, Winter 1986)* (1992). That said, it would
not be right to describe Wall as a contemporary history painter:
it would be more accurate to say that he has brought the compo-
sitional resources, mode of address, and scale of history painting
into dialogue with Baudelaire's call for a painting of modern life to
produce a "painting" of everyday contemporary scenes and events,
and hence modern life, *as* historical—that is, historically freighted,
significant, hence worthy of the closest attention. I put painting in
scare quotes to indicate that I am not claiming Wall *is* a painter; the
claim is rather that there may be no reason *not* to regard him as such
given Fried's account of how artistic media develop over time. In
fact, it may be more accurate to call this a *picturing* than a painting,
but I shall come on to that.

For all the differences in Wall's oeuvre, not least what might be regarded as its basic oscillation between the rhetoric, or mode of address, of the documentary and the staged, the straight and the manipulated (which has clearly tilted toward the former over the last decade), what his images share is a commitment to the depiction of everyday life. More specifically, they share a conception of what it is to depict everyday life keyed, if not exclusively to painting, then certainly more to painting, photography, and cinema construed as a *pictorial continuum* than to photography conceived as a discrete medium. Wall himself recently made this clear: "Photography, cinema, and painting," he wrote, "have been interrelated since the appearance of the newer arts, and the aesthetic criteria of each are informed by the other two media to the extent that it could be claimed that there is almost a single set of criteria for the three art forms. The only additional or new element is movement in the cinema."[13] On Fried's conception of an artistic medium, a conception grounded not in any literal properties of the medium in question, but on a work's participation in what might be called a *structure of artistic intention*—as embodied by its mode of address to a particular artistic tradition, and the kind of conviction it seeks to elicit in its viewers as to its standing in relation to past work in that tradition—this would make Wall as much a painter, cinematographer, or perhaps "pictographer" as it would make him a photographer "proper," since it is as much the achievements of not only past painting, but also a more inclusive, nonmedium-specific or generic conception of the *pictorial*, as it is of photography per se, that Wall seeks to rival in a contemporary idiom.

Conversely, consider the contrasting case of Gerhard Richter. Richter, who worked as an assistant in a photographic laboratory before training as a social-realist painter in former East Germany, describes his practice of painting from photographs as "photo-painting." By this, Richter has in mind something far stronger than simply painting pictures *of* photographs, or painting pictures *from* photographs, something more accurately thought of

as putting painting in the service of photography, namely, *making photographs by painting:*

> [Photography] has no style, no composition, no judgment. It freed me from personal experience. For the first time, there was nothing to it: it was pure picture. That's why I wanted to have it, to show it—not use it as a means to painting but use painting as a means to photography.

When the interviewer then asks, "How do you stand in relation to illusion? Is imitating photographs a distancing device, or does it create the appearance of reality?" Richter replies,

> *I'm not trying to imitate a photograph; I'm trying to make one.* And if I disregard the assumption that a photograph is a piece of paper exposed to light, then, I am practicing photography by other means: *I'm not producing paintings of a photograph but producing photographs.* And, seen in this way, those of my paintings that have no photographic source (the abstracts, etc.) are also photographs.[14]

So Richter understands his own practice as an attempt to make photographs—what he calls "pure pictures"—by hand. If we take Richter at his word (and perhaps we should not), this effectively turns him into an automatic, or perhaps quasi-automatic, recording device mimicking the mechanical apparatus (strictly speaking, that of the enlarger rather than the camera, in so far as Richter's practice is one of enlarging an existing image) to the best of his abilities with the laborious work of the hand, in an attempt to escape the strictures of subjectivity and personal experience. In Cavell's terms, Richter's practice mimics the "sterility" of the camera (and of the photographic apparatus more generally), both in terms of its lack of subjectivity or knowledge of its own activity, and in terms of its inhuman, mechanical nature (at least once, the image to be transcribed has been chosen).[15] But Richter partakes of what Cavell calls photography's "automatism"

in a deeper way. In *The World Viewed*, Cavell frequently draws attention to the necessity of getting to the "right depth" of the question concerning photography's automatism.[16] For Cavell, this is photography's relation to *skepticism*. On Cavell's understanding of the latter, Richter's attempt to circumvent his own subjectivity—what Cavell would understand as a failure of "acknowledgement"—by mimicking the camera's automatism so as to produce a "pure," subjectively uninflected picture would be of a piece with the skeptic's desire to arrive at an indubitable knowledge of reality unconstrained by the limits of human finitude, our irreducibly subjective knowledge of the world as it appears to creatures like us. Richter's attempt to circumvent the limits of subjective experience, by turning himself into a transcription machine—"no style, no composition, no judgment. [Photography] freed me from personal experience"—would be a species of skepticism, when viewed through this optic.[17] As such it partakes of skepticism's fundamental paradox, namely, that by removing the constraints of subjectivity from the reproduction of reality, photography facilitates its perfection, but the price to be paid for such perfection is a world from which subjectivity is mechanically cut adrift, and which it therefore cannot acknowledge as its own.[18] To the extent that Fried is sympathetic to Cavell's philosophical outlook, what I am calling Richter's "skepticism" may bear on Fried's general aversion to his work.[19]

Moreover, in so far as the camera records automatically for Cavell, that is, in so far as it cannot *not* record what falls within its field of view, there is a remarkable consonance between Cavell's and Roland Barthes's conceptions of photography—at least on Fried's reading of the latter—at this juncture.[20] Barthes famously dubbed the conviction, elicited by photographs, that "that has been" the *noema* of photography,[21] that is, the thought that what appears in the picture once existed before the camera. Analogously, Cavell speaks of the photograph presenting a "world past," a world that is present to me, but only at the cost of

my spatio-temporal absence from it.[22] If Richter's photo-paintings partake of photography's automatism in Cavell's sense, can they also be said to participate in its *noema*, in Barthes's? Clearly not, so long as one takes photography's "indexicality"—the fact that photographs have a direct casual dependence on what they depict, being in part the product of its reflected light impacting on the film's light-sensitive surface—to be the final guarantor of photography's existence as a discrete art. But taking indexicality as the essence of photography is presumably not an option for Fried—and it is Fried's account that I am interested in—given that on his theory, artistic media are not defined physically, causally, or ontologically, but in terms of compelling conviction (first in the artist and then in their audience) that a given work is an exemplar of its kind. Indeed, *were* one to define photography in terms of indexicality, that would immediately rule out Wall, many of whose images are manipulated to such an extent that the final image (as opposed to its constituent parts) no longer functions as an index in any straightforward sense.

In sum, recourse to Peirce's distinction between icons and indexes can no longer ground categorical distinctions between photography and other media in an age of digital technology, excluding the "photographer" Wall, rather than just the "painter" Richter; whereas understanding photography more broadly, say in terms of *eliciting the conviction that* "this has been," in virtue of its automatism, rules in much of Richter, while ruling out much of Wall.[23] The anomic photo-paintings that have been Richter's stock-in-trade throughout his career not only partake in photography's *noema*, understood in this way, but also arguably do so in a particularly brutal way, consisting of little more than the representation of photographs pared back to the banality of its bare assertion.[24] Though many of these images, especially those deriving from press photos, have disturbing subtexts, their appearance *as images* is disturbing, if at all, only for their banality and absence of affect—what Richter describes as their lack of style, composition,

or judgment. Hence, if Wall brackets photography's documentary function, by which I mean its claim to directly capture "what has been," by *constructing* images in a manner traditionally thought to be the province of painting, Richter undermines painting's status as an expressive medium, by producing pictures so devoid of personality—so "automatic"—as to be unsettling as paintings.[25]

Clearly, more would have to be said to demonstrate that, when really pushed, Fried and Cavell's early conception of an artistic medium turns out—against all expectations—to be so *accommodating* as to risk undercutting the very idea of the "specific" medium it is meant to capture; or that according to Fried's own conception of an artistic medium, Wall can be best understood as subsuming painting, photography, and cinema into a generic conception of the pictorial, with the means of digital photography, and Richter as aspiring to reproduce the anomie of the photographic document with the means of painting.[26] But what I have said should at least suffice to head off its *prima facie* implausibility.

It remains to say what I take to be at stake in making this argument: it is part of a broader project to uncouple the discourse of aesthetics, particularly the idea of artworks having a distinctly aesthetic value, which I would like to retrieve from the discourse of medium specificity, which I take to be untenable and, in any case, orthogonal to questions of value in art. This runs directly counter to the dominant tendency in postmodern art theory over the last twenty-five years, especially as it approaches photography: this has been to defer, albeit implicitly, to a modernist conception of the aesthetic, only to conclude that the artistic merits of what the latter is forced to exclude warrant discarding aesthetics altogether in the theory of art. This was the animus that motivated postmodern antiaestheticism, and it lingers in the symptomatic marginalization of aesthetics in the contemporary art world. In my view, this is a result of failing to disentangle medium specificity, the modernist conception of aesthetic value, from aesthetic value per se. It is the fate of aesthetics in our time.

In making this claim, I trust it is clear that my project is *not* to bash modernist theory once more. That is, it is meant as anything but an exercise in postmodern theory, given the antiaesthetic, antimodernist terms in which the former has by and large cashed out. Rather, my goal is to retrieve the notion of aesthetic value from *both* its modernist appropriation—as pertaining only to work within, but not across, artistic media—*and* its inevitable consequent postmodern rejection as an irrelevant concern of art in a "post-medium" age.[27]

Notes

1. These remarks are extracted and adapted from a longer paper that considers the relation between Fried's recent "photographic turn" and the early criticism and theory for which he is still best known in art theory. I would also like to acknowledge the support of a Leverhulme Trust research fellowship while working on this paper.

2. See Michael Fried, "Shape as Form: Frank Stella's New Paintings," originally published in *Artforum* 5 (November 1966): 18–27; and Michael Fried, "Art and Objecthood," originally published in *Artforum* 5 (June 1967). Both are collected, together with a substantial retrospective introduction to his early criticism, in Michael Fried, *Art and Objecthood* (Chicago: Chicago University Press, 1998).

3. See, for example, Stanley Cavell, "Natural and Conventional" in his *The Claim of Reason: Wittgenstein, Skepticism, Morality and Tragedy* (Oxford: Oxford University Press, 1979), 86–125; and Stanley Cavell, "Excursus: Some Modernist Painting," in his *The World Viewed*. See also Stanley Cavell, "Music Discomposed" and "A Matter of Meaning It," in his *Must We Mean What We Say?* (Cambridge: Cambridge University Press, 1976).

4. For a justification of this claim concerning the nature of Fried's conception of an artistic medium, see the essay from which the current remarks have been excerpted and adapted, provisionally titled "On the Very Idea of a 'Specific' Medium: Michael Fried on Photography and Painting as Arts."

5. See Michael Fried, "Barthes's *Punctum*," *Critical Inquiry* 31, no. 3 (spring 2005): 562–63, 569–71. See also Michael Fried, "Jeff Wall, Wittgenstein et le quotidian," *Les Cahiers du Musée National D'Art Moderne* 92, special issue on "Photographie" (July 2005).

6. Fried makes this claim in "Jeff Wall, Wittgenstein and the Everyday," which he delivered as the Lionel Trilling Seminar at Columbia University on November 10, 2005. The remarks here draw on my response. Fried's paper has to date only appeared in French; see n. 38.

7. Jim Elkins makes a very similar point in his response to "Barthes's *Punctum*" in "What Do We Want Photography to Be? A Response to Michael Fried," *Critical Inquiry* 31, no. 4 (Summer 2005): 938–56. I agree with Elkins that this is likely to be controversial, but I think he tends to gloss over rather than address the stakes of this controversy head on. Elkins also does not consider the various ways in which that controversy, if it is indeed forthcoming, would be warranted or unwarranted. But that is not his concern.

8. See Fried, "Art and Objecthood," especially 163–64.

9. In answer to questions along these lines at recent talks, and in conversation, Fried himself sometimes describes this as "throttling back" on his earlier claims about the medium—not, importantly, vis-à-vis the past, but vis-à-vis the present. Such concerns, Fried grants, clearly do not have the same urgency *today*.

10. Jeff Wall, cited from "Representation, Suspicions and Critical Transparency: Interview with T. J. Clark, Serge Guilbaut and Anne Wagner" (1990), in *Jeff Wall*, edited by Thiery de Duve, Arielle Pelenc, and Boris Groys (London: Phaidon Contemporary Artists, 2002), 112.

11. De Duve, Pelenc, and Groys, *Jeff Wall*, 124; my italics.

12. I have in mind Wall's recent autobiographical piece, "Frames of Reference," in which he claims, to my mind unpersuasively, "People who write about art often think my work always derives in some direct way from nineteenth century painting. That's partly true, but it has been isolated and exaggerated in much of the critical response to what I'm doing. *I'm totally uninterested in making reference to the genres of earlier pictorial art*" (my italics). Wall goes on to say that what he derives from painting is chiefly "a love of pictures" and "an idea of the size and scale appropriate to pictorial art." The latter seems convincing, but the former is surely overstated, perhaps as a result of trying to offset an equally overstated claim in the opposite direction (say, that he is *only* interested in referring to the genres of past painting). But to deny *any* interest in referring to earlier genres whatsoever flies in the face of both his practice and his earlier claims for it. See Jeff Wall, "Frames of Reference," *Artforum* (September 2003): 191.

13. Wall, "Frames of Reference," 190.

14. Gerhard Richter, "Interview with Rolf Shön" (1972), in his *The Daily Practice of Painting: Writings 1962–1993* (London: Thames & Hudson, 1994), 73; italics mine.

15. The latter fact, that Richter chooses what images to transcribe, is not a bar to the analogy in so far as the same holds true of photography: the photographer has to select what to capture (has to point the camera, at the very least), just as Richter has to choose an image to transcribe. For Cavell on the camera's sterility, see Cavell, *The World Viewed*, 184–85.

16. See, for example, page 21: "It is essential to get to the right depth of this fact of automatism... photography satisfied a wish... to escape subjectivity and metaphysical isolation—a wish for the power to reach this world, having for so long tried, at last hopelessly, to manifest fidelity to another."

17. "Photography overcame subjectivity in a way undreamed of by painting, a way that could not satisfy painting, one which does not so much defeat the act of painting as escape it altogether; by *automatism,* by removing the human agent from the task of reproduction." Cavell, *The World Viewed,* 23.

18. I owe this way of formulating the relation between photography and skepticism for Cavell to Stephen Mulhall's discussion in *Stanley Cavell: Philosophy's Recounting of the Ordinary* (Oxford: Clarendon Press, 1994), 228–30. See Cavell, *The World Viewed,* ch. 2, especially 20–23. I am grateful for Stephen Mulhall's comments on the longer paper from which these pages are extracted.

19. In fact, this aversion isn't complete; Fried is fond of citing and showing *Lesende (Reading),* 1994, as an absorptive image, but this is far from typical of Richter's practice.

20. In "Barthes's *Punctum,*" Fried's recent reading of Roland Barthes, *Camera Lucida: Reflections on Photography* (New York: Hill & Wang, 1981), Fried makes much of the fact that the *punctum* is a detail that the camera could not *not* record, in recording a given scene or subject in its entirety. According to this reading, the *punctum* is something that is *seen* by the viewer, without it being *shown* to them by the photographer. As such, it functions, according to Fried, as an "ontological guarantee" (553) of a given photograph's nontheatricality. See for example page 545, where Fried cites Barthes's remark: "the detail which interests me is not, or at least is not strictly, intentional, and probably must not be so; it occurs in the field of the photographed thing like a supplement that is at once inevitable and freely given [MF's trans.]; it does not necessarily attest to the photographer's art; it says only that the photographer was there, or else, still more simply, that he could not *not* photograph the partial object at the same time as the total object." See Barthes, *Camera Lucida,* 47. Fried comments, "The *punctum,* we might say, is *seen* by Barthes but not because it has been *shown* to him by the photographer, for whom it does not exist" (546).

21. "Painting can feign reality without having seen it... in Photography I can never deny that *the thing has been there.* There is a superimposition here: of reality and of the past. And since this constraint exists only for Photography, we must consider it, by reduction, as the very essence, the *noeme* of photography. What I intentionalize in a photograph... is Reference, which is the founding order of Photography. The name of Photography's *noeme* will therefore be 'That-has-been.'" See Barthes, *Camera Lucida,* 76–77.

22. "Photography maintains the presentness of the world by accepting our absence from it. The reality in a photograph is present to me while I am not present to it; and a world I know, and see, but to which I am nevertheless absent... is a world past." Cavell, *The World Viewed,* 23.

23. If this distinction, as it stands in the full complexity of Peirce's own work, ever really did do this work. For an argument to the contrary, see James Elkins, "What Does Peirce's Sign System Have to Say to Art History?" *Culture, Theory, and Critique* 44, no. 1 (2003): 5–22. In Peirce, see, for example, Charles Sanders Peirce, "Logic as Semiotic: The Theory of Signs," in *The Philosophy of Peirce: Selected Writings*, edited by Justus Bechler (London: Routledge, 2000); and Charles Sanders Peirce, "The Icon, Index and Symbol," in *The Collected Papers of Charles Sanders Peirce*, vol. 2, *Elements of Logic*, edited by Charles Hartshorne and Paul Weiss (Cambridge, MA: Harvard University Press, 1932).

24. By this I have in mind the broad sweep of Richter's photo-paintings, encompassing family portraits (from *Uncle Rudi* [1965] got up in his SS uniform to the family portraits of the late 1990s); holiday snaps (such as *Family at the Sea-Side* [1964] rendered in identical drab grisaille to that of *Administrative Building* from the same year); press images (such as *Woman with an Umbrella* [1964] or *Eight Student Nurses* [1966]); various more or less "Romantic" landscapes (from the *Seascapes* [1969–1970] to *Barn* or *Meadowland* [1984–1985]); and encyclopedic works (such as *48 Famous Men* [1971–1972]). I do not think this is true, for example, of Richter's *18 Oktober 1977*, of which Richter has said that it seeks to transform horror into grief. For just this reason, it remains atypical among Richter's photo-paintings. Unlike the others, it aims to do *more* than flatly reassert the photographic document's claim—from press photo to holiday snap—to depict what has been. See Gerhard Richter, "Conversation with Jan Thorn Prikker concerning the Cycle 18 October 1977" (1989), in Richter, *The Daily Practice of Painting*, 189.

25. Hence Wall's coinage, in 2002, of "*near* documentary" to describe his recent work. Fried has paid close attention to this coinage, finding in Wall's claim that such works purport to show what the events depicted were like when they passed *without* being photographed an antitheatrical intention. See Michael Fried, "Being There," *Artforum* (September 2004): 53. See also Fried's discussion of *Adrian Walker, artist, drawing from a specimen in a laboratory in the Dept. of Anatomy at the University of British Columbia, Vancouver* (1992), in Fried, "Jeff Wall, Wittgenstein et le quotidien." Together with "Barthes's *Punctum*," this will no doubt feature in the book on photography since the Bechers on which Fried is now working, provisionally titled *Ontological Pictures: The Argument from Recent Photography*, for Yale University Press. Wall addresses the issue of his relation, past and present, to what he calls a "classical aesthetic of photography as rooted in the idea of fact" in a fascinating 1998 interview with Boris Groys in de Duve, Pelenc, and Groys, *Jeff Wall*. There are many aspects of that interview that are relevant here, not least Wall's claim that he tried to put this claim in suspension "by emphasizing the relations between photography and the other picture-making arts, mainly painting and the cinema. In those the factual claim has always been played out in a subtle and more sophisticated way. This was what I thought of as a mimesis of the other arts" (151–54).

26. I consider these issues in more detail in "On the Very Idea of a 'Specific' Medium: Douglas Crimp and Michael Fried on Photography and Painting as Arts." The project gestured toward in the coda is that of my forthcoming monograph *Aesthetics after Modernism*.

27. I take this notion from Rosalind Krauss. See Krauss, *"A Voyage on the North Sea."*

FOLLOWING PIECES

ON PERFORMATIVE
PHOTOGRAPHY

Margaret Iversen

In his article called "Surrealist Precipitates: Shadows Don't Cast Shadows," Denis Hollier considers the cast shadow as exemplary of the type of sign admired by the Surrealists. The shadow, he argues, is "rigorously contemporary with the object it doubles, it is simultaneous, nondetachable, and, because of this, without exchange value."[1] As Hollier notes, the shadow is the clearest example of an indexical sign that is "less a representation of an object than the effect of an event."[2] This, he says, citing Breton, is what gives it a "circumstantial-magic dimension" ("circumstantial" meaning the opposite of magical, that is, factual, nonessential, and everyday).[3] For Hollier, works such as Jean Arp's sculpture *Bell and Navels* (1931), which incorporate real shadows, "open the internal space of the work to the context of reception, mixing it with that of the beholder."[4] The literary equivalent of the cast shadow, he says, is the first person. Just as the cast shadow indicates the object, the "I" is an index of the subject of enunciation: "The I opens up language to its performative circumstances.

The unfolding of Breton's autobiographical texts, such as *Nadja* (1928), was just as much unanticipated by the author as it was for the reader."[5] Both *follow* the narrative. *Nadja* does not have a dénouement; rather, as Breton said, it has an unresolved ending, "left ajar, like a door."[6]

The "descriptive realism" of the novel is here replaced by what Hollier calls "performative realism." This literary activity is directed against the novel. In the "Discourse on the Paucity of Reality" (1927), Breton urged writers to speak for themselves, rather than inventing sham human beings.[7] In *L'Amour fou*, he recommended recording experiences as in a medical report: "No incident should be omitted, no name altered, lest the arbitrary make its appearance."[8] In the 1962 introduction to *Nadja*, he claims to have adopted a tone "as impersonal as possible," like that of a neuropsychiatrist.[9] For him, the realist novel is only real-ish; it suffers from a paucity of reality. Breton's texts, by contrast, have characters who exist and who have proper names. They are also liberally "illustrated" with photographs. Breton says that the photographs were included to relieve him of the necessity of writing tiresome descriptive passages, but Hollier suggests that, along with the first person and narrative inconclusiveness, they effect an "indexation of the tale."[10]

Apart from this brief reference to the photographs in *Nadja* and a citation of Breton's observation that automatic writing is to invisible objects what photography is to visible ones, Hollier does not reflect further on what relevance these thoughts on the index might have for rethinking Surrealist photography or photography in general.[11] His interest is in narrative. But since photography is an indexical medium, the connection Hollier makes between the indexical and performativity has important implications: it offers a way of rethinking photography, particularly, as we shall see, photographic practices that have emerged since the late 1960s and 1970s.

In Peirce's typology, the index is classified on the basis of its mode of inscription, that is, the close, sometimes causal connection between the sign vehicle and the object. In his scheme, it is the icon that signifies by virtue of resemblance, and hence the photograph should be classed as a hybrid type of sign, part index, part icon.[12] But the hybrid form of the photograph can be uncoupled. Manipulated digital photography, for example, plays up iconicity at the expense of indexicality, while Man Ray's exploration of what he called the Rayograph is an exemplary case of a type of photography that takes advantage of the noniconic, indexical aspect of the medium. In "Notes on the Index," Rosalind Krauss observes that the Rayograph "forces the issue of the photograph's existence as an index." She describes the images resulting from putting objects directly onto light-sensitive paper as the "ghostly traces of departed objects."[13] Man Ray himself put it beautifully: he called the Rayograph "a residue of an experience… recalling the event more or less clearly, like the undisturbed ashes of an object consumed by flames."[14] This was also central to Roland Barthes's conception of the temporality of the photograph as developed in *Camera Lucida*. He understood the medium in general as an emanation from a past reality—a "that-has-been."[15] But the weight that Barthes gave to the photographic trace of an object, once present, now absent, though present in a ghostly form, is foreign to the idea of performative photography being articulated here. As we shall see, the photo-document as performative realism does not record some preexisting object or state of affairs. Rather, the camera is treated like an instrument of discovery, such as a telescope. Hollier imagines the index as a shadow, as having a fugitive reality and an ephemeral temporality. Photography imagined in these terms would have a very different nature from Barthes's conjuring of the uncanny photographic "return of the dead." Barthes's photograph revives the image of a lost object; what I will call "performative photography" tracks and records a contemporary event. Like the

narrative of *Nadja,* such photography *follows* the event, not know-ing the conclusion in advance.

Much of what Hollier says about the index recalls art dis-courses since the late 1960s and the 1970s; indeed, he cites Krauss's two-part essay, "Notes on the Index: Seventies Art in America," which was mainly about installation art rather than photography. What Hollier says, however, can cast new light on photographic practices of the late 1960s and 1970s. In fact, Jeff Wall's remark-able essay "Marks of Indifference" (1995) offers an interpreta-tion of conceptual photography in terms that sometimes recall Hollier's discussion of performative realism. He reads the work of a number of key artists as a parody of photojournalism or as the imitation of amateur photography. These "non-autonomous" photographic practices were imitated precisely because of their antiaesthetic status that, paradoxically, enabled photography to escape from its fine art photography ghetto to become Art. Of key importance for Wall is the reorientation of the idea of the picture. The photographs he discusses do not so much represent a preexisting object or view as record an ongoing event. As he notes, "[T]he picture is presented as the subsidiary form of an act, as 'photo-documentation.'"[16] Wall also observes how in the work of, for example, Robert Smithson, an exposure of Minimalism's "emotional interior... depends on the return of ideas of time and process, of narrative and enactment, of experience, memory and allusion." Smithson's work, he remarks, "is in part self-portrai-ture—that is, performance." And, of course, Smithson's format in, for instance, "A Tour of the Monuments of Passaic, New Jer-sey" (1967), could have been inspired by Surrealist texts, involving as it does first person reportage of perambulations in his curiously defamiliarized hometown, combined with deadpan photographic illustrations of discoveries made en route.[17] Rather than a parody of photojournalism or travel writing in general, as Wall and oth-ers maintain, Smithson's texts might profitably be seen as an imi-tation or parody of the Surrealist essays by Breton or Aragon,

which record an itinerary through the streets or arcades of Paris, displaced onto the barren postindustrial landscape of New Jersey. (Incidentally, Smithson owned a copy of *Nadja*.)[18]

Wall offers an interpretation of Ed Ruscha's work as an imitation of amateur photography, but I think his work might just as easily have been described, like Smithson's, as a parody of photojournalism. In any case, Smithson was undoubtedly influenced by Ruscha's groundbreaking 1963 book, *Twentysix Gasoline Stations*, which consists of photographs of gas stations along Route 66 between Los Angeles and Oklahoma City. Ruscha set himself a simple brief—to photograph the gas stations en route—and understood the photographs as records of these large-scale ready-mades. Depersonalization, in terms of both the preset project and the uninflected snapshots, overlays what is, in fact, a record of anti-landmarks or poor monuments along the route home.[19]

Positioning the work of Ruscha and Smithson, among others, in relation to nonautonomous and unaesthetic photographic practices helps to explain some of its character, but the operation of parodying has to do a lot of work. It does not quite capture the characteristic affectless, depersonalized, often repetitious, deadpan use of the camera. A recent article about conceptual art by Liz Kotz, "Language between Performance and Photography," is helpful in explaining this quality. She puts conceptual art in touch with earlier performance-based pieces that were governed by a notational system or "score." The performance follows the score, but the outcome in each instance is unforeseeable. As Kotz says, "[S]uch notational systems dislocate photography from the *reproductive logic* of original and copy to reposition it as a recording mechanism for specific realizations of general schemas."[20] This shift obviously brings the execution of a work closer to an utterance in language. Yet this linguistic emphasis does not in itself bring out the open-ended, experimental character of the work. The brilliance, for instance, of Lawrence Weiner's *Statements* of 1968, such as "A removal to the lathing or support wall of plaster

or wall board from a wall," is the unanticipated pattern of pipes and wires that are exposed when the minimal instruction in *performed*. In a very similar way, for his *Thirtyfour Parking Lots in Los Angeles*, 1967, Ruscha gave an aerial photographer instructions to photograph empty parking lots around Los Angeles, thereby revealing hitherto unnoticed herringbone patterns and variegated oil stains. I conclude that the condition under which photography became acceptable to this generation of artists was as a part of performance executed in accordance with a set of instructions or simple brief.[21]

The conception of photography implicit in the work of Smithson and Ruscha may be profitably compared with the highly critical view of photography advanced by their contemporary, Robert Morris. His photophobic view was shared by a number of artists associated with Minimalism, Fluxus, and Performance. In 1971, he was already contrasting the "instantaneous photograph" with the sort of new, walk-through, installation work. The experience of "being" afforded by installation is contrasted with the "having done" of what he disparagingly refers to as "thing art."[22] This idea is further elaborated in "The Present Tense of Space" (1978). There, Morris's well-known opposition, set out in his earlier essays, such as the "Notes on Sculpture, Part 4: Beyond Objects" (1969) and "Anti Form" (1968),[23] between bad (or conservative) static gestalt versus good extended spatio-temporal experience, is compressed into the pair of terms *image/duration*. The photographic image is particularly sternly criticized. The "cyclopean evil eye of photography" creates a flat and duration-less image.[24] "It is, of course, space—and time—denying photography that has been so malevolently effective in shifting an entire cultural perception away from the reality of time in art that is located in space."[25] With photography, says Morris, "the viewer remains completely detached and psychologically distanced."[26] The kind of work he advocates resists settling into an autonomous, consumable object, and it is therefore temporary and situational, that is, made for a

particular time and place and later dismantled, which means, as Morris acknowledges, that it absolutely relies on photography for its dissemination. Nevertheless, what we have here is an argument about how the situational and performative aspect of the new "process" art, and the provisional, "dedifferentiated" modes of perception it fosters, are threatened by photography. In other words, rather than exploring, with Ruscha and Smithson, the performative possibilities of photography, Morris denounces it.

One way of expressing what is at stake here can be glossed in terms of the difference between performance and performativity. Making use of Derrida's critique of J.L. Austin's theory of "performative utterances" in *How to Do Things with Words*, Peggy Phelan defines a "performance" as a unique and spontaneous event in the present tense that cannot be adequately captured on film or video.[27] This radical notion of performance lies behind the hostility of some performance, site-specific, and land artists to photo-documentation. "Performativity," in contrast, signals an awareness of the way the present gesture is always an iteration or repetition of preceding acts. It therefore points to the collective dimension of speech and action. Of course, Derrida would object that there is no such thing as a "performance" that is not a repetition, since "iterability is a structural characteristic of every mark."[28] For him, it is impossible to distinguish between citational statements, on the one hand, and singular, original statements, on the other. This is because an intention to say or do anything can never be entirely present to itself; there is always at work what he calls a "structural unconscious."[29] The distinction is nonetheless useful for thinking about different art practices and their aims. The term *performative* is often used in critical writing in a less precise way to mean work with an element of performance, but I would like to see it reserved for the work of those artists who are interested in displacing spatial and temporal immediacy by putting into play repetition and delay. So, for example, while Morris's attack on photography seems to imply a value set on "performance," the work of Smithson and

Ruscha (or Bruce Nauman, or Dan Graham) can more readily be seen as more strictly "performative."

These issues were addressed in an article by David Green and Joanna Lowry called "From Presence to the Performative: Rethinking Photographic Indexicality." They call for a reinterpretation of photographic indexicality, arguing that the concept of the photograph as the trace of a past event does not exhaust our understanding of its indexical properties. They advocate putting less stress on causal origins (as Barthes does) and more on the way it points to the event of its own inscription. "The very act of photography as a kind of performative gesture which points to an event in the world... is thus itself a form of indexicality."[30] This analysis seems particularly appropriate in the cases of conceptual photographic work they cite, such as Robert Barry's photographs of invisible gases that call into question the documentary value of the photography. However, I want to explore the possibilities of performative photography beyond pointing.

Denis Hollier's idea of performative realism mainly concerns the Surrealist reorientation of literature, away from fiction and toward the recording of a performance. In this way, the work becomes the effect or trace of an event. It is important for my argument that Hollier stresses the trace rather than the event itself. While some of his remarks about the shadow suggest the immediacy and ephemerality of the shadow's "performance" and the viewer's active participation, à la Morris, when he comes to discuss narrative, it is in terms of the record of a performance. But is *Nadja* conceived as the record of a singular and original performance, or is it properly performative in the sense I have defined? Certainly, the narrator, Breton, strives to displace his intentionality in a number of ways. Nothing could be further from a type of utterance that, as Derrida put it, intends a "full meaning as master of itself" and where "intention remains the organizing centre."[31] As Hollier remarks, both the author and the reader follow the events. This seems to describe very well Breton's authorial

position, but it also describes his position in the narrative—literally following Nadja. She is his guide to a Paris haunted by the past and the marvelous. He sees it anew through her hypersensitive eyes, "like ferns," and so his authorial first person is split, displaced, and delayed. The apparent contradiction between the insistent first person narrative and the impersonal structural model underlying the theory of performativity is reconciled by Breton's adherence to a psychoanalytically informed sense of the self. In the first lines of *Nadja,* he reposes the question "Who am I?" as "Whom do I haunt?"—a reformulation that is intended to extend what would count as personal identity to include a field "whose true extent is quite unknown to me."[32] The narrative of *Nadja* is restricted to episodes of Breton's life "only insofar as it is at the mercy of chance" and so escaping his control.[33] In this way, depth, presence, and interiority are effectively dispersed.

If one takes into account Breton's adherence to the facts, his avoidance of an expressive subjectivity, and his submission to chance, then Vito Acconci's position in his *Following Piece* becomes only a slight exaggeration of Breton's position in *Nadja.*[34] Acconci set himself the task of following a randomly selected stranger walking in the street while remaining himself unobserved. The task ended when the person entered a private space. The performance was repeated every day for three weeks in October 1969. He called this activity "Performing myself through another agent."[35] Like Breton's record of his daily meetings and nonmeetings with Nadja (which coincidently took place from the 4th to the 12th of October), a detailed record of each chance itinerary was mailed to a different member of the art community. Also like Breton, he later commissioned a photographer to document the activity. As Anne Wagner has observed, this lengthened the parade of followers by two: the photographer and the viewer of the photograph.[36] Although Acconci's systematic pursuit differs substantially from Breton's "desperate pursuit," especially in that the interest lies in the activity itself, rather than in what is found along the way, there is an analogous

displacement or deferral of agency.[37] In the notes for the work, first published in *Avalanche* 6 (1972), Acconci wrote,

> Adjunctive relationship—I add myself to another person—I let my control be taken away—I'm dependent on the other person— I need him, he doesn't need me—subjective relationship.
>
> Fall into position in a system—I can be substituted for—My positional value counts here, not my individual characteristics.[38]

These remarks call into question the appropriateness of the idea of "narcissism" for thinking about Acconci's video-work. In her early essay on video art, "The Aesthetics of Narcissism," Krauss used the particular example of Acconci's *Centers* to illuminate something about the medium. She compared the self-referential nature of video feedback with a narcissistic enforcing of the ego.[39] But Acconci does not project an ego in any of his work. Rather, he understands his body in a generalized way—as "the body"—described as "a system of possible movements." He is not interested in his individual subjective experience, but always takes himself "as an exemplar, a model."[40]

The photographic record of the performance of *Following Piece* was something of an afterthought—something to disseminate in art journals. Around the same time, however, Acconci performed various bodily activities accompanied by a camera: the titles of this series of works, twenty-three in all, give some sense of the minimal activities involved: *Stretch, Jumps, Blinks, Push up* (all 1969), and *Spin* (1970). In his "Notes on My Photography 1969–70" (1988), Acconci tells us that these works were a way of throwing himself into his environment.[41] His effort was based on a reading of Merleau-Ponty, who declared that the embodied self "is the way that man is in the world, and only in the world does he know himself."[42] In these works, Acconci aims at intertwining himself with the world. The photographs of each activity were originally collaged together with text panels of general

instructions for carrying out the activity and a note of the date and place of the photographed event. Some of them resemble an inside-out Muybridge, where the person in motion takes a series of snaps that describe the action. In *Fall*, for example, one instruction is to "snap the shutter as I hit the ground." Some examples in the series, however, are, in Muybridge fashion, a series of stop-motion images of Acconci, say, rolling in the sand—as in *Drifts* (1970).[43]

What distinguishes this work is its reorientation of the use of photography away from recording something constituted in advance and toward using it as an instrument of analysis, discovery, or measurement. Often, aspects of an activity otherwise unseen by the subject are revealed. *Blinks* makes this most apparent as the instruction is to click the camera when the eyes blink. Or again, in *Lay of the Land*, Acconci lies on his side and takes photos from five different points of view: feet, knees, stomach, chest, and head. The photographs collaged together become, then, something more like the result of an experiment, rather than the representation of an object. This is close to Austin's distinction between utterances that involve doing something rather than reporting something. Or, as Acconci nicely put it, they are photos "not of an action, but through an action."[44]

During the month of February 1979, the French artist Sophie Calle undertook her own following piece, *Suite vénitienne*. In some ways it resembles Acconci's since it involved setting a task and documenting the activity with a camera.[45] Calle decided to travel to Venice, track down a man she had met once at a party in Paris, and follow him. In order to avoid recognition, she disguised herself with makeup, a blonde wig, and dark glasses—a getup that ironically attracted unwanted attention in the street. The work consists of fifty-five photographic panels documenting the pursuit and twenty-four text panels of her detailed, day-by-day diary, plus three maps. Its original book form brings out its relation to *Nadja* because, like Breton, Calle included captions under some of the

images that are excerpts from the diary.[46] It also resembles *Nadja* in that the texture of the city—Venice's piazzas, churches, bridges, canals, and cafés—plays an important role. Yve-Alain Bois stresses the voyeuristic and sadistic side of the project, yet there is also a definite element of risk; Calle puts herself at the mercy of another.[47] Sounding very like a latter-day Breton, she says, "I see myself at the labyrinth's gate, ready to get lost in the city and in this story. Submissive."[48] The ambivalently sadistic-submissive aspect of the work, reminiscent of Acconci's, gives it a hint of eroticism, and although Calle had no personal interest in the man, Henri B., at all, her behavior might well be interpreted as that of an obsessed stalker. In this regard, the reversal of gender norms is clearly an important aspect of Calle's project.

An insightful essay by Jean Baudrillard, "Please Follow Me," is included in the book version of *Suite vénitienne*. He suggests that Calle's relentless pursuit, over fourteen days, involved a "subtle murder." By following in his footsteps and mimicking his actions (for example, taking photos of the same views that he photographs), she is a subversive double—a living "citation" that robs the original of meaning. Shadowing him, she usurps his shadow. But it works the other way around as well. "She has lost herself in the other's traces. But she steals his traces." Because the choice of Henri B. was more or less arbitrary, he is a nobody, and as Baudrillard observes, that means that her documents "are not souvenir snapshots of a presence, but rather shots of an absence."[49]

Calle's project is aptly described as performative photography because, on the one hand, there are the elements of task setting, of submitting herself to arbitrary structures and the consequent authorial divestiture. On the other hand, there is the reorientation of the picture toward the recording of an ongoing, open-ended event open to unanticipated consequences. Her use of the camera mimics that of the private detective. She even experiments with a camera attachment made up of an arrangement of mirrors that allows one to point the camera away from what one is photographing. Indeed,

after this project, she engaged a private detective to follow her and record her movements over several days as if she wanted her turn in the game as the one pursued (*The Shadow*, 1981).

The work of the Mexican artist Gabriel Orozco also shows a consistent interest in performativity. Much of his work involves walking through the streets in a state of intense alertness and openness to the things that interest him visually. His work is thus quite different in spirit from Acconci's or Calle's dogged pursuits. Orozco takes photographs along the way of "readymade" or assisted ready-made configurations. He claims a lack of interest in pictorial composition, using the camera in as neutral a way as possible. This accords with his quasi-ethical attitude of receptiveness or vulnerability, perfectly figured in his work, *Yielding Stone*, 1992, a ball of plasticine that has been rolled through the street, picking up marks and debris. His work conveys an attraction to ephemeral configurations of "low" materials and an easy spontaneity. Yet Orozco is also interested in rule-governed games, like chess or billiards (or football), that simultaneously impose repetition and generate variation. David Joselit relates this combination of rule and chance to the Duchampian rendezvous or the Bretonian encounter, describing the work as "both restricted and open-ended."[50] He points to the example of *Until You Find another Yellow Schwalbe*, 1995, the title of which recalls conceptual instruction pieces. During his stay in Berlin, he would park his own yellow motor scooter alongside an identical one he came across in the street. The series of photographs documents this promiscuous coupling of yellow swallows (*Schwalbe* is German for swallow). Whether, as in this case, the artist executes a mini-performance or someone else does, as in *Extension of Reflection* (a kind of Zen drawing made with rainwater for ink and bicycle wheels for a brush) or *Waiting Chairs*, it is not the performance but the trace left behind that Orozco records. He favors a slight temporal displacement. Or, as he himself has said, his still photography shows "the wake of the past."[51]

Orozco's pursuit of the index as a trace of what Hollier called "the ephemeral wake of time" has led him to make videos. In some ways, video is the natural medium of performativity, with its do-it-yourself antiaestheticism and unedited recording. Certainly, Acconci took to it like a duck to water. Yet, because of its capacity for simultaneous transmission, it is equally live, continuous, and immediate—in other words, an adjunct of performance. In Orozco's hands, video is an extension of his photographic practice. He walks and records: "sometimes I follow a dog, sometimes I follow a backpack." Unlike his still photography, the visual interest is bound up with movement of objects—a spinning bicycle wheel or falling leaves—or the camera. There is no planning and no postproduction. "Walking down 6th Avenue, I'll suddenly see something that intrigues me—a plastic bag, a green umbrella, an airplane tracing a line in the sky. That's how I get started." He'll follow something down the street, walking and recording, until it turns a corner and disappears. "The metaphoric links between things are not something I plan but something that just happens." There may be an actual gap of a few minutes between shots, but he says, "The connection themselves are real, not metaphoric." They are related by contiguity or proximity. He describes one tape, made in Amsterdam, called *From Dog Shit to Irma Vep* (a poster of a beautiful Chinese actress): "Between these two events there's an entire day of walking, now condensed into 40 minutes of a recorded tape"—"a day of awareness," as he put it.[52] Orozco explicitly distances his practice from the idea of pure chance. Rather, he deliberately focuses on something until, as he says, "the tension between my intentions and reality becomes too great and the whole thing breaks down." His procedure generally has, then, the riskiness of improvisation within an arbitrary structure.

Artists since the 1960s have found in photography a medium that lends itself to the redefinition of the image. That redefinition spurned the idea of recording a preexisting object or situation in favor of using the camera as an instrument of experimentation or

exploration. This quality is often reinforced by the quasi-systematic nature of the instructions or brief. Photography is thus conceived, not as a melancholic "that-has-been," but more as a future oriented and interrogative "what-will-be?"

In an interview Orozco remarked, "What is most important is not so much what people see in the gallery or the museum, but what people see after looking at these things, how they confront reality again."[53] This ambition, first clearly articulated by the Surrealists, has echoed down through the art of the twentieth century. Yet that legacy has, in turn, enabled us to reevaluate the significance of Surrealism.

Notes

1. Denis Hollier, "Surrealist Precipitates: Shadows Don't Cast Shadows," translated by Rosalind Krauss, *October* 69 (Summer 1994): 114.
2. Hollier, "Surrealist Precipitates," 115.
3. Hollier, "Surrealist Precipitates," 117.
4. Hollier, "Surrealist Precipitates," 124.
5. Hollier, "Surrealist Precipitates," 129.
6. André Breton, *Nadja*, rev. ed. (Paris: Gallimard, 1964), 18; and André Breton, *Nadja*, trans. Richard Howard (London: Penguin, 1999), 18. See Mark Polizzotti's introduction to this edition for several caveats concerning both the objectivity of the tone and factuality of the narrative.
7. André Breton, "Introduction to the Discourse on the Paucity of Reality," translated by Richard Sieburth and Jennifer Gordon, *October* 69 (Summer 1994): 133–44. From André Breton, *Point du Jour* (Paris: Editions Gallimard, 1970).
8. André Breton, *L'Amour fou* (Paris: Gallimard, 1937); and André Breton, *Mad Love*, translated by Mary Ann Caws (Lincoln: University of Nebraska Press, 1987), 39.
9. Breton, "Avant-dire (dépêche retardée)," in *Nadja*, 5.
10. Breton, "Avant-dire (dépêche retardée)," 6; and Hollier, "Surrealist Precipitates," 126. In his article "La photographie dans Nadja," Jean Arrouye acknowledges this function, but also notes that the text functions like an index, pointing to what in the photographs is relevant and conferring on them a specific meaning. See Jean Arrouye, "La photographie dans Nadja," *Mésuline* 5, "Le Livre Surréaliste" (June 1891): 128.
11. André Breton, "Max Ernst" (1921), in André Breton, *Les Pas perdus* (Paris: Gallimard, 1924), 101; and André Breton, *The Lost Steps*, translated by Mark Polizzotti (Lincoln: University of Nebraska Press, 1996), 60.

12. Charles Sanders Peirce, "Icon, Index, Symbol," in *The Collected Papers of Charles Sanders Peirce*, vol. 2, *Elements of Logic*, 159; and Charles Sanders Peirce, "Logic as Semiotic: The Theory of Signs," in *The Philosophy of Peirce*, 98–119.
13. Rosalind Krauss, "Notes on the Index: Seventies Art in America," *October* 3 (Spring 1977): 68–81, and Rosalind Krauss, "Notes on the Index: Seventies Art in America (Part 2)," *October* 4 (Fall 1977): 58–67.
14. Man Ray, "The Age of Light," in *Classic Essays on Photography*, edited by Alan Trachtenberg (New Haven, CT: Leete's Island Books, 1981), 167.
15. Barthes, *Camera Lucida:* translation of Roland Barthes, *La chambre claire: Note sur la photographie* (Paris: Gallimard, 1980).
16. Jeff Wall, "'Marks of Indifference': Aspects of Photography in, or as, Conceptual Art," in *Reconsidering the Object of Art*, edited by Ann Goldstein and Anne Rorimer (Los Angeles: Museum of Contemporary Art; Cambridge, MA: MIT Press, 1995), 254.
17. Robert Smithson, "A Tour of the Monuments of Passaic, New Jersey" (1967), in *Robert Smithson: The Collected Writings*, edited by Jack Flam (Berkeley: University of California Press, 1996), 68–74.
18. Aragon's *Paysans de Paris* is itself a parody of a travel guide; see Louis Aragon, *Le Paysans de Paris* (Paris: Gallimard, 1953).
19. See *Ed Ruscha and Photography* (New York: Whitney Museum of Contemporary Art, 2004).
20. Liz Kotz, "Language between Performance and Photography," *October* 111 (Winter 2005): 15.
21. The *locus classicus* of this combination of the instructional and the aleatory is Marcel Duchamp's *Three Standard Stoppages* (1913–1914).
22. Robert Morris, "The Art of Existence," in his *Continuous Project Altered Daily* (Cambridge, MA: MIT Press, 1993), 97.
23. Robert Morris, "Notes on Sculpture, Part 4: Beyond Objects," *Artforum* 7, no. 8 (April 1969): 53; and Robert Morris, "Anti Form," *Artforum* 6, no. 8 (April 1968): 35.
24. Robert Morris, "The Present Tense of Space," in his *Continuous Project*, 197.
25. Morris, "The Present Tense of Space," 201.
26. Morris, "The Present Tense of Space," 203.
27. Peggy Phelan, "Andy Warhol: Performances of Death in America," in *Performing the Body/Performing the Text*, edited by Amelia Jones and Andrew Stephenson (London: Routledge, 1999), 223–37; and Peggy Phelan, "The Ontology of Performance: Representation without Reproduction," in *Unmarked: The Politics of Performance* (London: Routledge, 1993), 146–66. See also J. L. Austin, *How to Do Things with Words*, 2nd ed. (Cambridge, MA: Cambridge University Press, 1975).
28. Jacques Derrida, "Signature Event Context," in *Margins of Philosophy*, translated by Alan Bass (Chicago: Harvester Press, 1982), 324.
29. Derrida, "Signature Event Context," 326.
30. David Green and Joanna Lowry, "From Presence to the Performative: Rethinking Photographic Indexicality," in *Where is the Photograph?* (Brighton, UK: Photoforum and Maidstone, UK: Photoworks, 2003), 48.
31. Derrida, "Signature Event Context," 323.
32. Breton, *Nadja*, 11–12.

33. Breton, *Nadja*, 19.
34. This was part IV of a series called *Street Works* that took place over three weeks in October 3–25, 1969. I asked Acconci if he knew *Nadja*. This was his reply: "Yes, I read *Nadja*, probably around 1965. Was it on my mind when I conceived/first-thought-about *FOLLOWING PIECE?* Not that I was aware of [it]—just as I wasn't aware that I might have been thinking about *L'Annee Derniere a Marienbad*, or Michel Butor's *Mobile*, or Quicksilver Messenger Service's *The Hat*, or many other sources that I loved and might have been stealing from." (Personal communication, November 2005)
35. See *Avalanche* 6 (Fall 1972): 30.
36. Anne Wagner, "Performance, Video and the Rhetoric of Presence," *October* 91 (Winter 2000): 63.
37. Breton, *Nadja*, 108; in French, "cette poursuite éperdue," 127.
38. *Avalanche* 6 (Fall 1972): 30. See Amelia Jones on the ambivalently aggressive and sadomasochistic nature of Acconci's performances. Here, he is simultaneously aggressive stalker and shadow. Amelia Jones, "The Body in Action: Vito Acconci and the 'Coherent' Male Artistic Subject," in her *Body Art: Performing the Subject* (Minneapolis: Minnesota University Press, 1998), 103–50.
39. Rosalind Krauss, "Video: The Aesthetics of Narcissism," *October* 1 (Spring 1976): 51–64.
40. See Vito Acconci, "Notes on Work 1967–1980" (1980), in *Acconci: Writing, Work, Projects,* edited by Gloria Maure (Barcelona, 2001), 350–51.
41. Vito Acconci, "Notes on My Photography 1969–70," in *Vito Acconci: Photographic Work* (New York: Brooke Alexander, 1988); reprinted in Douglas Fogle, *The Last Picture Show: Artists Using Photography, 1960–1982* (Minneapolis: Walker Art Center, 2003), 184.
42. Maurice Merleau-Ponty, *Phenomenology of Perception,* translated by Colin Smith (London: Routledge, 1962), x–xi. For an account of the phenomenological dimension of this body of work, see Christine Poggi, "Following Acconci/Targetting Vision," in *Performing the Body/Performing the Text,* edited by Amelia Jones and Andrew Stephenson (London: Routledge, 1999), 255–72.
43. See Kate Linker, *Vito Acconci* (New York, 1994). She refers to him as a maker of "banal and iterative events." Also *Vito Acconci: A Retrospective, 1969–1980* (Chicago: Museum of Contemporary Art, 1980).
44. Acconci, "Notes on Photography," in Fogle, *The Last Picture Show,* 184.
45. In conversation with me and in other interviews, Calle has insisted that she was unaware of Acconci's *Following Piece* when she made *Suite vénitienne*. However, after she'd taken the photos a friend told her about it. She made a trip to New York to visit Acconci, who "gave her his blessing." See the account of this episode in Cécile Camart, "Sophie Calle, 1978–1981: Genèse d'une figure d'artiste," *Les Cahiers du Musée national d'art moderne* 85 (Autumn 2003), 64. See also the retrospective exhibition catalogue *M'as-tu vue?* Centre Georges Pompidou, Paris, 2003–2004.

46. Sophie Calle, *Suite vénitienne* (Paris: Éditions de l'Étoile, 1983; and Seattle WA: Bay Press, 1988); and Jean Baudrillard, "Please Follow Me," in Calle, *Suite vénitienne*. Sadly the *Nadja*-like captions were removed in the English translation. The work was displayed for the first time by White Cube Gallery, London, in 1996.

47. Yve-Alain Bois, "Character Study," *Artforum* (April 2000): 126–31. See also his contribution to the Pompidou retrospective, *Paper Tiger*.

48. Calle, *Suite vénitienne*, 6. Also relevant is Breton's account of his trailing of Jacqueline Lamba through the streets of Montmartre in Breton, *Mad Love*, 43.

49. All quotations in this paragraph are from Calle, *Suite vénitienne*, 78.

50. David Joselit, "Gabriel Orozco" (review), *Artforum* 39, no. 1 (September 2000): 173.

51. Gabriel Orozco, *Photogravity* (Philadelphia: Philadelphia Museum of Art, 1999). Benjamin Buchloh writes of the temporal dialectic in Orozco's photographs "between the not yet and the nevermore." He also touches on the nerve of my argument when he refers to conceptual artists' interest in photography's "capacities to collect and represent information on the subject's modalities of spatial and temporal experience." See Gabriel Orozco, "Cosmic Reification: Gabriel Orozco's Photographs," in *Gabriel Orozco* (Cologne: Serpentine Gallery and Verlag der Buchhandlung Walther König, 2004), 86, 76.

52. Gabriel Orozco, "A Thousand Words," *Artforum* 38, no. 10 (Summer 1998): 115.

53. Orozco, *Clinton Is Innocent* (Paris: Musée d'Art Moderne de la Ville de Paris, 1998), 59.

TIME EXPOSURE
AND SNAPSHOT

THE PHOTOGRAPH AS PARADOX

Thierry de Duve

Commenting on Harold Rosenberg's *Tradition of the New,* Mary
McCarthy once wrote, "You cannot hang an event on the wall,
only a picture." It seems, however, that with photography, we have
indeed the paradox of an event that hangs on the wall.[1]

Photography is generally taken in either of two ways: as an
event, but then as an odd-looking one, a frozen gestalt that con-
veys very little, if anything at all, of the fluency of things hap-
pening in real life; or it is taken as a picture, as an autonomous
representation that can indeed be framed and hung, but that then
curiously ceases to refer to the particular event from which it was
drawn. In other words, the photograph is seen either as natural
evidence and live witness (picture) of a vanished past, or as an
abrupt artifact (event), a devilish device designed to capture life
but unable to convey it. Both notions of what is happening at the
surface of the image have their counterpart in reality. Seen as live
evidence, the photograph cannot fail to designate, outside of itself,

⌐eath of the referent, the accomplished past, the suspension of time. And seen as deadening artifact, the photograph indicates that life outside continues, time flows by, and the captured object has slipped away.

As representatives of these two opposite ways in which a photograph is perceived, the funerary portrait would exemplify the "picture." It protracts onstage a life that has stopped offstage. The press photograph, on the other hand, would exemplify the "event." It freezes onstage the course of life that goes on outside. Once generalized, these examples suggest that the time exposure is typical of a way of perceiving the photograph as "picture-like," whereas the instantaneous photograph is typical of a way of perceiving it as "event-like."

These two ways are mutually exclusive, yet they coexist in our perception of any photograph, whether snapshot or time exposure. Moreover, they do not constitute a contradiction that we can resolve through a dialectical synthesis. Instead they set up a paradox, which results in an unresolved oscillation of our psychological responses toward the photograph.

First, let us consider the snapshot, or instantaneous photograph. The snapshot is a theft; it steals life. Intended to signify natural movement, it only produces a petrified analogue of it. It shows an unperformed movement that refers to an impossible posture. The paradox is that in reality the movement has indeed been performed, while in the image the posture is frozen.

It is clear that this paradox derives directly from the indexical nature of the photographic sign.[2] Using the terms of Charles Sanders Peirce's semiotics, though the photograph appears to be an icon (through resemblance) and though it is to some extent a symbol (principally through the use of the camera as a codifying device), its proper sign type, which it shares with no other visual representation (except the cast and, of course, cinema), is the index, that is, a sign causally related to its object. In the case of photography, the direct causal link between reality and the image

is light and its proportionate physical action upon silver bromide. For a classical post-Saussurean semiology, this would mean that, in the case of photography, the referent may not be excluded from the system of signs considered. Certainly, common sense distinguishes an image from reality. But why does common sense vanish in front of a photograph and charge it with such a mythical power over life and death? It is not only a matter of ideology or of naïveté. Reality does indeed wedge its way into the image. The referent is not only that to which the sign refers, but also that upon which it depends.

Therefore, we ought to introduce a slightly different vocabulary from the usual semiological terminology in order to attempt a theoretical description of the photograph. We shall consider the semiotic structure of the photograph to be located at the juncture of two series. (It is not the place here to justify the choice of the word *series*. Let us say only that it is the dynamic equivalent of a line, and that the crossing of two lines is necessary to organize a structural space, or matrix.)

The first series is image producing. It generates the photograph as a semiotic object, abstracted from reality, the surface of the photograph so to speak. Let us call it the *superficial series*. The second series is reality produced (one might even say reality producing, insofar as the only reality to be taken into account is the one framed by the act of taking a photograph). It generates the photograph as a physical sign, linked with the world through optical causality. Let us call it the *referential series*.

We may now return to the paradox of an unperformed movement and an impossible posture. When in the late 1870s, Eadweard Muybridge's snapshots of animal locomotion, especially the studies of the horse's different gaits, came to be known in France and the United States, they occasioned a considerable furor among painters and photographers.[3] Whether or not a horse should be depicted in the unexpected, yet "true," postures that were revealed by the infallible eye of the camera, and whether or

not the artist—including the photographer when he strives for artistic recognition—should remain faithful to nature as recorded rather than interpret it, were the main issues under debate. Yet these aesthetic controversies are symptomatic of what was felt as an unbearable disclosure: that of the photograph's paradoxical treatment of reality in motion.

The nineteenth-century ideology of realism prescribed, among other things, the attempt to convey visual reality adequately. And to that end, photography was sensed—either reluctantly or enthusiastically—as establishing a rule. But with the onset of motion photography, artists who were immersed in the ideology of realism found themselves unable to express reality and obey the photograph's verdict at the same time. For Muybridge's snapshots of a galloping horse demonstrated what the animal's movements were, but did not convey the sensation of their motion. The artist must have felt squeezed between two incompatible truths that can be approached in terms of a contradiction in aesthetic ideology. But basically this contradiction is grounded in the paradoxical perception of photography in general, for which the example of Muybridge is simply an extreme case.

The paradox of the unperformed movement and the impossible posture presents itself as an unresolved alternative. Either the photograph registers a singular event, or it makes the event form itself in the image. The problem with the first alternative is that reality is not made out of singular events; it is made out of the continuous happening of things. In reality, the event is carried on by time; it does not arise from or make a gestalt: the discus thrower releases the disc. In the second case, where the photograph freezes the event in the form of an image, the problem is that that is not where the event occurs. The surface of the image shows a gestalt indeed, emerging from its spatial surroundings, and disconnected from its temporal context: the discus thrower is caught forever in the graceful arc of his windup.

The referential series of the photograph is purely syntagmatic, whereas the superficial series is an absolute paradigm. Contrary to what happens in a painted or drawn image, there is no dialectic between syntagm and paradigm, though both series cross at one point. In other words, this is how we live through the experience of this unresolved alternative, while looking at a photograph: either we grasp at the thing (or its sign, or its name), the gallop of the horse, but this thing does not occur in the referential series that in fact contains only the verb (the horse gallops); or, if we wish to grasp the verb, the flux, the movement, we are faced with an image from which this has escaped (the superficial series contains only the name, the shape, the stasis). The paradox sets in at the crossing point of both series, where they twist to form an unnatural, yet, nature-determined, sign, accounting for what Roland Barthes calls the "real unreality" of photography.[4] The snapshot steals the life outside and returns it as death. This is why it appears as abrupt, aggressive, and artificial, however convinced we might be of its realistic accuracy.

Let us now consider the time exposure, of which the photoportrait is a concrete instance. Whether of a live or dead person, the portrait is funerary in nature, a monument. Acting as a reminder of times that have died away, it sets up landmarks of the past. This means it reverses the paradox of the snapshot, series to series. Whereas the snapshot refers to the fluency of time without conveying it, the time exposure petrifies the time of the referent and denotes it as departed. Reciprocally, whereas the former freezes the superficial time of the image, the latter releases it. It liberates an autonomous and recurrent temporality, which is the time of remembrance. While the portrait as *Denkmal*,[5] monument, points to a state in a life that is gone forever, it also offers itself as the possibility of staging that life again and again in memory.

An asymmetrical reciprocity joins the snapshot to the time exposure: whereas the snapshot stole a life it could not return, the time exposure expresses a life that it never received. The time

exposure does not refer to life as process, evolution, diachrony, as does the snapshot. It deals with an imaginary life that is autonomous, discontinuous, and reversible, because this life has no location other than the surface of the photograph. By the same token, it does not frame that kind of surface-death characteristic of the snapshot, which is the shock of time splitting into *not anymore* and *not yet*. It refers to death as the state of what has been: the fixity and defection of time, its absolute zero.

Now that we have brought the four elements of the photographic paradox together, we can describe it as a double branching of temporality: (1) in the snapshot, the present tense, as hypothetical model of temporality, would annihilate itself through splitting: always too early to see the event occur at the surface, and always too late to witness its happening in reality; and (2) in the time exposure, the past tense, as hypothetical model, would freeze in a sort of infinitive, and offer itself as the empty form of all potential tenses. (See Table 1.)

Photography not only overthrows the usual categories of time. As Roland Barthes suggests, it also produces a new category of space-time: "an illogical conjunction of the *here* and the *formerly*."[6] To what Barthes says, we can add that this formula adequately describes only half of the photographic paradox, namely, the space-time of the snapshot. The space-time of the time exposure would in turn be described as another illogical conjunction: *now* and *there*.

Here denotes the superficial series as if it were a place: the surface of projection of the photographed event, once it is made clear that the event never occurs there. The surface of the image is received as a fragment of space that cannot be inhabited, since inhabiting takes time. As the snapshot locks time in the superficial series, it allows it to unreel in the other one. *Formerly* denotes the referential series as if it were a time: a past tense enveloped by the present and in continuity with it. *Formerly* refers to a past sequence of events that are plausible but deprived of any location.

Table 1

SNAPSHOT	TIME EXPOSURE
Signifier (photograph)	
Abrupt artifact	Natural evidence
For example: press photograph	For example: funerary photograph
Superficial series ("image")	
1. Theft of life	Protracted life
Unperformed movement → possible posture	
2. Singular event: gestalt	Recurrent time
"The gallop of the horse"	
3. Death: not anymore and not yet	Life: systole, diastole
4. Here: pinpointed space; sharpness	Now: potential time; out-of-focus
5. Trauma: too early, blow	Mourning: presence, (memory), hypercathexis
MANIA	**DEPRESSION**
Referential series ("reality")	
1. Fluency of life: impossible posture, performed movement	State of death
2. Continuous happening: flow	Bygone past
"The horse gallops"	
3. Life: present (or past) tense	Death: time absent: 0
4. Formerly	There
5. Trauma: too late, anticathexis	Mourning: absence (reality), decathexis

Now denotes the superficial series as if it were a time, but without any spatial attachment, cut from its natural link with here. Therefore, it is not a present but a virtual availability of time in general, a potential ever-present to be drawn at will from the referential past.

There denotes the referential series as if it were a place, that is, the referential past as frozen time, a state rather than a flow, and thus a space rather than a time.

When we bear in mind that these two illogical conjunctions, which we have been trying to specify with the help of opposite models (time exposure versus snapshot), are at work in every photograph, then we shall be able to restate these models in less

empirical terms. To look at a photograph as if it were instanta-
neous (a snapshot) would mean to apprehend the superficial series
as spatial and the referential series as temporal; to look at a pho-
tograph as if it were a time exposure would mean the reverse. The
significant difference between "instantaneous" and "time expo-
sure" would be the commutation of time and space along the axis
of either surface or referent, or, reciprocally, the jump in focusing
on surface or on referent, along the axis of either time or space.

What does the twist in the categories of time and space
imply in terms of psychological response? We are not dealing
here with the *reading* of a photograph, which belongs to the field
of semiology. Barthes remains in that field when he states that
the illogical conjunction of the here and the formerly is a type
of *consciousness* implied by photography. But we are dealing with
something more basic to the understanding of photography. That
more fundamental aspect can be said to be on the level of the
unconscious; but of course the unconscious is involved in *reading*
too. What is in question here is the affective and phenomeno-
logical involvement of the unconscious with the external world,
rather than its linguistic structure. It is most probable that the
necessity of stressing this aspect once again proceeds from the
indexical nature of the photograph.[7]

The word *here*, used to describe the kind of space embodied
in the snapshot, does not simply refer to the photograph as an
object, a thing endowed with empirical measurements that we are
holding, *here*, in our hands. Because the photograph is the result
of an indexical transfer, a graft off of natural space, it operates as
a kind of ostensive gesture, as when we point with the index fin-
ger at an object to indicate that it is this one, here, that we mean.
In a sense, the very activity of finding a "focal point"—that is,
selecting one particular plane out of the entire array of the world
spread in depth before us—is itself a kind of pointing, a selection
of this cut through the world at this point, here, as the one with
which to fill the indexical sign. Finding the point of focus is in

this sense a procedural analogue for the kind of trace or index that we are aware of when we hold the printed snapshot in our hands. Both poles of this phenomenon—the means to the image and the result—have in common a contraction of space itself into a point: here as a kind of absolute.

The aesthetic ideal of instantaneous photographs is sharpness. Though there is a trend in photography that tends to blur the image in order to express motion, this contradicts the built-in tendency of snapshots toward sharpness, and relates to the practice of time exposure. Some years ago, there was an aesthetic controversy among photographers as to whether a completely blurred photograph of moving objects should be acceptable or not. Those who rejected this practice claimed that there must be one point of sharpness and that this is enough. Theoretically, they are right. Photography may not become totally abstract, because that would constitute a denial of its referential ties. One point of sharpness suffices to assert its own space, for the essence of the point is precision.

How does one relate to a space of such precision? One thing is certain: it does not give way to a reading procedure. For an image to be read requires that language be applied to the image. And this in turn demands that the perceived space be receptive to an unfolding into some sort of narrative. Now, a point is not subject to any description, nor is it able to generate a narration. Language fails to operate in front of the pinpointed space of the photograph, and the onlooker is left momentarily aphasic. Speech, in turn, is reduced to the sharpness of a hiccup. It is left unmoored or, better, suspended between two moorings that are equally refused. Either it grasps at the imaginary by connecting to the referential series, in order to develop the formerly into a plausible chronology, only to realize that this attempt will never leave the realm of fiction; or it grasps at the symbolic by connecting to the superficial series, in order to construct upon the here a plausible scenography, and in this case also the attempt is structurally doomed. Such a shock,

such a breakdown in the symbolic function, such a failure of any secondary process—as Freud puts it—bears a name. It is trauma.

We know of certain photographs to be truly traumatic: scenes of violence, obscenity, and so on. However, I wish to claim that the photograph is not traumatic because of its content, but because of immanent features of its particular time and space. The trauma effect is of course a limit, but an internal one, enhanced by the subject matter of the photograph, yet not dependent upon it. As an example, one might recall the famous press photograph from the war in Vietnam, in which we see a Saigon police officer about to shoot a Vietcong soldier. This is certainly a traumatic photograph. But although the traumatism seems to be generated by the depiction of the atrocities of war and assassination, it depends instead on the paradoxical "conjunction of the here and the formerly": I will always be too late, in real life, to witness the death of this poor man, let alone to prevent it; but by the same token, I will always be too early to witness the uncoiling of the tragedy, which, at the surface of the photograph, will of course never occur. Rather than the tragic content of the photograph, even enhanced by the knowledge that it has really happened ("We possess then, as a kind of precious miracle," says Barthes, "a reality from which we are ourselves sheltered"), it is the sudden vanishing of the present tense, splitting into the contradiction of being simultaneously too late and too early, that is properly unbearable.

Time exposure implies the antithesis of trauma. Far from blocking speech, it welcomes it openly. Only in time exposure (portrait, landscape, still life, and so on) may photography appear with the continuity of nature. The portrait, for example, may look awkward, but not artificial, as would be the case of a snapshot of an athlete caught in the midst of a jump. When continuity and nature are perceived, speech is apt to body forth that perception in the form of a narrative that meshes the imaginary with the symbolic and organizes our mediation with reality.

The word *now,* used to describe the kind of temporality involved in time exposures, does not refer to actual time, since it is abstracted from its natural link with *here: hic et nunc.* It is to be understood as a pause in time, charged with a potential actualization, which will eventually be carried out by speech (or memory as interior speech), and is most probably rooted in the time-consuming act of looking.

The aesthetic ideal of time exposure is thus a slight *out-of-focus.* The blurred surroundings that belonged to the nineteenth-century style of photo-portrait act as a metaphor for the fading of time, in both ways, that is, from presence to absence and from absence to presence. Whenever photography makes use of blurring or related softening techniques, it endeavors to regain some of the features through which painting traditionally enacts time. The chiaroscuro, for example, is not the background of shape, but its temporality. It loosens the fabric of time and allows the protruding shape to be alternately summoned and dismissed. The blurring of the image in photography is the same. The painterly illusionism of depth finds its photographic equivalent in the lateral unfurling of the photograph's resolution, not only its blurred margins, but also its overall grain.[8] It allows the viewer to travel through the image, choosing to stop here and there, and in so doing, to amplify the monumentality of a detail, or to part from it. The kind of time involved by this *travail* is cyclic, consisting in the alternation of expansion and contraction, diastole and systole.

This particular surface temporality of photography is congenial with the ebb and flow of memory. For a portrait (as typified by the funerary image) does not limit its reference to the particular time when the photograph was taken, but allows the imaginary reconstruction of any moment of the life of the portrayed person. (That is the charm of a photo album; each photograph is a landmark in a lifetime. But memory shuffles in between landmarks, and can erect on any of them the totality of this life.)

So photography in this instance is a consoling object. This movement in systole and diastole is also the one that runs alongside what Freud called the *work of mourning*. To put it simply, what happens in the mourning period is a process in which the subject learns to accept that the beloved person is now missing forever, and that in order to survive, he must turn his affection toward someone or something else. In the course of this process, substitutive objects, like things that have belonged to the deceased, or an image of the deceased, can help obey the demands of reality. In Freudian terms, this means that a certain quantity of libidinal affect must be withdrawn from the object to which it was attached (*decathexis*), awaiting to be refastened to a new object. Meanwhile, the loosened affect temporarily affixes itself to "each single one of the memories and expectations in which the libido is bound to the object."[9] This process Freud calls *hypercathexis*. We can assume that the substitutive objects of the deceased can act as representations of these "memories and expectations," and thus that they are themselves *hypercathected*.

We may suppose—again because of the indexical nature of photography—that there is something like a mourning process that occurs *within* the semiotic structure of the photograph, as opposed to what would happen with other kinds of images, like drawing or painting. A real mourning process can obviously make use of any kind of image as substitutive object. The mourning process then remains exterior to the semiotic structure of the image. But photography is probably the only image-producing technique that has a mourning process built into its semiotic structure, just as it has a built-in trauma effect. The reason is again that the referent of an index cannot be set apart from its signifier. Though it is better exemplified by the time exposure, any photograph is thus prone to a process of mourning, whatever its content might be, whatever its link with real events as well. That the portrait be funerary or not—or, for that matter, that the photograph be

a portrait at all—is a matter of internal limits, which can be no more than emphasized by the subject matter.

Within the semiotic structure of the photograph, the referential series acts as "lost reality," whereas the superficial series acts as "substitutive object." So what the diastolic look accomplishes when it summons the shape and inflates it is the hypercathexis of the superficial series of the photograph; and what the systolic look accomplishes when it revokes the shape and "kills" it is the decathexis of the referential series.

Trauma effect and mourning process as photography's immanent features induce two opposite libidinal attitudes. The mourning process is that of melancholy or, more generally, that of depression. As to the shock of the traumatism, it is followed by a compulsive attempt to grasp at reality. The superficial series being suddenly wiped out of consciousness, it provokes a manic anticathexis of the referential series, as a defense reaction.

We now begin to understand that the paradoxical apprehension of time and space in photography is akin to the contradictory libidinal commitment that we have toward the photograph. On a presymbolic, unconscious level, it seems that our dealing with the photograph takes effect as an either/or process, resulting in an unresolved oscillation between two opposite libidinal positions: the manic and the depressive.

In Szondi's typology of basic drives (the Szondi test, by the way, is the only so-called projective test to use photographic material), the manic-depressive dimension appearing in human psychopathology and in human experience has been called *contact-vector*. This is generally understood in phenomenological terms as representing the fundamental attitudes of our being-in-the-world. According to Szondi and other psychologists, this manic-depressive vector is mostly presymbolic, and is the realm of *Stimmung*, or mood. It is also believed to be the terrain in which aesthetic experience, especially visual, is nurtured.

More than any other image-producing practice, the photograph puts the beholder in contact with the world through a paradoxical object that, because of its indexical nature, belongs to the realm of uncoded things, and to the sphere of codified signs.

We have discovered the manic-depressive functioning of the photograph by insisting on the didactic opposition of snapshot and time exposure. And we have seen that the trauma and the response to it in the form of a manic defense reaction acted as an internal limit of the snapshot's instantaneity, while, on the other hand, the mourning process, which partakes of the funerary nature of photography and induces the depressive position, acted as an internal limit on the time exposure. But of course there is no such thing as an empirical definition of snapshot and time exposure. One cannot decide on a shutter speed that will operate as a borderline between them. These were only didactic models provided by intuition, but they were used to unravel one of the paradoxes of photography. These models do not point to technical or aesthetic standards; their concern is photography in general. Yet they helped to label two opposite attitudes in our perceptual and libidinal apprehension of the photograph. Though these attitudes coexist in front of every photograph, they can be told apart. Moreover, the alternative character of mania and depression suggests that though both attitudes are coextensive, they do not mingle. Photography does not allow an intermediate position, or a dialectic resolution of the contradiction.

Hegel's prophecy that art was about to come to an end was published in 1839, the very same year in which Talbot and Daguerre independently made public the invention of photography. It might be more than mere coincidence.

Notes

1. Originally published in *October* 5 (Summer 1978): 113–25. Reprinted with the author's permission.

2. In "Notes on the Index: Seventies Art in America" (*October*, nos. 3 and 4), Rosalind Krauss stressed the importance of the indexical nature of the photographic sign, and its impact on contemporary art since Duchamp. For a general introduction to the semiotics of the index, see Charles S. Peirce, *Collected Papers*, vol. 2, book 2, pp. 129–87.

3. See Beaumont Newhall, *History of Photography* (New York: The Museum of Modern Art, 1949), 83–94; Van Deren Coke, *The Painter and the Photograph* (Albuquerque NM: University of Mexico Press, 1964), 156–59; Aaron Scharf, *Art and Photography* (Baltimore: Penguin Books, 1971), 211–27.

4. Roland Barthes, "Rhetoric of the Image," in *Image/Music/Text*, translated by Stephen Heath (New York: Hill and Wang, 1977), 44.

5. The German word *Mal* (which yields *malen*, to paint) comes from the Latin *macula*, stain, from which the French *maille* (mesh) also derives.

6. Barthes, "Rhetoric of the Image," 44.

7. In her "Notes on the Index," Rosalind Krauss reaches similar conclusions: "Whatever else its power, the photograph could be called sub- or presymbolic, ceding the language of art back to the imposition of things." See *October* 3 (Spring 1977): 75.

8. Since chiaroscuro is the temporality of shape, that part of the painterly illusionism of depth that relies on it (chiaroscuro itself, atmospheric perspective, *sfumato*, etc., as opposed to linear perspective) is ultimately founded on the time-consuming practice of painting. The taking of the photograph doesn't allow such a practice. Hence the fact that those photographers who aimed at pictorial equivalence repeatedly insisted on preparatory operations and especially on laboratory work, which surround the push-the-button moment of taking a photograph. The aesthetic of blurring brings the photo-portrait closer to the painted portrait, and was defended mostly by the pictorialists. Nevertheless, the process does not imitate painting, but shows that great portraitists such as Cameron, Carjat, Nadar, or Steichen had a remarkable intelligence for the medium. Beaumont-Newhall relates that Julia Cameron "used badly made lenses to destroy detail, and appears to have been the first to have them specially built to give poor definition and soft focus," See, Newhall, *History of Photography*, 64.

9. "Reality-testing has shown that the loved object no longer exists, and it proceeds to demand that all libido shall be withdrawn from its attachments to that object.... [Its orders] are carried out bit by bit, at great expense of time and cathectic energy, and in the meantime the existence of the lost object is psychically prolonged, Each single one of the memories and expectations in which the libido is bound to the object is brought up and hyper-cathected, and detachment of the libido is accomplished in respect of it." Sigmund Freud, "Mourning and Melancholia" (1917 [1915]), in *The Standard Edition of the Complete Psychological Works*, vol. 14, translated by James Strachey (London: The Hogarth Press, 1957), 244–45.

INTRODUCTORY NOTE

Rosalind Krauss

The index has attracted much opprobrium to itself over the last two decades. The idea that a photograph could be stenciled off the real world without internal adjustments was always greeted with horror, particularly by photographers who themselves wanted to assume the status of artists. Most recently, the idea has been opened to the scorn Michael Fried has heaped on what he terms the "literalism" of Minimalist art—a literalism that leaves the work open to all the possible interpretations of its various viewers, since it has no way of internalizing its own intentions toward meaning. Fried writes,

> Barthes's argument becomes "literalist" when it depends on the subject's subjective experience (as in Minimalism's absolving itself of internalizing the constitution of the work—its presentness).... The literalist work is incomplete without the experiencing subject—and thus theatrical. (Meaning is essentially indeterminate, so that every subject's response is equal to every other.)[1]

It is this equivalency of response that the index insures. The theatricality of this abandonment of meaning condemns it in Fried's eyes.

Joel Snyder has always rebuffed the notion of the index as not taking into consideration the historical codes internalized by the photographic lens itself. In *Camera Lucida*, Roland Barthes had already refuted this:

> It is the fashion, nowadays, among Photography's commentators (sociologists and semiologists), to seize upon a semantic relativity: no "reality" (great scorn for the "realists" who do not see that the photograph is always coded), nothing but artifice: Thesis not Physis; the Photograph, they say, is not an analogon of the world; what it represents is fabricated, because the photographic optic is subject to Albertian perspective... and because the inscription on the picture makes a three-dimensional object into a two-dimensional effigy. This argument is futile: nothing can prevent the Photograph from being analogical; but at the same time, Photography's noeme has nothing to do with analogy (a feature it shares with all kinds of representations). The realists, of whom I am one and of whom I was already one when I asserted that the Photograph was an image without code ... the realists do not take the photograph for a "copy" of reality, but for an emanation of past reality: a magic, not an art.[2]

Camera Lucida is buoyed by Barthes's identification with the idea of the index, which Barthes names in relation to its "referent," as in his insistences "In short, the referent adheres" and "The photograph is literally an emanation of the referent. From a real body, which was there, proceed radiations which ultimately touch me, who am here."[3]

The panelists heap scorn on what they take as Barthes's (and my) naïve assumption of "radiations," which in their language translates into "photons." Snyder narrows on what he sees as this confusion: "When people talk about indexicality, they generally confuse photons with objects, and they think it is objects that are necessarily indexed by photographs." My own Assessment to the

panel is titled "Notes on the Obtuse," not only as a narcissistic recall of my own "Notes on the Index," but also as a reminder to the panel of a bibliography to which they seem to be immune.

Notes

1. Fried, "Barthes's *Punctum*."
2. Barthes, *Camera Lucida*, 88.
3. Barthes, *Camera Lucida*, 6, 80, respectively.

THE ART SEMINAR

This conversation was held February 27, 2005, at the University College Cork, Ireland. The participants were: Jan Baetens (Katholieke Universiteit Leuven), Diarmuid Costello (Oxford Brookes University), James Elkins (University College Cork / School of the Art Institute of Chicago), Jonathan Friday (Kent University), Margaret Iversen (University of Essex), Sabine Kriebel (University College Cork), Margaret Olin (School of the Art Institute of Chicago), Graham Smith (University of St. Andrews), and Joel Snyder (University of Chicago).

James Elkins: Let's start by considering some of the ways that people have talked about photography in the last thirty or so years. And let's try to use that exercise to open the more abstract question of why it is that photography remains so hard to conceptualize.

Let me begin, then, with the model of indexicality, which has been a pervasive, if not a preeminent, model for photography for over thirty years. Just to open the conversation, I would note that no matter what else happens with indexicality, it should matter that it hardly appears as a simple concept in Peirce's texts. I'll give just one illustration: the familiar triad *icon, index, symbol* is first of all just three of nine in Peirce's basic schema: *icon, index, symbol* are signs in relation to objects, as opposed to signs in relation to themselves (*qualisign, sinsign, legisign*), or signs in relation to the interpretant (which he calls *rheme, proposition,* and *argument*). Now I mention this because one of the times the word "photography" appears in Peirce is in a list of ten further concepts. On that list, he names a kind of sign—the *dicent (indexical) sinsign*—for which he gives the double example "a weathercock or [a] photograph."

Now first of all, it's amazing and wonderful that photography belongs in the same category with weathercocks: but more to the point, the word "indexical" appears only in parentheses in the category of weathercocks and photographs. The main point for Peirce, in this passage, is that such things are *dicent* (by which he means, roughly, propositional) and *sinsigns* (signs in themselves that operate *without* references but have a quality he called *secondness*).

Even without wading farther into the lovely swamp of Peirce's theory, it is clear that something about what most writers on photography mean by *indexical* is missing here: surely a photograph should not be even secondarily defined as a sign that works independently of referents.[1]

I open with this example to make a simple point: Peirce's sign system is extremely complex—much more so than this example even hints—and that complexity is entirely unused and unnecessary when speaking of photography. It could also be argued that the use of the index in isolation from the symbol and icon is a misuse of Peirce's theory, since he was adamant that *every* sign includes elements of all three. Hence calling a photograph "indexical," or saying its most important property is indexicality, is misreading Peirce.

Joel Snyder: Just a matter of history: the *index*—we are all anti-essentialist, but the "the" comes up nevertheless—is generally invoked as an all-purpose explanation that isn't seriously intended to engage questions about photography; it is meant to put an end to questions. Arguments about *the index* or *the trace* are arguments from authority—they depend on the intellectual weight of the philosopher, Peirce, and it is always the same six or seven lines by him that are trotted out to support the notion that all photographs are indices. This is not a serious way of trying to make sense of photography—and it certainly isn't a serious way of grappling with Peirce's immensely difficult ideas. When people talk about indexicality, they generally confuse photons with objects, and they think it is objects that are necessarily indexed by photographs. It may very well be the objects that are indexed, but nothing in the way of an object need be indexed by a photograph.

There's another thing I'll point out in passing. This doesn't originate with me; it originates with Gill Harman, an analytic philosopher at Princeton who says in a wonderful essay called "Eco-location" (it's about Umberto Eco) that contrary to what Eco argues, Peirce didn't have a theory of signs; he had a list of signs. I think that's probably true, and if you want to think through the issue of indexicality you would have to begin with the notion that this is a very provisional

way of sorting signs, but it is hardly a *theory* of signification.[2] An index, according to Peirce, is a sign and so must be significant to someone who is engaged by or engages it. A suntan is a sign that a person has been out in the sun. It is not a sign of any of the objects that reflected light onto the person's skin. A photograph that looks like a grey smudge isn't an index of whatever object or objects may have been in front of the camera during the exposure of the film. If it were, we could name the objects, and there may have been no objects at all in front of the camera at the time of exposure.

Margaret Iversen: I'd like to say something about the context in which discussion of the index arises, which I think is related to the rise of the simulacrum—the proliferation of the copy of the copy of the copy. The appeal to the index tries to give the photograph some kind of purchase, beyond the simulacrum. The inexorable logic of the copy is challenged by the logic of the index. That is the work it is doing.

JS: Could you explain what that work is?

MI: Let me give an example. A friend of mine scans her family photographs into a computer, and spends a lot of time perfecting them, so that her family history is now a complete simulacrum of what it was, before she digitally "improved" it. What is lost is the photograph as a document of what was there, willy-nilly, even though it may offend one's narcissism. The "blindness" of the camera, its inability to censor, is part of the reason why photography is of interest in a way that is different from the interest taken in painting.

Margaret Olin: But doesn't that assume that what the photograph "saw" was really there? Maybe what was really there was the improved version. In working with it digitally, your friend may be getting back more to what was already there.

I mean that photographs distort. Getting from what's out there to what ends up on the photograph isn't just automatic. What I really need to know is your definition of "what was really there." What was "really there" that she has improved? And which should we accept as the truth?

MI: Well, she was overweight. She could in fact digitally improve her outline. [*Laughter.*]

Graham Smith: It may be worth mentioning that Sir David Brewster, principal of the United College of St Leonard and St Salvator at St Andrews, was in 1844 troubled by the inconsistent and unsatisfactory nature of his own appearance in photographs. "I am still puzzled about the operation of the camera," he wrote to Talbot in April. "Some cameras represent me thin, slender and not stout whereas others view me like…" At this point there is an illegible word in the manuscript, but it concludes with "… of the stout gentleman."[3]

JS: You know, Eastman Kodak produces books on how to photograph overweight people, how to photograph cross-eyed people, how to photograph people with dark skin or light skin. There are all sorts of ways of getting around what you might see as—

MI: —if you go to a professional, sure.

JS: Well, no, the question is: what is the standard here? Is she *really* overweight? There's a whole ontology in back of what you're saying.

Let's try it another way—

JE: It's a remarkably vexed example we've chosen here—

JS: —say I take a photograph of Jim, with my Hasselblad, at one second, under this light. He's a very good subject, and stays still, but alas! Just as I hit the shutter, he goes *ah-choo!* [*Joel mimics a convulsive sneeze*] and the exposure goes right

on, and we end up with a picture of Jim from here [*the neck*] down, and up here [*the head*] it's this grey smush. It's very easy to do.

What, then, is this photograph an index of? A man who has a smushy face and a very good body? [*Laughter.*]

JE: Or an overweight body and a smushy face!

JS: This is the first kind of problem you run into with the index. If you try to go from what you see in the photograph to what was actually in the world at the moment of exposure, you eventually screw up the way we talk about photographs. What we see in photographs is not, either necessarily or even generally, what we would have seen in front of the camera when the picture was taken.

GS: I am reminded here of Ernst Gombrich's famous example in *Art and Illusion* of a bird that is drawn banking in flight so that it appears to have only one foot. Those of us brought up in the Western traditions of foreshortening and perspective know that the foot appears to be missing because of the artist's attempt to convey perspective. Australian Aborigines, on the other hand, were disturbed by the "incomplete" image.[4] I don't see why we can't accept both elements of the photograph as true images of Jim. Beauty is convulsive after all. (And would it be appropriate also to make some reference here to Ott's *Sneeze?*)

Jonathan Friday: Why have you put the emphasis on seeing? The index, or indexicality, is a mode of representation, and the point is that whatever a photograph indexically represents was in front of the camera. If you say, "The smudge was not in front of the camera," I agree, but then the smudge is not indexically represented. What was in front of the camera in your example was Jim, and he is indexically represented whether or not the smudge looks like him. With indexical-

ity, notions like "looks like" have no purchase. Tree rings indexically represent the age of the tree, but they don't look like the age of the tree, any more than the smudge looks like Jim, or even Jim sneezing. You seem to be running together the categories of index and icon in the example of the blurred photo of Jim. It's an index, and you're asking, "An index of what?" and expecting an answer in terms of iconicity.

JS: That's what most people are interested in photography for.

JF: When we speak of a photograph being an index, it's a particular kind of index. There are all kinds of indices, though they are typically taken to be signs that point to something through causation. (I should add that I am not particularly interested here in what Peirce has to say about these categories, but in what can be said about them.) But in photography you've got this category of sign that is curious, because it is not a mix of an icon and an index; it is literally the coincidence of the two. It is an index that points iconically. A picture is a pointer: it points to something. And in the example of the photograph of Jim sneezing, I suppose we could say it points to that event, which took one second, and nothing more than that. But if you say, "I want an object," then I'd say, "Okay, that's Jim."

JS: You don't want to say that it's a picture of Jim. You don't want to torture the language that way. The "of" here is going to be simply by way of causal relationship.

JF: Why is it not a picture of Jim?

JS: Because we can't make Jim out. It's not a sign of Jim, it can't be a sign of Jim—

Sabine Kriebel: Jim sneezing.

JS: No, it's not.

SK: What is it then?

JS: It's a blurred picture of a human being. I don't know what else you could say.

What if it's a complete quiver, so you can't make out anything except the room? Talbot has wonderful pictures like that, where the carriage is there, and maybe there's a horse's hoof, and there's a lot of what-do-you-call-it? at the front of the carriage.

JF: But these seem to be matters of interpretation, and in that you're right, but—

JS: —If you're going to go into the story about it's being a sign, and I'm not so sure we should go into that at all, but if it's a sign, then it is going to be relative to somebody. It's not merely a sign that's out there; it's a sign that's significant. So if it's going to be a significant sign, then I think you'll have a hard time making sense of a whole bunch of pictures, beyond saying, "Well, we know for certain that it was caused by something."

JF: If you want to say this about *the* photograph, then I couldn't agree more. It will not do as an account of *the* photograph. But it will do for many, many photographs. *Most* photographs are straightforwardly interpretable indices: they point to something that was in front of the camera, and we can understand what that something was because it is iconically presented to us. So now you say, "Here are some photographs where we can't make out some or all of the subject matter." Okay, fair enough, perhaps these are not "significant signs"; perhaps they are indices that we can make little or nothing of. But these are not representative examples.

JS: Where is the pointing? [*Points at his glass of water.*] This is an index. What does the arrow point out? It's a metaphorical pointer. Say I look at a photograph of this glass of water, and you might say, "Something is pointing." But there is nothing

that is pointing. It's a picture of this glass, not a picture of a glass that is pointed at. If you are saying that the picture allows us to attend to the glass, who would want to argue with that? But the picture isn't ostensive, though we could point at the picture and say (rightly), "That's a glass."

JF: To say a photograph indexically *points* is simply a way of flushing out what "picture of this" means in this particular case.

JS: But it's not "flushing out"; it's ducking the question. What you want to say is that when you see a photograph of this, something else is going on. What else is going on? Drop the pointing, because there is nobody pointing.

MO: Maybe the problem is getting iconicity mixed up with indexicality. Maggie, I think your friend's situation involves this kind of confusion. Everyone has had the experience of thinking, "Well, this photograph makes me look fat, and I'm not fat." Sure, there was something out there, and that is the indexical aspect. But the photograph doesn't resemble "me." If I want it to resemble me, I have to go in there and do something else to it to make it resemble me. Otherwise I have to be a little more skillful with my photography, use a more flattering lens, if I want my index to resemble me, that is, to do more than just be an index. Sure, a photograph points to something, but that's just a trivial aspect of photography.

JF: I am not going to stand up and say it's a significant fact, because I think it will be of limited help if we are looking for a unique feature of photography. There is nothing about the index that will allow us to say, "Now we've done it. We can go home now, because we've understood photography's mode of representation."

JE: Given that the term *indexicality* is problematic, and the reference to Peirce is problematic, I wonder if we might clarify

things by avoiding the term, which is not even a metaphor but something more like a euphemism. I would also set *pointing* aside: and then what would be left of what you are claiming?

JF: I think the index is actually relatively straightforward. It is the icon that is extremely complex. That's the one we really need an account of. Peirce says "resemblance," but no resemblance account of depiction will stand up to analysis. Those accounts just don't work. But look: in their simplest form, indices are signs that are directly connected to their causes. Causes point to their effects; effects point to their causes. Unlike icons and symbols, an index implies the existence of something that directly causes it to be, in at least some respects, as it is.

JE: The causal effect, then, as opposed to pointing, and also as opposed to indexicality as in Peirce. Then the question would be about causation and exactly what you are demanding of it.

JS: That seems right.

MO: But the index covers a lot of territory, as in the case where someone says, "Look at the photograph, this is my friend; she's fat," when in fact she is not fat.

MI: And that's using indexicality to subtend iconicity, and that's where we tend to get into trouble. The index doesn't guarantee the resemblance of the image. As we've seen, it can be a blur. On the other hand, the indexical character of the medium means it can record things the photographer was not aware of. These things need to be pulled apart.

MO: You can get into a lot worse trouble than that, as in "Look! There he is at the rally, next to Angela Davis!" Maybe he was, and maybe he was not. If he was there, then maybe

they were pals; but maybe he was about to tear her head off. Depending where the photograph was published, each interpretation makes a different political point.

JE: If indexicality is inadvisable, and pointing is an inaccurate metaphor, then why isn't causality an adequate way of talking about what it is you want to say about photographs? I would think causality wouldn't be adequate, because as soon as you start using the word, you're going to be talking about photons and other subatomic particles, and surely that is not what anyone means by "causality" in photography.

JF: This is where I would depart from Peirce, because I don't think it is necessary to talk about causality to get at the notion of an index. For example, the little kinds of drawings one finds on toilets, the "Male" and "Female" signs—

JE: We certainly have had a wonderful succession of examples, haven't we? A woman who thinks she is overweight, a person reduced to a smudge, a man running from a fire…

JF: —they are not just indexes, but there is something indexical in them. They are saying to you, "Look, go this way if that's what you're looking for."

JE: [*Points to a green "Exit" sign on the wall, showing a schematic running figure, an arrow, and a rectangle denoting an open door.*] Like the fellow behind you, in the green sign.

JF: Yes, and they've added the pointer, too, just in case you weren't sure. You've been using examples here in which people want to overcome the indexical, but that's not always the case. When, for example, I give a lecture, and I put on a slide of a painting, a photograph of a painting, I am asking people to look at the painting. Of course, I don't have the painting. I am not showing a drawing of a painting or a painting: I

am using a photograph to point to something, to indicate something.

I don't know what the objection is, unless you want me to say this uncovers the fundamental nature of photography. It doesn't.

MI: The thing about the pointing, or the index, is that you have to have the object in the same room or within eyeshot in order for the pointing to work. So it has something to do with proximity, doesn't it? Pointing only makes sense if you successfully point *at* something. So there is an idea of proximity built into your examples, which is also built into the photographic process.

JE: I am tempted to say we have two different, equally muddled concepts on the table, not even including indexicality. The objection Joel raised a minute ago about pointing (that a photograph is not something that points) is right, I think, regardless of whether photographs are taken to point in different ways. The question would be, Under what circumstances do you wish to say that a photograph points? Why do we need photographs to be things that point?

The second muddled concept is causality. I don't think we've really gone near it at all. I don't see how you could talk about causality for very long by sticking to examples outside of particle mechanics or physics—by sticking to examples like the famous one Peirce gives, in which smoke from a chimney is caused by (and is therefore a sign for) fire in the hearth. It's poetic, but it doesn't help conceptualize photography.

JS: [*Pointing to the green "Exit" sign.*] Would that be a better index if it were a photograph?

JF: I don't think so. Indexes don't come in better or worse. They're just a way of dividing up kinds of signs.

JS: Let me try it a different way. Let's say that we have a painting of my mother. It is an exceptionally good painting. I point out to you that there is a pertinent sense in which my mother was a cause of that picture: but for Mom, this picture wouldn't exist.

So why isn't it an index of Mom? Now you'll have to specify the kind of causal relation you want.

JF: What would have to remain true of this painting you've just described? Among other things, that we know it's an icon—

JS: —It's a picture of Mother. [*Goes to the blackboard, and draws a schematic face.*] Why do you assume she's an icon? She doesn't have a nimbus around her. [*Draws one.*] She's not flat; it's Mom. Calling it an icon doesn't add anything.

JF: It's a picture—it's another word for picture.

JS: But icon sucks blood from index. They are in a parasitic relationship.

JF: Why parasitic? They are two categories within a system of representational kinds.

JS: Because you say of a photograph, "Face it, it's indexical, it points." But then there's the issue of iconicity, as if it is somehow a coincidence that photographs are pictorial at all. It's not a *coincidence.*

JF: It's not as if they're mixed, as Peirce sometimes says. But the photograph is, if you like, the coincidence, the utter and complete amalgamation of those signs. Photographs, or at least *many* photographs, are iconic indexicals: they point pictorially. And they are not the only instance: mirrors, for example—

JS: —Mirrors aren't pictures.

JE: This might be a good place to suspend this particular line of argument, because it can only go, I think, back to the issue of automatism, which hasn't so far seemed tractable. Besides, one of our panelists has a headache [*Diarmuid Costello has been holding his head in his hands*] and several others haven't said anything yet.

Diarmuid Costello: No, I am okay; I've just been thinking about how the conversation has been going. It seems to me that what your worry is, Jim, is about sloppy art historical appeals to Peirce.

JE: Initially, that is exactly right.

DC: Appeals that have been used to underwrite something that you think can be said without the term *index*.

JE: The thing in question, then, may not be worth saying, and may not be coherent: but that's the question we have been exploring.

DC: One sort of worry, then, is that whatever it is that is being said could be said without the appeal. But then that is being used to beat the insight—if it is an insight—about photography right out of court. We may not necessarily want to go that far down the road that starts with a worry about sloppy art historical appeals.

JE: That is right.

DC: So it seems to me that the question is, What kind of *work* was the appeal to the concept meant to enable?

JE: Yes, that's exactly what I was hoping we could ask. I was going to put it this way: under what circumstances was it *not* thought to be problematic that a central description of photography was so closely dependent on photons, of all things? When was that not counterintuitive?

My own sense would be that in the 1970s, indexicality was a way to say that photography was a legitimate medium—that it was able to support serious critical attention—without either returning to a naïve realism, or giving it away to aesthetic values that would have been imported from painting.

Jan Baetens: I think it might be interesting to historicize the discourse on indexicality, because I have the impression that our current ideas are a consequence of the art historical appropriation of the medium of photography. I am thinking, of course, of Rosalind Krauss, and her theories on postmodern art as indexical. I have the feeling that indexicality became a crucial problem from that moment. One might suppose that we will stop worrying about indexicality at the very moment when we will stop thinking of photography in art historical terms.

MO: Do you think that some of the problems that we have discussed along with indexicality were problems before Krauss? Isn't that what Joel is trying to say when he says, "It was already a problem with Daguerre"?

JB: Yes, but the central position of indexicality, and the very idea of starting this discussion with indexicality, is a fallout of the art historical appropriation of indexicality. I am convinced it is not a *problem.*

JE: I don't think I would identify problems around indexicality with art history per se, because I am not convinced there is a discourse wholly outside of it—but I want to save that question for the second half of our conversation. I would say there is a pressure exerted on the discourse that makes it effectively insoluble, and that is merely that people don't want to say that they're using vague terms, metaphors. Indexicality is a brilliant solution to that, and even some of the ill-focused

terms that we have been playing with are fairly good solutions. So an attachment to, or perplexity with, indexicality is a symptom of the discipline. That's how I would bind those two terms, *index* and *discipline*.

Certainly, though, the *moment* in history has passed when indexicality seemed to make good sense.

JB: I would like to return to the two concepts of the index and of pointing.

JE: It's completely impossible to close this subject! [*Laughs.*] Which I think is very interesting. Sorry, go on.

JB: I do not think that they are synonyms, but "photograph" can be taken as a pointer. A few minutes ago, Joel, you gave the example of the picture of the glass of water, which you refused to consider as pointing—

JS: Nothing in it points.

JB: —I would like to make the opposite claim: all pictures are pointers, because by framing, selecting, and presenting the subject, they point toward not simply the glass of water but toward some aspects of it. And in that case, there is no distinction to be made between photographs and other types of pictures.

In that way, it is possible to dissociate the notion of indexicality from pointing, and begin considering the notion of pointing within the photographic icon.

JE: Maggie Iversen, in your paper you refer to an article by David Green and Joanna Lowry, which appears to be related to Jan's proposal.

MI: Yes, although they have quite a narrow purpose to do with conceptual photography: they want to shift the idea of the index away from the referent, and see it as framing or pointing to something.[5] The example in question, such as Robert

Barry's *Inert Gas Series,* documents an event that you can't actually see. The title says, "Helium has been returned to the atmosphere." So pointing is going on with respect to the gas, but there's no indexical imprint of it. It is no doubt aimed at calling into question documentary photography.

JB: Iconic pointing, to me, is a kind of inwards pointing: what the photographic picture is pointing to is something inside itself, and not outside itself in reality. I don't think the indexical interpretation of pointing is very interesting, and it obscures the existence of internal, visual, inward-bound pointing, iconic pointing. That kind of pointing shows that photographs work the same ways as other pictures do.

DC: But then that comes back to the question of what the term "index" was originally supposed to do. When you go in the direction you're indicating, you have something that is true of all images that resemble something—

JB: —I did not mention resemblance.

DC: Okay. All things that pick out something in the world in a selective fashion, in effect anything that *frames* a portion of the world, does what you're talking about. But that is to undercut, or at least ignore, the work that I take it the idea of indexicality was originally supposed to do, which was to *distinguish* one kind of image making from other kinds.

JB: It's not even a question of picking out something in the world, but pointing out something that is represented, in the subject matter, to a viewer. Often it is said that since the photograph automatically reproduces something that is outside photography, that the medium is *unable* to point, since it reproduces in an automatic and indiscriminate fashion. I believe on the contrary that the very indexical pointing of the photograph should not prevent us from seeing how it

also points toward something at an internal level, that is, within the frame.

JE: It is interesting that we are coming around again, out of history and back to some claims that have just been strongly refuted. I would take it that one of the reasons it is so hard to cut off all the heads of the hydra of indexicality is because we have ideas about things we want to say about photographs that are, perhaps, not very clear. But it might also be that the hydra is still alive because we differ in the conclusions we draw from even very similar assertions about indexicality and its synonyms. Some of us, for example, might take the causal side of indexicality and use it to support a realist account of art, and others might conclude that the index is a symptom of a certain anxiety about the real, or even the Lacanian Real. Sometimes there's a realist intention behind uses of the index, and sometimes an antirealist intention.

MO: We should also note that indexicality was used to do a lot more than merely differentiate photography from other media. It was part of the discourse of the trace, which had no necessary connection to photography: it was about wanting to have a trace of the real to stand for the real. In that respect, it is the heir of a previous discourse of touch—some of the historical dimension Jim asked us to engage.

DC: I am also surprised that we have not talked about tracing, or imprinting, because those are the terms in which indexicality was often invoked in discussions of photography. It has not always been about pointing, at least not in art theory. (And it is a very metaphoric use of the term "pointing" when you say that pictures "point.") I take it that what was *trying* to be said was that what was there had in some sense imprinted itself on the photographic materials.

JE: But, of course, the trace and an imprint lead into another swamp of metaphors. There is a wonderful essay by Bill MacGregor on the subject of seventeenth-century French print culture and metaphors of imprinting: he shows how metaphors of printing and imprinting, memory and memorization, learning, traces, lines, engraving, and so forth were already well mixed, or muddled, four centuries ago.[6] So whatever you want to say about traces already has a long history of confusions.

DC: Okay, but that confusion itself doesn't say there isn't something people are trying to get at. If you found a footprint in the sand on the beach, is anyone going to deny that someone or something made that print? Isn't the print a trace that registers something?

GS: I don't have a problem with understanding W. H. F. Talbot's early cameraless photographs as "traces" or "imprints" of their two-dimensional subjects. Surely this is precisely what his photographs of botanical specimens, fragments of lace or pages from early printed books are? This description of them underlies Talbot's own insistence, on the printed slips he inserted into the second and later fascicles of *The Pencil of Nature,* that "[t]he plates of the present work are *impressed* [my italics] by the agency of Light alone, without any aid whatever from the artist's pencil." Of course, this idea thinking becomes more complex and difficult (but not impossible) to articulate when the subject is three-dimensional.

JS: What if you found a smush in the sand on the beach? That footprint is a sign; this smush is not a sign.

DC: But this is where I would agree with Jonathan's earlier point. Your rhetorical strategy here is to take an undecidable case, and use it to put pressure on the concept itself. I think that the very—

JS: But look—

DC: —I think that that's wrong, because the problematic, borderline case actually piggybacks off the very point you're using it to question. It requires the very concept that you want to use it to simultaneously deny.

JS: Look, you're using the concept *impression* here, *vestigium*, right?

DC: Yes.

JS: Where is the impression in photography? Locate it for me. It's a figurative use. So what is the figure doing? This is not a *Drucken*, where you take and—[*makes a gesture of forcibly printing something*]. So where is the impression? There has to be one, by your account, right?

DC: Right.

JS: Why think of it as an impression at all? A print is an impression *of* something, but that's not what happens in photography; that's not what the scientists say.

JE: What you really want is an account based on the Schrödinger wave equation, and what happens to the molecules—

JS: That's exactly right. You have to get to the index by way of the icon. There is no way to get there without it.
 There *is no* impression. This is the whole problem with the idea of mechanical reproduction. I'm sorry if this is going to shock anyone, but you can't reproduce me. There's just no way you can do it. You can make a photograph of me, but you can't reproduce me. My parents were the only ones who were able to do it.

DC: Yes, yes.

JS: The whole notion of reproduction is a vexed one, and I think it goes back to Joshua Reynolds and the idea of copying (and

surely to way, way back in the history of picture making). Therefore you think of pictures as copies, and so it seems to follow that a photo of me is a copy of me, but it's not.

In any case, what I'm trying to get at is that it seems to me that you think impression is going to carry the day, and I don't see that there is any impression in photography. There are disturbances, local disturbances… of crystal lattices.

GS: I'm not sure that I entirely follow you here. I can see that in traditional printmaking processes, we have a matrix of a certain kind, which may be a relief or an intaglio. I don't see that there is a difference, fundamentally, between that and a matrix that is produced by a rearrangement of molecules or silver salts, or whatever it may be photographically.

JS: If you have a negative, then you can make prints from it, and I am not going to go into the question of impression there. The question is whether the production of a negative involves impression.

GS: I agree with that. It seems there are two steps in the creation of an impression from a matrix, and the second step, if one accepts the negative as a form of matrix from which impressions are made; they are not made by pressing things on top, although there is a sense in which they can be—

JS: What sense?

GS: Well, when we're dealing with contact printing, then there is a sense in which the paper negative and the paper positive are produced by an actual sandwiching—

JS: But you could leave them together in the darkroom, and still get a picture. I mean, where's the pressure coming from?

GS: Yes, okay. Let's say we can accept that in relation to the negative and the positive that is produced from it; I don't see a fundamental difference between that and the object (or

subject) that is being photographed, and its impressing itself, in a two-dimensional fashion, on the light-sensitized paper.

A better analogy may be with serigraphy, another print-making process. It might be said that the pigment makes its way through those areas of the screen that are not blocked to it in much the way that light is able to pass though the light portions of the negative. The conceptual and practical overlapping of photography and screen printing is closest when the screens themselves are produced photographically, as was the case with many of Andy Warhol's prints and pictures. This explains why Warhol's work was shown in at least one of the great photography exhibitions of the sesquicentennial year.

JS: That is precisely what I was calling into question. I think you have to recognize, Graham, that this is all being done on a figurative level. When I photograph Margaret Iversen, she doesn't come rushing up to the camera.

JE: She does according to Epicurus!

MO: Yes, in Lucretius, right.

JS: Sure, then films are rushing from her. But we don't believe that any longer. So the question is, How are you going to account for what goes on on a piece of film? I'm the last person who wants to make it mysterious. But you need to start wondering about image formation: how do you make an image? And then, what? If you want to use the language of Herschel, it is *transferred.* Clearly, *copied* is not quite right.

GS: I guess fundamentally, I am less unhappy with the idea of photons than some.

JS: But photons don't *impress…*

GS: Talbot thought so and said so.

DC: Okay. Let me try it this way: take the example of the painting of your mother that you said was in some sense

causally dependent on your mother. That's true so far as it goes, but it bears asking, In *what* sense, exactly? I agree that it could not be a picture of your mother if your mother did not preexist its being painted. In *that* sense, it's true that its being a picture of your mother is causally dependent on your mother. But it is also true that someone could have painted the same picture *without* it being causally dependent on your mother. It is entirely conceivable that someone could have painted a picture that is in all respects indiscernible from the one you're talking about, which was *not* causally dependent on your mother in the way you mean.

JS: Then it wouldn't be a picture of my mother.

DC: But isn't that precisely the point! The example provides the kind of insight that this vague talk is supposed to capture: that if it was a *photograph,* rather than a painting, of your mother, then your mother was there. Darkroom or other kinds of manipulation aside, it is a picture of your mother. It's just as banal and pedestrian as that. In some sense, your mother was present to the act of the photograph being taken—which is why, I take it, digital technology is widely thought to have transformed the photograph's ontology by undermining its indexicality.

JF: I have never met your mother; I've never seen your mother. But if I painted the picture, it would be an iconic picture of your mother.

JS: No, it wouldn't.

JF: Why not?

JS: You can do that for Mary Magdalene; you can do that for Jesus. But you can't do that for my mother.

JF: Why?

JE: [*Laughing.*] There's an incredible self-aggrandizement in this claim: he could do it for Jesus, but not for my mother!

JS: [*Points to the cartoon face with the nimbus, on the blackboard.*] Is that your mother? Of course: I say it's your mother.

JF: I'd say it was a pretty bad picture of my mother, actually.

JS: That's a bad picture of *my* mother. The point is: how could you make the distinction?

DC: What is it you take yourself to be implying?

JS: The question can be taken at the elementary level of denotation. I can't arbitrarily depict your mother. I could draw this, for example. [*Goes to the blackboard.*] Look, when the car was over here [*draws a vaguely rectilinear shape*], his mother was over there [*draws a smaller, somewhat lumpier shape*]. Okay, that's a denotation of your mother. But you want to make a picture *resemble* my mother. If you want to make a picture represent my mother, you need to really represent my mother.

JF: I just need to know, then, what you mean by *picture*. We don't need to go into theories of depiction here, but it sounds like resemblance is central to what you think a picture is.

JS: Can I do it functionally? Something that would get Mom past the border guard. That [*the cartoon face*] won't.

GS: Photographs that get us past immigration officials or that we show to police when we are stopped for speeding are notorious for *not* looking like the person they are supposed to identify.

JF: So Picasso's *Portrait of Kahnweiler* is not a picture of Kahnweiler.

JS: I gave you a functional definition, and by that definition, no. You want me to have a theory of depiction, and I

don't own one. It's an unfair question. What I am asking is, How can you make a picture of my mother without knowing my mother?

JF: I might listen to what people have said about her, their descriptions and the like. I might look at other pictures of her, perhaps even other pictures by people who have never met her. I might base my picture on all this, as well as my imagination of what she must be like. I'm certainly not saying anything I might draw is a picture of your mother just because I say it is, but I doubt your functional definition picks out what is either necessary or sufficient for a picture.

SK: I don't think we need to keep this at the level of the mysterious or metaphoric. We've been knocking things out of the way that don't work, and I'd like to know what does work. Trace, for example: well, the photograph of the sneeze is a trace. It's a blur, something that happened, but it's also a trace. I would contend that we're not going to find one set of words, or one vocabulary, to talk about all of photography. Give me, then, something practical. What words would any of us find useful to describe individual photographs, or the space of object and impression making? I'd like to root our discussion back into language that we think *is* useful or productive.

JF: One shot might be—and I don't think this is definite— might be *encoding reflected light.* I don't by any means want to go to photons, and I also want to say that *encoding reflected light* won't work with a lot of photographs.

SK: Everything is going to be inadequate.

JE: Needless to say: in the terms we've been pursuing, *encoding* will just become another ill-defined trope.

JF: Like Joel, I don't like *impression*. But thinking of encoding reflected light—that's a system by which light is translated into tones on paper—

JS and MI together: Translation: another metaphor! [*Laughter.*]

JF: I don't have a problem with the fact that we reach for metaphors here; the question is, What are the good or helpful metaphors? You say they are ill-defined, but are they? Underlying these metaphors is our knowledge of the various photochemical processes, and our knowledge that with the discovery of these processes a very new way of making pictures was invented. We are trying to say something about photography, its relation to the things it depicts—and if the metaphors we choose have some degree of inadequacy, that may be because we have different purposes and interests. For those who still believe that photography has something to do with reflected light, and see a purpose in keeping that fact more or less in the foreground, the kinds of metaphors we have been proposing have some purchase.

JS: The reason why I dig my heels in with this is not merely because of unbearable—unsupportable—generalizations, but because they drain from us the knowledge we already have, that photography is incredibly plastic, and *that* indexicality stops us from seeing the plasticity, and enjoying it, and enjoying our own behavior with photographs. You look at photographs, and you say, "That couldn't be!" or, "That's phony," or, "That's beautiful." You say all sorts of things about photographs, as long as you're not thinking *index* or *causal relation,* you're free to speak. Worse than that, it seems that when people talk about photographs, they entitize—

DC: They what?

JS: They make entities. And I have a deep feeling about this, which comes from my practice as a photographer that pre-

ceded my going into the academic end of the business, that very often what you say is in the world is contingent on the photograph and not the other way around. This is true with Daguerre, when he takes the first picture for the Academy of Sciences, shooting across the Seine from roughly where the Orsay is now. There is a lot of traffic on the river, and a lot of traffic in front. He makes the picture, holds it up, and says, "I have fixed the image of nature," to the assembled scientists and artists of the Académies. In fact, if you look at the picture, none of the people, the traffic, the horses, are there. The entities have not been determining in the way that the language of indexicality seems to force (or that people seem to jump at). I can't defend this beyond saying that in my bones, it's what I believe. You don't measure photographs against the world: you measure the world against photographs. To enjoy photographs, or to study them, or think about them critically, requires not a one-to-one translation, but a recognition—and this is Weston's thought—that the object matter in the world does not determine the subject matter of a photograph, even when you are dealing with the most formulaic cases: it's the formula that determines the object matter. What I fear about the causal stuff is that it stops you from seeing the photographs as pictures.

JE: I think it might be time for me to intervene, because I sense that there have been as many dead ends as arguments in our conversation. I don't mean that's a sign of failure: I take it as symptomatic, something to consider in the second half of our conversation when we turn to reasons we may think photography is difficult to conceptualize. Certainly up to this point, the attempts to say what we may mean by *index* or any of its proposed alternates resembles the action of two repulsive magnets: we move

rapidly toward what we think is a clear goal, and then the repulsive force increases and takes control and we are pushed away in an unforeseen direction.

Or, to make another analogy: Joel, your diagnosis of the conceptual flaws and inapplicability of indexicality is like a doctor saying, correctly, that a patient's illness is caused by such-and-such a virus. Meanwhile, the patient says, "Yes, but I've been having hallucinations, and I have this twinge in my knee, and this pain behind my ear...."

JS: But it's very important to tell the patient that there's not a man standing there with a knife, ready to kill him.

JE: It is indeed, yes.

MI: My response to what Joel is saying is that peace is going to break out any moment now. [*Laughter.*] All you have to do now, Joel, is say that indexicality is a necessary but not sufficient condition.

JS: I don't want to do that! I will go to my grave believing this: without electromagnetic radiation, there would be no photographs. But it's not indexicality.

JE: This is a ferociously tenacious subject, given that only some of us even want to recuperate even parts of it. But I really do want to continue the task of the first part of this conversation, which is the provisional inventory of ways that photography has been explained in the last three decades. It is significant that the index can serve as the alpha and omega of photography's issues (to appropriate something Joel said yesterday), but I want to consider other models as well.

A second explanation of photography would be the *punctum*, Barthes's word for the little prick or stab that I feel when I encounter a photograph. In most places in *Camera Lucida*, *punctum* is the opposite of *studium*, by which he means whatever knowledge about a photograph can be

explained, systematized, taught, or otherwise made public. He has little interest in *studium,* and yet—and this is a point I don't think academic approaches to photography have quite taken on board—*studium* is by definition *all* that is done in classes on photography.[7]

Nevertheless, the *punctum* is ubiquitous in texts on photography. So I would like to nominate it as the second model that we might find inadequate. Here I would mention just one reason why the *punctum* is perhaps less than welcome as an explanatory term for even local moments in photographs, or avowedly subjective and personal reactions of the kind that typically lead to citations of the *punctum.* That reason is that the *punctum* is by definition private, so if you are talking to an audience, any audience, for any rational purpose, it is odd—illegitimate—to cite the *punctum.* The *punctum* is solipsistic, and it closes down dialogue and discourse, unless you are willing to interpret *it* loosely, in which case you are in the same relation to it as you would be with indexicality. Every citation of the *punctum* in the literature on photography—and it is my hunch that there are many instances of the *punctum* for every mention of the index—every citation can really not be anything more than a placeholder, an illegible mark that says to the reader, "I perceive something here that you will necessarily see differently."

MO: Or, "You may not even see the *punctum* here at all."

MI: I find it quite useful to put the *punctum* in relation to Benjamin's "Little History of Photography," where he talks about the double portrait of Dauthendey and his wife. He tells us that the wife committed suicide some years after the photograph was taken.[8] Benjamin says that you feel a desire to search the picture to find the flaw, to locate the traumatic moment in her face, which the camera so to speak could not censor, could not *not* see. But you can only do that

retrospectively, after the tragedy. This establishes for me the necessity of desire in relation to the *punctum*....

MO: But that's her trauma, and not the trauma of the viewer; the *punctum* is the trauma of the viewer.

JS: Generally it seeks you out; you don't seek it out. It wounds you.

JE: It is also worth saying, because I started out talking this way about Peirce, that you would also have a problem citing the *punctum* because it is embedded in a very problematic text, which is theory but also memoir, fiction, and a unique experiment in writing, and so you have to carefully extract those moments you want to take as the *punctum*. In other words, you are compelled to ignore the text, even while you may be paying great attention to "texts" in and around the photograph you happen to be studying: and I wonder if there is ever a way to justify that short of denying that anything other than sheer logical argument has a place in your own interpretive project.

MI: Anyway, why do only photographs have *puncta?* Doesn't it have something to do with involuntariness—what Benjamin called the optical unconscious? The *punctum* is closely related to the found object, something found as if by chance. The *as if* is important because it is finally the desire or lack in the beholder that the object answers. In *The Four Fundamental Concepts of Psychoanalysis*, Lacan refers to the *sujet troué* (the subject full of holes) playing on the term for its complementary *objet trouvé*. In just the same way, there's no *punctum* without desire—which is unconscious, hence the passivity and surprise of encountering *punctum*. The *punctum* is neither objective nor subjective, or both, and that's why Barthes is so vague on this point.[9] The automatism of the camera mimics

the automatism of the subject, giving access to an unexpected, antirealistic *sur*reality.

JB: That has to do with indexicality.

JE: Well, but there is another way to answer that, and that is as Michael Fried does. For him, the salient characteristic of the *punctum* has to do not with indexicality but intentionality: the *punctum* has to be something of which the photographer was unaware. The claim would be that a painter cannot be unaware of what goes into a painting in the same way as a photographer. So you can answer that without indexicality.

JS: But it also means you have to quiz the photographer! "Are you *sure* you didn't mean to put that in?"

JE: I think of the *punctum* in psychological terms, by which I mean that when I encounter a reference to the *punctum* I don't tend to inquire about how well-founded it is (it's not, by definition), and I don't try to see what it reveals about the artwork in question: I tend to be more interested in seeing what the writer was trying to get out of the *punctum*. My suspicion, often, is that it is a way of smuggling in a notion of the ineffable or nonverbal—ideas that come ultimately from romanticism, and might not be compatible with an otherwise carefully defended and scholarly argument. The *punctum*, I think, is linked to some not wholly justified citations of the aura. They are both ways to bring in something ineffable, private, or even sublime—something that couldn't otherwise be put into a book or essay or academic paper, something the author might not want to follow through, but merely acknowledge.

DC: I'm not sure I see exactly what the problem is here: it is one thing to indulge in vague talk about being "pricked" or "wounded" by particular photographs, or about photographs or other things possessing "auras" in ways that may

not be scholarly defensible. I agree that this *can* be done in ways that are less than persuasive, and that such talk may be incompatible with scholarly argument—though you would obviously have to defend that claim. But I don't see why this *has* to be the case simply in virtue of such terms being invoked. It's not the same thing, for example, as making space—*structurally,* as it were—in a theoretical account for the very ideas of affect or transcendence. It is quite possible to build such things into theories in perfectly respectable ways. In fact, it would be hard to imagine what would become of aesthetics as a discipline were it *not* able to record the fact that our relation to images, and other experiences, is not solely cognitive.

For my own part, I would not want to identify Barthes's *punctum* with Benjamin's aura in the ways you seem to be suggesting, because the former concerns idiosyncratic private affects, whereas the latter concerns historically shaped modes or structures of perception and experience—which would be shared (or at least shareable) by definition. Though I agree with you that the terms have been similarly abused in the literature. I'd say that Benjamin's notion of aura has frequently been abused in art theory in very similar ways to those you set out for Peirce's notion of indexicality: it has been wrenched out of context, simplified, and frequently misapplied.[10] But we were talking about the *punctum....*

GS: Let me ask: could the *punctum* be used to designate such things as the surprise that Talbot registers when, on occasion, he discovers in photographs motifs of which he had been unconscious?

JS: He is just discovering things he had not noticed when he made the picture. Whether or not they are *puncta* depends on whether or not they—

JE: Whether there is a diary in which Talbot confesses, "I was *pierced* by that detail...."

JS: "I didn't look at that thing, I never saw it. I swear, on a stack of Bibles, and now, it's *stabbing* me!"

JE: And it's so hard to find those diaries!

GS: I would like to say that the very fact that he is astonished by what he has not seen is a kind of *punctum*. He is pierced by that discovery.

JS: Surprised. No dagger appears....

GS: Surely the dagger is metaphorical, not real. When we say we are "struck" by something, we rarely mean there was an actual physical blow.

JF: Jim, I was struck at the beginning when you said the *punctum* was private, because I always thought of it as autobiographical: that he can describe it, he can tell you about it—

JE: But that's studium, when he's telling you about it.

JF: But he does say, "For me, the *punctum* is such-and-such." People can read that, and see; it's autobiographical.

JS: Barthes is thinking about the *punctum* as being below the level of language. It is incommunicable.

JF: The experience itself is incommunicable, but—

DC: But the role it plays in his account is anything but—

JS: Now we come to your notion that you can point at it. But you can't say a damn thing about it. Now you're literally going. [*Makes an indescribable gesture.*]

JF: The *punctum* is an iconic experience. I say, "I know what it is for him, but I can't experience it that way."

JS: You and he can look at the same thing, but you couldn't begin to describe the feeling. It is incommunicable.

MO: He actually says that details that he picks out in a photograph appeal to a kind of fetishism of his, an "amorous preference" for knowledge. He identifies this as a studium—which isn't something that he has "little interest in," as Jim said, but rather something that interests him in a public way. The way that it interests him is not interesting, but it still interests him. By contrast, the *punctum* itself is so private that it is not actually in the photograph at all. The necklace he uses as an example of the *punctum* is not in the photograph: it's in another photograph, and he just imagines it into the photograph.[11] The Barthes *punctum* is a literary device to make us understand how he could feel his kind of pain. It is analogous to the smell and taste of the madeleine. *That's* a *punctum.*

GS: This seems right, in the sense that it draws attention to the involuntary nature of the *punctum*, like Proust's sense of that memory. The *punctum* is perhaps in keeping with Alois Riegl's *ungewollte*, whereas the studium is the *gewollte*.

JE: It is also important that it's a pain. So the desire to think of photographs as things that possess that range of emotions, from pain to loss and mourning, is one of the reasons I think people cite the *punctum* so often.

MI: It is similar to a slip of the tongue or symptom: it's a link in a chain of associations that go down to the navel of the dream, so to speak. It cannot be completely unraveled. That's why the detail itself can be completely insignificant and why it can move around.

JE: I wonder where we might go with this, if our conversation were to be exclusively on the *punctum*. We have three ideas on the table about how the *punctum* might be adjusted

to accommodate descriptions of photographs (in Benjamin's essay, in Talbot, as autobiography). Against that we have reasons why the *punctum* cannot be enlarged. And I have mentioned other reasons to be suspicious of it, of which the most important, for me, is the kind of elliptic citation that permits the *punctum* to function as an allusion, made from a safe distance, to terms that might otherwise, arguably, be suspect—terms that include the aura, the ineffable, the sublime, the madeleine, and in the end of course the transcendent.

But again I want to move on, and at least mention some other models that have been used to explain photography. A third, after the index and the *punctum*, might be temporality. Photographs have often been explained by appealing to what is taken as their distinctive mode, or modes, of temporality.

Yesterday, when we were talking about temporality, I did not notice that it was an approach anyone wanted to abjure, but on the other hand there was no one set of terms with which everyone was content. We had, in a compressed list: *stillness,* the operative term in Jonathan Friday's paper, which was contemporaneous with writing about cinema; *instantaneity,* which belongs to the period before cinema; the notion that photographs (especially, again, nineteenth-century photographs) entail notions of immobility, stasis, or constraint; and Joel mentioned an idea of Valenciennes's, from 1799, that artists should study nature's animation because the camera kills it. There were other terms, and other names. I did not have the impression that we settled on any set of approaches to describing photography's temporality, or that we had found a way of describing temporality that could stand as, maybe not a sufficient, but as a necessary, part of what we would mean by photography.

And that is so even though there are accounts of photography in which temporality is preeminent. We were congratulating ourselves for getting through the day without mentioning

Deleuze (because, I suppose, his terms tend to orient many discussions).

MI: I would rather talk about temporalities rather than temporality. I like Thierry de Duve's *Pose et instantané* because it is a typology: of the "time exposure"—which is more associated with portraiture and funerary monuments and the time of remembrance, and with a slightly archaic feel—and of the "snapshot," like the press photo—which is fast film and technology able to capture instantaneity, so that it becomes a frozen moment rather than a still pose. There are probably a lot more.

JE: At least for me, it is harder to see the work done by distinctions among temporalities, because they seem local, applicable to specific instances. Most recently, I think of George Baker's essays dissecting temporal configurations in specific works. I don't mean that's a bad thing—apropos of Sabine's call for useful terms—but it makes theories of temporality a little more difficult to see as a whole.

SK: In the back of my mind are Benjamin's comments in the "Short History of Photography" that some photographs require a different amount of exposure time and therefore sitting time. I think of his remarks regarding the difference between daguerreotypes—the time of exposure and the exposure time that is then registered in the actual photograph—and a snapshot made in the 1930s. Or, to extend this to the present, to a contemporary digital photograph. Temporality is not just about certain artistic projects, but also about certain historical periods of photography.

JS: You're saying that temporality in photographs is about social relations.

SK: Yes—

JS: This seems to me, and I adore Benjamin, just brain-spun or theory-spun. The idea that the daguerreotype *looks different* from a collodion wet plate, and that it looks different from a slow gelatin plate, because something has happened in the industrial West, in modernity, and in the collapse of a certain kind of relation between a photographer and a sitter—all this is *required* by the theory, it isn't dictated by the ways the pictures look. Or if it is, I am insufficiently sensitive to the differences between daguerreotype portraits and other portraits made with slow materials during the end of the nineteenth and beginning of the twentieth centuries.

For me it's a peculiar thing to figure out if Benjamin is responding to pictures, or if pictures are responding for Benjamin to his beliefs about what must be the case. Even though I think very highly of Benjamin, and find a number of the essays very important for my own work, I always worry about his freighting of the eyes: your eyes have got to carry all of modernity. You have to carry all of modernity with you at every given moment, and then you will see things in the arcades that you would not ordinarily see. I love the *Arcades Project,* but there are real issues about what's driving what—and this isn't an issue of "pure vision," or at least of my eyes being innocent and pure.

SK: I do see differences in temporality between daguerreotypes and, say, 1930s Leica photographs, but I wouldn't be able to say about different processes circa 1890.

JS: But all those social relations have changed: the industrial proletariat has moved on; the artist-client relation has changed. Presumably, then, we're supposed to see that in the picture, and I just don't.

SK: How is this tied to temporality for you, then?

JS: I don't know what to make of it. I don't know how you address it. I have looked very hard for the formulae of portrait photography, and how those have changed. But I am not sure I see changes driven by.... Look, what he wants to say is that a fifteen-second exposure of a human being in 1843 produces a *kind* of picture, captures a kind of relation across time, which actually allows for the aura of the person to show, and the aura of the handwork, or something.

SK: That is presence: isn't it just time?

JS: But it's also art. Those pictures have aura, and as you get later into the century, photographs lose it. Why? He says it has something to do with time, but the divine Walter didn't know very much about the technology of photography, so he is making guesses, which are dictated by his notions of what the internal collapse of the society looks like in respect to the relation between photographs and their customers, for example.

JE: My own impression about the discourse on time in and around photography is that it is still at a very early stage. When we were talking yesterday, for example, Bergson came up for what—about fifteen seconds?—and we didn't even mention people like Ricoeur, and Deleuze... on other days it could have been quite different. My own impression is that academic talk about temporality in photographs is not that far from habitual art-world ways of talking, in which you say things like "My photographs are all about time" or "My photograph addresses time" or "My photograph interrogates time."

MI: There's a nice collection called *Time and the Image,* which has a series of things, including something by Laura Mulvey called *The Index and the Uncanny.*[12] She suggests that the photograph's apparently uncoded emanation of a past reality

gives it an uncanny character, especially in the context of digital photographic technologies. The uncanniness has something to do with the resurrection of a past reality in the midst of a present simulacral world. So it's not just the photographed object-world that is from the past; the technology itself is already passé.

JE: It's almost as if an expressive value is assigned to the very notion of taking time as a theme, that it's almost enough—

JS: How would you avoid that in photography?

JE: Oh, you wouldn't avoid it. I'm saying that as an explanatory model, when people put it forward as an explanation of what they are doing, it is enough just to form a sentence with a reference to the work, an expression of temporality, and a linking verb of the artist's choice.

JS: You have to exercise the shutter one way or another....

JE: Yes, but the question is the circumstances under which a photographer feels she has to *say* something about that—about time in the work.

JS: Yes, in a crit.

JE: Or, I'll also say, you're in a seminar on Bergson. Even in that kind of setting, the value attached to a very wide latitude of observations about temporality ensures that the discourse has soft boundaries.

DC: One of the reasons that it is hard to get a debate going with any passion about this topic, and I sense this was also true of Barthes's *punctum* (and this touches on a central claim of Jan's paper), is that these questions are internal to a different discourse on photography from the one that includes indexicality. At least, that is my impression. These are questions internal to a literary discourse on photography; the *punctum*, as Barthes himself describes it, is part of a rather romantic

literary discourse about affect, and questions of time in photography seem to be bound up with literary conceptions of narrative, memory, and loss. The question about indexicality exercises us because it is about the ontology of photography; it is a claim about what photography really is.

JE: It lends itself to argument. But then again the pervasiveness of these three themes, I would think, is roughly comparable in the literature.

We could go on, if our purpose were to inventory all the methods that have been applied since the 1970s. Among the others is one that was very important, I would even say essential for a number of years: the idea of photography as a medium characterized by an absence of aesthetic qualities—that "there is a discourse proper to photography," but "it is not an aesthetic discourse." [13] (Krauss herself never says "qualities" in "A Note on Photography and the Simulacral": instead it's "aesthetic norms," "aesthetic discourse," "aesthetic unities," "aesthetic universe," "aesthetic dimension," "aesthetic status," "aesthetic difference," "aesthetic position"—there are over a dozen variations.)

Many questions need to be asked about the antiaesthetic move, but I think the most challenging would be if it can be seen as anything other than a moment in history—if it has any *Nachleben* except in historiography.

DC: I think you're right to single out photography as the privileged medium for the antiaesthetic moment in recent art history—what one might call "high" postmodernism. Presumably this was at least in part a result of photography's many other instrumental uses and utilitarian functions, which make it difficult to subsume under some unified aesthetic discourse, as Krauss's remarks imply. (Though curiously—and this may itself be symptomatic of a certain art historical recuperation of photography—such uses of the

medium have been largely absent from our own discussion so far.)

But beyond that my sense is that the pressure to theorize photography in antiaesthetic terms at a certain moment in its recent history as an art medium was largely a result of contingent facts about the art world of that time, rather than the intrinsic nature—or natures—of photography as a medium with many different uses. Most notably, the fact that those artists identified with antiaesthetic uses of "photography" (Levine, Lawler, Kruger, Sherman, or Prince) turned to photography at the very moment when the art world witnessed an explosion of neoexpressionist painting that the theorists championing the former saw as an adversary to be defeated. So it may be that art uses of photography—such as appropriation—came to be valorized in antiaesthetic terms largely because they were being opposed to the regressive language in which contemporary painting was then being celebrated. The degree to which this opposition between photography and painting was gendered is also striking—just look at the artists in each camp!

As to whether the antiaesthetic conception of photography has any afterlife, beyond its historical moment, I suppose this is something that remains to be seen. Though I think the reception of the post-Bechers generation of photographers (Gursky, Ruff, Struth, and Höffer, but also Wall) will function as the relevant test case. In so far as the large scale of such work, its modes of exhibition display and address, undoubtedly bring it closer to painting, it will be interesting to see whether this sparks a rejection, or questioning, of such works' claim to being in the medium of photography. To the extent that it does, this could be seen as a legacy of the antiaesthetic, revealed whenever "photography proper" is opposed to photographic practices that seem to blur the boundaries with painting. I think Joel's paper could be read

in this light, and perhaps even my own; to the extent that they are, they are themselves indicative of this transformation of photography's conventions of production and display—a fact that it is exacerbated by many of these photographers' use of digital technology to construct their images in ways more reminiscent of painting. The fact that Michael Fried, the champion of modernist painting, is now writing a book on these very photographers only confirms this.

JE: It may be an opportune moment to bring this first part of our conversation to a close. The point, of course, is not to be exhaustive, but it is worth pondering what other explanatory models might be named. I can think of one in particular that would threaten to engulf all the ones we've talked about: the idea that photography is a kind of "writing with light" or that photographs are texts. It's an emphasis that is associated, in varying ways, with writers like Eduardo Cadava, Graham Clarke, and Victor Burgin.[14] Within that discourse, which also nourishes some art historical accounts—I am thinking at the moment of Carol Mavor's book on Victorian photography—there is also room for understandings of photographs as symptoms of narratives that find expression in very different areas of culture.[15] But I won't open that subject here, because it will come up immediately in the second part of our talk.

GS: The idea that photography is a kind of writing or drawing with light and that the Sun is the artist is of course central to Talbot's thinking and was expressed in the titles he gave to his photographically illustrated books—*The Pencil of Nature* and *Sun Pictures in Scotland.* It is expressed vividly by Julia Margaret Cameron in her picture showing Cupid drawing with a pencil of light. The idea that photographs *may* be texts also appeals to me. It certainly underlies much of my own thinking about travel photography in the nine-

teenth century. I believe "photography" can take the place of "painting" in Horace's famous statement in *Ars Poetica*—*ut pictura poesis*.

JE: The second topic, then, is reasons why we find photography hard to conceptualize. One immediate reason is that it is not one subject, but several. That reason ramifies, and we will need to open the question of medium and media—but I would like to begin with something that I think precedes questions of media, and that is, Who gets to speak for photography?

It could be argued that writing on photography comprises an unusual history. In the nineteenth century, people who wrote on photography were often photographers, and I do not know if we would want to say there is a fundamental discontinuity between photography and other media, in which painters wrote about paintings, and so forth. But in the twentieth century it becomes unclear who was speaking for photography; the list includes some authors who are not academics, but are invested in writing in a broader sense—writers like Susan Sontag, Roland Barthes, André Bazin, and others. It is an open question whether that poses a problem for the unity of the field.

GS: Perhaps we need here some recognition of twentieth-century photographers who have written eloquently and often profoundly about photography? I think of Robert Adams, for instance....

JB: I would like to denounce, in a certain sense, the professionalization of the discourse on photography. By that I mean the appropriation of the discourse on photography by strictly scholarly academics. The discourse is then no longer held by photographers themselves, who are excluded from the very discussions of their own work.

JE: That would then be a third "period" in the history of writing on photography, in a sense "after" the writerly interventions by Barthes and others?

JB: In that transformation, I would distinguish two steps. The first is an intermediate step, with people like Sontag and Bazin, who are both let us say inside and outside academia. But today, it is telling that there are no practicing photographers around the table—

JE: There are lapsed photographers at the table.

MO: Yes, lapsed.

JB: No professionally active photographers. That is a symptom of the shift, which I deeply regret. I think it limits our vision of photography as a discourse, in the Foucauldian sense of that word, to what can be said and taught in university contexts. Many constraints determine, limit, and narrow that conception.

JE: Yesterday you mentioned that our bibliographies are very narrow.

JB: Yes, and I include myself in that, as should be clear. That is one of the aspects of our essays that is most salient: we all quote the same authors, and I think that we have at least all read those authors, which is not always the case—

JE: Is that a good thing? I thought you were denouncing academic discourse.

JB: We are at least good academicians. (At least we do not quote authors whom we have not read ourselves, although of course that does not solve the problem of professionalization.) In addition, there is a kind of star system in the discourse on photography. You are no longer taken seriously when you don't quote certain sources, and conversely you are disqualified if you quote certain sources too extensively.

When I list the names of the people we have cited in our essays, the list is astonishingly short, in two senses: because the same names recur, and because the same names are excluded. Deleuze would be an example of an astonishing lack.

JS: Are you offering Deleuze as a nonacademic name?

JB: No. He is central, at least, in the French academic system.

JE: Are you saying that as long as we're stuck in academic writing we should cite Deleuze, or are you denouncing him as well?

JB: I am saying two things at once. First, that we should cite, quote, and use the work of more colleagues and professional photographers than we do now; and second, that our work is fundamentally art historical, except in the case of Jim's paper.

JE: Why?

JB: Because you use different kinds of photography, and you asked questions that help us leap outside art historical questions, which I think hinder our reflection on photography.[16] Most of the questions we have discussed so far are determined by art historical interests such as indexicality. The art historical bottom line explains, in the end, why we are discussing indexicality. The same should be said for medium specificity, which we will be opening in a few minutes.

I think that what we have been saying up to now belongs too much to academia, with a specifiable consequence: the terms are overused, and tend to lead into the kinds of onto-logical-metaphysical discussions that we encountered this morning.

DC: What would you say about the example of Jeff Wall, a photographic practitioner very much of the moment, who writes about photography? When he writes, he does so with a kind of art historian's hat on—

JS: It's beginning to sound like a sin—

DC: But my point is that he is presumably *not* the kind of photographer Jan has in mind, when he makes his appeal for practitioners to be brought back into the debate. What you might want him to write about is the technical detail of how he gets his pictures, because that would be an internal, practitioner's perspective. But more often than not, he writes in an art historical or art theoretical mode. Given that an artist like Wall would embody, I take it, what *you* perceive to be the problem—he has a platform, arguably, in virtue of speaking the kind of academic language you are denouncing—then what kinds of photographers, talking about what kinds of things, would you want?

GS: I have a similar reaction in relation to the issue of art history. I feel strongly that we have many different art histories. This may be a reflection of my own antediluvian nature, but the bibliography that Jan identifies as being a common or shared bibliography is not in actuality the one to which I would most typically refer. I have a nodding acquaintance with much of the material we have been discussing; but I might mention Gombrich, Meyer Schapiro, or Aby Warburg as being more of a touchstone than, for instance, Deleuze.

I think we need to think again of the diversity of approaches; Jan has identified a commonality. Is that to some extent happenstance? A reflection of the group we have gathered—and of my being a dinosaur among you new creatures?

MI: Yes, that is a striking point, because this is a photography theory conference, not a photography symposium.

GS: Nor is art history simply theory.

MI: Yet what strikes me about the group of people here is how heterogeneous it is, actually. Normally I'm surrounded by

art historians, but here we have some philosophical types, and some literary types, and so on. I find that's the exciting thing about working on photography: it hasn't actually congealed and become a totally academic discipline yet.

JE: Would you see this as different from the way things are in the contemporary discourse on painting?

MI: Yes. Particularly in this gathering, which tries to bring together people who are currently reflecting on the nature of photography.

JE: Does it matter to any of us that there are strong methodological differences among us, and that those methodological differences would lead to differences about such utterly fundamental things as the nature of reality? For example, Joel said that his essay avoids questions of commodity fetishism because it obscures issues he wishes to explore—but there are a number of historians of photography whose work begins from assumptions about commodity, capitalism, and economy, and who would potentially find themselves at odds with—or undermined by—an approach that tunnels underneath those assumptions. Or, in another example, several of us here are interested in psychoanalysis and even take it as an ultimate explanatory model, by which I mean that psychoanalytic concepts are understood as final terms of explanations, with no further effective appeal. From such a perspective, the interest we have taken in indexicality could appear as a symptom of unease about what is real, or Real in the Lacanian sense: a very different conclusion from one that might be drawn by an epistemologist. (I am deliberately omitting names here, which I suppose is a sign that the topic is sensitive.)

We have among us various interpretive approaches: a kind of sociological approach, exemplified for photography by Pierre Bourdieu; some phenomenological criticism;

a Marxian perspective; technical accounts, which none of us would want to the exclusion of other ways of talking but which none of us would want to exclude; ontological inquiries; and, ultimately, philosophical approaches to the extent that they can be distinguished from historical approaches. I wonder if people reading through the finished version of this book, and reading the essays we have contributed, might not expect such a collegial conversation. So aside from the uninteresting fact that we wish to remain colleagues and friends—assuming that we do—then is there a reason why we have not raised these issues?

Do those kinds of differences contribute to our disunity, and therefore to difficulties we have in conceptualizing photography?

MI: I wonder if we might be more up-front about our *investments* in photography. When our conversation really sparked, on the subject of indexicality, it was because of a disagreement about investments. I am pretty clear that my interest in automaticity comes from a certain aesthetics of depersonalization, chance, the encounter, and surrealist thinking and how all this reappears toward the end of the twentieth century. That is where my interests lie.

JE: If you then encountered a paper, let's say, that approached photography through its ontology or temporality, then you'd be able to use it, if you liked it: or, if you wanted, you could say, "No, this is not how photography needs to be conceptualized." The former would be collegial and friendly, and the latter more direct about philosophic differences.

GS: There is a difference between rhetoric and polemics. We have differed rhetorically in our discussions, but they were not so invested as to become polemical. In terms of my own engagement in the field, let me mention a conversation I once had with a friend. When he was about to characterize

my own investment in photography, he said, "If I were going to be insulting, Graham [and I knew by that, of course, that he was about to be insulting], I would see your approach to photography as being largely antiquarian in nature." I don't agree, although there are occasions on which my work has had an antiquarian flavor. It seems to me that surely most of us could approach photography in several ways, depending on the problem that presents itself. I could, for example, take a connoisseur's approach to photography, and become concerned with different states of Talbot's work, or with variants in Hill and Adamson's work. On the whole, I am more at home with literary, historical, and sociological approaches, and so I don't think there is necessarily that exclusivity of approach that underlies your question.

JF: It is not clear to me at all that there is a necessary conflict at this interpretive level. The idea that comes up in some theorists, that they are going to find some truth about the medium, reflects the ambitions of the sciences, where the idea is to find and build a body of knowledge, to discover the true and unmask the false. In the humanities we do not typically use theories for that, but rather as tools for the enrichment and deepening of understanding. Many different theories may achieve that, *even* theories that contradict one another. Some theories will be useless in regard to some works, but helpful in relation to others. We need to look to the purpose of the inquiry, what is trying to be understood and why. There are complex epistemological and methodological issues here, and we can't pursue all that is at stake in them in this context, but likewise I doubt the necessity of a singular theoretical or conceptual approach, and the implication that the only options are polite repression or conflict or open conflict.

JE: Personally I do not find it persuasive to describe the humanities as a place where people have different kinds of ideas and just take bits and pieces from one another in the name of a general enrichment. But perhaps we can return to the broader question of who gets to speak for photography.

MO: I think the history of photography has changed. At one time it was more of a field than it is now, which reflects changes in what counts as a photograph. At one time, I think that photography history covered a set, canonical group of photographs, and you could pretty much count the photo historians, and tell them easily apart from the art historians; they did not tend to write about painting and installation. Now you have people coming together to talk about photography who weren't writing about photography ten years ago, or who also write about painting or installation, or who don't even write about visual art.

JE: Can these distinctions we're making help with our question regarding the difficulty of conceptualizing photography? It may be that to turn these distinctions into useful analytic categories, we would have to do something similar to what Jan is asking for, *denouncing* (it's a strong word) academic discourse: but what would happen if we were actually to succeed in giving up thirty years of academic writing on photography? If such a thing were even conceivable, where would we then find ourselves?

JB: I am not making a brief for abandoning those three decades of scholarship. My plea is to broaden the range of the people having the right to speak for photography.

JE: But then how would it be possible to take seriously the writing—newspaper reviews, commercial catalogue essays—that presents itself as nonacademic?

JB: That is perhaps the most important question—for which I have no answer. The first thing that comes to mind, although it is only half an answer, is the writing of people like Jeff Wall, who are so well-trained in the academic system that it is impossible to tell the difference between what they write and art historical writing. His texts are interesting, seductive, and dangerous, because he is not at all representative of what photographers are actually capable of writing.

JE: I have noticed a promising "nonacademic" use of Wall's work in some photography departments in the United States. There he is sometimes taken mainly as an opportunity to produce satires and travesties. Student artists will set up their 8 × 10 view cameras and ask their models to stand in unnatural poses for long periods of time just in order to produce pictures that look awkward. Alternately, they will use large-format photography and elaborate setups to produce small prints that are manipulated to look like snapshots. In doing such things, the artists are not engaging any of Wall's writing, not to mention the art historical writing about him.

JB: Wall's preeminence has also to do with the star system that I mentioned. There is place for one or two artists, and that narrows down the possibilities for photographers who are discovering new kinds of image making. They do not have voices because there is no relay, no link to the concerns of the academic world. They themselves are unable to articulate their own work to the level where it is of interest to academic writing.

The same problem occurs in painting and sculpture, but photography has a different history in that photographers had a strong voice at the beginning of the twentieth century, which they have not sustained given the rise of academic discourse. To me this is a big, big problem.

JF: Could you spell that out? Where is this exclusion occur-
ring? I have never talked to a photographer or a writer on
photography that felt excluded.

JB: I see this every day. It is a kind of terrorism by academic
discourse, which terrifies photographers working in the
field, unless they are academically trained.

GS: I wonder if we need to acknowledge here the place of
photography as a practical field within the university con-
text, in addition to the emphasis Jan is placing on teaching
and writing about photography in the context of history
of art or other departments? John Szarkowski had inter-
esting things to say about the institutionalization of the
practice of photography in *Photography until Now*. There
is also another category of thinking and writing about
photography: that generated in a museum context. John
Elderfield has interesting things to say about this in his
article "The Precursor."[17]

DC: It is impossible to discuss this question of professional-
ization without discussing the change in *status* of photog-
raphy as a medium—or at least resource—for artists since
conceptual art, and especially over the last twenty-five or
thirty years. This academization we're talking about maps
almost directly onto the canonization of certain kinds of
photographic practices as art practices per se—their sub-
sumption within *generic* art discourses and theories, rather
than isolation in specialist theories of photography. In this
respect, Sherman's *Film Stills* were made in a very differ-
ent milieu for photography as a fine art medium than, say,
Ruscha's books. This is even more true today, as the cover-
age and museum exposure of *artists* like Wall, Gursky, and
Ruff demonstrate.

　　It seems to me that if you really wanted to break out of
this to talk about photography more broadly, you would

find yourself faced with a bewildering array of photographic applications. To take just one example, you might want to talk to people who are at the forefront of developing sonic imagery, or engineers who design PET scans, forms of radiography that are used to detect tumors that don't show up under normal scanning. That is presumably at the forefront of the development of photography of a certain kind, a technical kind, which has a direct utility. But what is the radiographer going to be able to say to us that will take us forward?

JE: Here's an example. We're putting together an exhibition here, called *Visual Practices across the University*.[18] One of our exhibits is an image made with side-scan sonar. It is an image of the ocean floor, twenty feet long and a foot high, made with an instrument that uses pings of sound and two transceivers to assemble strips of data. It looks like a lunar landscape, but it can't be "read" like an image: you think you're seeing hills and valleys, but actually the value scale denotes hardness, softness, and other properties. The long vertical axis of the image records distance, as you'd expect, but the shorter horizontal width of the image records time *and* distance—entirely contrary to intuition. That stuff is out there with, apparently, *no* discourse around it. But from my point of view, it is a good thing that the discourse is wholly different, that it seems empty or "merely" technological.

JB: On the one hand, I would be glad if there would be more images like the kind Jim Elkins studies, which are not clearly linked to art historical problems. Then I think we could renew our vision of photography, and also evacuate certain false problems such as indexicality.

On the other hand, our view of photography would be enriched if we made room for new kinds of vernacular

photography—by which I mean, ultimately, a kind of anthropology of photography.

JE: I find it interesting that this conversation is unproductive. We have made, I think, three gestures beyond the kind of academic discourse Jan has conjured: toward photographers who have no links to academic concerns, toward scientific and technical innovations in photography outside the arts, and toward a more inclusive sense of vernacular photography. In no case is it clear what discourse could be extracted from those practices, or how it might alter the configuration of our familiar bibliographies. I have interests in the first and second of these, so I will add just one example of what I think might be done.

Another exhibit in the show is a project to make three-dimensional scans of Irish inscribed stones, to preserve them for future study. A laser scanner is used to import an enormous amount of information about the position of every point on the surface of the stone, with a theoretical resolution of one millimeter. The results, on computer, can look more solid—and more important, more clearly legible—than the originals. They can be oriented in any way, distorted at will, made to look wet or dry, colored, and even remade using another laser technology into duplicates of the original stones. And yet the people who use this technology don't often talk about pictures or sculptures. They use the wonderful, poetic expression *point clouds*. That, to them, is what the database is, and what comprises the "pictures." Now there is a way of talking about photography without any of the terms we have been exploring.

But we should move on. Another principal reason why photography resists conceptualization is that it can be seen as not one but several practices or—to bring in the more charged word—several media. Diarmuid, you said that

"there are no fixed boundaries between artistic media," hence "there will be no fixed domain of non-art between established and discrete media." I thought it might be helpful to begin with that because it entails a topographic or geographic way of thinking about media. I wonder, then, why mobile boundaries entail the consequence that there is nothing between them.

DC: That's a tough question: what I would want to say is that this way of thinking entails that nothing can be located *either* within *or* between media a priori. To make this plain, let me reply in terms of my essay. If you have a conception of a medium, like Fried and Cavell's, according to which you retain, at one and the same time, the thought that media have essences, and the thought that these are historically indexed (such that at any given moment in time, there is an essence to an artistic medium, even though artistic media change over time), then it seems you cannot *also* say that something that "falls between" artistic media no longer counts as art. Given that on such an account you cannot finalize the boundaries of artistic media once and for all, it is no longer clear what falling within *or* between artistic media (and thereby counting or not counting as art) would mean.

Or rather, though there will be things that might be said to "fall between" artistic media given the state of the conventions of those media at a given historical moment, this can only ever be an *historical* fact, and not an *ontological* fact about those media. But I would hesitate to even call it an historical "fact." Locating something between (or within) media can only be a provisional claim, I think, for more than historical reasons, since where we are inclined to draw the boundaries between media will ultimately depend on conflicting narratives and competing histories about what is valuable or significant, about which there is no reason to

suppose we will reach consensus. Joel's paper broaches this problem when he says that Gursky's work doesn't function in the medium of photography. Joel, I know you don't want to say he's a painter, but I am inclined to say that it makes as much sense to see his practice, or Wall's, in those terms—at least on a strong reading of Fried and Cavell's theory. Of course, this would be to push that line much harder than either Fried or Cavell is likely to endorse, but I can see how an argument to that effect might play out.

JS: I made a rather stronger claim. My claim was that medium is irrelevant, that it is pointless to talk about "Gursky's medium." The audience is not interested in medium. It doesn't constitute part of the reason why it looks at the work, why it appreciates it, how it understands it. It is the same with most curators as well. The people who get into trouble working with Gursky or Struth are people like Peter Galassi. He has a *requirement* to find the photographic medium character of the work, and produces an essay that is utterly unconvincing.[19]

JF: When you're talking about the MoMA audience, I agree: photography has nothing to do with their appreciation or the pleasure they take from Gursky's work. But when you say photography has nothing to do with the audience's understanding, I want to step back for a moment and wonder why you think that. It strikes me that maybe, as an empirical fact, we could go around and ask them, and they'd say, "Photography doesn't help my appreciation, or increase my pleasure." As for appreciation and pleasure, they get the final word, but I doubt they do with regard to understanding. Suppose we ask them about understanding; they might say, "Knowing the medium adds nothing to my understanding." But as for understanding, they do not get the final word. It might

make a difference to know that it started as a photograph, or if it were purely a painting.

JS: But look. I am doing sociology: not history (although one day, it will be history), and not conceptual analysis, although I like to do both. What I am doing here is just trying to report, as honestly as I can. There is no interest in the medium of photography, as I understand what that means. I have yet to meet one person who, in trying to understand a Gursky, wonders if it's f/16 at 1/130 sec, or done with a CCD or Tri-X. None of that is part of the discourse.

DC: Is that true also when you talk to photographers about Gursky? It's not my experience.

JS: Yes. This stuff is just falling in between the cracks. So my response to what you're saying is, It's not a question of what's falling *between* media. There's an important sense in which I think medium has just—

DC: —dropped out?

JS: It is no longer a center of contention. Or a center that is generating new work.

DC: Right. But then we're in agreement. What I was trying to explain is where I differ with Fried: *he* presumably has to think—if he stands by his earlier criticism—that it "falls between" media, in virtue of blurring the boundary between painting and photography. Though I'm not sure this thought can be maintained if one pushes that line really hard.

JS: Fried's current position is that the work of photographers can "take on the address" of the work of painters. That may mean they live at 125 Gerard Street—that's one form of address. I would love to have a better idea of what he means by "address" in this context.

DC: Presumably he means their works address their behold-
ers in the way that antitheatrical paintings once did. This is
where our conversation touches on Jan's worries. This whole
approach to what makes these people interesting—why
Michael Fried can now turn to these photographers, if they
are photographers, is because he can subsume them under a
set of concerns derived from painting, concerns that stretch
back to the antitheatrical tradition in eighteenth-century
French painting. And *that* seems to bracket all the prob-
lematic mess about photography's uses outside a highly cir-
cumscribed, fine art conception of photography. Such that it
may not even be right to talk about photography per se: these
could just be artists who use photographic means—to adopt
Joel's formulation.

GS: I find Joel's point very provocative and interesting. I am
reminded of Barthes saying that the photograph is *always*
invisible. I wonder if what you're saying about Gursky and
Struth is an extension of something that is particular to
the medium of photography rather than apart from it. In
the context of traditional media, if I look at an etching or a
drypoint, then I consider the work as an expression of that
medium; I enjoy the nature of the burr, the inking, and so
on; there is a visibility to the object. I think, Joel, that con-
temporary viewers' responses to those large images speak
ultimately to the notion of photographs being invisible. The
photograph as an artifact, as a physical thing, is invisible.

JS: I am not sure that I'm getting your point, Graham. My
sense is that when my students go to look at these things,
to get a sense of what they could do as artists, the issue of
medium doesn't count. One of the problems here is to under-
stand what a medium is.

Let me describe one moment in the history of the Museum
of Modern Art. In 1937, Beaumont Newhall put together

a show called *Photography: 1839–1937.* It is a kind of "Jan Baetens" show. What goes up on the wall is everything: daguerreotypes, Hill and Adamsons, Nadar's pictures of the catacombs, Disderi's *carte-de-visites,* Roentgen photographs, radio-produced photographs, fabulous pictures of shorelines taken from a height of 20,000 feet. These are all thrown together. It's as though Newhall is saying, "I can't tell you why these belong together at the Museum of Modern Art. I just know there is something aesthetic about each and every one of them. I don't have a coherent account of what makes this thing necessary. But here are 827 pieces." It was an immense show, in a little brownstone in the East 50's in New York. That was the moment when everybody got in. But post-1937, in the United States—I can't speak for elsewhere—what happens is the idea that all of *that* is not a medium. There was every kind of photographer you can think of; some had Fairchild Camera and Instrument Company as the agent of production, or Eastman Kodak… but increasingly, the history of photography as it gets put into museums and as it is taught in universities (when it is finally taught in universities) is the history not of everything, but of those works that claim a certain tradition of photographs. Increasingly, starting in 1962 with Szarkowski, the photographs turn in on themselves. They become more and more about what it means to be made *in the medium* of photography, and about the discovery of what that medium is. The idea is that you don't instantiate everything you know about photography; you try to instantiate what, within this set of constraints, can be produced that is new—because novelty is the driving force.

If *that's* what medium is (and it is certainly at least part of what Michael Fried thinks a medium is, and what Stanley Cavell thinks a medium is), Gursky is not working in the medium of photography. There is no attempt on the part

of any of these photographers to point backwards, to make pictures that get the conviction that Edward Weston's photographs get. They are not meant to be intimate: they are intended to be precisely the opposite.

When I first started teaching the history of photography, I had to caution my students when I showed them slides of daguerreotypes. I said, "These things are little [*makes a framing gesture with his fingers*]." Now I can't even fit a full Gursky onto the screen. I have to caution them, "You must understand this is much smaller than the real thing."

This is not the moment in which quantity becomes quality, but it does mark a real difference in the ways these things are being made, and the ways they are being evaluated, appreciated, and understood (to the extent that they are being understood).

MO: My ears pricked up when you said they're the opposite of intimate. I thought, "Oh, well they *are* in the same discourse then," since they flagrantly violate its terms. In some ways, I wouldn't completely place the new photographs outside this history. They play on the idea of intimacy by being so big, for example, the large portraits that Struth has done. And some of his street scenes are uncannily reminiscent of daguerreotypes in gigantic, crazy, huge proportions.

SK: The Gurskys also have immense detail. The detail is profusely replicated, so you are absorbed despite the colossal size of the image. I think he was playing that that. Another reason why I think Gursky operates within the discourse of photography is that you can't get that glossiness, that sheen, in painting. This glossiness is emphasized by the fact that he fuses his photographs with a Plexiglas surface; the photographic sheen is almost exaggerated that way. It signals photographic processes. He collaborates with the fashion

photography industry in Düsseldorf, and so again I'm not convinced it's not part of the history of photography.

I also want to ask: how are we going to absorb this issue of the digital? Gursky is a hybrid case; some works are digitized, some aren't. Part of peoples' fun, when the audience looks at Gursky, is to try to figure out what is manipulated and what isn't. I don't think that's very interesting, but I did want to insert the digital into our conversation. I don't think it's a complete revolution. Consider someone like Lev Manovich, who takes on William J. Mitchell and says, "Look, in theory digital photography is a radical shift, but in practice there are continuities."[20]

I understand Gursky as exploring certain continuities. Maybe this is where generational differences come in, but I see Gursky as an extension of limit-cases of photography. That is also what I understand photomontage to be: it explores boundaries. Rather than being *in* the medium, it pushes certain boundaries.

JB: I am glad you mentioned Manovich. For him, the digital "revolution" does not start with the digital but rather in the 1920s with montage. That is a very interesting subject, the broadening of the digital "revolution."

I concede, Joel, that Struth may no longer be considered a photographer. But I do not agree that examples such as Struth make the notion of medium specificity useless. I think you're generalizing, starting from some blurred practices, perhaps marginal cases—

MI: —heightened cases—

JB: —and that you're deducing too much. On the contrary, I think that the theoretical practice of medium specificity continues to be immensely, dramatically useful, provided you dissociate it from those art-theoretical, art-historical

discussions regarding the nature of art—let's say the Cavell and Fried line.

I think a different *use* of medium specificity is possible, fruitful, and even necessary. That is the way it functions in literature, where the notion of medium specificity continues to be not only a "hot" issue but also something that is widely recognized and accepted as a tool for innovation. Reflection on medium specificity helps the artist to find new ways of working, even if those ways bring him or her outside of their idea of a given medium.

JS: If you ask a young student who wants to use a camera and photographic materials where he or she starts—where the issues are, what are the exemplary moments, what Hill and Adamson mean, what Diane Arbus means—

JB: Hasn't that to do with their training? That they have teachers telling them that what matters is no longer these artists, or this history of photography?

JS: Look, I'm not crying because of this. I think it's really interesting, and I'm especially interested in it because I never expected it. I would never, in a million years, have thought this was going to happen. If you can be medium specific, and have no interest in the history of your medium, then people like Gursky are medium specific. If what it means to be medium specific is that you pick up a camera, film, or CCD, and go banging away, then you're medium specific.

MO: "Go banging away"? You're trying to tell me there's no value judgment there?

JS: No, I'm just trying to take an argument based upon a certain kind of historical practice. In fact, I take myself to be sounding at this moment very uncomfortably like Rosalind Krauss, but on the other side. What I'm trying to say is that if what it means to be a photographer is to be engaged in

working through problems of the medium, then the issues of tradition, materials, touchstones, skills, the issue of what new thing you're trying to create, and what the constraints on that newness are—if those things drop out, then I don't understand why anyone would want to say that what we're seeing in artists like Gursky is continuous with the activity of the medium of photography. It's an historical argument, involving convoluted issues of aesthetics and sensibility, but that's what it took to be a photographic modernist. With the end of that, it seems to me you could say, "Well, that person works in the medium of photography but doesn't pay any attention to the medium or the tradition, and is mostly interested in the kind of work that is being done now"— that's always fine. But what does it add to say the person is working in the medium of photography?

DC: Joel, listening to you speak, I'm beginning to think you may be overstating the problem. When you said that you've yet to hear a Gursky, a Struth, or someone in this group explain why their work should be regarded as in the medium of photography, it occurred to me that, in 1943, it wasn't *Pollock* who was claiming he was making paintings in a way that commanded assent; it was *Greenberg*. It takes someone like Greenberg to come along and construct an historical narrative by bringing out, making salient, what it is that ties this work back to a tradition that it extends….

So, to argue the case for the other side: one might say there is no greater problem in the case of these photographers than there is, say, in the passage of modern sculpture from the monument, to work that's off the plinth, to constructed sculpture, to sculpture in the expanded field. I think the changes we're talking about in the medium of photography are really rather minor by comparison. So the onus is not on *Gursky*. The construction of an historical nar-

rative is presumably what Fried takes his project to be. When you bring up a term like *intimacy* or the lack thereof, you're effectively gifting Fried his answer, because that's absolutely the language of theatricality and "address." The field is then wide open for someone like Fried to come back and give you a story about how the new work ties in to the history of photography's attempts to address the beholder.

JS: Here's the answer. If you ask Pollock, in 1943, "Why are you banging your brains out, trying to get something done, trying to get Peggy Guggenheim's interest?" He's trying to be a painter, and whether he has a spiel or not, he really *wants* the spiel. It's important to have the spiel. I'll tell you that Thomas Struth does not want this spiel. Cindy Sherman does not want this spiel. She has tried very hard to distance herself from the medium.

DC: I think that case is easier to make with Sherman. Struth or Gursky never fail to talk about the way they have both inherited and departed from the Becher legacy. That ties their work back into the history of photography—assuming they make it count.

JS: That's a DNA test, and I don't think it works; I have also heard Struth talk as if he's utterly untethered to anything, and that paintings are the things that interest him the most.

MI: Mary Kelly always used to say, "I'm not a feminist artist: I am an artist whose work is informed by feminism." She didn't want to be ghettoized in this little class of "the feminist artist." She wanted her work to be opened out—to be art, in fact. It seems to me that Cindy Sherman and some of these other recent artists also don't want to be corralled into what used to be the "ghetto" of photography.

JE: Those political issues are very important, and it's also important to take into account the contemporary criticism of people like Struth, as appalling as that literature might be. In the art historical discipline we are all working with— the one in which Michael Fried also operates—what matters is the discursive field that surrounds the work. Fried's work especially pays attention to contemporaneous critics. Even though the relevant criticism has now sunk to an abyssal level, so that no one wants to pay attention to it, a discursive field exists in the form of gallery blurbs, essays in exhibition catalogues, and newspaper reviews. In that literature, the work *is* called photography. Eventually, that is the contemporaneous "evaluation" that has to be taken into account.

MI: Digital photography is a new medium, and there is not yet a fully developed discourse around it. Video, too. It takes time.

DC: Taking a meta-perspective on this conversation, wouldn't the very fact of this conversation indicate that this work *does* raise the question of the medium in photography, and that is the classic question that works in a medium raise?

JE: You have been reading a *lot* of Fried, haven't you?

MO: To go further, the artwork may not be raising the question at all, so much as we are. That's why the mention of the opposite of intimacy got to me, because we can use the term *opposite* to place the work in the discourse, making the new work respond to the canonical works. So maybe we are all examples of what Jan Baetens is talking about, trying to force this material into art historical discourse. It may be hard for us to talk our way out of that.

JS: I am not going to respond by saying it's a wonderful idea to keep our talk out of art historical discourse. We're talking about artworks. If Jan wants to talk about other kinds of

photographs (and I know a lot about other kinds of photographs, and I'd love to talk about them), that's fine. But if we are talking about the works of the people we've been discussing, they would seem to fall rather naturally into art historical discourse.

MO: But perhaps we're talking about those works because our subject is art historical discourse. I didn't write about the things we're talking about in my essay, for example.

JE: But you might have things to say about "address," intimacy, and so forth, from the perspective of your essay.

MO: Okay, I'll join the discussion! I'm willing to talk about Struth. I heard him discuss August Sanders's work in Berlin last year. That conversation brought out interesting links between contemporary photographers and…

DC: Joel, the force of your argument must be that when you look at, say, aerial photography, you don't *immediately* bring it into the discourse of art history. That would support your case, wouldn't it? It would say something about photography as a practice with certain functions in the world, as opposed to photography as something designed for the display of large works, intended for sensuous gratification.

JS: Yes; what's wonderful about the 1937 exhibition, for me, is that the works remind me that the cooked story of photographic modernism got cooked long after 1937. At the time, it wasn't immediately apparent what modernist photography was going to be. So everything got put up on the walls, and over the years things started coming down. That seems to me to be the invention of the photographic medium. After the show left the museum, it went to Abraham & Strauss, a department store in Brooklyn, and then to other department stores. Those were very different times.

The idea that a photographic medium allows in everything that's made photographically just doesn't accommodate the notion of medium. Sometimes this gets just horrifyingly funny. For example, you go to a show, and you see a photograph, and the label says, "Silver gelatin print." That's supposed to be a wonderful help to everyone who comes to see the show. It's supposed to be a way of specifying the particulars, and to honor the particular picture by identifying its materials.

MO: Which is done for paintings: "Oil on canvas" ...

I must admit when I first saw one of Struth's large prints, I called a friend and asked her, "What is chromogenic development?"

JS: And once she told you, you understood Struth perfectly, didn't you?

MO: Actually, she had to call another photographer!

JS: Does *chromogenic development* mean it's a cibachrome print?

MO: Actually, I was trying to find out if they were digital. But it turns out it's a specific way of making large prints.

JS: Exposing them line by line onto a single piece of paper.[21]

JB: Let's make a thought experiment. You enter a gallery, and see an image. It's not a Gursky, but a perfect painted copy of it. In the case of a painting, the result would be totally uninteresting. But when you know you're confronted with a photographic image, that raises questions about where photography is going today. Those questions are typically about medium. Gursky and other photographers are doing today what Pollock was doing between 1943 and 1945. What they are doing would have no sense outside of photography, and certainly no impact.

JS: It is exactly what you are saying that I was trying to put a "NOT" sign in front of. So we just disagree. Exactly what you just said, I don't think is sayable any longer.

MI: But people probably said that Pollock wasn't exactly painting, right? Not using a brush, and so forth. Artists are always pushing the limits of their medium.

JS: I would be the first person to admit I was dead wrong. I would be just as happy to be right as wrong. I've never made predictions like this before.

DC: We might try approaching the issue of medium specificity in photography from an entirely different perspective. We would probably get very different results, for example, if we were to apply the terminology of speech act theory to different sorts of photographs, photographs that *function* in very different ways. Maggie's paper raised the question of a *performative* photography, a photography that does not function to document some event or entity in the world that precedes its being recorded, but is itself an agency that brings something into being through its own action. This is not dissimilar to Austin's distinction between constative and performative utterances; it is like the difference between saying, "The cat is on the mat," which describes a state of affairs in the world, and saying, in the right circumstances and if one is invested with the necessary powers, "I pronounce you man and wife." Or, to take a simpler case, "I promise—." In these sorts of utterance, the act of stating it brings it about.[22] It wouldn't be difficult to imagine analogous uses of photography—both within and outside art—for the latter. Maggie has already suggested that some of Vito Acconci's and Sophie Calle's uses of the camera might function in this way.

Of course, Austin went on to dissolve his opening distinction between constative and peformative utterances

into a series of more complex distinctions and subdistinctions between locutionary, illocutionary, and perlocutionary acts. Whether one could map *all those* onto photography is another matter, and may raise similar worries to those Jim raised about appeals to Peirce earlier—namely, is appeal to Austin even necessary to make the simple point that different uses of photography, in different situations, and for different purposes, achieve very different things? But it would at least have the heuristic value of invalidating lazy claims that *all* photographs are *x* or *y*, by focusing attention on what we *do* with and through photography; and that has the advantage of drawing attention to just how *varied* the kinds of things we do with photography actually are. This would be akin to Wittgenstein exhorting his imaginary interlocutor not to assume that there *must* be something common to all the things we call "games" but, rather, to "look and see" just how varied they really are.[23]

JE: This is not unrelated to what Peg Olin does with the responses people have to photographs.

And since we're thinking of ways to shift the conversation away from modernist art historical terms, I also want to know why this seems to be a moment in which we want to change the way of talking about photography in these particular ways. One reason could be that the discourses we've been considering have been exhausted (or have exhausted us!). If medium specificity has run a certain historical course, that could be a reason for saying, "Let's look at what photographs do," as Diarmuid and Maggie have proposed, or "Let's look at how people look at photographs," as Peg has done. But there might be other reasons, for example our partly incommensurate methodologies.

MI: Well, I had a very specific interest in the idea of performative photography. I wanted to rethink the idea of a picture

and, also, move away from the Barthesian melancholy of the
"that-has-been." That view seemed very much against the
grain of the 1970s photographers I was interested in. They
had an experimental, open-ended way with the camera—I'm
tempted to say future-oriented, as against Barthes's preoc-
cupation with the past.

MO: I think this theme draws three of our essays together—
mine, Maggie's, and Jonathan's—all of which try to think
of the photograph as a starting point, rather than an ending
point. The papers come from three different places, and end
in different places, but share something, in that all of them
reverse the question of indexicality: the issue becomes not
what gives rise to photographic representation, but to what
the photograph gives rise.

JE: These approaches also have the ghost of Bourdieu floating
around. There's a passage in another ghostly text, Krauss's "A
Note on Photography and the Simulacral," in which she says
that if you're aware of what Bourdieu says (that photography
serves a self-definitional function for the middle class), there
are two things you can do: either give up photography, or
identify yourself "with a special kind of photographic prac-
tice, which is thought of as different."[24] That is a passage
that has always perplexed me, because of course that second
option is what she goes on to do, even though the argu-
ment is that she's gone on to differently posed problems. A
similar problem, I think, faces approaches to photography
that share a sociological point of view, because there will be
a moment in which the writer has to say, "Okay, I'm outside
this problematic, because I understand it"—but then it turns
out they aren't, they're inside it all along.

MO: Krauss rejects the sociological approach because she wants
to stay in the art world, whereas I want to look at the nonart
world, but in a broader fashion than Bourdieu did.

DC: The longer this conversation goes on, the more I'm inclined to agree with something central to Jan's essay, which I don't think I would have been inclined to agree with at the outset. Whenever we begin to talk about photography outside the art historical frame of reference, it's as if the conversation just dies. We don't know what to say, or how to proceed. We talk about aerial photography, PET scanning, all the uses that photography has, but when such examples come up, beyond acknowledging their existence, no one really seems to know what to do with them. There's no take on it.

JE: That's why I am listening to the places where the conversation dies, because those kinds of photography are very interesting to me. I wonder if the idea that "there's no take on it" might not be an illusion, a function of the fact that whatever is said does not fit with the only vocabulary we have. And I wonder if that can be anything but a good sign, because it indicates we're not recognizing something we already know.

MI: It is interesting that media specificity and indexicality are the only issues that have ignited everybody. I was reflecting on this, and wondering why it was the case. One only has these conversations late in the day: it's the Owl of Minerva phenomenon. Media specificity is no more; we have postmedium work, and hybrid forms of painting and photography....

JE: If you compare the ways media used to be discussed: the talk was heated, and there was a politics at stake. Whole careers of critics and historians have centered on the importance of specific practices that could be defended as medium specific. There is nothing of that in our conversation.

MI: And indexicality, with digital photography, is marginal.

SK: But I am still not happy with the ways that digitality has not been central in our talk....

JE: My sense of that particular subject is that the reason we haven't taken up the issue, even though it appears in several of our essays, is that criticism of digital photography swings madly from a kind of millennial hope for the absolute destruction of all previously known ontologies, to a kind of technophilic discourse in which you say, "Well, we're just fiddling; it's really a photograph." Manovich is an interesting example, but I wonder about the historical purchase of concepts such as "granularity" or "compression." I wonder why it does not matter that some such concepts are not wholly convincing or useful to some people working in the history of photography. And I wonder, too, about the vacillation within studio art departments over the putatively opposed strategies of hands-off point-and-shoot, on the one hand, and potentially unlimited manipulation, on the other. There is an impoverished discourse of naïveté and naturalism on the one side, and similarly limited talk of invention, technology, and subjectivity on the other. I don't see any middle ground there yet, with a few exceptions—I think of Brian Massumi, for example, or Thomas Elsaesser—which may just be a sign of how young digital photography is.

JS: One of the things that's striking to me about the Nikon 5700, the Epson 990 printer, the inks, the paper, and so on, is that they all work to produce Walgreens' prints. The notion of a commercially feasible photograph is the notion Kodak has been pushing for forty years. There are no new, somehow digitally peculiar lenses; the film at the focal plane isn't irregular.

JF: Night-vision technology is another example. People take images at night, without flash. I don't know what they're doing with it—

JE: I think it's going into those same family-photo albums that Walgreens' sells, that Bourdieu studied, except they're creepy albums, with black leather covers.

JS: It's a continuation of what people wanted in the 1920s, to be able to go out and photograph people unaware, using natural light.

MO: It means that more people can do Brassaï's *Paris at Night*.

JE: Well, on those metaphors of owls and night, I think we should wrap up. I thought an interesting way to conclude would be to think of ways we are still inside photography, so that it is effectively not conceptualizable. A clear example of that, for me, is Joel's theme of the automatic. Reading the essays and listening to our conversations, I would say that the automatic is something we haven't yet got *around*. (I don't think indexicality is one of the things we're still inside, despite the fact that it is fun to argue about. For me at least, what's really going on with the index is some hope people have about the real world; I don't think the issue there is photography.) Three more reasons to think we might be inside photography, that the subject may own us rather than the other way around, are the differences between our approaches, which we have not quite managed to name; the weird fact that we have been talking about texts and ideas— Barthes, Bourdieu, and the index—that are over a quarter-century old; and our inability to come to a consensus about what discourses we are, in the end, all speaking.

Notes

1. This is pursued in James Elkins, "What Does Peirce's Sign System Have to Say to Art History?" *Culture, Theory, and Critique* 44, no. 1 (2003): 5–22.
2. Gill Harman, "Eco-location," in *Film Theory and Criticism: Introductory Readings*, 2nd ed., edited by Gerald Mast and Marshall Cohen (New York, Oxford University Press: 1979), 234–56.

3. Quoted from John Ward and Sara Stevenson, *Printed Light: The Scientific Art of William Henry Fox Talbot and David Octavius with Robert Adamson* (Edinburgh: Her Majesty's Stationery Office, 1986), 109.

4. Ernst Gombrich, *Art and Illusion: A Study in the Psychology of Pictorial Representation*, 2nd ed., rev., The A. W. Mellon Lectures in the Fine Arts for 1956, Bollingen Series XXXV/5 (New York: Pantheon, 1961), 139, figure 99.

5. David Green and Joanna Lowry, "From Presence to the Performative: Rethinking Photographic Indexicality," in *Where Is the Photograph?* (Brighton, UK: Photoforum and Maidstone, UK: Photoworks, 2003), 47–62.

6. Bill MacGregor, "The Authority of Prints: An Early Modern Perspective," *Art History* 22, no. 3 (September 1999): 389–420.

7. I argue this in James Elkins, *Visual Studies: A Skeptical Introduction* (New York: Routledge, 2004).

8. Walter Benjamin, "A Short History of Photography," in *Classic Essays on Photography*, edited by Alan Trachtenberg (New Haven, CT: Leete's Island Books, 1981), 199–216.

9. For an account of the Lacanian background to *Camera Lucida*, see Margaret Iversen, "What Is a Photograph?" *Art History* 16 no. 4 (1993): 450–63; and Margaret Iversen, "Readymade, Found Object, Photograph," *Art Journal* 63 no. 2 (Summer 2004): 44–57.

10. Diarmuid Costello, "Aura, Face, Photography: Re-reading Benjamin Today," in *Walter Benjamin and Art*, edited by Andrew Benjamin (London and New York: Continuum Books, 2005).

11. Margaret Olin, "Touching Photographs: Roland Barthes's 'Mistaken' Identification," *Representations* 80 (2002): 99-118, especially 104–5 on James Van Der Zee's *Family Portrait* (1926).

12. *Time and the Image*, edited by Carolyn Gill (Manchester: Manchester University Press, 2000).

13. Rosalind Krauss, "A Note on Photography and the Simulacral," in *Overexposed: Essays on Contemporary Photography*, edited by Carol Squiers (New York: New Press, 1999), 169–82, quotation on 178.

14. Eduardo Cadava, *Words of Light: Theses on the Photography of History* (Princeton, NJ: Princeton University Press, 1998); Graham Clarke, *The Photograph* (Oxford: Oxford University Press, 1997); and *Thinking Photography*, edited by Victor Burgin (New York: MacMillan, 1994).

15. Carol Mavor, *Pleasures Taken: Performances of Sexuality and Loss in Victorian Photographs* (Durham NC: Duke University Press, 1995).

16. Referring to a work in progress, *Camera Dolorosai;* related text is James Elkins, "Harold Edgerton's Rapatronic Photographs of Atomic Tests," *History of Photography* 28 no. 1 (2004): 74–81.

17. John Elderfield, "The Precursor," in *The Museum of Modern Art at Midcentury: At Home and Abroad*, Studies in Modern Art, vol. 1 (New York: Museum of Modern Art, 1994).

18. *Visual Practices Across the University*, edited by James Elkins (Paderborn: Wilhelm Fink Verlag, 2007), forthcoming.

19. Peter Galassi, *Andreas Gursky*, exhibition catalogue, Museum of Modern Art (New York: Abrams, 2001).

20. Lev Manovich, *The Language of New Media* (Cambridge, MA: MIT Press, 2002); and William J. Mitchell, *The Reconfigured Eye: Visual Truth in the Post-photographic Era* (Cambridge MA: MIT Press, 1992).
21. "Chromogenic color prints, which are the most common type of color prints, contain no dyes prior to processing. The image dyes are synthesized in the thin gelatin emulsion layers by a process called *chromogenic development*. Exposed light-sensitive silver halide (silver chloride, silver bromide, or silver iodide) is developed in a color developing agent (usually a phenyl-enediamine) which produces metallic image silver and oxidized developing agent. The oxidized developing agent reacts with organic molecules known as color couplers (which are normally put into the emulsion layers during manufacture, or, as in the case of the Kodachrome Process, the couplers are dissolved in the color developers) to produce cyan (usually a indoaniline dye), magenta, and yellow (usually azomethine dyes). The metallic silver produced in the course of development is chemically removed by the end of processing; the color image consists only of the three organic dyes. For a detailed discussion of chromogenic development, see Grant Haist, *Modern Photographic Processing*, vol. 2 (New York: John Wiley and Sons, 1979)." From Henry Wilhelm, "Monitoring the Fading and Staining of Color Photographic Prints," *Journal of the American Institute of Conservation Online* 21, no. 1 (1981): 49, http://aic.stanford.edu/jaic/articles/jaic21-01-003_appx.htm (accessed March 1, 2005). [Ed.]
22. J. L. Austin, *How to Do Things with Words* (Oxford: Oxford University Press, 1962).
23. Ludwig Wittgenstein, *Philosophical Investigations*, trans. G. E. M. Anscombe (Oxford: Blackwell, 1953), §66.
24. Krauss, "A Note on Photography and the Simulacral," 175.

4

ASSESSMENTS

Michael Leja
Index Redux

As I read the discussion transcript, it reveals much more at stake in the concept of the index than a fun topic to argue about. The vehemence of the effort to sweep the index off the table seems to me to call for explanation as much as does the idea's former fashionability. Certainly it has been used in sloppy, formulaic, and inappropriate ways in writing on photography—and on other kinds of art, for that matter, but it is hardly unique in that respect. The refusal by several discussants to dispense with the term suggests that there may well be a baby in the bathwater. Peirce's semiotic categories are notoriously unstable and obscure, but they have proven remarkably useful and persistent, nonetheless.

Why should not photons count as an explanation for the physical relation of a photograph to things in the world? Not that I am especially qualified to talk about photons, but I am perplexed by the disdain for that level of explanation. Certainly the relation between a thing in the world and the lines and tones that correspond to it on a photographic negative or print is never simple, mechanical, or unambiguous, but the physics of light plays an essential part. In fact, there is another good reason to talk about photons in this context: the photon is simultaneously wave and particle as the photograph is index and icon. This analogy is imprecise, however, since the photograph has yet a third semiotic character—as symbol. That the symbolic dimension of photography's semiotic operations did not figure at all in the discussion, despite James Elkins's observation early on that Peirce understood all signs to combine attributes of index, icon, and symbol, is surprising. The degree to which the interpretation of indexes and icons is permeated by symbolic operations should not be underestimated.

I find enduring utility in interpreting photographs, like all signs, as mixtures of Peirce's three semiotic components, but ones in which the relative proportion of indexicality is higher

than usual. To approach photographs in this way makes their similarity to weathercocks much more than a charming eccentricity of Peirce's theory. It encourages comparison with other kinds of visual signs in which a special relation to things in the world is claimed through indexical signification—death masks, reliquaries, or gestural abstract paintings, for example. Photography theory would benefit from treating photography as less sui generis and more deeply implicated in the semiotics of larger visual traditions.

And yes, by all means, let us historicize the terms in which photography is understood across its history. Although the concept of the index rose to prominence in the 1970s as part of a rationale for minimal and process art, into which photography became absorbed, the association of photography with indexicality began much earlier. I refer not only to Peirce's abiding meditation through the later nineteenth and early twentieth centuries on photography's place in his arcane and evolving semiotic theory. Although he vacillated on the question of whether photographs were primarily icons or indexes, he never doubted that they necessarily had an indexical element. But perhaps the process of historicizing the relation of photography and indexicality should begin even earlier. A Southworth and Hawes daguerreotype of a plaster mask of Nancy Southworth Hawes, dating from 1845–1850, correlates the life cast and the photograph. Similarly, paper prints to which are attached clippings of hair and fabric and other samples of the people and things represented in them mobilize an inchoate notion of indexicality. "Index" names a particular kind of semiotic claim: to immediate contiguity with the world. Whether we call this a theory or a classificatory principle, it has a history much longer than photography's and a relevance to photography that still seems indispensable.

Nancy Shawcross

Seeing Is Believing: An Afterword on Photography

In 1911 the Curtis Publishing Company, which issued the magazines *Saturday Evening Post, Ladies' Home Journal,* and *Country Gentleman,* launched the first marketing research operation in the United States. The company's archives contain surveys and research reports for consumer products as well as studies on what advertisements work best in what markets. Included within these files are the advertising department's own visuals used to convey to clients the maximum profitability in placing an ad in a Curtis-owned periodical. Consider these scrapbooks as the PowerPoint presentations of their day. Underscored in the investigations conducted by the Division of Commercial Research is the force of images to grab a potential customer's attention, to draw him into considering the product being pitched: "One fine photograph… is… more effective than spoken words." The "SAY IT WITH PICTURES" strategy from 1935 seeks, of course, to retain the accounts of companies thinking about spending their advertising dollars on radio-based campaigns or to lure away companies already doing so. The Curtis advertising department, however, was sincere in wanting to maximize the effectiveness of any advertisement it solicited and printed, and it conducted objective research based on the standards of the time. One conclusion—as articulated by John Oliver LaGorce, editor of *National Geographic* magazine and president of the International Cartographic Association—was that "a man or woman forgets what they read or hear but not what they see."

As part of the community of images, photography carries with it such truisms (be they mythological or scientifically demonstrated). Some—like Roland Barthes in *Camera Lucida*—suggest that the photographic medium differentiates itself still further from other visual media through its intrinsic ability to engender belief *because of* the physical properties of its technology and processes. Photography possesses, in other words, a heightened capac-

ity to testify, to document, and to offer the possibility that one can believe in the existence (at least the onetime existence) of what one sees in a photograph. We are all too sophisticated to belabor the limitations and corruptions of this notion of photography's aura vis-à-vis reality, but it is also misguided to eschew the cultural legacy of the sensibility. We find ourselves, however, in the midst of a profound technological development that will reduce or eliminate photography's privileged status—as it relates to reality (the physical world)—in the community of images. Much of the West's cultural response to the medium of photography derives from the technical properties of analog photography. It is too early in the history of digital photography for the general public to embrace and evaluate fully the implications of a photographic world generated exclusively or predominantly by digital methods. The documentary quality that has accompanied analog photography since its inception will dissipate over time, as digitally born images—even those initiated with a camera and laser-printed on Chromogenic photo paper—replace images created via analog photographic techniques. To paraphrase P.T. Barnum: a digital photograph can fool some of the people all of the time, and all of the people some of the time, but it cannot fool all of the people all of the time. "Fool" means that the viewer either will not realize that the print is digitally crafted or, if told, will not deem the fact significant. Once digital images pervade our visual landscape and the recognition of their mutability invades our critical analysis of what we see, the association with reality will no longer adhere.

Barthes sought the ontology of the photograph in the notion that the medium chemically *imprints* a temporally specific visual frame. His note on photography does not address the traditional concerns and viewpoints of either the photographer or the art historian. It is awkward, therefore, to apply his notions of punctum and *studium* to a theory of art. They are neologisms he adopts in his idiosyncratic exploration of *his* reaction to and critical evaluation of the medium. Failure to acknowledge Barthes's conclu-

sion that the photographic punctum is time truncates his analysis, thereby misrepresenting it. Yet the terms are seductive and may, in fact, help model the increasing use of visual material (often photographic) in other media. W. G. Sebald's inclusion of images in his fictive narratives challenges his consumers and complicates expectations. Without question some of the photographs in Sebald's novels feed our *studium*, while their placement within the text punctuates the writing in a way that evokes the notion of punctum—at least etymologically. A Sebaldian punctum, however, resides not in the photograph but in the physical world—in the paths of the narrator's travels. This punctum is an object, a person's story, or any trace that remains of the past, reorienting time from a linear scheme to "various spaces interlocking according to the rules of a higher form of stereometry, between which the living and the dead can move back and forth as they like."[1]

Although marketing research may seem an inappropriate or at least peculiar context in which to discuss the medium of photography, it echoes Barthes's early work on image analysis, particularly several pieces compiled in *Mythologies*. Ultimately for Barthes, one good look at a photograph is far more effective than hours of oratory in conveying the existence of the past; yet throughout his career he remains suspicious of how context manipulates our response to visuals, particularly the photomechanical (still or moving). Ironically, Barthes considers "trick" photography too obvious to warrant much critical attention, because by its very nature, (analog) photography does not lie. Does that contention remain viable with digital photography? If so, how? And what, if anything, constitutes "trick" photography in a digital environment? Perhaps these queries can build a path out of the maze in which the ontology of the photograph stands embedded.

Anne Collins Goodyear

The Portrait, the Photograph, and the Index

Reflecting on the roundtable in which she participated, Margaret Iversen noted the animated response stimulated by the question of indexicality.[2] The question of photography's relationship to the notion of the index has long roots. Yet, as James Elkins and his fellow discussants acknowledge, the attribute of indexicality is hardly neutral, carrying with it considerable art historical and philosophical freight.[3]

The goal of this essay is to reframe the question, sidestep it perhaps, so as to see it from another perspective, and then to return to the question of the relationship of the index to the photograph. What I would like to suggest is that the photograph's claim to represent indexicality does not inhere in the medium, but rather represents a historically specific response to a larger social, cultural, and even political desire for a method of recording "truth."[4] To make this argument, I turn to a narrow, yet powerful class of images: the western portrait.

The origin myths of western portraiture are intimately bound up with those of photography. Portraiture, Pliny tells us, was "invented" when Dibutade, daughter of the Corinthian potter Boutades, sought to record the likeness of the lover compelled to leave her. The maiden traced his shadow onto a wall, creating an "exact" transcription of his presence, based on the image cast by his shadow. Her father then cut out the form and filled it in with clay, which he fired, to produce a copy of the young man's form.[5] Intimately connected with the "birth" of self-portraiture, around a.d. 1500, is the mirror, with its inevitable link to the story of Narcissus, who wasted away by the side of a pond transfixed by the reflection of his own features.[6] "This I fashioned after myself out of a mirror in the year 1484 when I was still a child," writes Albrecht Dürer of his first self-portrait, attesting to its indexical origins.[7] Each of these accounts reveals what might be described as a magical urge to capture and preserve permanently what we

know to be a transient existence. During the eighteenth and nineteenth centuries, the vogue for including locks of hair with portrait miniatures bespoke a desire to capture the "essence" of a fleeting life.[8] The popularity during the same period of silhouettes and profile drawings, used to great effect by Lavater to develop his physiognomic theories, suggests the social and scientific currency of the indexically generated portrait.[9]

The legend of the Corinthian Maid and Narcissus have both been invoked in connection with the invention of photography, with multiple renditions of the Corinthian Maid appearing in British painting of the 1770s and 1780s, and with Baudelaire using the myth of Narcissus to condemn photography's mirror-like reflections of the sitter.[10] Photography's capacity "to cause... natural images to imprint themselves durably and remain fixed upon the paper," as William Henry Fox Talbot described his aspirations in devising a system of photography, finds a counterpart in the history of portraiture.[11] Portraiture thus enables us to trace a desire for indexicality that, as I will argue, both precedes and supersedes that of the photograph, while reflecting a common impulse to capture a "real" trace of human presence.

With its invention, photography provided a new system for mechanically, and seemingly impartially, "registering" its subject.[12] Though it must be noted that unlike other "mechanical" modes of portrait making, such as the physiognotrace of Saint-Mémin, used to great effect during the opening decades of the nineteenth century, the photograph did not actually index sitters, but rather the light reflected from their figures through a lens and onto a chemically sensitized surface.[13] Yet the powerful causal relationship between the presence of a sitter and the image registered on the film or plate would continue to be evident through the late twentieth century, making the camera an important device for recording the human portrait. The magical sway of the camera's apparently "uncoded" message asserts itself nowhere more powerfully than in Roland Barthes's *Camera Lucida*, which opens

with the author's observation about a photograph of Napoleon's youngest brother, Jérôme Bonaparte: "I am looking at the eyes that looked at the emperor."[14] Yet, if the photograph's seemingly transhistorical realism can be located in its lack of idiosyncratic "linear syntax," the system by which the camera delivers the light to the plate can in no way be considered "natural," representing, as it does, the confluence of a long tradition of western recourse to the lens as a tool of draftsmanship.[15]

The problem of the photographic "index" in the digital era surfaces in this discussion, but deserves further exploration. Referring to the semiotic theory of Umberto Eco, we are reminded that meaning resides in the sign-function born of the meeting of two systems: content and expression.[16] With the digitization of the photograph, the indexical "content" of the work is no longer pinned to a particular syntax. Nor can the iconic appearance of the work be assumed to reflect an indexical cause based in the natural world. Paraphrasing Roland Barthes's influential evaluation of the photograph as an image in which the "referent adheres," William J. Mitchell points out that "the referent has become unstuck."[17] Given the virtually indistinguishable appearance of digital and conventional photographs, the indexical qualities traditionally associated with photography for over a century and a half fall away.

Yet, returning to portraiture, we note the index persists, surviving the demise of its invocation in the realm of photography. I turn, in this regard, to the work of Marc Quinn, one of several "young British artists" who has engaged himself with the problem of representing self and other. While revealing what might be described as a broadly photographic sensibility, Quinn's work is in no way trapped by the limits of this metaphor. Quinn has reported the fascination with Dutch art he developed as a graduate student in art history: "I was particularly struck by the idea of fixing natural images and representations of different periods or seasons on the canvas. It was like seeing the depiction of moments

from different eras, frozen together. This led to my interest in time, which is not a real matrix, but rather a mental one."[18] Literalizing the notion of "frozen time," frequently associated with photographic realism, Quinn has produced multiple works in a variety of media invoking frozen or suspended substances. Perhaps best-known is Quinn's *Self* (1991). Consisting of a sculptural representation of the artist's head, the work does not simply rely upon iconic appearance to make a connection with its maker. Instead, the medium itself, alternately reported as consisting of eight or nine pints of the artist's blood, approximately the same amount in the human body, leaves the artist's mark upon the piece, registering not only his presence but also his very genetic makeup. The indexical power of the object inheres in the medium used to produce it, just as the materiality of the photograph once implied a causal relationship between the art object and the individual pictured. Quinn puts it succinctly: "The material is life."[19] He plans to recreate *Self* every five years until his death.

Quinn has compared his work to photography, noting that "My work is... like a series of snapshots of particular moments in... life."[20] This observation is at the crux of Quinn's *A Genomic Portrait: Sir John Sulston* (2001), representing a leading British geneticist who helped to decode the human genome, commissioned by the National Portrait Gallery in London. Resembling a large laboratory slide, the work consists of a thick steel frame, enclosing glass through which one perceives small dots of Sir John Sulston's very genes, cultured in bacteria, suspended in agar jelly. The highly polished frame reflects the presence of the viewer, much as a mirror, or Narcissus's pond, does, providing indexical evidence of the observing other, and firmly linking the object to a long tradition of portraiture.[21] Despite the abstraction of the work, Quinn describes it as "the most realist portrait in the [English] National Portrait Gallery since it carries the actual instructions that led to the creation of John. It is a portrait of his parents,

and every ancestor he ever had back to the beginning of Life in the universe."[22]

The circumstances of the work's acceptance into the collection of this traditional institution provide a golden opportunity to compare the indexical pull of the new medium to that of photography. As requested by the National Portrait Gallery, which requires "recognizable likenesses," Quinn created a pair of photographs—one picturing himself, and the other picturing the scientist—at roughly the same scale as the (framed) genetic portrait. Yet, if these pictures, conventional by today's standards, provide a measure of appearance, akin to a mug shot, they also demonstrate a shift in the status of the photographic likeness from indexical marker to mere illustration, a handmaiden, or prop, to that which supersedes it.[23] Today it is the genetic portrait of Sir John Sulston that hangs independently in the galleries of the museum, while the photographs remain in storage.

"You can't reproduce me. There's just no way you can do it. You can make a photograph of me, but you can't reproduce me," Joel Snyder argues in the course of this roundtable. While Snyder's claim remains accurate, he succinctly articulates the central claim, and promise, of the indexical medium. As though anticipating Snyder's hesitation, Quinn has claimed about his DNA self-portrait, *Self-conscious,* "You could clone me from what's in this test tube."[24] I have attempted to demonstrate, by recourse to the trope of the portrait, that indexicality is not inherent to the medium of photography *per se.* Instead, the index resides in our intuitive understanding, as viewers, of the causal relationship between a visual sign and the subject represented. As I have argued, photography, due to the complicating introduction of digital media, no longer connotes an indexical or physical relationship between image and medium. The authority of the index, it seems, is instead a historical function, perhaps transhistoric in its reach, whose lure extends beyond the photograph, arguably creating the desire that prefigured its existence, and a residue that endures beyond it.

Peggy Ann Kusnerz
Beyond Art

The Art Seminar transcript records a lively and engaging conversation. The distinguished group of scholars considered thirty years of efforts to "conceptualize photography" before turning to the question of why it is so difficult to characterize the medium. At the end, this reader concluded the discussion was, with some notable exceptions, a faith-based and not a reality-based recitation (to borrow terminology used by the 43rd president of the United States). The faith in this case is the discipline of art history, and the dialogue recorded is framed in the language of that field's catechism. Therein lies the problem.

The models, rubrics, and methodologies of traditional art history, applied exclusively, will not illuminate the essential nature of photography. Following decades of debate over the question "Is Photography Art?" there is a certain irony in needing to note that photography is *more than* art. A new, original model of conceptualization is required for this medium that functions in many different arenas. In order to develop and articulate this model, voices from the studio, practicing photographers, and thoughtful thinkers in the fields of history, anthropology, business, journalism, sociology, literature, and the sciences, among others, need to be brought into the discussion.

In addition to expanding the circle of discussants, this reader would ask that any conversation about photography include remarks on photographs, *specific* photographs. The "Photography Theory" deliberations would have been enriched if panel members had been given a common set of photographs to refer to in their exchanges. The speakers' comments about the work of Andreas Gursky, although general, were useful, but the hypothetical examples of photography offered earlier in the meeting, although vivid and often humorous, failed to focus and clarify the discussion.

Consider how an examination of the following three photographs might have shaped the flow of the conversation. All three

images have appeared on recent covers of the journal *History of Photography* and were used to illustrate essays in the publication. The first photograph, *Portrait composite des frères Reclus A,* was made by Nadar (Félix Tournachon) in 1885. This albumen print is a blend of images; five different portraits of five different men were superimposed to form a new portrait. Catherine De Lorenzo sees this work as Nadar's attempt to find a photographic metonym for the anarchist theories of Élisée Reclus.[25] But how would one talk about notions of "indexicality," "trace," and "impression" in regard to this image?

The second photograph was made by an unknown photographer working for the City of New York sometime between 1939 and 1941. The focal point of this 35mm snapshot is a sign attached to a tripod, which is situated in the middle of a snow-covered street. The arm of a pipe-smoking man reaches out to steady the sign. This black and white print, drawn from a vast municipal archive of over 700,000 similar images, is referred to by Gabrielle Esperdy in her paper on the WPA Real Property Survey of New York City.[26] Theoretically, the photograph offers intriguing possibilities. Is the photograph an example of "iconic pointing"? What is the "address" of such a photograph? Where would Peirce locate this photograph in his schema?

The final photograph shows a well-dressed man, a Nikita Khrushchev look-alike, visiting *The Family of Man* exhibition in Munich. This visitor looks at a life-sized photograph of a family, who look back from the wall into the eyes of the visitor. The multiple layers of looking in this image are disorientating. Eric Sandeen uses the photograph in a study of *The Family of Man* exhibition and U.S. foreign policy, but a theorist might engage the same image as a puzzle of "temporality."[27] All three of these photographs are in some way mysterious and ambiguous pictures. All three would provide an excellent starting point for a discussion of the punctum.

The roundtable raised more questions than it answered, and further discussion is needed in order to make firm any

conceptualization of photography. The Art Seminar will serve as a benchmark in that effort.

Alan Cohen
Photography's Histories

Jim Elkins asked me, as a photographer and photo historian, to respond to the conference discussion. My immediate "yes" opened, for me, a long, complicated reevaluation of just how to respond to the analytical and descriptive narratives about photography. Most histories of photography are built upon a chronological, linearly inevitable, unresonant and unbudgeable literature balanced between the apocryphal and the real. From the mid-twentieth century forward, these social, political, and intellectual histories evolved without linking photography to its true fulcrum, its technological foundation.

The painterly, literary, and biographical languages that have plumb-lined photography since its invention have made the medium difficult to define and, at times, obscured its true technical base. From this photographer's point of view, the conference's attempts to more precisely assay what a camera records are most welcome but, at this moment, problematic. The distinguished conference participants, in the text that surrounds these observations, wrestled with theory and meaning posited in analog photographs. The central factor here is that the primacy of analog photography—the photography of film and darkrooms—has passed. Every new direction within the medium is digital and therefore every discussion of the medium must confront the fragile authenticity of this radical new contingent photography. So, while the conference is timely, it reminds me of a faux, playful academic talk I heard years ago. The professorial speaker was intoning about an imaginary author who, we were told, had produced a body of work that could be divided into three parts but that, unfortunately, the writer had died in the middle of the second. Photography has also had, as I measure it, three primary periods since its invention in 1839,

and is therefore really three media. I feel that the conference is annexing one medium to describe the photographic practices and conventions of the other two.

If the photograph, as a chemical-optical product, is best anchored to and referenced by its technology, then logically we should anticipate that the most profound transformations and practices—material and conceptual—are an outgrowth of that technology. In this way, the central properties of photographic images in their differing incarnations can be considered apart from each other and from those of painting, drawing, and printmaking.

As a tool of interrogating nature, photography, across its various histories, offers a means to peer into arenas previously barred to our own senses. Photography has made visible and coherent, in its own language, the dynamic visual forces within common acts and those resident within the science of an increasingly unknowable and unverifiable universe.

Photography, over its lifetime, has appropriated and certainly borrowed painting's legacy as the means of insight into history and memory. At the time of its invention, film's extended exposure times of twenty minutes or more duration made it—like painting—an unimpulsive form of memorialization, poetic yet truthful. That first era lasted perhaps forty-five years, from 1839 to the early 1880s. The instructive work of this period was made by pointing the camera at enduring or celebrated objects. The resulting film-based topographical studies connected, justified, compared, and created unfiltered histories of place and persona.

In its second incarnation, lasting nearly one hundred years, from Étienne-Jules Marey's mid-1880s imagery to Harold Edgerton's mid-1980s imagery, photography remade the visions of the corporeal—from body gestures to expansions of the atmosphere by thermonuclear detonation—into time via a shutter that allowed film exposures to be compressed into the range of a millionth of a second. These isolated fractional observations prefigured larger unifying whole truths that overcame safe autoptical visual norms.

The revolutionary time-centered work of that era rescued knowledge from being the captive of a sight-anchored experience with the clock or with light. Photography offered a visual mapping of time that was logical and strangely unreal—a vision that concurrently defined scientific and artistic truth.

The digital era, the current third photography, ongoing since the middle 1980s, surrenders and substitutes unconfuted factualness for easy fabrication. Given digital photography's nearly undetectable ability to gerrymander truth, words are needed to outline and anchor what might be untrue to the eye. The intangible digital reality refutes, even denies, our historical, scientific understanding of photography. Photographers have entered new territory and have become optical painters with light. They are the heirs to a hundred-and-sixty-seven-year-old tradition of creating eventful and effortful evidence and a revolutionary virtual, interactive effortless art. Photography is, nonetheless, still being misinterpreted as a filmic, documentary, world-based, fixed vision tethered to fact. The linguistic and cultural theories that have channeled the narrative of painting (and partitioned it from the second photographic medium), now equally apply, at long last and with equal rigor, to digital photographic practice. Is it appropriate to ask if the collective efforts to establish hegemonic definitions about photography are late utopian and fetishistic?

Martin Lefebvre
The Art of Pointing: On Peirce, Indexicality, and Photographic Images

The Art Seminar on photography conducted by James Elkins begins with what has been a central issue in discussions and debates over photographic representation since the late 1970s and early 1980s: its so-called indexical aspect.[28] Setting up the discussion, Elkins is correct to point out, "It could be argued that the use of the index in isolation from the symbol and icon is a misuse of Peirce's theory, since he was adamant that *every* sign includes elements of all three. Hence calling a photograph indexical, or

saying its most important property is indexicality, is misreading Peirce." But no sooner is the point made than the discussion proceeds to neglect the methodological and theoretical consequences that it entails. As a result, a certain confusion ensues in the discussion, with the notion of indexicality being pulled in several directions at once. Not surprisingly, the debate illustrates the seemingly irresolvable issues one may be led to when "misreading" Peirce. From the start, then, the problem is that the basic idea behind the index (i.e., that a sign may stand for its object by virtue of an existential connection with it) has been wrested out from the context of Peirce's semiotic and pragmatist philosophy.

In what follows, I will limit myself to a consideration of the methodological and theoretical consequences alluded to above and hopefully dispel some important and profound misunderstandings that still plague the use of Peirce's semiotic conceptions—in this case, indexicality—in art theory and cultural criticism.

Before I begin, a warning is in order: the index is not in any way a panacea to the myriad problems raised by the photographic image—including several aesthetic problems. This is in fact one of the most important lessons to be had in reading the roundtable discussion. To restrict what we say about a photograph to indexicality is to say very little (which does not mean, however, that such a claim is irrelevant), for it reduces the image's contribution to knowledge and limits any potential semiotic growth. It is important to keep in mind that Peirce's semiotic is chiefly a pragmatic theory of knowledge through signs. Signs are merely how we come to know things about the world by representing it. As we shall see, every object in the world relates existentially to an indeterminate number of other objects, either directly or indirectly. This amounts to saying that every worldly object possesses an indeterminate indexical potential. Restricting photographs to their indexical status is just as unproductive as restricting verbal language to the status of symbol without considering the various semiotic functions of words in, say, a proposition. Images and

language, like most other semiotic systems, are composed of signs that possess iconic, indexical, and symbolic functions.

These preliminary remarks, however, are not meant to disqualify the indexical character of photography, its ability to stand for something by virtue of an existential connection to it. Far from it. But neither photography nor Peirce's semiotic are well served by *confining* photographs solely to indexicality without any other consideration than the medium's ability to "record." Of course, in discussing the photographic index, most have in mind the relation between the image and what stood in front of the camera when the picture was struck—which, by the way, is only one of an indeterminate amount of existential connections the image has to the world. Yet indexicality only becomes important when a sign (a photograph) is interpreted in such a way that its epistemic value is understood to rely chiefly on its existential connection to what it stands for.

1. A Brief Look at Semiotic Taxonomy

As Elkins notes, the well-known trichotomy of icon, index, and symbol belongs to attempts made by Peirce to classify signs. There are several such taxonomic schemes in Peirce's work, but the best-known and most malleable is the one laid out in a "Syllabus" he produced in conjunction with a series of lectures delivered in 1903 at the Lowell Institute.[29] In it, Peirce divides up the various classes of signs according to three sets of trichotomies: qualisign, sinsign, legisign; icon, index, symbol; and rheme, dicent, argument. Each trichotomy considers the sign from a specific angle. We can think of the three trichotomies as answering three separate questions:

> What is the signifying character of a sign, or, to put it differently, what makes a sign into a sign?
> How does the sign represent its object, that is, on what basis does it come to stand for its object?

What does the sign reveal of its object, or, to put it differently, how does the sign conceive or interpret its object?

Each question pertains to what Peirce considered to be the three unalienable components of a sign: the Representamen, the Object, and the Interpretant. In answering the first question, Peirce recognized that the signifying character of a sign may be a quality it possesses regardless of any manifestation of it (qualisign), that it may be the fact of its manifestation *hic et nunc* (sinsign), or that it may be due to a habit or a law such as a convention (legisign). In answering the second question, Peirce saw that a sign may stand for its object by virtue of a likeness to it (icon), by virtue of an existential connection to it (index), or by virtue of a habit or a law (symbol). Finally, a sign may be interpreted as a sign of possibility (rheme), a sign of fact (dicent), or a sign of an object (itself a sign) having the power to determine a specific interpretant by virtue of a habit or a law (argument).

According to Peirce, these three sets of trichotomies yield ten *classes of signs*. For each class of signs, the above three questions must be answered (which is why, as we shall see, each class is formed as a *triadic compound*). This being said, it is important to consider, albeit briefly, why only ten classes can be derived from the three sets of trichotomies presented above.

The answer lies in Peirce's theory of the Categories.[30] Designed as a corrective to Aristotle's and Kant's long lists of Categories, Peirce's approach sets out to show that whatever is present to the mind can only be so as a representation. However, by unpacking the components of such representation he arrived at three universal phenomenological conceptions, or Categories: the conception of a First, or quality, whereby something *may be represented as* (for example, reference to a quality can be understood as a pure possibility regardless of anything else, including the "thing" where the quality may manifest itself); the conception of a Second, whereby *something* can be represented (reference to a correlate, to

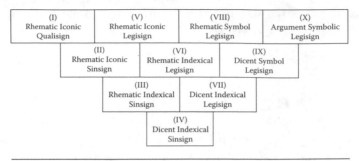

Figure 1 Peirce's 1903 Taxonomy of Ten Sign Classes

some-thing); and the conception of a Third, whereby a Second (an existent, *some-thing*) and a First (a quality as pure possibility) are brought together in representation (reference to a *sign*). Accordingly, the conception of a Third logically requires attending to the conceptions of a Second and a First. Similarly, the conception of a Second logically requires attending to the conception of a First. However—and even though all that is present to the mind can only be so by way of Thirds (representations or signs)—it is possible to attend to a Second by making abstraction of the Third (for example, when our bodies or minds blindly react to some stimulus or to some event without any consideration for it as the manifestation of a general cause), and to attend to a First by making abstraction of a Second and a Third (for example, when attending to a specific quality of feeling irrespective of the actuality of experience through which the quality manifests itself).

Now, if we return to the brief description given above of three sets of trichotomies, we see that they also divide up according to Firsts, Seconds, and Thirds—that is, quality, existence, and law or habit. Thus, qualisigns, icons, and rhemes are concerned with quality and possibility; sinsign, indices, and dicents are concerned with existence; and legisigns, symbols, and arguments are concerned with habit or law. Moreover, it must be understood that the three components of the sign, the Representamen, the Object, and the Interpretant, also correspond respectively to the First, Second,

and Third dimensions of a sign. Consequently, if the triadic sign compounds made from these three trichotomies conform to the architectonic principle of the Categories, it must yield ten classes of signs. Peirce used the schema shown in Figure 1.

It follows, then, that a qualisign cannot also be an index, a symbol, or an argument; and that an icon cannot be an argument, although it can be a legisign (class V). Accordingly, only a legisign can be a symbol and an argument (class X).

Now for Peirce, everything that can be present to some mind may be so on the basis of the three phenomenological categories of Firstness, Secondness, and Thirdness, and must therefore possess *monadic, dyadic,* and *triadic* properties. Every phenomenon is thus capable of being represented and of representing on the ground of any one of those properties. In other words, a phenomenon may be represented or may represent iconically (through some likeness to a quality that it possesses), indexically (by way of a real connection to some thing), or symbolically (by being so interpreted). Moreover, these three ways of representing must be present for a genuine sign to really represent its object: the icon assures that the sign connotes its object, the index assures that the sign denote its object, and the symbol assures that the sign be interpreted as representing its object by determining a more elaborate sign—the Interpretant—to also stand for it.

2. The Index

Indexicality corresponds to the semiotic function by which signs indicate their object—what they are about or stand for. Without indices, our representations would only stand for objects that are utterly vague and indistinct or general and without any anchor in the world.[31] Such representations would not denote and would be senseless. For instance, within a proposition, the index is that whose function it is to bring to our attention the *denotatum*. This can be achieved by way of a demonstrative adjective or pronoun such as "this" or "that," as for instance when I say, "This table is

solid." However, the context in which the proposition is used may also serve the purpose of indexing the statement, as can a wave of the hand pointing toward the table in question. For example, in a room where there is only one table, the statement "the table is solid" is indexed—connected to the world—by way of the communicational context. There is no need to use a linguistic index, such as a demonstrative, because the speakers will understand from the start that the statement concerns the table they have before them. Of course, propositions are symbols, which is to say that their "being" is to be represented (either through convention or by force of habit). A symbol that would not be interpreted, explains Peirce, would be nothing at all (semiotically speaking). In themselves, symbols only refer to general objects. Thus, out of context or in the context of a textbook on English grammar, statements such as "the table is solid" or "this table is solid" cannot refer to anything in particular. They can only refer to the class of possible tables that possess the quality of "solidity." *It is the index that enables the proposition to be meaningful and gives it the power to refer to the world.* Within a normal situation of communication, the proposition "this table is solid" can therefore lead the listener to eventually judge of the truth or falsity of the statement.

Now suppose a different context. Imagine that someone arrives, holding a heavy parcel in his hands, in a room where there is a table. The person asks where he can lay down the parcel. Suppose we answer, "The table is solid." What was a proposition a minute ago now becomes an argument, that is, a more elaborate and more complete sign, according to which it is possible, in a general manner, to rest heavy objects on solid surfaces and, by way of consequence, on the surface at hand (for instance, the table). Applied to this particular situation, the argument goes something like this: "the table is solid, therefore you can lay the parcel on it." The dynamic Interpretant will be the deliveryman's gesture of putting the parcel on the table. However, in order to unfold, this simple event requires the service of an index. Here, the context

enables the indexing of the statement, helping the deliveryman to know which table is meant. The index, in short, is what enables the inferential move that leads from rule to result. Indexicality, in this regard, is an essential requirement of representation. Now, the indexical function supposes that an existential relation obtains between sign and object. Whatever occupies the indexical function within semiosis must be really or existentially affected by the object of the representation, that is, by whatever the sign is about. In the case of the above example, the existence of the table is that which enables the context or the demonstrative adjective to apply to it the proposition. In the case where a demonstrative adjective is used within a communicational situation such as the one at hand (for instance, if I say to the deliveryman, "*This* table is solid"), it is clear that its presence in the statement is quite literally *caused* by that of the table in the real-life situation, without which the adjective would be unintelligible.

Within language, then, there are signs that, in the context of their use, have an indexical function: proper names, demonstrative adjectives and pronouns, relative pronouns, indefinite pronouns, adverbs of location and time, and prepositions, among others. Such signs are important because they work to relate the abstractions of language with worldly particulars and enable us to act—as we have seen with the example of the deliveryman. Such signs, however, do not exist solely within language. In fact, anything that is affected by something else may serve to represent, by contiguity, that which affects it. This, for instance, is the case of a weathercock turning in the wind, of a scar indicating a past wound, of fingerprints or footprints at the scene of a crime, or of smoke as a sign of fire. But there is often a great confusion when it comes to exemplifying indices, as can be seen by the roundtable discussion. Any object present to the mind can be so according to Peirce's three phenomenological categories. This is to say that it must possess monadic, dyadic, and triadic properties according to which it may be represented or may itself represent

something. Take, for instance, the wind and a weathercock. The wind possesses, among other things, the dyadic character of affecting certain objects with some regularity. It is therefore possible to represent it on the basis of this character. As for the weathercock, it possesses, among other things, the dyadic character of being affected by the wind, but it can also be seen to possess the triadic property of representing the wind through this effect. This last property, the weathercock's representative character, is general and only particularizes itself when a given wind makes it turn by virtue of the effect it has on it. At that moment the weathercock functions indexically with regard to a particular wind, this does not, of course, prevent it at the same time from acting as an icon, index, or symbol of other objects (for instance, it could be used as a symbol of belonging to a certain social class in a given context).

Images are also likely to represent and be represented by way of their monadic, dyadic, and triadic properties. This is what makes possible their use in limitless semiotic contexts, from the exit sign pointed to by James Elkins during the roundtable discussion to documentary film and art. In the face of such complexity, the commonly held belief according to which paintings (such as Joel Snyder's painting of his mother), drawings, or computer-generated images (CGIs) are icons while the photographic image alone is indexical is largely insufficient. This attitude, moreover, reveals certain more or less implicit presuppositions that it may be useful to bring to light.

In an essay I published a few years ago in *Cinémas,* cowritten with Marc Furstenau, I tried to show that since any worldly thing whatsoever—whether it be a photograph, a film, a painting, or a CGI—is dyadically connected to the world (or reality) in a potentially limitless number of ways, each one of them can form the basis for an indexical function.[32] This implies that it is absurd to pretend that a photograph is *more* indexical that a painting or a CGI, since it is impossible to quantify the number of ways in which something may serve as a sign. For instance, among the different

things to which a photograph is existentially connected, we find not only the object that once stood before the lens, but also the photographer (without whom there would be no photograph), the lens that was used, the choice of film stock, an aesthetic taste or an aesthetic movement, a defective camera mechanism (this is what happens when you show a blurred or underexposed picture to the dealer where you bought your camera as *proof*, or index, that the camera is defective), as well as everything else to which any given photograph may be associated existentially either permanently or merely in passing fashion. If this is the case, then we must contend that a single photograph can serve to indexically represent a great number of things, many of which are neither photographic nor artistic in nature, nor even connected with whatever object stood before the lens at the time the image was struck. Theoretically, then, this implies an indefinite number of signs within any single photograph. The same principle holds for CGIs, paintings, drawings, and, for that matter, everything else that exists in the world! What we need to keep in mind here is that in order to determine the object of a sign, we need first to determine its use, that is to say, the way that we have (or the way semiosis has) of profiting from the semiotic exploitation of its monadic, dyadic, and triadic properties in relation to some purpose. Of course, within certain situations and with regard to certain purposes, some uses of the photograph are more common than others. Among them, we find the use according to which the photograph appears as a sign, a representation, of whatever has left its imprint on it by being photographed. When semioticians assert that the photograph is an index, this is the use to which they are referring as an implicit point of departure—and far too often, we should add, they consider this to be the only possible or valuable use that can be made of the connection tying photography to reality. What is at stake, then, is the ability of the photograph to stand in, for the photographer or the spectator, for what once lay in front of the camera's lens by virtue of the existential link that obtains between them.

That it does so by resembling more or less the object in question is, logically speaking, a whole different issue that concerns iconicity. For Peirce, a genuine index (as opposed to a *pure* index) always possesses an iconic dimension. The index denotes the object, and the icon connotes it—it affords a representation of it by way of some quality that both sign and object share. Margaret Iversen's friend may complain that a photo of her is not a good likeness (she looks "fat" or, better yet, "fatter" in the photograph), but there is no denying that there is *some* likeness to what stood in front of the lens at the moment the shot was taken. Of course, the photograph of the person *is not* the person, but it represents the person along with some of his or her qualities. Indeed, even the tree rings mentioned by Jonathan Friday may be seen to involve an icon for they *diagrammatically* represent the tree's age: the number of rings shares a likeness to the number of years the tree has lived.[33]

The indexical use of the photograph whereby it is said to stand for what once stood in front of the camera is often said to be what distinguishes the photographic image from other, more traditional, forms of images. This is the idea behind Diarmuid Costello's claim that "the work that... the idea of indexicality was originally supposed to do [for art theorists] was to *distinguish* one kind of image making from other kinds." It is also what we are supposed to understand when we are told that CGIs, like paintings or drawings, are not indexical. But is this really the case?

It will be said that paintings or CGIs are not *directly* caused by the existence of the particular or singular objects that they depict, as is generally the case with the traditional photographic image (notwithstanding trick photography or photomontage, of course). Yet are we really to conclude that indexicality is absent in the representation of these objects? In that case, what are we to make of portraits, say that of Joel Snyder's mother or of Napoleon painted by David? What about the movie CGIs of the Roman Coliseum in *Gladiator* (2000) or those of New York partially submerged by the Atlantic before sudden refrigeration under a new ice age in

The Day after Tomorrow (2004)? Are not these images indices in some sense of the *existence* of Joel Snyder's mother, Napoleon, the Roman Coliseum, or the city of New York? Can we not say that the existence of these objects has *caused* their representation? After all, does not David's portrait of Napoleon constitute—among other things, to be sure—one of the innumerable *traces* left by the existence of the emperor of the French? Historians, of course, are not fooled by all of this, as can be seen from the way that they often use paintings from bygone eras as indices with regard to the past, to its customs and objects such as furniture and clothes.

In an attempt to answer the above questions, I have shown elsewhere that it is useful to distinguish between two types of indexical relations: *direct indexical relation* and *indirect indexical relation*.[34] In the first instance, what we find is a *direct* contact between object and sign—as is the case with photography, fingerprints, the dilation of mercury under the effect of heat, and a weathercock turning in the wind. In all of these examples, the object acts as the efficient cause of the sign. The latter is produced dynamically, reactively, and directly with regard to its object. In the second instance, the sign is only indirectly affected by the object. This is the case with a pointing finger indicating something by pointing at it, as well as of demonstrative adjectives and other indexical linguistic signs. It is also the case for paintings such as David's portrait of Napoleon. In all of these cases, the object acts indirectly through some other efficient cause. In the example of David's painting, Napoleon can thus be said to be the sign's *formal cause*. Now if all portraits, whether they be photographic or painted, necessitate the existence of their object as a determining factor in the existence of the sign, then the only difference between them—from the point of view of indexicality—lies in the fact that photography requires a direct contact between the object and the sign, whereas in a painting both are indirectly connected through yet another sign (namely, the painter) which is in direct contact with the painting (*efficient*

causality) and either in direct or indirect contact with the object. As is the case with Napoleon's portrait, CGIs are less directly connected to their object than are traditional photographs. Yet the Roman Coliseum of *Gladiator* or the transatlantic cruise ship of *Titanic,* though they may be produced digitally, still enjoy a real existential connection to the real Coliseum or the real *Titanic* of which they are, in some sense, "portraits."

Napoleon, the Roman Coliseum, *Titanic:* the choice of objects here is not random. All of these "objects" have existed in the history of humanity. They have left many traces and are known by just about everybody—including those who produce and screen these images. We will see shortly the importance that such knowledge holds for Peirce. For the moment, what matters is that the existence of an object has determined its representation even though this determination functions indirectly. Having said this, and contrary to what one might think, indexicality is not only required when the image depicts things that we know have existed. The requirement of indexicality also holds when painting or CGIs show us beings that have never existed properly speaking. Take for instance the drawing of a man such as can be seen on anatomical charts. Even if we were to assume that, unlike the portrait of Napoleon, this is not the image of any particular man, we need to understand that its use as a symbol by medical students and doctors—its use as a general representation of human morphology—first requires by its users the recognition of an existential and causal connection between image and object. In other words, using the chart as a symbol presupposes that the image be determined not only by the *qualities* of human morphology (in which case it is iconic) but also by the *embodiment* of these qualities, by their *existence* in all the particular occurrences of the general type that constitutes *Homo sapiens sapiens* and to which the "imaginary" man of the chart also belongs, at least in some regard. Nothing in the chart proves that the man whose traits are depicted actually exists or has existed, but here the semiotic stake

is no longer the depiction of a particular, singular man such as Napoleon, but rather that of a general type, a human morphology, whose image, by offering to our sight one of its many occurrences and in being affected by it, is also an index of it.

The belief that paintings or CGIs are, by nature, less determined by reality, less indexical than traditional photographic images, thus appears ill-advised (this, of course, is the view taken by Lev Manovich and William Mitchell). According to Peirce, in fact, every embodied sign, from the moment that it stands for something, is by logical necessity indexically connected to reality in one way or another—which is why Peirce also claims that it would be impossible to find pure icons in the world. Through indexical connections, signs can begin to fulfill their epistemic role in assuring the intelligibility of what Peirce calls the "entire Universe of Being."[35] According to Peirce, it is only by way of semiosis, or the action of signs, that we can hope to apprehend reality as truth. And this is why, as a whole, the fictions of literature, of painting, of theater, and of the cinema are meaningful to us. In order to be intelligible, fictional or imaginary universes have to be related to the world. An embodied sign, for instance a work of fiction or a painting, that is totally disconnected from—or better yet, "unconnectable" to—our world is not only an impossibility but also would be beyond intelligibility. In this sense the ultimate object of our representations, including fiction, can only be reality (the one and only). However, this in no way implies that there is no semiotically pertinent difference between photographic images on one hand and painted portraits or CGIs on the other.

In order to get a clear picture of what is at stake in such difference, I propose that we begin by considering a short excerpt from Peirce's 1902 "Minute Logic"—which, as far as his semiotics is concerned, is surely one of his most important unfinished works:

> We say that the portrait of a person we have not seen is *convincing*. So far as, on the ground merely of what I see in it, I am led to

form an idea of the person it represents, it is an Icon. But, in fact, it is not a pure Icon, because I am greatly influenced by knowing that it is an *effect*, through the artist, caused by the original's appearance, and is thus in a genuine Obsistent relation to that original. Besides, I know that portraits have but the slightest resemblance to their originals, except in certain conventional respects, and after a conventional scale of values, etc.[36]

Here, Peirce illustrates how a given painting can equally function as an icon, an index, and a symbol according to how semiosis exploits its monadic, dyadic, and triadic properties. Let us consider this example carefully.

To start, note that Peirce adopts the perspective of the viewer. What is at stake, then, is a spectatorial semiosis wherein the image serves as the sign of something possible, of an existent, or of a type (by way of one of its particulars). Next, note that the portrait is said to depict someone whom the spectator has never seen. I want to underscore the importance of this fact, which might otherwise appear as a mere detail. Supposing I have never met or heard of the person whose painting I now see before me (the portrait of Joel Snyder's mother, for instance), how could I know that it is an index of that person? At this juncture we need to point out that, according to Peirce, such ignorance does not in any way change the hard and blind fact of the indexical nature of the relation between sign and object, for this relation is quite independent from the interpretation of the sign. To put it simply, a given piece of mercury could dilate itself under the effect of heat and a given fire produce smoke even if the relation that unites them were to remain without consequence, that is, even if no one were ever to interpret it—which, as I mentioned before, is not the case for symbols since the only relation they have with their object requires that they be interpreted through convention or habit.[37]

The passage I have quoted highlights the fact that an indexical relation—in this case, that which obtains between the sitter and

his portrait—does not assure its interpretation as a sign of existence, a sign of fact. It is here that knowledge, both supplemental and independent of the sign in question, intervenes. In this example, it is knowledge about the pictorial genre to which the painting belongs. For not only have we learned to identify paintings that belong to the genre of portraiture, but we also know through sundry collateral observations that a portrait is usually defined as the pictorial representation of a person existing or having existed. This knowledge offers a context that participates in the indexation of the image. That is to say that it assures its interpretation, much like in our previous example where the context indexed the statement "the table is solid."[38] Obviously, then, we cannot limit our investigation solely to the sign-object relation and must take into consideration the way the sign is *interpreted* (something only vaguely hinted at in The Art Seminar discussion). Only by considering the sign's interpretation will we see at work the fundamental semiotic difference that pertains between photographic images on one hand and paintings, drawings, and CGIs on the other.

3. Interpreting Images: Rheme, Dicent, and
Collateral Knowledge

In order for a sign to fulfill its indexical function, it must be interpreted. This holds equally for signs whose indexical relation to their object is direct and for those for whom that relation is indirect, even though there is some asymmetry between them. Such asymmetry can easily be explained, however, if we compare the relation that unites smoke with fire, on the one hand, and, on the other hand, that which unites a demonstrative adjective or pronoun with a nominal subject. In both cases, interpreting the sign requires what Peirce calls *collateral knowledge*. Interpreting the pronoun requires knowledge of language and its uses, while interpreting smoke requires some knowledge regarding its physical cause. The sign relations are asymmetrical: in the absence of any such knowledge, the smoke will continue to be affected by

the fire, whereas in the absence of linguistic knowledge of the use of the pronoun, the latter's relation to its object will be nonexistent. This is because the demonstrative is also a general sign, what Peirce calls a legisign.[39] In the first case—that of smoke and fire— the indexical relation will be said to be *genuine* (or direct); while in the second case—the pronoun and the nominal subject—the indexical relation will be said to be *degenerate* (or indirect).

This distinction, we have already seen, is useful in accounting for various types of images and in particular for differentiating photographic images from paintings, drawings, and CGIs. In addition, however, we need to consider that indexical relations will not be interpreted in the same way whether they are genuine or degenerate. Let us take the example of linguistic propositions before we consider the case of images.

The proposition distinguishes itself from other linguistic signs in that it *says* something about its object. This is its use, its interpretation. If someone says to me, "This table is solid" the actions that I am ready to commit should I judge the proposition to be meaningful—for instance, lay a heavy parcel on it—are based on the fact that I interpret the statement as referring to a precise thing in the world that is represented as possessing certain qualities. (Whether or not this turns out to be the case is an altogether different matter.) The proposition, in short, is a sign interpreted as a sign of fact. Consequently, as we have seen, it cannot bypass indexicality. We have also seen that, within the proposition, the index or indexical elements can only precisely refer to their object in context, and not just any context. For instance, on hearing someone state, "This table is solid," in a room where there is no table to be seen, and in the absence of any further contextualization, or in reading the sentence in an English grammar textbook, the statement will cease being a proposition for it cannot be connected to any particular object in any universe of discourse: it lacks sufficient indexicality. Of course, the demonstrative article will continue to play its syntactic role and, supposing that the hearer

or reader possesses collateral knowledge regarding language and tables, the sentence will excite in his imagination some composite image of tables such as one of them *should* be (that is, solid) were it to determine the proposition to represent it. In this sort of situation, however, the statement does not refer to a fact anymore, but rather to the mere *possibility* of a fact. Such a sign, a sign interpreted as the sign of some possible thing, Peirce calls a *rheme*. A proposition, on the other hand—a sign interpreted as the sign of a fact—he calls a *dicent* or *dicisign*. A given sign can pass from being a rheme to *becoming* a dicent, a movement Peirce likens to semiotic *growth*. Using the same example as before, we can say that for anyone who knows the English language and knows what a table is, the sign's growth from rheme to proposition is assured by the context in which it is asserted. The statement "This table is solid," by being indexically connected to some real, existing table, *grows* into a proposition. It can also grow into an argument, which is still a more elaborate sign that is interpreted as the sign of a rule by which premises lead to some conclusion. What is important to consider here is that linguistic signs are unable "in themselves" to represent facts and that any linguistic component that serves to indicate an object is de facto a degenerate index. Thus, in order to become a proposition, in order to be interpreted as a sign of fact (dicent) and no longer as a sign of a mere possibility (rheme), a linguistic statement requires indexing either through context or through a constellation composed of the context as well as linguistic signs with indexical functions (degenerate indices) whose task is to enable denotation with regard to a given universe of discourse. To this must be added previous collateral observations of the object (for instance, one must already have an idea of what a table is).

Let us now see whether this is equally true of images. We begin by claiming that every type of image—photographic, filmic, painterly, and digital—can be interpreted as a sign of fact. Peirce himself recognizes this much when he asserts several

times over throughout the *Collected Papers* that a portrait paint-
ing accompanied by a caption, a title, or simply a proper name
identifying the sitter constitutes a dicent in equal manner to a
proposition or a photograph.[40]

Peirce, then, seems to be comparing painting with photogra-
phy. However, the comparison rests on one crucial difference: of
the two, only the painting requires a caption or a proper name in
order to acquire dicent status. Obviously, the role of the proper
name is to assure that the indexical relation between painting
and object be recognized or identified. Whence the necessity of
distinguishing between the indexical relation and its interpreta-
tion. We all know that a portrait, a landscape, or a still life may
be painted from nature, in which case they are indices (though
indirect or degenerate). Also, even in the absence of indications
such as titles, captions, or proper names, anyone who witnesses
the artist paint from nature, or anyone who sees in the painting a
familiar landscape or recognizes a familiar face (Joel Snyder look-
ing at a portrait of his mother), will be capable of interpreting the
painting's indexical nature and see it as the semiotic equivalent of
a proposition—as a sign of fact. However, such an interpretation
rests on collateral knowledge about both painting (for example,
I know that it is possible to paint from nature) and the object
represented (for example, I recognize the subject depicted as a
member of my family). The role of this knowledge is to index the
painting in such a way as to enable its interpretation as a sign of
fact, all the while overcoming the "natural" degeneracy of picto-
rial indexicality with regard to the depicted object. In the absence
of such semiotic "supplements," it is simply impossible to *interpret*
the painting as the representation of a fact. Of course, as we have
seen, no painted or drawn image of a man or of a landscape can
be without indices. No painting or drawing is a pure icon, and no
embodied sign is exempt of indexicality. It would be impossible to
contemplate an image, to be conscious of it and recognize what is
depicted—whether it be a man, a landscape, or a boat—without

positing a dyadic (and therefore indexical) link between it and everything else that it is not, which is to say the rest of the world where we find real men, real landscapes, and real boats. But this dyadic link is degenerate. And this is why in the absence of any supplemental indexation, such a sign cannot be interpreted as standing for a particular, singular existent, but rather as the sign of a possible object (for example, a possible occurrence of the type "man," "landscape," or "boat").

Conversely, photography does not require a caption or a proper name in order to be interpreted as a factual sign since the knowledge that enables it to be interpreted as such always accompanies it. In other words, because there is, in principle, only one mode of production for photographic images and because this mode implies a direct or genuine existential relation between the object lying in front of the lens and the print, photography—for anyone who knows this mode of production—offers itself as the representation of a fact. This is true even when the spectator does not see the photographer at work with his "model" or possess previous acquaintance with the model in question. The collateral knowledge that makes it possible to interpret the image as a sign of existence is already included since it pertains generally to the medium and belongs to all photographs. This is akin somewhat to what Jean-Marie Schaeffer has called the *arché* of photography, according to which a "photograph functions like an indexical image as long as we know that it is a photograph and know what this fact entails."[41] But this should not be understood to mean that the same photograph cannot also function as an icon or, under certain circumstances that enable it to grow semiotically, acquire the status of an argument.

Understood as a dicent, a photograph says, to use Barthes's expression, "this has been" whether or not we can identify with any precision what "this" refers to—for instance, think of Christian Schad's or Man Ray's photograms, which can make it difficult to

identify the objects having left their shadows on the photographic plate. This, in turn, is not without consequence when it comes to differentiating the photographic dicent from the pictorial dicent. In fact, while the pictorial dicent generally requires the identification of the particular whose image the painting reproduces ("this is a member of my family" or "this is a familiar landscape"), the photographic dicent, because it is founded on a knowledge of the medium itself, may do without the recognition of the photographed subject. This is not to say, however, that a photograph cannot be vague. In fact, the addition of captions, as is often the case in press photography, serves precisely to overcome what—according to the usage we want to make of the photograph—can be seen as a certain vagueness in photographic representation. This addition of supplemental indices (names of people photographed, identification of location and of events, and so on) enables one to further determine the photographic object according to the purpose at hand. This demonstrates that we should avoid seeing the dicent as the *essence* of photography, for the interpretation of a sign is determined both by its semiotic potential as well as by the use that is made of it according to a given epistemic purpose (what it is that we seek to know in using the sign). Admittedly, there can be no doubt that photographic images have the potential "in themselves" of being interpreted as factual signs. They may be distinguished from paintings on that ground since paintings, as we have seen, require additional or supplemental indexation in order to do so. Yet we should not forget that the mere fact of existence, as Peirce tells us in "A New List of Categories," does not constitute a predicate. A good example is given during the roundtable discussion about the blurred photograph of James Elkins as he sneezes. But let us imagine that the image is blurred to the point where it is absolutely impossible to make out what has been photographed. If the photograph's status as index remains in such a case, its interpretation changes, since without any supplemental indexation it becomes impossible to judge its meaningfulness with regard to

the material thing that it depicts (only those people who were in the room when the picture was taken have enough information to see the image as a dicent sign). In this regard, and in this regard alone, the image appears *senseless*, logically speaking. In this context, the photograph will be interpreted as a rheme, that is, as a sign of some existing, though absolutely vague and undifferentiated, thing, as are possibilities that can be neither true nor false. Of course, this example is a limit case if we consider the bulk of photographs that exist, but it instructs us in understanding that *no single photograph can entirely exhaust the determination of its object*. Consequently, if every photograph is a potential dicent sign by virtue of its indexicality, it is also a potential rheme by virtue of the vagueness that haunts it. Therefore, its semiotic identity is relative to the way it is put to use concretely, which is a properly *pragmatic* idea if ever there was one. One may then contemplate comparing the different usages we have of photographs and of images in general. For example, it would appear that in some instances the object of the photographic dicent, given the instantaneous nature of the production of the image, may be seen as more determinate with regard to duration than that of painting, where there could have been several sittings over weeks or months. However, as pictorial media, both photography and painting remain highly indeterminate with regard to temporal representation. In fact, "in themselves," that is without any supplemental indexation or collateral knowledge about the world, neither a photograph nor a painting can say anything about the moment being represented.

4. Conclusion

All embodied signs must possess an indexical dimension by way of which they *indicate* their object, which is why there cannot be in our world of existents any *pure* icons. But this—according to use and epistemic purpose—does not prevent signs profiting from their monadic properties in order to represent iconically. When I look at a photograph in order to know what the Eiffel Tower looks

like, I may easily abstract the fact that the tower really exists and that its photograph represents it as a fact. In such a case, the interpretant of the photograph is an icon: the photograph excites in me the image of the Eiffel Tower, that is, the image of its qualities as they are represented by some of the visual qualities of the photograph. This is why it is important to avoid any definition of photographic images in which the existential connection that obtains between the photograph and the object depicted would constitute, from a semiotic perspective, the essence of the medium. Instead, indexicality must be seen as the foundation of one of many possible ways of using photographs. That we should define things through their use rather than through a metaphysical quest for essence surely constitutes one of the most important legacies of Peirce's pragmatist philosophy.

I have tried to show that semiotic use, whatever it may be in any given situation, is always founded upon a relation between the sign and its object. This relation formulates the condition of possibility for such usage. However, the relation is also subject to variation according to the semiotic exploitation of monadic, dyadic, and triadic properties of phenomena. Photography, like painting, may represent iconically, indexically, or symbolically. Thus, with regard to how they are used, with regard to their interpretants, each one of these types of images is likely to appear under the guise of a rheme, a dicent, or an argument. The difference between them lies in the conditions under which each of the two types of images may grow within the "grid" of Peirce's classification of signs.[42] Photography and painting do not grow semiotically according to the same pattern: they do not require the same semiotic supplements or the same collateral knowledge in order to be interpreted as factual signs. We might be tempted to say that it is easier, more natural, for a photograph to be interpreted as a dicent. But this is just a way of speaking. We could just as easily say that it is more economical, semiotically speaking, for a photograph to serve as a dicent since it requires fewer supplementary

signs or collateral information joining the image to enable its use as a sign of fact. Of course, this situation is likely to change with CGIs, which "mimic" the look of photographic images. But this is not due to the fact that CGIs have lost all contact with reality by renouncing indexicality, as is too often portrayed. Rather, as I have tried to show, it is because indexicality, with regard to CGI imagery, has become indirect and logically degenerate. The effects of this degeneracy on our consumption and use of photographs are yet to be determined, however, and it is legitimate to question whether the knowledge that a given art "photograph" was generated by a computer instead of being shot conventionally changes anything in our reception of it. Of course, it becomes a different matter when we consider news coverage or documentary photography. Moreover, once it becomes impossible to distinguish a photograph from a CGI, the epistemic value we give photography may very well change.

Discussing the various image-signs "in themselves," and the semiotic supplements they require for any one of their interpretations, as I have done here, is nothing less than a methodological fiction elaborated solely for heuristic purposes. For the fact is that we cannot distinguish between a sign and its usage. To be a sign *already* implies being interpreted, *already* implies fulfilling a semiotic function, and *already* implies occupying a place within the vast semiotic chain that comprises the collateral knowledge that enables it to be interpreted in one way or another. Within a Peircean conception of semiosis, there is no *zero degree* of the sign except in methodological fictions and heuristic endeavors. All signs possess some object and are therefore interpreted within a context, according to previous knowledge, and with regard for an epistemic purpose according to which their role is to make known the objects they represent. In this essay, I have taken, as a point of reference, the relation between an image and what it depicts. But it must be recognized that this is but one in an indefinite number of possible semiotic relations as concerns the image and not the

ground for some zero degree of the image-sign; and even under those terms of reference, it is impossible to reify the painting as a rheme and the photograph as a dicent. The difference between a painting and a photograph lies in the way painting can achieve dicent status, and it is only to illustrate this point that I have made use of the expression "in itself" when speaking of painting or photography. There is no minimal unit of signification in Peircean semiotic, only sundry semiotic functions according to which signs can help us achieve some knowledge of the world.

David Green
Indexophobia

What I fear about the causal stuff is that it stops you seeing photographs as pictures.

—Joel Snyder

That the discussion in Cork rarely approached consensus would, I think, come as no surprise to the organizers and participants. In recent decades, the study of photography has been released from the confines of a relatively small and virtually autonomous enclave of photographic historians and taken up in the wider field of academic studies, including—most prominently—the domains of art history, cultural and media studies, and philosophy. That each of these fields, in bringing its own methods and modes of analytical enquiry, construes photography differently is only to be expected. However, if one adds to this the fact that gathered under the rubric of "photography" are a number of quite diverse practices and heterogeneous objects, then the possibility of even agreeing on how one might start to discuss what photography is and how we might come to understand it seems a forlorn exercise.

What might not have been quite as predictable regarding the course of this discussion was the rapidity in which intellectual arguments were laid bare as starkly defined ideological positions. Photographic theory, like any other realm of intellectual inquiry,

is subject to particular affiliations, beliefs, and values that, among other things, impose themselves and delimit what can be admitted into a frame of reference and what cannot. The issue of the indexicality of the photograph was clearly one that proved, in this particular context, the most divisive. But perhaps we can extrapolate from the specifics of this situation something that appears more generally in discussions of photography and the arguments that have surrounded its meaning and value.

It is certainly true, as the discussants note, that any talk of the photograph as indexical postdates the writings of Peirce and probably, to be more precise, that period in the 1970s when Peirce's work became more visible, alongside that of Saussure, in the revival of semiotics. But I do not think that it is too much to claim that the issue of indexicality has never been too far away in any theoretical discussion of photography. (Although clearly for some, the index was seldom far enough away.) Daguerre's description of photography as "the spontaneous reproduction of the images of nature" and Fox Talbot's claim that it was "the process by which natural objects may be made to delineate themselves" are nothing if not appeals to the idea of indexicality. And from these writers to Sontag and Barthes, there is an unbroken lineage of thought that acknowledges the importance, even centrality, of understanding the photograph as an indexical sign, even if the terminology differs. (I should add that I take any attempt to talk of the photograph in terms of "impression" or "trace," as in The Art Seminar, as merely euphemistic). In drawing attention to the fact that the photograph's indexicality has figured large in a history of thinking about photography, I do not want to suggest that the issue is unproblematic. As was suggested by Margaret Iversen, "indexicality is a necessary but not sufficient condition" by which we understand the photograph. That any account of the photograph purely as index remains insufficient is due precisely, of course, to the fact that it is also an icon, but not *incidentally* so. As Jonathan Friday points out, the indexical and iconic aspects of the photograph are inseparable. The photograph "is literally the

coincidence of the two." Indeed, it is for this reason that the photograph is virtually unique among the examples of the index offered by Peirce. The causal relationship that exists between object and image provides for a relationship of resemblance. By turn, it is the iconic character of the photograph that allows us to read it as an index. If indexicality and iconicity are inseparably bound together within the photograph, we must ask what is at stake in the move to suppress one of these of terms so as to promote the other. What is to be feared from the index? What is the motivation to exclude all that "causal stuff" from our attempt to understand the nature of photography? I do not think that the answers to these questions are hard to find. Indeed, they may prove to be depressingly familiar.

What often gets lost in the numerous commentaries on Barthes's *Camera Lucida* are his remarks at the very beginning of that essay in which he insists upon the founding difference between the photograph and all other kinds of image. That difference is quite simply reference: "A specific photograph, in effect, is never distinguished from its referent (from what it represents), or at least it is not immediately or generally distinguished from its referent (as is the case for every other image).... It is as if the Photograph always carries its referent with itself." It is this "sovereign contingency," this inescapable connection between the photograph and what it represents, that determines the nature of our encounter with the photograph. As Barthes explains, "Show your photographs to someone—he will immediately show you his: 'Look, this is my brother; this is me as a child,' etc.; the Photograph is never anything but an antiphon of 'Look,' 'See,' 'Here it is'; it points a finger at certain vis-à-vis, and cannot escape this pure deictic language."[43] Thinking about the photograph's referentiality as analogous to deixis suggests that photographic meaning might lie not within the realm of representation but simply as a mode of designation. Photography gives itself over entirely to the referent through an act of ostentation, slavishly pointing to something as "this." This "this" might be as close as one can

get to a pure index but at a cost of rendering the photograph—as Barthes puts it—"somehow stupid." Perhaps worse still, the photograph might not even be comparable to the most elementary of speech acts: it is more a kind of inarticulate, mute gesture that, as Rosalind Krauss observes, "could be called sub- or pre-symbolic, ceding the language of art back to the imposition of things."[44]

The imbecility of the photograph lies in its contiguous relationship to its referent. But the force of this relationship is dependent upon an aspect of the photograph that marks it out as a particular kind of indexical sign: photographic indexicality assumes a distinctive character by virtue of its being technologically produced and mediated. If in any photograph the object depicted is the emanation of the object itself, impressed upon a surface by means of optical transmission and made visible by chemical processes—events that are always potentially independent of any human agency. In other words, photographic indexicality is intrinsically associated with the severing of the link between an "author" and the photograph itself. Indeed, by extension, the fact that photographs can be made automatically must lead us to conclude, following Lacan, that neither do they require a viewer. The photograph continues to function as a "certificate of presence" of a thing even when there is no one there to acknowledge it.

We can perhaps begin to perceive the problems posed by the photograph-as-index. First, in as much as it can be regarded as beyond or before the reach of meaning, photographic indexicality is redeemable neither by semiotics nor by aesthetics. Closely inscribed within the orbit of its referent, the photographic index is resistant to the more traditional kinds of interpretation and evaluation of pictures. Second, the erasure of the subject from the photographic act—a subject is no longer necessary as either producer or observer—constitutes a potential crisis in photographic practice and criticism. Clearly one response to this crisis is to attempt to deny the importance of indexicality to an understanding of the photograph and to stress instead its iconicity or,

more preferably, its reading as "a picture." In terms of photographic practice, there have been numerous and varied strategies of achieving this. The most obvious, and among the earliest, was for photography to simply imitate painting. Nineteenth-century photographic Pictorialism contrived to look like painting but, somewhat ironically, it had to fall back on substituting one kind of indexicality for another, the trace of the bodily gesture attempting to disguise the mechanical nature of the photographic image. For the photographic critic or theorist, the photograph as index threatens redundancy. If, as Barthes contends, the photograph "has something tautological about it: a pipe, here, is always a pipe" then the critic is potentially left simply pointing at something that points to something else and appearing equally as stupid.[45]

Barthes, however, offers one solution. Faced with an impasse of his own making, he decides, he says, to "make myself the measure of photographic 'knowledge.'"[46] The subjective dimension that had been evacuated from the photograph when it was submitted to the logic of the index is returned to it not as a process of reading or of understanding, but of feeling. Such is the legacy of the *punctum*.

Sharon Sliwinski
A Note on Punctum

As I read the transcript of The Art Seminar, a text that began by announcing that it was held on February 27, 2005, it occurred to me that I was imagining the conversation as if I were present. I became like an audience member, silently cocking my head in the direction of each new speaker as they interjected. This state of "as if"—a unique product of the faculty of the imagination—perhaps bears some resemblance to what occurs in the face of a photograph: one is implicitly asked to imagine herself as if she were a spectator to the event or scene or object pictured, even if this event is merely James Elkins sneezing at a roundtable conversation in Ireland. Long before the modern camera became a little box one

looks through, an inextricable connection was forged between the "eye" of the lens and the subjective "I." Perhaps one might go so far as to say the "I" gained an entirely new purchase through its coupling with the seemingly all-seeing gaze of the camera.[47]

It must be noted, however, that the state of "as if" also contains a kernel of the negative. Despite the fact one may be deeply affected by an image, one is generally also keenly aware that one is not, in fact, present to the scene pictured. This is to say a kind of splitting occurs in the event of regarding a photograph: one is invited to imagine oneself as a spectator to what is depicted, while at the same time, one is aware of oneself as simply a spectator looking at a photograph. And strangely, the more one is affected by what is in the image, the more painfully this secondary negation seems to be felt: "They were *only* photographs," says Susan Sontag of her first, early encounter with images from the Nazi death camps, "of an event I had scarcely heard of and could do nothing to affect."[48] In my mind, this complex imagining—the complexity of the spectator's *experience* in the face of a given photograph—is what makes "photography" particularly difficult to conceptualize. Although we may actually wield the camera, photography affects us in surprising ways, works us over, and influences and shapes our concerns, and often all without our consent. As Elkins points out at several places in The Art Seminar, the "failure" of photography theory is not so much a failure as symptomatic of the excessiveness and elusiveness of the medium's effect. This surprising, superfluous quality is perhaps what the all the terms discussed during the course of the roundtable—indexicality, *punctum*, temporality, and antiaesthetic—attempt to describe, for better or worse.

I want to comment on just one of these here, Roland Barthes's concept of *punctum*. As many of the participants at The Art Seminar note, *punctum* is notoriously difficult to define. Barthes's own definition is almost purposely indistinct. He variously describes *punctum* as a "sting, speck, cut, little hole—and also a cast of the dice. A photograph's punctum is the accident which pricks me

(but also bruises me, is poignant)."[49] The list trails on in the paren-
theses, and Barthes gives the impression he is never quite satisfied
with his description.

Punctum is, in fact, the Latin word for "point." Perhaps
not coincidentally, the roundtable seemed equally suspicious of
Barthes's term and the idea that a photograph points to some-
thing. During the course of The Art Seminar, *punctum* was vari-
ously perceived as Barthes's attempt to smuggle in a notion of the
ineffable, the nonverbal, or perhaps something akin to the pri-
vate life of the mind. Indeed, Barthes casts *punctum* in opposition
to *studium* (yet another Latin word), which is the public life of
images, the photographer's intention, the cultural references con-
noted in a photograph. *Punctum* and *studium*, when they appear in
Camera Lucida, are usually presented side by side. One cannot feel
punctum without the presence of *studium; punctum* is what breaks
the dominion of *studium*.

Throughout *Camera Lucida*, Barthes often draws attention
to a particular detail or "point" of an image as an incidence of
punctum: the strapped pumps a woman wears in a family por-
trait from 1926, the bandage on the finger of an "idiot child" in
a New Jersey institution. What is important about these details
is their expansive quality; they disturb a conventional interpreta-
tion of the image. Although Barthes uses these particular points
as illustration of *punctum,* we should not think of the concept as
simply a holdover from romanticism or an appeal to the category
of the transcendental. It is an attempt to describe what is indelible
in photography itself. In this respect, *punctum* is perhaps much
more than a particular detail that calls out to a spectator. Indeed,
punctum can be thought of as the very means by which photogra-
phy makes the ineffable actually *appear.*

Margaret Iversen was right to recall Benjamin's phrase, "the
optical unconscious," during the discussion. Here is Benjamin
from "Little History of Photography":

No matter how artful the photographer, no matter how carefully posed his subject, the beholder feels an irresistible urge to search a picture for the tiny spark of contingency, of the here and now, with which reality has (so to speak) *seared* the subject.... For it is another nature which speaks to the camera rather than to the eye: "other" above all in the sense that a space informed by human consciousness gives way to a space informed by the unconscious. Whereas it is a commonplace that, for example, we have some idea what is involved in the act of walking (if only in general terms), we have no idea at all what happens during the fraction of a second when a person actually takes a step. Photography, with its devices of slow motion and enlargement, reveals this secret.[50]

For both Benjamin and Barthes, then, photography has the capacity to make evident a visual space that is simply not perceptible by any other means. The effect of this manifestation should not be understated: the medium generated an expansion of the very imaginative capacities of the human psyche. It is no coincidence, in other words, that Freud's great discovery of the unconscious occurred in the age of photography.

But if we do not wish to stray into the domain of psychoanalysis, there are more concrete examples from the early history of photography that can help illuminate *punctum*. For instance, in Charles Darwin's last great book, he turned his attention to the expression of emotion in man and animals. People from every corner of Darwin's life supplied him with stories—a pet terrier that frowned in concentration, a hummingbird persistently frustrated by flowered wallpaper—and a museum keeper from Australia even sent a detailed account of monkeys throwing temper tantrums like children. The massive book that Darwin eventually published on the subject is itself structured like an index and chock full of details (*punctum*?): "The Indian elephant is known sometimes to weep," he writes at one point. "In the

Zoological Gardens the keeper... positively asserts that he has several time[s] seen tears rolling down the face of the old female when distressed by the removal of the young one."[51] Several commentators have suggested the book remains unsurpassed by modern science, but what goes relatively undernoticed is the fact Darwin's study was deeply dependent on the medium of photography, both substantively and conceptually.

On one hand, Darwin used photographs and line drawings throughout his book as illustration of facial expressions, including several staged images commissioned from Oscar Rejlander. The book is notable in this regard because it presents some of the first mechanically reproduced photographs of the period. But the primitive state of the technology—still dependent upon long exposure times—was simply not up to the task of candidly recording fleeting facial expressions. So Darwin was forced to rely on what he could acquire from portrait studios, medical and psychiatric institutions, and individual enthusiasts in England and abroad. He was especially indebted to a French physician, Guillaume Duchenne, who was pursuing research on muscle activity. By chance, Duchenne encountered a man whose facial nerves were insensitive to pain, which made him an ideal candidate for one of Duchenne's unusual experiments. The doctor galvanized the man's facial muscles, "fixing" them in place long enough to acquire photographs of various expressions for further study. Darwin reproduced several of Duchenne's images in his book and positioned them as proof of his central thesis: that some expressions are universal and a continuum can be seen between the mental life of humans and animals.

In my mind, each of the illustrations Darwin carefully chose to accompany his text demonstrates *punctum* or, in Benjamin's language, "unconscious optics": they make evident an idea that was simply not perceptible by any other means. The expressions that fleetingly pass over human faces were, to Darwin, a daily, living proof of animal ancestry. This is photographic thinking—not only because the camera allowed for a greater precision of analysis

but also because it could "point" the way to entirely new conceptual spaces.

David Bate

The Emperor's New Clothes

It was fascinating to read the transcript of the photography theory Art Seminar. Unencumbered by the usual vapid artspeak so common today in photography debates, The Art Seminar material is massively refreshing and a reminder that intellectual positions are still being argued and are worth debating. As I read it, there are four central concepts that frame the seminar discussion: the *index,* the *punctum, time,* and the *specificity* of the photographic artwork. It is interesting to see how these notions roll from one to the other as separate entities, yet remain linked. I will try to describe what I mean.

In the first concept raised, the index, the debate depends upon the interpretation of the concept. In photography theory, there are two camps of theorists: the realists and the antirealists. The realists include Roland Barthes, André Bazin, Susan Sontag, and Rosalind Krauss, while the antirealists, who believe there is transformation between the referent and the picture, include Umberto Eco, Victor Burgin, Peter Wollen, and John Tagg. Those positions are, I think, well mapped. The semiotic confusion among the former group appears when the index is taken to be the meaning that is produced from the photograph. Barthes, for example, does not refer to Peirce at all and depends on Saussure's simpler linguistic concept of the sign, which has a sliding scale between "natural" (motivated) and "cultural" (unmotivated) signs, with photographs as the former and language as the latter. Krauss has done much to develop this position in her work on photography. Here, a theory of the causality of the image (the index as a sign caused by its referent) is confused with the meaning that the picture has. The camera and photograph, as with a humble pencil, share the fact that the graphic marks made from the instrument

may well be indexical, but that has no necessary relation whatso-ever to the meaning attributed to the picture. This, at least, is my position, as outlined on page twenty-four of my book *Photography and Surrealism*.[52]

The popularity of the *punctum,* the second concept dis-cussed, coincides with the issues involved in the first debate on the index. If the punctum is a yearning intentionality on the part of the viewer, the desire that a spectator invests in a photograph is nevertheless involuntary, as Margaret Iversen says. This *punc-tum* affect is usually seen to have its cause located in the original event depicted in the photograph. Thus it is the lost reality of the moment "photo-graphed," the indexed referent, that causes the *punctum* or uncanny feeling. I think the interest in this *punctum* stems from two related issues. The first is simply that the opposing concept, the *studium,* is so fundamentally weak in *Camera Lucida* that no one can be bothered to examine it. You would have to go back to the old structuralist Barthes of "Rhetoric of the Image" or "The Third Meaning" to find the more sophisticated understand-ing of what he means by the *studium.* One would also find there a clearer discussion of the relation of the photograph to time.[53]

Then there is the whole shift away from high theory in cul-tural theory generally, of which photography theory is a small branch. As Terry Eagleton expounds in his book *After Theory* (2004), "No idea is more unpopular with contemporary cultural theory than that of absolute truth."[54] The rampant subjectivism of much contemporary criticism, in particular, with respect to art photography has actually meant that theorization about the specificity of meaning in the photographic image has fallen away. This brings me neatly to the final part of the discussion about the specificity of photographs and the role of photographers in such debates. I found a text the other day by Ansel Adams published in 1935 examining the differences between the painted image and the photograph. It goes into great detail about the function of the line in photographs. Adams is best-known today as the heroic

photographer who took large-format black and white photographs of Yosemite National Park in the United States. As a modernist, he is not supposed to be a theorist, or to actually participate in theoretical debates about photography. My point is that, even though he is known for making romantic pictures of sublime nature, even as a "purely visual" practitioner he participated in theorizing photography. I cannot think of any practicing photographers today who participate in such a way. (Jeff Wall's writings are informed by art historical debates in a way that support his practice but do not explain its principles.) Contemporary "posttheory" cultural theory and art photography have militated against such developments, particularly through the ineffable effect of the *punctum*, which has taken hold in teaching academies and universities. The *punctum* is the new emperor's clothes: if I do not see them, it is my stupidity and I have failed to understand the art. The *punctum* has enabled a wholesale return to romanticism in theories of signification, mythified and made respectable through the name of Roland Barthes. Of course, I am not opposed to the concept of the *punctum* itself, merely a lack of thinking on the part of those who overuse it.

This brings me back to the beginning of the discussion, concerning what concepts are useful for a theory of photography. I find myself asking, again: what is the point of a theory, what is it trying to do, what is its *purpose*? In a sense, I suspect photography theory has begun to evaporate, for a whole range of reasons. Perhaps the main one is that photography itself in its analogue form has already been dispersed by scientists, media institutions, the police, artists, and travelers: its dispersion began as soon as it was invented, so that photography has served a myriad of institutional purposes. Now photography is mutating into a digital environment where the boundaries are even less clear. I welcome the beginnings of discussion about that!

Abigail Solomon-Godeau
Ontology, Essences, and Photography's Aesthetics:
Wringing the Goose's Neck One More Time

Not the least of the difficulties that arise when a group of schol-
ars attempts to "conceptualize" photography *as such* lies in the
fact that unlike painting, sculpture, drawing, and printmaking,
photography is by definition a form of mechanically reproducible
image making generated by a machine.[55] The machine may be
rudimentary (that is, a pinhole camera) or technologically com-
plex, but the material agency by which a photograph is normally
generated links photography, notwithstanding its own specifici-
ties, more closely to film or video, *technologies* of image produc-
tion. Consequently, while the photographic image is a picture,
and in this respect, allied to discourses, disciplines, and categories
within which the image is the subject of inquiry, its mode of pro-
duction and its primarily nonaesthetic uses are such as to make
it an unwieldy theoretical object. And although the origin of the
word "technology" is the Greek word *technē,* meaning art or craft,
current usage distinguishes between locutions such as the paint-
er's technique or the technology of bronze casting, and technology
as such. Further, the greatest use of photography is for manifestly
unaesthetic purposes. A painting or sculpture may be bad, but
by definition it belongs—categorically—to the domain of art. A
given photograph may sometimes belong to or be repositioned into
the domain of art, but in terms of its normative uses, this is rarely
the case. In fact, it is overwhelmingly not. Photography, rather,
belongs to the domain of just about everything in modern culture
from the most private to the most public, from civic identity (the
photo ID, the passport) to mail order catalogues, from the printed
page to the billboard, from the bridal album to the Internet, from
the postcard to the kiosk.

 Given these attributes—the camera as a machine and photog-
raphy's staggering ubiquity and limitless uses—from where should a
"conceptualization" of photography initially take its moorings? How

would either an ontology or even an epistemology of photography be formulated at the beginning of the twenty-first century when the recognition that we live in a photographically saturated image world has become so commonplace as to be effectively a cliché?

In this respect, it is significant that the central themes of the roundtable conversation, and especially those that spark its most animated moments, are centered on two basic issues: indexicality (with which the conversation opens and continues for fifteen pages) and medium specificity (with which it closes, and which is also discussed for many pages). In between are exchanges about Barthes's use of the term *punctum,* photography's relation to art historical discourse, a bit on Benjamin and the aura, a bit on postmodern uses of photography, a bit on new scientific technologies of imaging, a bit on the temporality of the photograph, and (longer) bits on the artists Andreas Gursky and Jeff Wall, climaxing with the debate on medium specificity sparked by the work of these latter. A clearer example of the poststructuralist maxim "Discourse defines the object" could hardly be found. Inasmuch as the participants are all academics and art historians, the task of attempting to conceptualize photography (and the predictable failure to accomplish it) is unmistakably skewed toward aesthetic issues. Although Pierre Bourdieu is invoked once or twice, there is no discussion of photography's profound imbrication with the social, ideological, or political. To do so would require some reflection on photography's instrumentalities, its material effects, even in the age of Baudrillardian simulation.[56] This is by no means an archaic debate, for everything from the acquittal of the L.A. police officers charged with the beating of Rodney King to the dissemination of the pictures of American soldiers' torture of prisoners in Abu Ghraib hinges on the claims, pro or contra, of photographic truth. (Significantly, in the Rodney King trial, the Los Angeles Police Department defense lawyers made the quintessentially postmodernist argument that truth is not located in the image—or, in this instance, the videotape; in the case of

Abu Ghraib—somewhat surprisingly given the digital technology involved—the truth of the torture has not been denied).

Although Barthes's notion of the *punctum* is discussed, it does not lead to any sustained consideration of the psychological dimensions of photography, how photographic images work on the spectator, how affect and significance are produced, or whether photography has a role in producing social reality. There is no consideration of the instrumentalities of either the image (in its material incarnation) or the *imago* (as its psychic representative). Whereas film theory deploys concepts such as "suture" to describe how the viewer is bound up and interpellated into the film, there exists no comparable formulation to account for subjective identification and projection in photography, and in any case, questions about forms of spectatorial investment in the image, either ideologically or psychically, are, as I have remarked, basically ignored. Although Bergson is mentioned once, and Deleuze very briefly, there is no serious consideration of photography's temporal modalities (one aspect of its material specificity), its freezing of time and movement, its associations with death and petrifaction, and the ways in which these attributes have figured in all previous ontological discussions. Indeed, there is no real debate as to whether or not there is, or can be, an ontology of photography at all, something that should logically be addressed if one is to have any purchase on the notion of conceptualization itself.[57] And what about digitization? Does the use of *this* technology, which eliminates all or part of the analogical elements of photography, precisely that feature upon which most previous theorizations have previously dealt and, needless to say, upon which the concept of indexicality itself depends, obviate the designation "photography?"

These are to my mind serious lacunae, and of far greater moment than Jeff Wall's or Andreas Gursky's photographic productions. But no less striking is the absence of discussion of most of those who have actually attempted to theorize photography, from Siegfried Kraucauer to Vilém Flusser, from André Bazin to Jean

Baudrillard. Alone among the historical figures who have considered the medium, only Walter Benjamin and Roland Barthes receive much attention. With respect to contemporary work on photography theory, and with the conspicuous exception of Rosalind Krauss (a powerfully absent presence in the proceedings) and a passing reference to Susan Sontag, no theoretical work on the photographic image is seriously discussed; Geoffrey Batchen, Victor Burgin, Eduardo Cadava, Jonathan Crary, Umberto Eco, Hubert Damisch, Georges Didi-Huberman, Christian Metz, Allan Sekula, John Tagg, Paul Virilio—the list of the unmentioned is long. As it happens, the bibliography in photography theory is remarkably modest, a fact that doubtless attests to the intractability of the subject and the immense difficulty of "thinking" photography as a discrete entity, but the dearth of what can be counted as theory in photographic discourse makes the neglect of these other theorists all the more striking.

Why then this great emphasis—and controversy—oriented to the notions of indexicality and medium specificity? Is the importance of these two concepts in the conversation somehow related to the professional formations of those addressing the subject? To the journals they read, the theorists they do cite; to, as Margaret Iversen at one point suggests, their own individual *investments*? Moreover, is there some way in which both notions—intellectual products themselves of a modernist episteme—are somehow at stake when the conceptualization of photography, ostensibly *toute entiére*, is actually about a specific *discourse* within photography?[58]

In order to pursue these questions, I would note here that indexicality, a term loosely derived from Peirce's semiotic classificatory system and given its most influential art and photographic second life in several essays by Rosalind Krauss, is merely a restating of what most mainstream nineteenth-century commentators took for granted. For them, as for Peirce and Krauss, the photograph has a specific relation to the object or view it represents (well or poorly; this is unimportant). Unlike other forms of imag-

ing, the photograph is thought to guarantee the actual physical presence of the object before the lens at the moment of exposure. Because the image is produced by the light reflected from the object that is imprinted on the light-sensitive support, the relation between object and image is considered to be causal, not conventional, and this, furthermore, is the case *notwithstanding any actual resemblance* that may obtain between image and object. (The classic examples given are the footprint in the sand, the fossil, smoke from a fire, and the like.) Whether characterized as "trace," "inscription," "analogon," "message without a code," "imprint," "transfer," "stencil," "impression," "motivated sign," and so forth, the resulting image is thought to have a relation to the real that is a function of its means of production. It is precisely this assumption that has underwritten all the juridical, evidentiary, scientific, and veristic uses of the medium. Moreover, it is these same attributes that have historically militated against the acceptance of photography as a legitimate medium for art making.

The truth claims of photography, however, have themselves a history of contestation. With respect to photographic truth, which Barthes himself considered "mythological," there existed always the counterexample of trick photographs, trumperies of all sorts, erased figures in group pictures, and inserted figures in others.[59] On a more philosophical level, the late nineteenth century's skepticism about empiricism and positivism (exemplified by Freud, Marx, and Nietzsche), the twentieth century's skepticism about objectivity and its recognition of the limits of the visual and the observable, the late twentieth century's rejection of universalizing truth claims altogether, and, last, the advent of digitalization have collectively operated to limit if not dispel an unnuanced notion of photographic truth. From a politically progressive position, moreover, the refutation of photography's truth claims, as well as the critique of the adequacy of the photographic record, has been of signal importance for critical purposes throughout the past century, especially insofar as these refutations have been motivated by

the recognition of the ways in which photography has been instrumental, both ideologically and politically, in the service of racism, imperialism, and sexism, and, not to put too fine a point on it, in its conscription to the interests and agendas of dominant classes and other formations of power. Furthermore, and no less important, such a critique has been also motivated by the recognition of photography's instrumentalities in producing our phantasmagoria of commodity culture and the construction of the Debordian society of the spectacle.

But the contestation of photographic truth, objectivity, or, if one prefers, indexicality has also been challenged for reasons unrelated to this critical enterprise. Here I refer to the modernist (or quasi-modernist) claims for the artistic autonomy of photography. From the 1850s to the present, art photographers and critics (and, more recently, museum curators, gallerists, collectors, and photographic historians) have insisted on the essentially *iconic* status of the photographic image while simultaneously appropriating its optical effects and even its referential capacities to a modernist notion of medium specificity.[60] It is in response to *this* formulation of the nature of photographic imagery, and its implicit claims to artistic autonomy, that prompted the insistence on photography's indexicality promulgated in several texts by Krauss. Thus, in employing Peirce's distinction between index and icon (and within this system, the photographic image is obviously both), it was not so much Krauss's intention to buttress any arguments about photograph truth as it was to support several distinct polemical arguments. First, that photography could only become visible, so to speak, as a theoretical object of investigation at the moment when it was becoming an outmoded technology. Second, notwithstanding its full-scale entrance into the art world (and art market) of the 1970s, and despite the imposition of art historical criteria to its history, the photograph historically constituted an essentially different mode of representation from the traditional plastic arts, a function of its reproducibility (i.e., in photography

there are only copies, no originals) and its photomechanical operation (i.e., its indexical status). Moreover, because photography short-circuits the coding or symbolic intervention operating in other graphic sign systems (pace Barthes's formulation of the photograph as "a message without a code"), its alignment is with the order of the imaginary, not the symbolic.[61] And finally, by exploring the concept of photographic indexicality through a reading of Walter Benjamin, as well as through Duchamp's deployment of it in works such as *Tu'm* and the *Large Glass*, Krauss was concerned to demonstrate how much of contemporary art was itself following the logic of the index, and it was this, rather than any stylistic or formal resemblances, that characterized (and in a sense unified) the significant art of the 1970s and 1980s. For Krauss, then, the signal importance of the use of the medium in conceptual art practices lay in its liquidation of modernist aesthetic values via its disruption of the autonomy of the sign: "Photography was understood [by conceptual artists]… as deeply inimical to the idea of autonomy or specificity because of its own structural dependence upon a caption."[62]

While Krauss's arguments about indexicality clearly inform much of the debate, her larger arguments with respect to a radically altered paradigm in contemporary art practice are not engaged. Thus, as the conversation on photography unfolds, indexicality seems to function as a kind of discursive alias (or mask) for a debate that ultimately pivots on where to locate the "art" of photography. Similarly, medium specificity sparks an argument about what (art) photographic work is to "count" as photography. In this respect, there occurs in the conversation a few telling moments where one can grasp what Iversen meant by calling attention to "investments," and where one can also see how the concepts of both indexicality and "medium specificity" are explicitly related to certain aesthetic stakes. The speaker here is Joel Snyder:

The reason why I dig my heels in [he is referring here to his increasingly exasperated rejection of indexicality as a photographic attribute] is not merely because of unbearable—unsupportable—generalizations, but because they drain from the us the knowledge we already have, that photography is incredibly plastic, and *that* indexicality stops us from seeing the plasticity, and enjoying it, and enjoying our own behavior with photographs. You look at photographs, and you say, "That couldn't be!" or, "That's phony," or, "That's beautiful." You say all sorts of things about photographs, as long as you're not thinking *index* or *causal relation*, you're free to speak, they entitize.... They make entities. And I have a deep feeling about this, which comes from my practice as a photographer that preceded my going into the academic end of the business, that very often what you say is in the world is contingent on the photograph and not the other way around.... You don't measure photographs against the world; you measure the world against photographs. To enjoy photographs, or to study them, or think about them critically, requires not a one-to-one translation, but a recognition—and this is [Edward] Weston's thought—that the object matter in the world does not determine the subject matter of a photograph, even when you are dealing with the most formulaic cases; it's the formula that determines the object matter. What I fear about the causal stuff is that it stops you from seeing the photographs as pictures.

As is evident, the intensity with which the argument about indexicality is disputed, and the recourse to an essentially aesthetic framework applied to photographic imagery, suggests that Iversen's introduction of individual investment might be useful to explore. In this respect, it is of some consequence that Snyder's position with respect to the photographic medium is closer to a vocational relation with the medium than is the case for most of the other participants, given his previous activity as a photog-

rapher, his involvement in the printing of Timothy O'Sullivan's nineteenth-century photographs from their negatives for exhibition and publication, and his affiliation with the photographic aesthetics long promoted by the Photography Department of the Museum of Modern Art. The only other participants in the conversation who can be described as having a comparably aesthetic orientation to the medium are Graham Smith and (judging by his interventions) Jan Baetens.

All of which is to suggest that Snyder's rejection of photography's indexicality and insistence on a certain notion of medium specificity have certain correspondences to arguments made by nineteenth-century and early twentieth-century art photographers and their supporters faced with the rejection of photography as an art. This rejection was premised on the belief that that the honorific designation "art" was inseparable from intention, subjectivity, imagination, and the forms of manual skill etymologically incarnated in the term "masterpiece."[63] Thus, it was that even those photographers with aesthetic aspirations chafed under the general assumption that they were, after all, "proletarians of creation."[64] In order to counter these objections, advocates of photography-as-art from the mid-nineteenth century on had recourse to a few basic arguments. First, that despite the "mechanical" attributes of the camera, a photograph is ineluctably shaped by the photographer's subjective and expressive choices; of subject, framing, cropping, printing, and so on. (The example used was that two photographers facing the same motif would produce two different pictures.) Second (and this was the modernist argument of the early twentieth century, especially in Germany and revolutionary Russia), the machine-made and technological aspects of photography could in fact yield new aesthetic paradigms, based precisely on its mechanical and optical functions. Photography and film were thus said to produce new and fundamentally modern forms of imagery whose aesthetics were both generated by and indissociable from how they were made. Accordingly, the kinds

of "photographic vision" produced by the camera, and the formal possibilities of editing and montage in film, could not be compared to the traditional plastic and graphic arts, but instead should be recognized as constituting the new language (and material) of modern art itself. (This was, of course, Benjamin's conclusion in his "Little History of Photography.") Hence Benjamin's insistence that the medium had itself overturned the traditional tribunals that had hitherto defined and evaluated the visual arts.

As this mid-nineteenth-century debate on photography has been somewhat reformulated (or perhaps merely refurbished) in contemporary debates, it seems that the technological, photo-chemical, and mechanical aspects of photography condemned by conservative aesthetics resurface now in debates on indexicality and medium specificity. Where once the critics of photography-as-art, such as Baudelaire, invoked the machine-made aspect of photography as one of the elements that precluded its pretensions to art, it now appears that indexicality, for those who reject it, plays a similar role. For those for whom photography's taken-for-granted connection to the world obviates or diminishes its artistic status or aesthetic potential (as does the insistence on its technological mode of production), it is necessary to insist that a photographic image is purely iconic. Yet, as this position has been most influentially promulgated by, for example, John Szarkowski and his epigones (and Snyder's position is remarkably close to his), this affirmation of "pure" iconicity is modified or mediated by the contradictory requirement that photography affirm its liens (however defined) with the external world. Hence the aesthetic/critical rejection of Pictorialism, manipulation of negative or print, digitalization, or, as develops later in the conversation, the insistence that work by Gursky, Jeff Wall, and so on is not "really" photography.

Here one can observe how indexicality and medium specificity are intertwined, although this relationship is never really clarified in the discussion if for no other reason than the lack of

consensus as to where exactly the "medium" itself is to be located. From the discussion it is unclear if the participants are situating it in the camera that takes the picture, in the negative upon which the image is registered (but only in *potentia*), in the final print, or in all three components. It appears, however, that at least for some of the discussants, the medium should be limited to certain types of photography, thus banishing certain particular or idiosyncratic uses (e.g., photomontage, thoroughly manipulated negatives or prints). For example, Joel Snyder:

> I'm just trying to take an argument based on a certain kind of historical practice. In fact, I take myself to be sounding at this moment very uncomfortably like Rosalind Krauss, but on the other side. What I'm trying to say is that if what it means to be a photographer is to be engaged in working through problems of the medium, then the issues of tradition, materials, touchstones, skills, the issue of what new thing you're trying to create, and what the constraints on that newness are—if those things drop out, then I don't understand why anyone would want to say that what we're seeing in these artists like Gursky is continuous with the activity of the medium in photography. It's an historical argument, involving convoluted issues of aesthetics and sensibility, but that's what it took to be a photographic modernist. With the end of that, it seems to me you could say, "Well, that person works in the medium of photography but doesn't pay any attention to the medium, or the tradition, and is mostly interested in the kind of work that is being done now"—that's always fine. But what does it add to say the person is working in the medium of photography?

Of course, "what it means to be a photographer" of any stripe *except* a modernist art photographer has nothing to do with problems of the medium, tradition, touchstones, and so on. The average news or advertising photographer, who is now in any case often using digital cameras, is not thinking about Edward Weston or photo-

graphic traditions when he or she photographs the war in Iraq or shoes for Bloomingdale's. But given that Snyder's arguments are utterly specific to a particular (and defunct) notion of photographic modernism, he is effectively arguing that those who work as artists with the medium of photography but are manifestly indifferent to its putative traditions, and reject any purist notion of what a photographic picture can be, cede their "right" to be considered within a history of photography as an art practice. By such logic, Robert Rauschenberg or, for that matter, Andy Warhol, should be excluded from a history of painting in the twentieth century, John Heartfield from histories of photography, and, as indeed Snyder later insists, most contemporary artists, such as Cindy Sherman, who has always made her work photographically.[65]

But here too, it is as though the absent presence of Rosalind Krauss is the invisible hand that guides the discussion, for the argument about medium specificity is clearly influenced by her recent essays on the subject.[66] But just as the debates on indexicality ignored her larger argument about the permutations of postmodernity with respect to the status of the sign, here too her return to the paradigmatically modernist notion of medium specificity ignores its broader context. For Krauss, who once championed the dissolution of medium specificity, thus parting ways with her equally influential contemporary Michael Fried, subsequent developments in contemporary art have prompted reconsideration if not reevaluation of the concept.[67] Rejecting most of the current manifestations of contemporary art, especially installation, and equally dismayed by its consumerist underpinnings and spectacularizing ploys, her return to medium specificity is an attempt to recuperate those elements of modernist practice associated with criticality and resistance to reification. That this is to my way of thinking both a nostalgic and conservative move is, in the present context, neither here nor there. But with respect to the conversation, and absent Krauss's commitment to what she believes to have been the criticality of (certain) modern and postmodern pro-

duction, when the conversation on photography engages medium specificity, it becomes an essentially formal argument; whereas, and as a recent essay by Alex Potts brilliantly demonstrates, issues around the concept of medium specificity are only meaningful, that is, not narrowly formal, when the larger stakes in such a concept, or in its rejection, are addressed in broader terms.[68] In other words, the ways in which deployments or refusals of medium specificity figure must be interrogated with respect to its ends, its aesthetic/cultural politics, its spectatorial address—in short, the "work" it is doing. In the case of photographic imagery, the work it is doing almost always trumps its medium specificity. Were this not the case, any half-screened or otherwise reproduced reproduction of a photographic image would be outside the category of *the* photograph or photography as such. For it is one of the determining conditions of both the photograph and photography itself that from the outset they have been inextricably rooted in and are produced in specific situations, contexts, and instrumentalities (not to mention their infinitely variable physical locations on page, in an album, in an archive, and in our wallets).

In thus attempting to conceptualize photography, to which task this conversation was directed, it would be minimally necessary to go beyond such unitary quasi-platonic essences as *the* photograph, or perhaps even photography, and begin with a more complex notion of an *apparatus*. Just as contemporary film theory understands film to be not the negative, nor the individual or serial linkage of images, nor the camera, nor the experience of viewing, but the entire complex orchestration of elements in which film is technologically, culturally, and ideologically forged, so too does any conceptual thinking on photography require that we consider all those elements of photography that exceed the camera, the individual picture, and the individual photographer. As with film, this includes the entire social, spatial, temporal, and phenomenological context in which these technological forms are variously viewed and received; the psychic determinations

by which modes of spectatorial identification and projection are secured; and not least, the industrial (or, alternatively, independent artistic) structures that underwrite, shape, manufacture, and disseminate them. As the conversation reveals, the impossibility of conceptualizing photography as a unitary or autonomous entity is doomed to fail, just as would be the case with any other technology that has become braided into all aspects of modernity, and now postmodernity. Whereas the debate on indexicality might have, perhaps should have, opened up the conversation to photography/photographs-in-the-world (for example, how do we, as good poststructuralists, want to think about the implications of the Los Angeles Police Department's lawyers contesting the notion of indexicality?), instead it has produced a great deal of conversation about photography-in-the-art-world. This is, of course, a perfectly valid subject to pursue, but it cannot lead to the promised land of conceptualization, nor can it provide any enlightenment as to why, more than a century and a half after photography's overdetermined debut, we still lack the means to conceptualize it.

Michel Frizot
Who's Afraid of Photons?
—Translated by Kim Timby

I found this discussion very interesting for several reasons, and I have a number of comments to make about it because it shows that the academics who work with photography are very knowledgeable about texts and theories, but differ in their interpretation of these theories. It reveals that after thirty years with ideas that each seemed so progressive and enlightening in their time, photographic theory is in a state of disarray. I would like to analyze this disillusionment and then make propositions that are more firmly founded in photography's specificities.

I will not spend too much time on the theory of indexicality, even though there was a lot to be said about it in the discussion.

Despite the fact that it was popular for a time (even in France, via translations of the work of Rosalind Krauss), I admit personally never having understood how these ideas borrowed from Peirce—a small part of his work, which did not specifically relate to photography—could be pivotal for us. I still wonder how we could have believed that a "definition" as simple and indefinite as that of the index could be relevant to formulating the difference between photography and other categories of representation, or what separates photography from other sign systems that are images.[69] How could we establish categories within photography based on a causal relationship defined in a way so uncertain as the relationship between fire and smoke (as in the saying "Where there's smoke, there's fire")? This borrowing from an eminent American scholar (Peirce) resulted in the weakness of the notion of the index; things were going around in circles because it could never explain the complexity of what happens in and with photographic procedure (hence the participants' difficulties in translating images into words).

Things become even more opaque when we try to take into account the triad *index, icon,* and *symbol,* as this only exacerbates the intrinsic imprecision of the index. We tried to find the *nature* of photography in Peirce's categories, whereas they were about the *effectiveness* of photography, as index, icon, and symbol. In fact, we may argue that photography belongs to all three categories of signs, although they do not apply to the same phenomenological levels (or stages of its consideration). The index refers to how photographs are produced; the icon to its concreteness (it is a tangible image, visible to human senses, perceptible via the means of human perception); and the symbol to human interpretation, to our projections, both personal and collective. We therefore see that this amorphous pseudo-theory situates photography in the realm of human perception, but is inoperative from that point on because it does not differentiate between the production and the interpretation of the image, or the stages that separate them (it

even confuses these different levels). It also suffers from uncertainty about the notion of "sign," as part of a semiotics of the image that never came into being (and that was supposed to be modeled on linguistics). Are we talking about "photography" as photographic process? Or each photograph? Or each individual sign identified as such in a photograph (given that we have been able to define "a" sign)? We may marvel at the fact that a theory having shown itself to be unsuitable is still considered useful (although, today, it seems to me to be much less present in Western European than in Anglo-Saxon scholarship).

On the other hand, we may admit that the index does stem from good questions—the question of the pointer, for example, the index as pointer, which is in fact just a metaphor for a finger pointed at something that we want to show ("index" also denotes the forefinger). But this pointing is only causality taken inversely: it is because indexicality is a causal relationship that what we see depicted in a photograph refers back, for us, to something that we know once existed. But what does a photograph point to? Some would say to an object, or reality. But for me, the only valid answer for photography is *to light* (and I even prefer *to photons*, as we will see below). The question of resemblance is a consequence of this, but it is not the result of indexicality. In other words, indexicality does not imply resemblance, and photographic resemblance is much too rich and specific to be described using the notion of the index. It is a function of how the forms are produced—by the optics of the camera—and it also depends on a viewer, who has his own blend of knowledge about the "real" and about photographic procedure. Here, once again, this complex question cannot be dealt with using only the notion of the index. A third interesting question was raised in the discussion surrounding the index, but was drowned by a lack of precision: that of "reproduction" (a treacherous word in French and in English), which is the reason for the weakness of some of Walter Benjamin's work on this question. The photographic act does not "reproduce" any-

thing; it *produces*. It produces photos and only photos. The repro-
duction of a painting is not a painting but a photo that retains
only certain characteristics of the painting. We may say, however,
that photography reproduces itself: a negative allows us to make
an unlimited number of images of different sizes and textures.
Personally, I prefer the notion of replication. Regarding this non-
issue of "reproduction," I think we need only retain the notion of
the matrix (the negative, as it happens, but not only the negative:
every photograph is a matrix).[70] But one thing should be specified:
all the properties of matrices do not apply to the photographic
matrix—the need to apply pressure to make an "impression," for
example (in specific technical contexts, one must be wary of words
that seem similar). Wrapping up this rapid examination of the
index, it seems to me that we need to do away with a particular
notion that is an obstacle to productive reasoning but that is still
all too present: reality. Photography does not refer to reality any
more than painting does because, in fact, we cannot define real-
ity. To grasp it, on the one hand we have our senses (sight, for
instance), and on the other hand instruments, technology, and
physical measurements. Photography is one of these means; it
bridges the gap with our senses, or at least supplements them, we
might say, but also contradicts them. Yet the only reality to which
photography has access is light, light coming from in front of the
camera. If a very "real" object does not reflect any light, it is not
real for photography; it is invisible, as this has no meaning for
a light-sensitive surface. If we think photography is about "our"
reality, it is because we are attached to the analogy between the
camera and the eye (ocular vision) that is also completely false, but
that maintains the illusion of an intimate relationship between
vision and photography that it is difficult to give up. The discus-
sion around the reality of the "blurred image of Jim" as index and
icon is telling in this respect.

I hope I will be forgiven for only briefly mentioning texts that
are important, but that have given rise to misunderstanding when

taken as theories. One example is Barthes's *Camera Lucida* (whose title in itself is a misinterpretation of terms, because a camera lucida is not comparable to the camera used in photography).[71] It is above all a work of literature, an essay on the image of the mother, and not a theory. It is an interior account of what goes on when one looks at photos, but it never approaches the question of how a photograph is made, or even who makes it (operates the camera). It does not ask, "Who photographs my mother? And what relationship is there between them?" "I therefore decided to 'derive' all Photography (its 'nature') from the only photograph which assuredly existed for me."[72] The *punctum* is in no way a precise element of a defined theory; it is an assumption, a private formulation, a consequence of the individualization of every person that looks at a photograph, who does not even try to make his point of view coincide with that of the photographer. Regarding Bourdieu, there is not much to say on a theoretical level, because his collective study is sociological, limited in scope, and not very pragmatic. But his book is also part of the integration of photography into an "episode" in the history of ideas that is worth reconsidering. This "episode" is part of the heritage of linguistics and structuralism, and comes at a time when we thought that an image could be considered as a sort of text.[73] In the 1960s, in this intellectual context, photography—a lowly imagery, neglected by academics and art historians since its invention—seemed to be an untouched field of enquiry, adapted to linguistic, structural, and sociological analysis (even though pertinent methodologies for this remained to be elaborated). And it was easier to handle than painting because it was defined by an identifiable and imperative technique (that was, in fact, promptly forgotten).

I will conclude the first part of my comments on the discussion with two remarks. First, the authors mentioned and the ideas brought up show the mutual fascination between the United States and Europe (France and Germany, in particular). But this knowledge is communicated via translation, which means that

certain texts have been translated and others have not, and that the thought of each author is inevitably distorted. Deleuze must be difficult to follow in English. I was also surprised that no one mentioned Jonathan Crary, who was widely read in France because his work had been translated (the same was true with Rosalind Krauss).[74] Nor Vilém Flusser, whose radical thoughts have been one of my influences, and who has been translated into English. Second, a prickly question underlies all of these issues: the integration of thinking on photography into art history, which is tied to the question of photography as an art, and to the position of photography specialists in university art and art history departments (as Jan Baetens says, "art historical questions"). This is an important problem that I will not get into, aside from insisting on the fact that we need to think about photography separately from considerations on art, and clearly separate different media as well as the intentionalities of each system of representation.

A last remark on the seminar: it strikes me that none of the participants brings up real photographs, aside from amateur or imaginary photos; no photos by a specific photographer were mentioned, and even more surprisingly (and which seems a shame) no photos were shown (projected, for example). As a result, photography is referred to in a very abstract way, using euphemisms or metaphors, whereas each and every photograph brings up particular questions, sometimes bothersome questions, and is a sort of reservoir of questions that we should ask ourselves. This is one of the advantages of *Camera Lucida:* it uses actual photographs to discuss the phenomenon of photography.

Now I would like to propose foundations on which we may elaborate a methodology for considering photography—a methodology that is specific to photography, is concerned only with photography, and fully takes into account the specificities of photographic procedure. We need to redefine photography in terms of the physical characteristics of its production; this means stating the basic physical principles on which the photographic process is

founded. We have to start with physics, which is the theory par excellence. Then and only then will we be able to take into account the practice of photography by an operator, and the diversification of its technical forms and of the operator's intentions. Finally, we will be able to adopt the point of view of the person who looks at photography, and consider the reception of the image and what a photograph conveys about the situation in which it was taken (and that it is up to the viewer to know how to decipher). In photography we must distinguish among the production process, the generic object represented by any given photograph, the specific image that we perceive here and now, the meaning each one of us gives it, and more. But we have to admit that all these aspects depend on knowledge, and on the realization of what constitutes the fundamental, technical specificity of photography.

We can refer back to the questions asked in the roundtable discussion with regard to the index or the trace, for example. How does causality work? What is the nature of causality? And what is the photographic image the trace of? If we want to be precise, we cannot be satisfied with answering "light," because the interpretation of this concept by each of us is always influenced by the richness and complexity of the meaning of light, an archaic concern. We have to consider photons, the action of photons. Today, we can no longer ignore what we have known for a long time about the photographic process. I noticed that several participants seemed to be afraid of photons,[75] which I think is a fear of leaving the reassuring sphere of the image—the sphere of the imagination, of associations, maybe of the sacred, and surely of art—and of moving toward something too technical, too rational or without feeling. We like metaphors and a kind of reasoning that dates back to a prescientific (or unscientific) era, but photography is one of the great techniques of the age of inventions specific to France and Great Britain in the nineteenth century. Photography is an entirely technical way of producing an image; its technical nature is precise, demanding, and imperative; and photography cannot

be made any other way than with photons. If I choose to talk about photons and not light, it is because the photon is a definite quantity and "photography" counts photons falling on a surface: it counts quantities of light.[76] Avoiding this precision by referring to "various photochemical processes" is unhealthy: *all* photographs are produced by the action of photons on a *prepared* sensitive surface. To speak of photons is also to take into account digital photography, which is not a "photochemical process" but is photography nonetheless.[77] The photographic image is the Western (or even universal ruptured from) tradition of manmade images; it is an image that is the result of the effects of physics. To make a photograph is to do a physics experiment, and so to redefine photography on solid ground, we must assert the *absolute primacy* of the photosensitive surface, a surface that is chemically prepared with a substance whose properties change when light falls on it (for example, it darkens or hardens). The sensitive surface acts as a photon counter; the effects of all the photons that fall upon a given point accumulate in such a way that the localized darkening of the sensitive substance is proportional to the amount of light received. Accumulation, quantification, and the fixing of this quantification in a stable state: these are what define the unique nature of photography. The photographic image is first and foremost the result of a photosensitive operation that is very precisely conditioned by physical parameters (photosensitivity, wavelength of light).

Having now defined photosensitive procedure, it so happens that in order to obtain more "interesting" images, we place the sensitized surface in a camera obscura—a *camera* that at first derived from the device used for drawing and adapted for photography, and that only later, at the end of the nineteenth century, started to resemble the cameras that we are familiar with. The camera determines the path the light takes or the path of the photons that travel in a straight line from outside the camera, toward the light-sensitive surface, and through the centre of the lens. Following the

laws of optics, the paths of the photons form a conic projection: any point on the sensitive surface is the projection of a set of points in the frame of reference situated on a line. I am mentioning this operation briefly only to explain the second fundamental principle of the photographic image: projective homology. Homology is a form of homothecy that preserves the relative proportions of things. This is why we recognize the shape of a tree, a house, or a face; we recognize what we have already seen, recorded without deformation. And this is what we call "resemblance."

Last, to make this presentation of the principles of photographic procedure complete, I must mention another characteristic known as "exposure time" or "shutter speed" (even people who do not really know how to take photos know that there is an exposure time). This relates to the management of time. During the photographic operation (the making of an image), we let the photons act on the sensitized surface, we quantify the photons that fall on each and every point over a precise length of time, which must be decided in advance. This length of time is finite. It has a beginning and an end that strictly delimit the photographic operation. The beginning is when we open the shutter, and this inscribes the act in time; a specific moment of occurrence is another characteristic feature of each and every photographic image.

Getting down to the basics of photography means getting rid of what has been obscuring things—emotional approaches to photographs, the personal investment of the photographer—so as to first consider what photography has always been, and remains, despite the original process being hidden. Hence, we may define the photographic operation as a particular precise operation in physics, regulated by a number of physical parameters that relate to the sensitive surface and to the apparatus to which it is subjected. It is then the operator's role (I have not forgotten the operator) to oversee the correct setting of these parameters and to bring together all the necessary elements for the experience. And this

is where photography becomes more interesting than simply the same experience repeated over and over, because the photographic image is the result of the interaction between this specific, highly regulated physical process *and* the desires, intentions, and wishes, as well as the mistakes or the gaps in knowledge, of a human being who learns how to play with all the characteristics of the apparatus. This operator decides where to work, the area to be examined, the direction in which to point the camera; he frames, chooses, and decides when to act, when to set off the operation (after having prepared the camera). He is the master of the circumstances of something that, once set off, takes place entirely out of his control.

The photographic image is therefore determined by a viewpoint—the point from which it is taken, and a direction of observation. It takes into account a section of space, or a field of reference. But this field of reference is only a field of light emission. *The photographic image is formed by the accumulation of the effects of photons falling on the sensitive surface over the length of the operation (exposure time), and it is only that.* It only takes into account the state of light emission or of light activity in front of the camera. In recording this state, quantified point by point over the surface, we obtain a matrix that can be saved and replicated later on in different forms while still remaining the same. A photograph of a photograph is a photograph, in principle identical. The photographic image is also defined by its occurrence at a certain moment, and it corresponds to a length of time that is controlled and can be measured. Taking all of these elements into account, we may come to the conclusion that it is a great simplifier: it records a fragment of space, a fragment of time, and renders colors only as variations in intensity. But it also possesses unprecedented properties in the realm of images that give it extraordinary normative and comparative qualities. For example, we can compare two photographs taken in the same place at different times (from the same point, with the same angle of view) and trust the differences between them.

A last property of the photographic image remains to be evoked: the replication (or multiplication) of the matrix. By that I mean that this image can be multiplied infinitely, and is always ready to be replicated. The phenomenon of photography was greatly amplified at the end of the nineteenth century by photo-mechanical printing processes, in which a photographic image is replicated on a printing plate. It is therefore thanks to the same photographic process that the image can appear in the press. The photographic image therefore has the potential to be diffused, shared, and seen by thousands, millions, and even billions of people sometimes.

From the moment the photograph is seen, looked at, examined, there is a confrontation between an artifact resulting from a physicometric process—an image formed by the quantification of physical, parametric elements—and a human system of perception (eyes and brain), a distinctive biometric system that is, in addition, influenced by acquired knowledge, by culture. The photographic image is now at the intersection of the physicometric data-recording system (quantity of photons) that engenders it, and the biometric, intellectual, culture-influenced system of human perception that tries to understand what was "recorded" (what was in front of the camera) based on what it perceives (the image that is there now). In other words, we try to understand what was recorded using only what we can see in the image that remains.

There lies the power of photography, of the photographic image: in its physicometric capacities (a matter of physics, of the measurement of physical quantities: photons, passing of time, moment in time, space) and in the new potentialities that they offer the human intellect. I would argue that the apparition of the new form of representation that is photography completely reorganized the way the world is perceived from the moment the world was essentially perceived via data transmitted by the photographic image—that is to say, starting in the nineteenth century. I would now like to discuss these specificities of the photographic image,

specificities that whether we like it or not now constitute our standard mode of perception: no longer directly, but via these images that work in their own, autonomous manner. Then we will be able to examine the consequences of this photon-based theory—that I find much more precise, well-defined, and specific than the causality of the index—for the viewer of photographs. This will lead us back to questions raised by Barthes and Benjamin, but our analysis will be supported and structured by the precise and methodical consideration of the process by which photographic images are created.

I will call the first specificity of photography its *power to attest*. This is what first strikes the eyes and the imagination. The absolute necessity of the combined presence, when the photograph is taken, of both a photographic apparatus used by an operator/decision maker (a photographer) and a spatial field of reference—a field of light emission—is what gives the photographic image its power to attest this presence. (In other words, there has to be a camera facing something that manifests itself with light.) Photography records any manifestation of light in this field, and therefore any object that reflects light. Its attestation encompasses the presence of any object, person, or combination of things in this space. This spatial attestation is accompanied by temporal attestation: every photograph is inscribed in a universal chronology, and the moment it occurs can even be registered in the image with different clues. This means that its power to attest concerns a temporality that can be described as follows: that thing was there, at that point in space, in that state, on that day, and at that time. For us, this is the most obvious "scientific" specificity of photography, which we have integrated as our lives have become ever more dominated by a chronological notion of time.

Because of this temporal attestation, we can define the specificity of the ties between photography and history simply by saying that the photographic image has defined the concept of an event. By this I mean that the event, in the twentieth century, has progressively come to be that of which we have photographic images.

The photographers we call photojournalists went where events were occurring (a natural catastrophe, a meeting, a celebration, a famine, a certain number of wars) and described those events using photographs—so much so that the events became photographic images. Little by little, the events came to be defined by the images that we received of them and that were propagated in great numbers by the press starting in the 1920s. This is an unprecedented anthropological phenomenon. We need only cite *Life, Picture Post,* or *Paris Match* to realize that the nature of an event—the collective perception of this event—is shaped by a handful of photos, and sometimes just a single photo, that comes to symbolize it. The history of the twentieth century has been built around photographs. We all can picture them, and most of humanity can picture them; this almost-universal awareness—a common visual culture—of photographs is also an unprecedented phenomenon.

It is clearly the certainty that a photographer was there at a specific point in history that allows us to confer this power on photography, to a point that we may confuse the event in its entirety with the images we have seen of it. (September 11, 2001, did not negate this power of photography, even though the event was filmed and seen on television; numerous photographs that were stills from films were published, as if they were more indicative, had more potential, or were more powerful because they could be contemplated with more permanence; they gave duration to that which was fleeting, to a sudden and ungraspable event.) Unlike ways of thinking that assume that a photograph is directly accessible, "transparent" for human senses, I think we need to insist on the distance, or rupture, that has been established between photographic representation and what we, humans, perceive. When we gained access to physical microtemporality—what we call the instantaneous—we were able to make photographs in one hundredth of a second, one thousandth of a second, one ten-thousandth of a second.... Photography gained in its physicometric capacities but further distanced itself from our biometric faculties.

When it gained access to a realm of time inaccessible to our senses, photography could show us things, people, facts, and phenomena as we could never see them with our eyes. Yet we judge or come to conclusions about behavior, emotions, and feelings based on photographically extracted fragments, states invisible to the eye. Photography has therefore created an entire system of vocabulary, a language of emotion, expression, violence, suffering, tenderness and affection, that is specifically *photographic* and underlies such things as advertising and photomontage.

As photography has touched different sensitivities and cultures, different behaviors and ways of expressing emotion all over the globe, it has given rise to a strange situation, where all these standardized, and in a certain sense artificial, images are taken to be universally representative. There is without a doubt a lot more to be thought out concerning the social impact of photography and individual specificities that are in harmony with or out of sync with its presumed universality—universality that is, in fact, that of journalism and agencies and the diffusion of images. In other words, do we all really receive these images in the same way?

This raises an important question: that of the deficiencies of photography, of its inability to take into account an entirety. The photographic image is simplification, an extraction of fragments from a "reality" that reaches toward infinity all around it. The photographic image contains many things—even unexpected things that we will only notice later on, such as clothing styles, customs, gestures, cultural clues—but it does not say anything of its context, of the moment it was made, of the intentions of the operator, of the circumstances and motivations that brought it into being. It is elusive. For example, the photographic image needs to be supported by a caption that inscribes it in a field of meanings and associations for the observer. Otherwise, it remains unintelligible: it evokes no interest; it does not speak to us. This dependence on a caption if the observer is to develop hypotheses about its meaning clearly shows that the photographic image is a

physical object that rearticulates human relationships. When it is made, this artifact is already the meeting point of facts, intentions, and the photographer's relationships with others; and when it circulates and is received via observation, text, and thought, these facts, intentions, and relationships are rearticulated by the observer's understanding and intellection.

Such transposition meets with one difficulty: a photograph has an individual, private destiny but a collective, public destiny. It is made by an individual, and seen by other individuals, but in a public sphere of diffusion that can be worldwide, where multiple determining factors come into play because of connotations that are political, social, and cultural. The constant recontextualization of photographs is a problem—a problem that is not limited to photography, and is present for art in general, for all kinds of representation.

If by "photography" we mean every photographic image ever made, we must admit that this is not an objective or neutral arena and that it is structured by human relationships (and not the contrary: photography does not structure relationships, although it relays them). The photographic image is an artifact, a technical object that is both sophisticated and defective, in which humanity has certainly placed too much meaning, comforted by the supposed (although sometimes imaginary) powers of photography— powers that are insufficiently tempered by a true knowledge of the conditions of production, processing, selection, diffusion, perception, and thought that necessarily surround all photographic images. On a theoretical level, it remains for us to reconsider all of these images as technical singularities that exist only via an assessment by human perceptions—perceptions that are disjoint from techniques—without masking their specificities, but rather by using them to our advantage. We will then be in a better position for defining the nature of photography's power over us.

Geoffrey Batchen

This Haunting

It is interesting how this conversation keeps coming back to the question of photography's ontology, and to indexicality and *punctum* as ways to articulate an answer. These seem very much to be concerns of the 1980s, and of the postmodern discourse it generated. I have to admit they are still my concerns too, but then I am a product of that moment myself. However, I wonder if a younger generation of scholars might be asking different questions (including whether photography is any one thing anyway, with a singular homogeneous ontology waiting patiently to be identified). At one point, Joel Snyder states that "we are all anti-essentialist," but in fact much of the panel's discussion, unable to escape the rhetoric of art, assumes to already know what photography is. To use the word "photography" is, after all, to make an inherently essentialist claim; it is to divide this entity off from all others. And why not? As language users, we are, in fact, all essentialists (and by the way, there is nothing more essentialist than claiming to be anti-essentialist). As Derrida might put it, essentialism is an inescapable metaphysics. On the other hand, as he also points out, there are better and worse ways of not escaping.

In this context, I agree with James Elkins that indexicality and *punctum* are two of the most abused terms in the photo-lexicon (including, incidentally, by Elkins himself). But the pattern of this abuse makes a revealing study. For many writers on photography, a reference to indexicality is a theological rather than a strictly Peircean claim; it represents a desire on their part for a real outside of representation. In *Camera Lucida,* however, Barthes gives us a far more complicated rendition of photography's realism: "false on the level of perception, true on the level of time."[78] He begins the book, for example, with an element of Peirce's account of the index that is often overlooked. "I am looking at eyes that looked at the Emperor," Barthes tells us, recalling his amazement upon first viewing a photograph of Napoleon's brother.[79] An index

is, Peirce says, "in dynamical (including spatial) connection both with the individual object, on the one hand, and with the senses of memory of the person for whom it serves as a sign, on the other.... Psychologically, the action of indices depends upon association by contiguity." Peirce's notion of indexical semiosis collapses any sharp distinction between a referent and the psychological associations a viewer brings to it. In Peirce's theory of semiotics, in other words, there is no real outside of the activity of representation.

This is in keeping with Barthes's argument in *Camera Lucida*. The MacGuffin he trails through Part One of the book, the distinction between *studium* and *punctum*, between shared and private meaning, has preoccupied many a reader. But anyone who swallows the bait and maintains this distinction, who separates one from the other—who speaks, for example, of "the" *punctum*—has missed the complexity of his overall argument. For what matters here is not the difference between *studium* and *punctum*, but the political economy of their relationship (what matters is precisely their systemic inseparability). Late in Part One, Barthes comes to what he calls his "last thing about the punctum": "whether or not it is triggered, it is an addition: it is what I add to the photograph and what is nonetheless already there."[80] In fact, in the French edition Barthes calls *punctum* a *supplément* rather than simply an addition. This is a significant choice of word. Consigning *punctum* to the logic of the supplement is to displace it from certainty, to put it in motion, to turn it in on itself. The most important element of the photograph is also, apparently, something supplemental, unnecessary, in addition to requirements. Like the referent, it is both there in the photograph and displaced from it, both natural and historical (and therefore not quite either). And indeed it isn't long before Part Two of *Camera Lucida* has collapsed the very distinctions that Part One has labored so hard to establish. "I now know," Barthes says, "that there exists another punctum... this new punctum, which is no longer of form but of intensity, is

Time."[81] What was once confined to only a few select photographs is now recognized as a constituent element of all of them.

The photograph that pierces him most powerfully, the infamous winter garden photograph of his mother, is also one of the most banal, so banal that he cannot show it to us—it is, for us, no more than *studium*. It turns out that the same photograph can be both *studium* and *punctum* (the one is always already in the other), just as every photograph, no matter what its subject matter, speaks, not just of "what-has-been," but also of the catastrophe of death in the future. Barthes can no more separate *studium* from *punctum* than Saussure can sustain his separation of signifier and signified; every photograph, like every sign, is produced within the dynamic play of this impossible relationship, of this haunting of one by its other. This haunting, to my mind, is *Camera Lucida*'s greatest legacy for photo-discourse, and is why it remains a rich topic for future conversations about the photograph.

Johan Swinnen
Signs That Trigger a Philosophical Response

Once upon a time, a fair-haired woman from France drove by this oasis. She shot a photograph of me. She told me: "I will send you the picture." I never received it. And I am in Paris now, for work. I am seeing photographs everywhere. Photographs of Africa, of the Sahara desert and its oases. I do not recognize anything. They tell me: "This is your country, this is you." I? This? I do not recognize anything.

—Michel Tournier[82]

I lay no claim to the status of philosopher. I am working as a historian of photography, art critic, and photographer. I function professionally in a territory triangulated roughly by image studies, time-based arts, and art history. This leads me at regular times to address theoretical issues related to photography. Given that, it was an intellectual pleasure to read a living conversation consti-

tuting by scholars certified as competent. I would like to thank James Elkins for his request that I comment on this discussion; I hope with my remarks and critical comments to contribute to the book's great energy and enthusiasm: the interesting aspect of photography is that you are always dealing with a medium historically implanted in different fields.

A few months ago I attended the lecture of a Belgian photographer, a specialist in wedding photography. Since the 1980s, he has been giving talks and writing about photography on a regular basis, and particularly about his own experiences; sometimes he adds very subjective reflections that have little to do with the photographic image itself. Often these are ironic reflections concerning, say, his egocentricities. Moreover, he despises the generally accepted opinion that photography can function autonomously as a visual art form. The old adage that "photography lies" is, as he uses it, an understatement. He wants to find his own way, to be able to look around him with the eyes of a child. Such an attitude is in itself commendable.

But by the same token, this attitude shows a lot of naïveté. Indeed, today there is a clear understanding that photography is not just the innocent, accidental, or mechanical generation of pictures. It is not, as many have thought for a long time, a simple reproduction of the nature of the world that surrounds us, but rather a language with structured forms and meanings. It is interspersed with a history that has enriched itself step by step.

Except for this man, no one today would dare to doubt that a photograph, in all its appearances, has increasingly become a fully valid, essential, and specific medium of expression, information, and communication. One notices that everywhere, photography contributes to news reporting as well as to visualizing messages in advertising. Simultaneously, in a totally different framework, it is used to capture memories and very personal experiences. In a certain way, it illustrates its own history.

Many times the rapid disappearance of photography has been predicted, particularly since the rise of television. Today video is viewed as a threat to amateur photography. However, the photographic camera continues to accompany people on their travels and during other activities. Cameras exist in increasingly automated versions, stimulating increasingly spontaneous uses. Furthermore, photography has found its place as an established art form in museums and galleries, where photographs are shown next to paintings and other contemporary forms of expression.

Photography has become difficult to judge because of the importance it has been given all over the world. Just recall Documenta X in Kassel, the Venice Biennale, and various exhibitions of Diane Arbus, Jeff Wall, Nobuyioshi Araki, Paris Photo, and so on. Photography is regularly featured as the object of commentaries and critiques, and it is treated to detailed historical, sociological, aesthetic, and semiological studies. After having been mostly nonexistent, the international, interdisciplinary discourses on photography have exploded since the 1980s.[83] The Art Seminar discussion does not give us a comprehensive picture of the rich variety of current texts and discussions on photography, but I am sure the Cork conversation can inspire a renewed focus on the medium in the world of scholarship. It goes without saying that the results of this research project into the field of a possible photographic paradigm cannot be summarized, since they represent divergent positions. It is important that the roundtable discussion presents a multiplicity of insights, perspectives, and opinions, and not irrelevant that it reveals the beauty of the panelists' argumentation, the boldness and audacity of their opinions, as well as the irony, the integrity, and the accuracy of their thinking.

Barthes was the third, after Gisèle Freund and Walter Benjamin, to question photography with the requisite depth. Photography introduced, between intelligence and things, an object of knowledge that situates itself outside the eye, but is identical to what occurs within the eye. In material terms a photograph

can be reduced to a range of grey halftones, but is in fact immediately readable and recognizable. When we take a photograph, we capture life in action, we even seize what we recognize as life itself. Roland Barthes defined this characteristic perfectly in his *Camera Lucida* by calling it "that is what was." A photograph is an affirmation with the value of a certainty, but as a matter of fact, I can't confirm anything using a virtual image.

(The "this is what was" is also the amazement of every photographer, when he watches the picture appearing in the developer tray. It harks back to the fascination we experience when looking at old photographs. This atmosphere of magic and wonder, mixed in with joy, can best be sensed when looking at a black and white photograph as it develops.)

We prefer this kind of photography, which not only is innovative but also embodies qualities that transcend the immediate context and might be interesting for the coming generations. This proves Sontag's proposition about the existence of a profound interrelationship between photography and Surrealism. Even the most simple and spontaneous kind of photography is Surrealistic, she says, because it is a duplication of reality, a *"sur-reality."* The regular daily routine of life, of ongoing things, is frozen and captured in a fascinating picture, which is at the same time both accurate and impossible. And the Surrealistic desire to remove the boundaries between art and life, consciousness and subconsciousness, professional and amateur, the intentional and the unintentional, is realized in the practice of photography. Photography has the ability to create a duplicate world that is more dramatic than the natural world. Not only more dramatic, but also more aesthetic, let's say more beautiful. Most of the time, reality is dull, overregulated, and officialized. By portraying this reality in a fragmentary way, the photographer suggests that there is a need for a second reality—a second reality that is always more beautiful and more pleasant. Reality has to be conquered by the photograph, rendering the subject more aesthetic and elevating

it to something mysterious—what Sontag calls the Surrealism of photography.

Philosophy and photography seem closely related, not because philosophy is a thinking upon, a "retro-spection," a reflection that looks back at what happened, and photography is always an all too recent event: but because photography and philosophy display a similar ambiguity. Both point out something and are therefore a knowing, but they also pose a question and are therefore a "nonknowing."

Photography is also ambiguous. It is the showing of something, a tiny piece of reality, framed by the camera or in the darkroom, that can at the same time make a significant claim to factual knowledge. Time and again, it is a questioning: what is the reality value of an image? And how does the objective become deobjectified by the subjectivity of the maker and the observer? This ambiguity has been called "the paradox of photography." Could it be more philosophical?

Barthes in particular opposed *doxa* in his thinking; *doxa* is the opinion that derives its strength from power in the broadest sense of the word: public opinion, beliefs of the silent majority, the middle-class outlook, everything that is supposedly natural, the force of prejudice, that of which one claims it is the way things are, simply because they are so. In Greek, the metaphorical meaning of the word *para* is "against." *Para tein doxan* means "against expectation." This last word also has a link with psychology, because it names the way that that our perception is determined by our expectations. "Dogmatic" has the same root as "doxa," referring to an unwillingness to change one's opinion. Barthes prefers the way of thinking he calls the *paradoxa*. Photography takes this paradoxicality to its extreme.

Every photograph is a *doxa:* it is reality as it is, furnished with the requisite truth. Or, as John Berger puts it, "Less than 30 years after the invention of this funny device for the elite, photographs were being used for police records, war reporting,

military reconnaissance, pornography, encyclopaedic documentation, family picture albums, postcards, anthropological documentation (which often, like in the case of Native Americans in the United States, went hand in hand with genocide), sentimental lessons in morality, aggressive modes of investigation (with the misnomer 'candid camera'), aesthetic effects, news services and official portraits."

Every photograph is a *doxa,* and yet photograph is also a paradox: it is a picture of reality, in other ways, a way of seeing. A photograph is an image, which means that it is not reality in our pan-photographic culture, where we cannot state anything with absolute certainty, where we don't receive our truths from direct perception. Without extra-photographic data, photography remains deeply silent. Is a photograph representing war a testimonial of an actual war, or is it a still from a war movie? It is exactly this questioning nonknowing that opens the way to interpretation, which can only happen at the level of photographic identity, where the reality to which the photograph appears to refer is unimportant or can solely be seen as "material." This sounds irreverent, but in a photograph it doesn't matter who that ordinary person might be or who this vagrant might be and which part of the Third World he might be from, or who this complacent citizen might be. Indeed, it deals with aspects of humankind itself. In this sense, as a "nonshowing showing" (we do not know reality, but we show it to one another, and we interpret and wonder), photography is very close to philosophy as "nonknowing knowing."

Because a photograph is multifaceted, the approaches to it are multifaceted: hence the simple knowledge initially given by history—the chronological inventory of photographers and styles—has been replaced by very different, theoretically inspired approaches. A sociology of photography, for example, relies on a systematic study of the different contexts of practice. As far as semiology is concerned, it has enabled us to comprehend the photographic image as a message, and to study the kinds of

communication it enables, and the codes it embodies. But like every form of art or literature, like every text, the photographic image will only be made complete by the reader who interprets it, and who in this sense actively participates in a kind of rewriting, recreating. A change in context often implies a change in the interpretation, in the reading. That is the reason why some hold the opinion that the best image is the image that can be approached from the greatest number of angles.

James Elkins notes three gestures that have been made beyond what can be called academic discourse: toward photographers who have no links to academic concerns, toward scientific and technical innovations in photography outside the arts, and toward a more inclusive sense of vernacular photography. Vernacular photography and theory are alienated from one another. Yet it is only when the metaphorical basis of the indexical and symbolic theories of photography (and other visual arts) is forgotten that the two approaches appear as separate and antagonistic understandings of photography, whereas in fact they are both—admittedly extreme—positions on a continuous scale. Philippe Dubois, a Belgian French theoretician of photography, argues that photography is interesting because it is a medium historically planted in different fields. His book *L'Acte photographique* emphasizes the way in which a photograph comes into being, as an optical and chemical object—whence the title, *The Photographic Act*.[84] In order to clarify the nature of photographic representation, Dubois introduces three qualities or characteristics: unicity (each shot is unique), testimony (by nature, every photograph bears witness of certain things), and indication (the photograph shows something that is there). On the basis of that last quality, and in keeping with what had also been said by Barthes, Dubois concludes that, in the final analysis, photography cannot say anything and will probably always remain enigmatic. A photograph does not clarify or interpret anything, and it does not comment. This is an almost nihilistic conclusion, which seems to be subscribed to by a great many

contemporary documentary photographers. The inherent danger of this conclusion is that photography might end up becoming rather gratuitous.

Toward the end of his book, Dubois defines what, in his view, is the very essence of photography: it is a cut, a section through time and space, and in this sense, it is unique. Because it is a section, it entails an "hors-champ," an out-of-the-frame, that can arouse our imagination, make us suspicious, or make the photograph titillating.

All this throws unexpected light on the astonishing statements of the wedding photographer. That particular evening had to do with his general frustration with the field of photography, especially regarding religion, sexuality, and the body. He said things like "photographs smell of the human race"; "photography is the Achilles' heel of the Church"; "when a woman poses nude in front of the camera, she always looks slightly cross-eyed"; "photographs of people kissing are often dirty pictures"; and "saving photographs is a disease." Such offhanded statements indicated a surprising narrow-mindedness, and betrayed a conservative bias. Even while cameras became increasingly easy to use, ever smaller and lighter, and more automated, and while those qualities opened photography out into a medium with the greatest artistic possibilities, this practicing photographer retreated within the narrow boundaries of an unmanageable concept. He could have made associations between middle-class conventions and the artistic pretenses of the Pictorialists of the beginning of the twentieth century, or noticed the contrived delights of constructivism and the geometric style of the 1930s, or taken pleasure in the supremacy of the reportage at the turn of the twenty-first century, or emulated the way the medium has been addressed during the last decades, but instead he replicated the same panoramic view of figures over and over, based on the same outlines. National pride and the belief in regional particularism—which precisely contradict the universal principles of photography—seem to motivate

the wedding photographer. It is not hard to see the preposterous, painfully cynical blindness of this man who has chosen to make the medium look ridiculous, hard not to wonder about how he advocates an emotional approach that is so subjective that it is of no concern to anyone outside his immediate viewers and clients. The wedding photographer made an excellent argument against exploring the medium and in favor of a slavish subjection.

But the story of photography, about image and theory, about practice and semiotics, is open-ended, and that's why it can be pretty amusing for a seasoned practitioner to attend such a terribly decent and archconservative lecture on a rainy winter night in a small provincial arts center. Our speaker managed to create confusion about photography, that intermediate object of knowledge, confusing subject and object and confusing curiosity, desire, and recognition, three elements that make up the foundation of the art of photography.[85]

In my opinion, it would be wrong to draw a major distinction between mass cultural understandings of photographs and fine art understandings. The philosophy of art, and of photography, can be considered part of cultural philosophy. We can ask ourselves whether in the case of photography the desire to be art is actually that important. Maybe photography just needs to be photography. Would not our wedding photographer, who owns a weekend cabin in the woods of Steinbach, think about this the same way?

What is photography? The question has been raised since 1839, and there has been no lack of answers. We are still not certain what photography is. The photograph is an object that is difficult for us to understand. Although the participants of the conversation in The Art Seminar take great pains to define their semiotic terms, they feel less necessity to define the words *photograph*, *photography*, and *photographing*.

I will conclude with a meditation on a word I think may be unfamiliar: *paroxysm*. After the interest in paradox that was typical of the 1980s and 1990s, we speak now, in 2006, about paroxysm.

The concept was introduced by philosophy of culture to denote certain extreme individual experiences and also to categorize social phenomena. It denotes the questioning of the border between happening and mishap, adventure and misadventure, belief and skepticism, communication and miscommunication, and also between love and hate, lust and pain, peace and war, scientific and myth, medicine and witchcraft, in short all terms that we could categorize under the antipoles "normal" and "abnormal."

Photography visualizes paroxysm. It is photography's paradox, the fact that it is fictitious but seems real, that enables it to visualize different instances of paroxysm. One can speak of paroxysm when a border is being shifted, crossed, and recrossed. This implies that one never ends up in a different category. Examples in the social context include celebration, and in the individual context there are many examples in erotics. Physical anomalies such as obesity, mutilation, combinations of the animal and the human, or androgyny could be instances of paroxysm. In photography there are for example Bart Michielsen, Araki, Duane Michals, Masao Yamamoto, Dirk Braeckman, Andreas Müller-Pohle, and Jürgen Klauke.

For the French philosopher Jean Baudrillard, photography is an alternative to writing. Yet he refuses to accept that there is a direct connection between the two. I interpret that denial in the light of Freud's blind refusal to accept that there was a link between his writings and Surrealism. Baudrillard takes photos for his pleasure or as a whim; he has no wish to be part of the history of photography or of photographic culture, but he seemed delighted to be invited to take part in an exhibition I organized called *Attack!*[86] After pursuing both writing and photography, he had come to the conclusion that the affinity between them lies in the way both isolate something in an empty space, exposing both the space and the object within an emptiness. He photographs objects and not faces, since a face produces an excess of meaning, and he does not like obsessive or conventional spaces. Both

in his writing and his photography, he seeks out enchanting or uninitiated spaces. Photography, he says, gives him more ecstatic moments than writing. "For me photograph is a kind of automatic writing—it is very different from the controlled writing of my texts. I am more fascinated and intrigued when I am photographing than when I am busy writing. When I write, I know more about what I am doing, I am monitoring it, I am able to direct and edit my work. And I have also found that my greatest passion is in the domain of images rather than that of texts."[87]

So Baudrillard photographs, but as is well-known he also writes about photography. He has also brought images and words together in single projects.[88] During a conversation (together with my colleague Willem Elias) on the selection of his photographs, in 1999, he showed some astonishment that his photos should be associated with the concept of paroxysm.[89] That is just as well, because there is no such thing as a category of "paroxystic" photographs. The profiles of paroxysm are too wayward to be classifiable.

Why then associate Baudrillard's photos with paroxysm? In the first place, there is the way in which he conceives of the activity of photography. He does not wish to be professionally involved with photography: "I am not a technological or professional photographer, I came to photography as a distraction or hobby."[90] And yet he is also not an amateur, because an amateur is often better than a professional, at least as far as technical concerns, such as an interest in photographic "finish," are concerned. Baudrillard works according to a certain preexisting "genre." As a nonamateur, nonprofessional photographer, he tries to analyze relations by isolating objects in an empty space. He tries to go as far as possible in that, and often fails, and as a result he fits the paroxystic profile.

In the second place, there are Baudrillard's photos themselves. He seldom goes too far in his photos. He likes showing the decay of nature and culture, but stops just before it degenerates

into a tourist's curiosity about wretchedness. He deliberately tries to avoid evoking an aesthetic appearance in his photos, but admits that his photos are beautiful: "In the photo a secret must be kept. I speak here as a sporadic user and wild practitioner. I regret aestheticizing of photography, that these kinds of images have become one of the fine arts and fallen into the abyss of culture."[91] Baudrillard is fascinated by objects, but his images linger in the memory as beautiful abstract planes of color. Baudrillard's photos are like swan songs. Images that try to keep out of the abyss, but cannot consistently do so, could be called paroxystic.

The third reason that the photos may be called paroxystic relates to a form of telepathy. After Baudrillard's participation in the exhibition had been finalized, we came across his book *Le paroxyste indifférent*.[92] Here a different profile of paroxysm is brought to light. With reference to his constant concern not to link the real and the rational together, we asked him where he situates his radical thought in relationship to philosophy. His reply was: just before the end, in the phase of *paroxysme*:

> The interesting moment is the moment of paroxysm, that is not the moment of the end, the moment very close to the end. Paroxystic thinking is located in a penultimate position before the extreme boundary beyond which nothing more can be said. It is not scientific, because science, as a system of exchange, information and storage, claims to give a final, objective meaning. But if there is no general representation of the world which gives the world meaning, then neither can a science exist which has the last word. That is certainly true of the humanities. The fact that disciplines like economy or history, are internally comprehensible, based on their premise, but nowhere else, results in their being increasingly disrupted by uncertainty.[93]

Baudrillard was pleading for a kind of stoical indifference. Instead of fantasizing the real using a belief system, and dreaming up an accompanying meaning, he prefers radical empiricism,

which skirts ideologies by precise research. In this way an emptiness can be created around the material object, without interpreting it: "There is a moment at which one can capture the image of the world in terms of appearance, and no longer in terms of calling up a world which has already been formed by the counterpart of thought, just before being decked out with a finality, just before it is 'perfected' (this is also a paroxystic moment)."[94] So Baudrillard's radicalism is paroxystic because it does not wish to be extremist.[95]

According to Baudrillard, the photographer takes account of the state of the world in our absence.[96] The lens explores that absence. In photography, things are linked together by a technical operation that corresponds with the coherence of their banality. There is a vertigo, generated by the never-ending details of the object, the magical eccentricity of limitless detail. The relationship of one image to another, one photo with another photo, is fractal. In Baudrillard's view, the photograph is what most makes us resemble the fly, with its compound eye and its disjointed flight. Oddly enough, the lens brings the nonobjectivity of the world to light: "It is precisely the lens, paradoxically enough, that reveals the non-objectivity of the world—that something that eludes analysis or comparison. Precisely through technology we leave comparison behind us and are in the middle of the trompe l'œil of reality."[97]

In the last ten years, the discourse of photography in Europe has been dominated by a documentarist dogma. Against that, and in the footsteps of Andreas Müller-Pohle, Hubertus von Amelunxen, Philippe Dubois, Jean Baudrillard, Geoffrey Batchen, and Willem Elias, my own work has developed, following a series of interests I like to focus in the word "paroxysm": photography as a means of making the visual world visible by breaking through the conventions of perception and disobeying the photographic apparatus.

I have always considered the teaching of photography as being a major desideratum, not to canonize a History of Photography, but

to break up any firm confidence in a single history, and to lead the subject toward a social and political responsibility by means of aesthetic education with photography. Photography has probably been the greatest challenge to subjectivity since the invention of writing.

Hilde Van Gelder
The Theorization of Photography Today: Two Models

One of the many crucial issues regarding the current theorizing of the photograph raised in the roundtable discussion is the question—introduced by James Elkins—of "who gets to speak for photography." From the onset of its history, as he points out, a central interlocutor in the debate on possible ontologies of photography has been the artist or maker of the images herself. Today, it is refreshing and revealing to reread some of these artists' statements. I would like to let three of them speak: Antoine Wiertz, Jeff Wall, and Alan Sekula. Using their comments on what photography is, I will distill two possible models to theorize photography today.

A fine example to start with is a brief yet highly visionary note by the eccentric Belgian painter Antoine Wiertz (1806–1865). In the June 1855 issue of *Le National*, he writes,

> Here is some good news for the future of painting.... A few years [ago], a machine was born, which is the honor of our times and which, every day, amazes our thoughts and frightens our eyes. In a century, this machine will be the brush, the palette, the colours, the address, the custom, the patience, the glance, the touch, the paste, the glaze, the *rope*, the shape, the finished, the represented. In one century there will be no more masons in painting: there will only be architects, that is *painters in the largest possible sense of the word.*[98]

Wiertz thus announces important changes for the discipline of painting, here conceived in the narrow sense of a craftsman-like, manual way of working, that are caused by photography's machinic

eye. Painting will no longer be considered as a traditionally well-defined and circumscribed activity. Instead, Wiertz argues, by the time the twentieth century will have reached its midpoint, painting will have become generic and malleable: *painting at large.*

Wiertz anticipates a model of image making through photography that I here want to define as *absorptive.*[99] Elsewhere I have asserted that certain current uses of photography, such as—among many others—the work of Thomas Struth and Andreas Gursky, have resulted in a new model of *picture* making.[100] In Gursky's or Struth's pictures, which I understand to be hybrid, composite images, photography has subjected painting to a modus phenomenon, in which—paradoxically—the osmotic effect has not been in favor of photography but of an enlargement of what now can be understood as painting.[101] Painting thus has been able to "absorb" photography in the sense that it succeeds in using the camera and the printing paper as tools for its own sake, as a colorful, painterly "medium"—here understood in Greenbergian essentialist terms of the instruments and carrier that are needed to make a painting—that replaces the brush, paint, and canvas. Struth's or Gursky's *tableaux,* a term one often encounters in the literature on the artists, can be considered as painted by the machine, as Wiertz had it—with the camera's eye. It is in this sense that they give birth to an enlarged concept of painting, where painting is not to be considered so much as specifically "pictorial" but rather as generically "pictural."[102]

From that conclusion, I want to argue against Jeff Wall's deduction that it is thanks to the "conceptual" deadlock of the late 1960s that photography has found its own definition as an autonomous Modernist art. According to Wall, photography is intrinsically characterised by its ability to depict a certain reality.[103] Wall's concept of "depiction" is what other authors have called, borrowing from Peirce, photography's iconicity. Wall argues that it is due to this inherent bond with its depictive character that photography finds its essential medium specificity and autonomy. But why do

contemporary critics keep on returning to the question of the essence of the photographic medium without agreeing on the answer—as the roundtable has amply made clear? Why does one, when reading about Wall's own photographic images or those of the above-mentioned artists, so often encounter the terms "tableaux" or "pictures" rather than "photographs"?[104] Why does Wall himself discern photography's depictive character as the only possible future for the "Western Picture" (capitals used in the original) or the *"tableau"* (italics in original), and not for the "photograph"?[105]

The formal conventions employed by this renewed kind of auratic art, in the Benjaminian sense of that term, are for example large-scale formats, technologically sophisticated color prints, and limited editions (often limited to "editions" of one). This has nothing to do with previously known photographic practices, but a great deal to do with the history of monumental painting. In Wall's case, the subject matter or iconographic contents of his pictures is so reminiscent of the figurative tradition of painting that it is not an overstatement to call it "history painting reassessed."[106] And when Thomas Struth photographs important history paintings in his series of *Museum Photographs* (1989–1992) or when he tries to redefine various genres of landscape painting in his *Landschaften* (1991–1993), there is no doubt that, through photography, he is experimenting with the borders of the painterly discipline and what can be included in its genres as they traditionally have been defined.

In the absorptive, pictural model of using the camera and the photo paper, photography is not an autonomous art that has found its own medium specificity. It is rather a "means," as Joel Snyder argues in the roundtable discussion, or a modus element that first and foremost serves to reinvent a long-gone figurative painterly tradition and finds that new life in the hybrid discipline of picture making or painting at large.[107] Why now would one have to question such practices? There can certainly be nothing wrong in experimenting with the limits of what can be regarded as painting

at a certain point in time. Yet, I believe that there are problems in respect to the possible meanings of these images. Regarding Wall's work, Rosalind Krauss has already argued that it flirts with pastiche in part because it disguises what it really does.[108] And even if one cannot say that this was always part of the above-discussed artists' intentions, one finds that the retrospective interests of their artistic enterprises load their images with a poetic-nostalgic effect that makes them lose a great deal of their critical potential.

It is the very capacity to offer a subtle critique that is probably photography's greatest tool, and it is a dimension that often remains largely un(der)explored in the absorptive, pictural way of working. Here lies a second track photography can follow. In this model, which I want to call *intervening,* photography generates artistic images that occupy a privileged position in uttering metaphorically layered critical reflections on the social and economical reality that surrounds us, without succumbing to plain political statements. Elsewhere I have thus defined Alan Sekula's way of working and contrasted his working method with Jeff Wall's, in a comparison between Sekula's *Dismal Science #50* (1989–1992) and Wall's *A Sudden Gust of Wind.*[109]

In several trailblazing essays, Alan Sekula stresses that, even if two photographs depict a similar reality (for instance, a landscape), their connotations can differ radically. As such, in contrast to Wall, Sekula insists that one cannot conclude anything substantial from the "ground zero" finding that a photo, however "banal," always depicts a reality. An image only obtains meaning in a certain culturally and ideologically determined context. Much more important and fundamental than its depictive power to (re)present reality is photography's causal relationship to it—or what has been theorized, again borrowing Peirce's terminology, as photography's indexicality.[110] Wall's argumentation somehow "forgets," obscures, or blurs indexicality, focusing on the iconic. But a photo is not simply iconic; it is, one can say, indexically iconic or iconic through and throughout its indexicality.[111] It is

true that a photo is always or almost always a stylistically "realistic" image, because it is a reproduction of reality. Yet, this is only so thanks to the fact that the photo is able to physically or indexically record that reality in a highly depictive way.

Indexicality is here conceived in terms of a cause-effect relationship.[112] The photo is a material, tangible form of communication between the image and the reality it visually displays. The photo digs its critical potential out of this privileged relationship to reality; it really has to say something about it because it arises out of it. There, I believe, lie the strength and potential of photography today. Photography in the intervening model testifies to an attitude, an artistic way of approaching reality, whereby the artwork is not only the result of a committed process of investigation but also an actual, personally experienced record of it. In this search for the deliverance of visual information about the reality surrounding us, photography does appear to be a medium. "Medium" here is no longer to be understood in modernist, autonomist terms of self-definition but in terms of a method that researches reality rather than aspiring to reinvent an updated realist style. Method does not aim to find reality's "essence"; it has boundaries and limits as a technique and aspires to do, at best, what it can do: critically reflect on reality. In the intervening model, photography is employed in an analytic way. The photographic image is a critical inscription of a reality it aspires to fathom. In the pictural model, on the other hand, the photographic images absorb the information about the reality they reveal into a synthetic totality with an all too often freestanding narrative dimension.

This said, one finds, when looking systematically at contemporary photographic production, that most images make intermediary cases. In the tableaux of Struth or Gursky themselves, or in the work of Jean-Marc Bustamante, for example, one encounters images that certainly do not totally give in to the poetic discourse of the pictural. The greatest danger for the intervening model, on the other hand, is hovering toward the all too overtly political. The

biggest challenge for photography today therefore appears to be to find a way to discover that narrow operative margin where the photo can position itself in between the poetic and the political.

David Campany
*A Few Remarks on the Lens, the Shutter,
and the Light-Sensitive Surface*

What is it that gives rise to the wish or the need to define something? It happens when we are attracted to it, or when we find it threatening, or when it is new to us, or when it is disappearing from us. Photography attracts definition, or *definitions*, because it fits all of these criteria, often all at once. It has done so for quite a while now. The Art Seminar demonstrates fairly comprehensively that photography eludes definition. It also shows that the more elusive it is, the greater the wish to pursue it. Photography has not been caught, and what emerges here is a fascinating account of why this might be. In what follows I will make a response to this state of affairs by looking at different approaches to the problem. For the sake of brevity, I will confine myself to thinking in the first instance to the *camera*.

Looking back at the many discussions of photography and its apparatus, I have noticed that the character of the argument tends to change depending upon which part is being considered. The camera, which is just one part of the apparatus, is itself made up of what we may think of as three distinct parts: the lens, the shutter, and the light-sensitive surface. When the lens is the center of attention, it is usually in relation to the depiction of space and the conventions of realism determined by theories of perspective and optics. Here we are in the realm of resemblance and iconicity. When the shutter is invoked—and it is not invoked much in this book—it is in relation to time and duration. When the light-sensitive surface is invoked—it dominates in this book—it is usually in relation to the question of indexicality, contiguity, and touch. To me this seems as reasonable as it is complex.

At different historical points and in different contexts, we can see that the emphasis on each component part of the photographic apparatus has varied. For example, think of how, between the mid-1920s and the mid-1970s, the shutter seemed to play a very active part in popular and more serious thinking about what photography is. The celebrated "decisive moment," in which the lens cuts out a bit of space and the shutter cuts out a bit of time, was thought be as close to the essence of the medium as you could get. It loomed large in popular and artistic accounts of what photography was or could be. Looking back, however, over the intervening half century, we can see that era was in part prompted as much by other media as by photography's autonomous search for its own essence. Cinema, a mass medium by the 1920s, had the moving image but it also created a new relation to still images. Photography began to pursue this stillness as "arrestedness." It mastered and monopolized arrestedness roughly until video intruded as a mass form to become widespread by the 1970s, with its portability, dispersal, and capacity to be readily fragmented. At that point the decisive moment, with its active shutter, began to wane with a new understanding of the medium. Photo reportage of "events," in its applied and artistic guises, receded. These days few people speak of the moment, decisive or otherwise, being unique to photography or definitive of it. The moment still haunts photography, of course, which is partly why so much staged photography in art since the mid-1970s renounced the decisive moment the better to explore what such a moment was or is. The early work of Cindy Sherman and much of the work of Jeff Wall come to mind in this regard. Both of them began in earnest in the late 1970s. Today contemporary photographic artists seem to prefer the stoicism of the lens to the ecstasy of the shutter. That seems to be what this now relatively slow medium is for them.[113]

So photography has always had a shutter in one form or another, but its status, its understanding, has experienced a rise and fall. Likewise, we could think of the various points at which

the light-sensitive surface—the component that makes photography at least in part an index—has peaked in the understanding of the medium. These would include the crises of historical memory felt in the wake of the two world wars. Think also of how the becoming electronic of the apparatus (with digital cameras) focuses discussion on the light-sensitive surface. Debates about digital cameras have made a fetish of their difference rather than their continuity with older equipment. (Digital cameras still have lenses, which makes them still analogical, but little is said of this.)[114] We might also recall the indexical turn in art's conception of photography in the 1970s, which was so well described by Rosalind Krauss. Art of that time stressed the photograph's status as a physical record, either by making use of it in practices such as performance and Land Art documentation or by digging up the foundations of its social status as neutral evidence.

Conceptions of the role played by the lens have also risen and fallen, but with fewer extremes. Think of the preoccupation with the "faults" of the lens and the artistic aversion to clear detail typical of pictorialist photography (shallow focus, vignetting, imperfect glass); or the return in recent art of the "straight photograph" (frontal, rectilinear, uninflected), which clearly marks a certain kind of ascendance of the perfectible lens and its descriptive capacity.

Since the beginnings of photography, lenses have basically stayed the same, or at least they have inched steadily toward a kind of perfection. About shutters—control of duration and exposure—we can say much the same. That is the front of the camera (I am simplifying, obviously). At the back, the light-sensitive surface has changed a great deal, especially in the move from paper, metal, and celluloid coated with chemicals to the electronic. Putting all these things together, which cameras do, we can say that photography stays the same and changes too.

Is that all there is to the apparatus and to photographic change? Yes and no. We should also add the question of subject matter, because although it may not normally count as being

part of the apparatus, it is indispensable to photography. Subject matter, without which photography would not be photography, has changed the most. There has been about 170 years of global change under modernity since photography's invention. I will return to this.

We tend to think of photography telling us something about subject matter, or at least about what subject matter can look like when photographed. But it also works the other way around. It is barely possible to understand photography outside of what and how it photographs. Subject matter affects what we think photography "is." For example, industrial subject matter (say, a steel and glass building) makes photography seem industrial. Nature (a forest or a cloud) makes it seem natural. The fleeting (a man jumping over a puddle) makes it a medium of the shutter. The immobile (say, a water tower) makes it a medium of the lens. And the desirable or the past (in the end, they are much the same thing) makes it an existential medium of connection and contact. The actual technical procedure of the photo might be exactly the same in each case (lens, shutter, film, and so on), but the subject matter seems to dictate how the photography is "felt." Here is a bizarre scenario to add to those that came up in the course of the roundtable. Imagine a formal photograph of a building. There is nobody in front of the building. The camera would seem here to be emphasizing its lens to us, with its powers of optical description of the thing and space before it. Imagine the next image on the roll is shot just the same but it happens to "freeze" a figure now running past. Suddenly the shutter seems to be a more active component. Imagine the building has since been destroyed or that the running figure is your since deceased lover. Suddenly the physical contact of light, the indexicality of the optically produced image, becomes more central. Perhaps it even becomes overwhelming, as it did for Barthes in *Camera Lucida*. The sense of a person or building "having been there" overcame him and flooded his conception of photography. Our grasp of lens, shutter, and light-sensitive surface

is never really this separate, but abstracting the idea may allow us to see how subject matter conceptualizes photography for us in different ways.

It can sometimes seem as if photography awaits the world to tell it what the medium is. I recall John Szarkowski's first major attempt at a definition of the medium when he was at New York's Museum of Modern Art. In *The Photographer's Eye* (1966), he came up with a set of categories. If a photo, any photo, "excelled" in one or more categories, it would be worthy of serious attention (his, and presumably ours). They were the frame, the detail, time, vantage point, and "the thing itself." It is a flawed if fascinating attempt, as many critics soon pointed out. Nevertheless, his inclusion of "the thing itself" is instructive. The other four categories seem to pertain directly to the procedures of the camera. The thing itself, that is, the subject matter, is resolutely not "of" the apparatus, yet it is necessary for the making of a photograph. We could go the whole hog and say that subject matter is part of the photographic apparatus: that would be a drastic redefinition, but by granting all the things necessary for photography a place in our thinking, it might get us closer to grasping the problem.

"The magic of photography," Baudrillard suggested, "is that it is the object which does all the work."[115] It is a suggestive idea (especially coming from the man who heralded "the precession of simulacra"). Might it suggest that beyond the art and craft of the image maker, it is the thing in the picture that is the real source of photographic meaning? Or is this itself an effect of photographic "magic"? In appearing to merely present us with the world as a sign of itself (as what Barthes called a "message without a code"), photography hides its own powers of radical transformation. Its transparency is more than it seems. It allows the photographer to camouflage the preparations that make the image of the object what it is. The photographer need not even be aware of the process, and that leads Baudrillard to conclude that "the joy of photography is an objective delight." It brings to mind Albert

Renger-Patzsch's famous essay "Joy before the Object" (1928). "There must be an increase in the joy one takes in an object," he declared, "and the photographer should become fully conscious of the splendid fidelity of reproduction made possible by his technique."[116] He argued for a photography of servitude, homage, and worship of the world's things. More than that, taking pleasure in photography for its own sake risked competition with the object (leading to the "error" of Pictorialism). For him, the task of the photographer was to imagine and then master an art of selflessness. The joy taken in photography would then be inseparable from joy taken in the world. The more selfless the photography, the more the delight would appear to stem from the object and the more enjoyable the making of the image. This transference of pleasure is always present in photography, but it can best be understood if we think of the most selfless and authorless uses of the medium: the copying of paintings for reproduction (I notice this scenario came up in the roundtable as a kind of "degree zero" photographic procedure). The photographer Edwin Smith described it thus: "Making an accurate colour transparency of a painting is perhaps one of the least creative of a photographer's tasks. If he is sensitive to the painting, there will be, if the work is admired, the consolation of having it to himself and of paying it the ritual homage of his own craft; though this pleasure may turn to torture when the work is despised—a condition not infrequent enough to be ignored!"[117]

Quite rightly, the vexed question arose in the roundtable regarding photography and pointing. It may be dumb of me, but this line of thought always calls to my mind the utopian concept of the "picture dictionary" as much as the thinking of Peirce. The best-selling pocket book *Point It* is subtitled *Reise-Bildwörterbuch / Traveller's Language Kit*. You can buy it in dozens of countries now. It comprises photos of 1,200 objects with a family resemblance to the straight "pack shot," as it is called in professional circles. Everything is there from Apple, Bicycle, and Caravan to X-ray, Yacht,

and Zebra. The principle is simple. Photographs are taken of various objects. The resulting images are assembled in the book. When words fail the tourist abroad, they can point at the right object in the photo. The book thus overcomes language barriers, providing of course we wish to communicate only with nouns. Photography's ostension, its capacity to point, works best when it points at discrete and familiar things such as named objects. (This is why conceptual art, in its disarming exploration of the camera as "dumb" recording device, tended to point it at banal objects.)[118] *Point It* makes no attempt to represent adjectives, prepositions, verbs, and so on, although this might be possible within limits: we could imagine a page of seascapes from "calm" to "stormy," faces from "sad" to "happy," or little tableaux such as "missed flight" or "lost luggage." The further photography moves from known objects, the less reliable its description of the world. If, as we are often told, the photograph is a universal form of communication, it is only at the level of the obvious and the already understood. It is clichés and only clichés that bind us in this increasingly fragmentary world, argued Gilles Deleuze. Indeed, what there is of a "global language of photography" is made up of images of hamburgers, carbonated drinks, cars, celebrities (people-objects), and sunsets.

I will make a brief social and psychoanalytic point here. Reality, Freud argued, is essentially that which gets in the way of our fantasies. In this sense, the photographic real is never just a matter of formal technique or "objective style." In photography, it is often the ugly that seems more real than the beautiful; the flawed seems more real than the perfect (that is why "cleaning up" an image with PhotoShop makes it look less real); plain buildings seem more real than named architecture; cheap commodities seem more real than luxury goods; work seems more real than leisure; TV dinners more real than posh food; the passport photo more real than the glamour portrait. As a result the photographic real is always marked at a social and political level. This may account, at least in part, for why it is that documentary photography, which

has invoked realism the most, has generally taken as its subject matter the various obstacles to fantasy and the various states of unfreedom that exist in the world (in recent decades, documentary photography has looked to consumption and commodities as subject matter, but the aim has still been to show them as obstacles—false, distracting things that in the end come between us and our happiness). No doubt this is in part a consequence of the "reality effect" of photography, derived from its blind inability to distinguish between what might be desirable in the picture and what might not. As the photographer Lee Friedlander put it recently, "I only wanted Uncle Vern standing by his new car (a Hudson) on a clear day. I got him and the car. I also got a bit of Aunt Mary's laundry, and Beau Jack, the dog, peeing on a fence, and a row of potted tuberous begonias on the porch and 78 trees and a million pebbles in the driveway and more. It's a generous medium, photography."[119] Uncle Vern and the Hudson were what Friedlander desired, but he got a lot more besides. But the point is that the photographic reality of Uncle Vern and the Hudson were guaranteed, so to speak, by their coexistence with the undesired stuff. (Interestingly, Barthes illustrated the same point with a startlingly similar example in his *Camera Lucida*. Talking of the André Kertész image *The Violinist's Tune* [1921], he asks, "How could Kertész have separated the dirt road from violinist walking on it?") Of course, if we are not interested in Uncle Vern or his Hudson, everything in the picture flattens to a banal equivalence with everything else. This is a phenomenon—seen as both attractive and dangerous—that runs through many of the conceptions of photography. It is there in the earliest accounts of the medium in the 1840s, and in different guises in Benjamin, Bazin, Barthes, Baudrillard, Batchen, and Burgin.

At a couple of points in the roundtable, there were allusions to a certain conceptual tension in the relation between the lens and the light-sensitive surface. As I have remarked already, the light-sensitive surface brings to mind matters of touch and contact,

while the lens implies separation. This is what makes photography "scientific," distant, and cool, yet also intimate, close, and tactile. It is also what leads Joel Snyder to suggest that what is indexed in photography is strictly speaking photons of light, not the object. (How could the object be indexed when a lens comes between it and the sensitive surface?) Light bouncing off the object passes through the lens, to be focused or not on the surface. Thus the photograph obtained is an index of that light, which may or may not be arranged by the lens in an iconically recognizable way. However because of the mediating presence of the lens (or pin-hole: we do not even need glass or plastic), the photograph is an index in another sense as well: it is an indication of the presence of a vantage point. That is to say it indicates a spatial relation between object and the light-sensitive surface. When we make sense of photographs, we make sense of both things at once—the viewed and the view. Again, a codefinition is in play between photography and the photographed.

I rather like this idea that photography and its subject matter define each other in both directions and that our conceptions of photography emerge from this. It allows for both a technical and a cultural reading of the medium, as something that "is what it is" and something that "is what we do with it." It also tells us something about why discussions that only admit to one direction—photography telling us about the world, or the world telling us about photography—tend to go around in circles, producing fixed but frustrating accounts.

Even so, accepting this two-way co-definition does not solve things once and for all. If we wish to discover why photography remains so elusive, the answers are to be found less within the medium per se, but in its status as recorder. Photography is inherently of the world. It cannot help but document things, however abstract, theatrical, artificial, or contentious that documentation may be. So the meaning of photography is intimately bound up with the meaning of the world it records. Moreover,

photography is a product of modernity. Modernity has meant change, in photography and in the social world. So the identity of photography as recorder is condemned to remain restless, mobile, volatile even.[120]

Joanna Lowry
Desiring Photography

Ultimately our relationship to technology does seem to be mediated by desire. One of the things that was fascinating about the roundtable discussion was an underlying sense that began to emerge of widespread irritation with photography itself; with the fact that though it seemed to promise to be interesting, it wasn't quite interesting enough. The participants, like all of us, wanted it to reveal something about the index, about the real, about time, but it couldn't yield quite enough philosophical purchase to enable these concepts to be developed and the discussion to move forward. It seemed in fact to be a kind of failed object of desire.

Perhaps, though, we are asking the wrong kinds of questions about photography. We don't even seem to be very sure what parameters that term refers to: is it the technology of production (cameras, printing processes, and so on)? Is it the set of cultural practices and discourses that have emerged around the uses of that technology? Is it an action—the practice of "taking a photograph" with all the social complexity implied by that phrase? Or is it the photograph itself as a peculiar type of image that perplexes us? The vague and shifting ambiguity of the object at the center of this roundtable discussion seemed quite typical of much of the wider thinking around the subject, slipping as it did between references to the sign, the medium, the practice, and the technology as though they were all the same thing. One of the things that is striking about the discussion is, I think, that all the terms being considered—indexicality, temporality, the *punctum*, the medium—seem to be the right ones, but somehow the discussion fails to move those concepts forward.

So my own inclination would be to turn the question around and ask not "What is distinctive about the photograph?" or "How can we understand the photograph?" but instead try to do something akin to what Wittgenstein tried to do with language and ask instead, "What do we do with photographic technology?" "How do we use it to make or disrupt meaning?" and "How does it intersect with the different discursive practices that sustain culture, identity, economy, visuality, or society?"

At the heart of this approach is the sense that we are dealing in the first place with a technology, or rather with a series of developing and changing technological practices. Obviously, any form of technology is part of culture and has certain types of social significance implicit in its very formation as an object as knowledge—and it also, by virtue of its design, produces knowledge in the form perhaps of what Vilém Flusser called "the program": it provides the parameters within which certain kinds of things become visible. But that is not the same as actually producing meaning. The interesting thing about technology is that it frames the world, thereby initiating change and making it productive, but it does not in itself produce meaning: meaning is not one of its inherent properties. Meaning happens when the technology intersects with discourses that are already in place. Photographs, as has been suggested a number of times by theorists like Barthes and Benjamin, are fundamentally meaningless: they are messages without codes. That is both the source of their magic and the secret of their banality. In this sense, they are more like natural objects than signs, objects that have the power (because they look like signs and because we project meaning onto them when we put them into circulation) to disrupt and disturb our understanding of the visual, of representation, and of the place of the image in culture.

Perhaps one of the reasons we are interested in these objects is because they slightly disrupt our sense of the security of the visual. The means of production of the photograph—photography's

chemical base and its automatism, its relationship to time and its reproducibility—are distinctive, as are its relationship to other technologies: film, digital technology, the Web, and mobile communications. These are all factors that contribute to this unease—they all present challenges to an ontology of vision centered on the self and on the body. Under the pressure of photographic technologies, the surface of the visual world around us becomes fragmented, doubled, folded, and confused. Photographic technologies create a topological disturbance of the visual: Anthony Vidler's exploration of the warped space of modernity seems to be particularly appropriate to discussions of the influence of photography.

But if photographs are not really best thought of as signs, then why has the dominant discourse around them been that of semiology? In a way it is ironic that for a long period of time, photography was the dominant terrain for the study of image analysis, and semiology was the dominant theoretical framework offered for the analysis of the photographic image. Semiological theories are particularly revealing when they are applied to certain very particular cultural uses of photography; they can illuminate our understanding of the ways in which particular cultural discourses and ideological structures operate in society, but they can only deal with photographs once they have become part of those discourses; fundamentally they deal with photographs as texts. Indeed it might be possible to assert that they are actual agents in the textualizing of photography. They have become part of the cultural apparatus that structures photography as a sign system. But it was always the stuff beyond the grid of denotation and connotation that really preoccupied us; hence our fascination with the *punctum* and with Peircean theories of the index and Lacanian theories of the real. These were theoretical frameworks that seemed to offer some way through the textual surface of the image to a putative origin of meaning, whether rooted in the natural world or in the operations of desire.

If we want to move beyond this impasse, what we need to think about is not what sort of signs photographs are, but how they subtly disturb our conventional understanding of what signs are, thereby creating a kind of uncertainty that is culturally productive, that we can exploit to make art, do science, and examine ideas. Most of the time, our cultural systems go into overdrive concealing this uncertainty—confirming the *studium*, protecting the program of the apparatus (as Flusser would put it), and creating forms of photography that obey conventional cultural rules and are rooted in fixed discourses of production and reception. But all these processes cannot obscure the fact that the photograph is a fundamentally uncanny object that can't quite be encompassed by our theories of the way in which signs work in texts.

Fine art practices have been important for our understanding of photography, not because of the tired discussions about whether or not or under what conditions photography can be considered to be a form of art practice, but because of the way in which certain forms of art practice have used photographic technologies and, in the course of their experimentation, revealed and made visible particular aspects of the technology. They have continually offered some rather different perspectives on what the parameters of the photographic might be. Surrealism, Conceptualism, performance art, postmodernism, and installation art have each, at different moments in time, played a role in suggesting how photographic technologies could engage with meaning in the world. They have responded to the technology's potential for inventing, documenting, archiving, mimicking, enacting, and engaging, in ways that are far more provocative than most theoretical debates on the subject. For these artists, photography was thought of less as being concerned with image making or pictures than as a technology that interrupted and confronted one's practice, challenged its premises—an intervention that made one have to think.

These practices have been particularly influential in the last couple of decades in shifting the discussion away from the

photograph as image and toward engaging with it as an object encountered in the world (phenomenologically)—or toward photography considered as a series of practices (performatively). But the prevalence of these types of philosophical approach have of course less to do with photography itself than they do with the ways in which photography is being used and deployed within culture. These are practices (and of course there are other social practices of photography besides fine art practice that do this as well: family photography, medical imaging, and webcasting) that put photography into discourse in a variety of different ways. They produce a variety of different contexts within which the photograph can be seen to problematize time, or indexicality, or the concept of the medium—but I am not sure that we can say that these problems are part of the ontology of the photograph itself. It seems more likely to me that photographic technologies produce or reveal them.

The problem of "medium" that kept emerging in the final part of the discussion interests me because that concept is part of a particularly complex historical discourse that seeks to link the materiality of the world with ways of producing cultural objects and ways of looking at and addressing them. In the 1980s, when photographic theory was dominated by cultural studies, the concept of "ideology" proved to be enormously productive in enabling discussions about the semiological operations of certain photographs to take place; I suspect the concept of "medium," as it is currently being reevaluated in the art world, is positioned in a similarly interesting place today. This rather specialist set of debates inherited from modernism does seem, in the current context, to have some potential for opening up a range of fundamental questions about how we confer meaning on the objects we produce, and how the materiality of the world is incorporated into that meaning. These are issues that seem more interesting in a cultural environment dominated by discussions about virtuality. In trying to interrogate how photographic technologies

intersect with changing discourses of "making" and "seeing," in using debates about "medium" not only to critique photographs but also to produce more complex languages about them, we may be able to open up a wider set of parameters for exploring the relationship between technology and culture and all the operations of the desire for meaning that mediate the two.

Carol Squiers
One Response

While it was fascinating to read pages and pages of discussion on the amorphously ubiquitous concept of indexicality in relation to photography, I was most compelled by the parts of the discussion where the conversation became "unproductive," as James Elkins put it. That apparently meant that everyone stopped talking. The unproductive parts of the conversation were those where images that were not made by artists were introduced.

This began, I believe, with Elkins's description of an image made with "side-scan sonar." The term alone got my attention, with its implications of an image-making system that could somehow record a "picture" of something without looking directly at it by using sound to create or "assemble" the pictorial data. Elkins points out that despite the fact that the image looks like a "lunar landscape," it cannot be "'read' like an image." As he describes it, what look like hills and valleys, modeled on a value scale, actually denote properties such as hardness and softness. And while the long vertical axis of the image records distance, the shorter horizontal axis records *both* time *and* distance.

A quick search on Google for "side-scan sonar" revealed an array of military, academic, and commercial uses for side-scan or side-looking sonar, including locating and mapping the existence of mine fields on the ocean floor and detecting and surveying the position of maritime archaeological artifacts. It is a technology that can be related not so much to the idea of surreptitious looking-from-the-corner-of-one's-eye as it is to the notion of sweeping

one's eye across a visual field. Except that the sweeping is done with sound, underwater. And although Elkins maintains that the visual product that results from this technology cannot be "read" like an image, many of those who research and work in this arena refer to the final product as an image. (See, for instance, the Pentagon reports on side-looking or side-scan sonar [SSS] data sold by Storming Media, a private merchandiser of such information.) So the definition of "image" is once again pried open to accommodate a visual entity that does not fit into traditional notions of the image, just as the definition of the photographic has been enlarged by digital imaging technology.

Unlike traditional art-making mediums, the "photographic" has a wide range of uses that continue to proliferate. We should not claim the images made for those other uses in the name of art. But we should take seriously the fact that new types of image-making systems such as the digital do form some kind of continuum with traditional photography, just as photographs made for many different purposes form a continuum that includes photographs made by artists. It is difficult to see how photographic art can be theorized in isolation from images made for functions other than the artistic in the ever-expanding field of photography. The medium keeps mutating, and artists certainly attend to that fact.

Patrick Maynard
We Can't, eh, Professors? Photo Aporia

The Art Seminar is a two-part critical consideration of some terms regarding photography, with which some people have been perceiving, thinking, and communicating over the last three decades, albeit only those in a community within academic art history. Outsiders will be puzzled. Not only does the conceptual basket tip only a few items onto the table (indexicality, referent, vestigium, *punctum*, aura, temporality, and the medium); the symposiasts themselves don't reach much agreement about what these words mean or even of what use they are. The result is an

impasse, followed in the second part by reflections on why that should be, and closing on a note of despair: thus the moderator, James Elkins, concludes that "this conversation is unproductive." We conclude far from a theory of anything.

The second part of the roundtable discussion raises the wider question why, within the humanities, the sort of thing reflected on in the first part should exist. A good question: after all, we are allegedly considering "thirty years of academic writing on photography" during which period, willy-nilly, the panelists have been forced to change their thinking to deal, even in nonexpert ways, with the Internet, globalization, new diseases and the return of old, the breakup of nations, genocide, bubble.com, pop media, as well as scientific topics such as black holes and retroviruses. During that time, neither photography nor its many important applications have stood still. Near the beginning of that period, sharp challenges were put to the whole history of photography as a fine art and the role of museums; those challenges were followed, in the 1980s, by photography's success in art galleries. Next came mass-market digital cameras, editing and storage, camera-phones, and the Internet. (As I write, Kodak has stopped making the Carousel and has laid off thousands of employees from its filmworks, while Dixons in the United Kingdom announced it would no longer sell 35mm cameras.) Photographic historical research during those decades produced widely interesting, informative, and clearly written general histories, enhanced by improved reproduction technologies, as well as researched, focused studies (by art photo-historians not represented at the roundtable), often in connection with exhibitions; and museums and archives expanded their photo holdings. All that, one expects, would have inspired new ways of thinking, virtually forcing new conceptions upon inquirers. What, then, accounts for the conceptual stagnation registered by The Art Seminar?

For answers, as well as solutions, we might consider the roundtable and this book to be a dialogue in the Platonic spirit, given that Plato's Socratic impasses or aporia are never really,

as the term literally indicates, "no way" (in Elkins's expression, "dead end") situations, but rather goads to readers' critical thinking. This is why those dialogues are such good teaching tools: by skillful means they draw our thoughts from us, inciting insights. Plato's characters will often say outrageous things, prompting readers to make their own formulations; but they will also say valid things, which are left for us to develop. Indeed the roundtable opens in the very style of those dialogues, by citing an authority figure, after which popular terms due to modern sophists are brought in play. Also in Socratic dialogue style, equivocations and red herrings punctuate the discussion, testing exasperated readers. Shades of Plato's hair-splitting sophist, Prodicus: there is even a comic dispute about three ways of understanding the word "index," based on pointing (apparently including an index finger), all conducted while the panelists agree they cannot really understand the authoritative source in Peirce.

As for outrageous motivators, my favorite is the uncontested idea (proposed by Elkins and Joel Snyder) that only proximate causes are causes: that if we are precise about the physical causes of the states of photos, it is all a matter of photons. Plato would have enjoyed the sophism. By similar argument, what caused the doorbell to ring was the clapper, not the person pressing the button or a short circuit. This means that I should not have fretted all those years about what was causing the irregular fog patches in some but not all rolls of film in my camera, because the answer was always photons. This is a true answer, but one of the sort that Plato and Aristotle ruled out as not explanatory. Also not a useful answer, since by its terms I would never have discovered that the physical cause was a leak around the rewind release button, which spilled light onto the film only when I pressed it to change rolls outdoors, and was easily mended with a little square of electrical tape. Diffuse on one side, the light traces on my negatives revealed a distinctive curved shadow on the other side, caused by shielding within the camera, which is how I worked out the cause. Since

I do not change rolls in direct sunlight, the affected exposures were rarely entirely ruined, as most of the darker and lighter states of the negatives and prints had other causes—the intended ones. These causes were the physical states of things, producing patterns of light on the film, through the lens: in other words, states of the things I photographed—people, buildings, plants, seas, clouds, skies. If the shapes and reflectances and motions of those objects had not caused those states of the film, they would not have been photographed: for example, if I hadn't gotten them into the field of the lens, if I had forgotten to remove the lens cap or load film, or if conditions were too dark or too bright, they would not have appeared in my photographs. That is part of what we mean by "photograph of." Accordingly, looking at the photos we can draw quite dependable causal inferences about these states and things, just as we can about the rewind button, but more precisely and over a much wider field, since there we have not an accident but a carefully engineered causal channel (for which I paid good money), stabilizing background conditions so that differences in just those causal variables would be recorded, the camera and film comprising a narrow filter. Medical and dental x-rays work by that principle, as do surveillance cameras. Thus going "from what you see in the photograph to what was actually in the world at the moment of exposure," far from confusing "the way we talk about photographs" (as Joel Snyder says), is essential for many of them. All this should be too obvious to need expositing.

Besides being provocative, there is a more important way in which the Socratic dialogues are usually not truly aporetic. Plato's characters often indicate good answers, the crucial question being how to take them. Euthyphron is meant to be right that piety consists in service to the gods (after all, Socrates defends himself with that very word in *Apology*), Menon right that virtue is a power to acquire fine things, Thrasymachus that justice is advantageous, Laches that courage is endurance, and Nicias that courage is knowledge of what is good. But service to the gods

doesn't consist in offering bribes, fine things are not gold and silver (without knowledge of how to use them), one's advantage is not simply egoistic, and the brave have both guts and judgment. There are several such moments in the roundtable. One is at the start of the second section, when Jan Baetens sensibly suggests that art historians put aside their scholastic terms and authorities and look to other photo communities for fresh, relevant conceptual resources. The idea is underscored by Diarmuid Costello's reference to the "instrumental uses and utilitarian functions" of photography and "a bewildering array of photographic applications," such as sonic imagery and PET scans, a comment that is expanded in Elkins's citation of sonar scanning, where the visual image of the seafloor shows not topography but hardness and softness. But just as my interest was raised by attention to some concrete examples, the lead was blocked by Costello's provocative claim that "no one seems to know" how to make such utilitarian uses relevant to our topic. Readers are invited to look closely at what it is that is not known, given earlier hints from Costello and Elkins: "what is the radiographer going to be able to say that will take us forward?" and "in no case is it clear what discourse could be extracted from those examples." Thus the moderator himself can conclude that "photography resists conceptualization," and is even "not conceptualizable." In the terms of Plato's *Phaidon*, we are invited to become photo-misologues.

It is best, then, to take all this as a joke or a hint. In his dialogues, Plato's humor often turns on ironic discord between what people are saying and what they are doing in saying it. Menon loses his grasp of virtue as knowledge by accepting a bogus dilemma just as he is informed how true beliefs can fly away; Laches fails to stand his ground; Nicias loses his head. With a little thought, we should be able to get the central joke of the roundtable. Since the context of the discussion is art history, the Platonic irony would be if these alleged photo-historians overlooked art history in the course of their conversation, and then declared the situation

irresolvable. And since that is exactly what happens, we need only follow the hint to see how photography, far from being "difficult to conceptualize," is easily understood.

After all, unlike the emergence of drama, stringed instruments, or painting from the mists of prehistory, photography is something we invented, in very recent, well-documented historical times. We have put it to our uses: we are inventors carefully explaining and marketing our "applications," as they were called in the nineteenth century. Each stage of photography's many reinventions was deliberate and quite well conceptualized at the time, and is well understood now as part of a connected story. Photography is no more difficult to conceptualize than are the combustion engines and telegraphs invented at the same time (by some of the same people), or sound recording, or radio. That photography's many uses and great importance, for good and for harm, should form a complex social and political set of stories is no surprise, but we would not on those grounds count copper-alloy technology, money, the modern harness, moveable type, eyeglasses, or automobiles as not conceptualizable. Furthermore, that photography should, like those other inventions, continue to develop technologically—recently, through digitalization—is entirely to be expected.

We do not need to do a great deal of work here, since the general history of photography has been written very well, many times, though not usually by academics. Let us consider some established empirical facts of the case. What is now accepted as photography's first invention was due to Niépce, and his interest was in copying prints. Lithography had only been around since the turn of the nineteenth century, and there was an ongoing interest in technologies for making multiple copies not only of prints but also of musical scores and autographic materials. There was also interest in copying ancient inscriptions: this shows up in the French government's arguments for buying out not only Niépce's but also his partner Daguerre's inventions. (If you think

this is just incunabula, think again: computer chips are printed by photo methods closely akin to Niépce's, not Daguerre's, right down to the material he used.) So the first use of photography, the historians report, was neither depictive nor detective. Photography in the age of mechanical reproduction? That is the age at which it was born, and that function has never left it. Witness the predigital setting of typeface from "camera ready" copy. We do not think of what you see on such pages as depictions of the original type, nor do we try to detect the originals; we simply take them as copies. One could think in these ways—perhaps technicians do—and in this lies our first important finding: it is a question of use, of function.

Cameras having been around for centuries, Niépce soon got on to making pictures of things with them, once he got his chemicals sufficiently sensitive, since the camera image is much weaker than the sunlight contact printing used in his reproduction process. As is well known, Daguerre's and Talbot's interests were from the start pictorial: the former used photography for commercial purposes with his painted dioramas, and the latter put photography to personal use, since he could not draw. Yet Talbot's paper materials were at first so insensitive that he could not produce camera images. Besides, what he got was negative, since he could not pass enough light through the paper to make a print, so he had at first to stress the sort of superimposition light tracings mentioned by Graham Smith, which need not function as depictions. When Moholy-Nagy and Man Ray got around to using these effects artistically, there is no puzzle involved in the fact that their results do not seem like depictions. We could, of course, put such shapes to such use, as depictions of lace or leaves, just as we can use hand shadows and imprints as depictions, and if we did they will look rather different. A child with a vivid imagination who sees shadows on the bedroom wall as threatening animal forms sees them differently from the adult who only sees moonlight: this would show up in eye movements as well as in verbal responses.

Well, as everyone knows, Talbot rapidly improved his processes and got his camera negatives and prints, and the oft-told stories of further developments and uses of photography do tend strongly to the pictorial. Still, histories of photography normally pause to note its other functions, especially that of photomechanical reproduction in mass publications following the First World War (sometimes called photography's "second invention"), which is not a depictive use, even when what it reproduced were depictions. And we should not overlook the recording and detecting functions that were running in tandem, either. Talbot was a good enough scientist to see that his short-wave sensitive materials were recording rays invisible to our eyes, and he thought these might be used for detective work. The subsequent scientific detection uses of photo materials are of great moment, from the discovery of radioactivity from fogged plates through the star spectroscopy that allowed us to discover stellar elements, redshift, and the expanding universe—all without depicting a thing. There are many similar cases, which take us back to detecting the light leak in the camera from nondepictive marks overlaid on depictive ones. Consideration of some recent ones should be helpful.

During about half of the thirty-year period during which theorists have allegedly not found new ways of understanding photography, scientists were changing their ideas about the most distant parts of the universe, partly through photography. Put aside art for the moment and consider the light shed on our topic by these "instrumental uses and utilitarian functions." The *Galileo* orbiter flight to Jupiter (1989–2003) featured, aside from its seven-part atmospheric probe, an array of instruments including an ultraviolet spectrometer, a plasma-wave detector, detectors for energetic particles and for dust, and a photographic camera. All of the instruments picked up data, stored them, and sent digital flows to Earth, which had to be received, stored, analyzed, and deciphered. The nice thing about the digital bits streaming from the camera sensor is that they could be processed so as to

be understood pictorially. "Pictorially" can be explained without mentioning visual resemblance. It just means that the data could be fed into the human visual system, a powerful natural information processor. (From the Galileo website, this applies to a lesser extent to other senses, too: "scientists sometimes translate radio signals into sound to better understand the signals. This approach is called 'data sonification.'") Maybe someday this will include touch.) As to the visual transfer, filtering, false color, and other enhancements were employed (I wonder why people assume that computer manipulation must falsify images) to adapt it for our cerebral equipment. (Vision is part of an information pathway that is optical, chemical, and electrical.) Special training was involved, as in all technical visual tasks.

In considering camera channels, we need not stick to pictorial outcomes. Photo information channels have long been used not only in parallel but also in relay to pass other kinds of information for reproduction, detection, and recording, as well as depiction. A bit closer to art, we have sound film. There, vibrations picked up by a telephone were amplified, then used to modulate a light valve, by changing the slit size between two wires carrying the current, photographically making a sound record on the running film negative reel, so that those variable-density marks, when printed together with the picture record, might be illuminated and read by a photoelectric cell controlling an electric current, which was passed by wires to horns behind a perforated projection screen, which, by telephone principles, converted them back to sound waves. Thus a depictive outcome, sound depiction: audiences could imagine hearing what they were imagining seeing. (Contemporary movie projection reverts to a simultaneous sound disk, a CD rather than the old platter.) This analogue causal chain of mechanical, electrical, and light transductions, as explained by "Professor Western [Electric]" in a wonderful Max Fleischer short from 1929, *Finding His Voice* (now in public domain and available on the Web), is a very instructive case, because the ingenious

combination of telephone and photographic technologies prefig-ures the *Galileo* spacecraft's remote sensing, but with a difference. The photographic process exemplified in the Fleischer short was not output as visual depiction: rather, it was a step in a record-ing process issuing in sound depiction. Besides this, the example underscores a second basic conception, which it is also fatal to neglect in our context of conceptions for photography: that such techniques typically combine, and in various ways.

Putting together the ideas, we can derive from these few straightforward facts of photo history three conclusions: (1) that photographic processes have had multiple uses since their incep-tion; (2) that these are human uses—that is, due to the functions we give them; and (3) that these techniques and functions com-bine with independently derived ones. From these, an obvious question arises: can photography's *own* techniques and functions also combine with one another, as Jonathan Friday insists?

The answer is yes. The *Galileo* example showed how the photo scanning, recording, transmission, and eventual interpretation techniques were assisted in their last stage by presentation of the data in pictorial shape, available because that signal channel began with optical lenses, forming camera images. What were the functions of those images? For scientists, they aided detection; for the general public, they provided the impression of actually seeing the surface of Jupiter, or a comet hitting it, or ice on its moons—as though *Galileo*'s telescope had been improved a hundred thou-sand times. Get visual: that photo-pictorial impression, shown on TV screens and in newspapers (and Web-posted as "*Galileo* Top Science Images"), is essential for public support of the scientific detection efforts in modern societies, even more so than reports on charged particle fields. That is part of the function of the depiction function. Notice how the prominence of the detection and depic-tion functions tends to exchange places here: the vivacity of the depiction—and modern audiences do care for vivacity (indeed, will pay extra for an invisible vivacity factor called "real time")—is

increased by the knowledge that it is also a detection, the depicting states of the display being caused by the very things depicted. To say that we have this sense with all pictures, that photos are no different in this, is a sophism. The Galileo website also shows paintings of things not photographed, such as the probe's descent into the planet's raging atmosphere. Seen as a painting, it looks different, because our perceptual activities change.

All this is consistent with treating visual display photos of things, including those of Jupiter, in other ways, for example simply as depictions, with no interest in seeing the planet itself. It is consistent with treating these images nonpictorially. Someone might just like the patterns of the "Conamara" region of the moon Europa, made by "interplay of surface colors with ice structures," or the red in the blue of volcanic eruptions on Io during an eclipse. Or, for depiction, photos of one thing may be commandeered to depict quite other things, as pietra dura stone is inlaid to depict textures of wood or feathers. Thus an image of ancient impact craters on Ganymede might be used to depict tree bark. Once again, use or function is the guiding idea.

Let us step back to summarize our historical account of photography so far. Using some simple history, we have considered some of the array of photographic applications, which, rather than being "bewildering," is quite intelligible and suggestive. Everything reported has been empirical, easily tested for truth and relevance. No arguments have been based on authority figures, and no jargon has been employed: everything has been stated in nontechnical terms. Much of what has been reviewed is important to billions of people and needs no specialist pleading. It's all very interesting material that is sure to continue to develop, and none of it is difficult to understand. Furthermore, this grouping of ideas and information, rather than turning in on itself, opens out, suggesting avenues of exploration.

Unconceptualizable? "No one really seems to know what to do with [all the uses that photography has]?" As "Mutey" in the

Fleischer cartoon remarks, "I can't, eh, Professor? Well, you just watch me!" We can conceptualize photography in its many forms, and we can conceptualize its past, present, and probable future in a clear and straightforward way—and with no mention of photographic "truth" or "authenticity," which prove unnecessary and even misleading. They, like the literary jargon terms of the first part of the dialogue, should be set aside, because our concern is not with sonorous words, and their histories and connotations, but with useful conceptions, which may be expressed in various ways. As Sabine Kriebel remarks, art historians need not keep these matters "at the level of the mysterious or metaphoric"—that is, unless they actually wish them to appear "insoluble" (as Jim Elkins apparently does). From this, we see why our dialogue should not have been about words, after all. What the art historian of photography has to learn from the radiographer is not what the radiographer will say, for it is information and ideas, not "discourse," that are to be "extracted from those examples."

How strange that people should not appreciate, either from documented history or examination of their own behavior, that we have given photography a number of independently important functions, and that we have combined these in different ways, just as we use the point of a knife to pierce, its edge to cut, its flat to spread, and its handle to pound—and that we sometimes cut in order to spread, and spread in order to cut. So it is with many of our tools, including our natural ones such as our hands, which Aristotle called "the tool of tools": hands are not only multifunctional, their functions combine in different ways, as they combine with those of other tools. Technological inventions such as photography or computer digitalization, of course, have no natural functions. They do have natural properties, in terms of which we can give them functions, depending on our interests, which may or may not be artistic. What such inventions allow is artistic use of various of their developing resources. Kept in mind, the implications for better understanding photographic arts are

clear. We have identified several independent, highly meaningful photographic functions, which can be used for artistic purposes in a number of ways. In addition to these factors, we have their combinations and their interactions among themselves and other art forms. Finally, modern art being self-aware, we also have thematizations of and critical reflections on all that. But if the photo artists "know what to do" with photography's many uses, why cannot scholars?

Given that most visual art is depictive, or at least representational, there is much for the historian to understand regarding photo-representations as art, but that is too large a topic to consider here. We know that much of the meaning of works that are representational is not strictly representational. For artistic meaning, there is much to investigate in photo functions based on their causally formative processes, including those of detection and recording. A good place to begin might be with our artistically relevant interests in all forms of visual art in terms of such causal processes, since even where we are centrally interested in what works depictively show, we are also interested in what, causally, shows up in them. Among Snyder's more provocative claims is that "there is no interest in the medium of photography," that such an interest plays no part in how or why the audience "looks at the work": more Socratic irony, it seems, since the statement undercuts itself by referring to "a work," with the highly relevant implication that it is an artifact made from materials and presented on purpose. More specifically, wherever artifacts are put on display, many, though not all, will take an interest in how they were made, from what they were worked up, and with what skills and intentions. This will form part of their perceptual experience—not least because many audience members are interested in making things themselves (a point usually overlooked by theorists). That holds for kinds of photographs as for textiles, glass, ceramics, furniture, buildings, graphics, paintings, metalwork, carving, and inlay. It

is likely that many viewers will wonder how Gursky produced his enormous photographs.

As any art historian knows, what a work is made from or of, and how it was made—by what processes and skill—and for what purposes, may become parts of the artistic content. It would be a remarkable fact if this should not hold for photography today. Photo materials frequently matter to audiences, and so do processes. Just as such causally formative factors as the artist's movements of hand, pencil, or brush are typically of interest and importance in our perception of works of calligraphy, drawing, and painting, causally formative factors such as the quick or slow actions of the camera shutter, original and reflected light sources, the reflectances of the objects photographed and their distances and movements relative to the photoreceptor, dye-transfer processes, and digital bit-depth may all be relevant aspects of the picture's meaning. It is clear that no one thinking only of the subjects of photographs could make much sense of art photography since the 1920s. Artistic explorations of any of these dimensions aside from the depictive are received as avant-garde, as "testing the boundaries" of the medium.

It would be best to develop such ideas further in the context of a close study of the works of individual artists, as art historians not represented on the roundtable have been doing for the past three decades. By putting aside notions of theory and trusting our own resources, new conceptual tools will arise inductively, through attention to particular cases: as one art historian states it, "less meta, more meat." I hope that this sketch suggests how a different approach to photography is provided by even brief consideration of a few clear, objective facts about the history of processes and uses. And as our topic is art, let us keep in mind that our hard-won modern idea of art has to do with its freedom. In the spirit of joy, curiosity, and inventive imagination exemplified by the Fleischer cartoon, I recommend to artists and audiences that they continue to explore photo processes, old and new (as Joel

Snyder says, "working through the problems of the medium"), and thereby explore both the world and themselves, putting aside the self-conscious constraints of other people's terminologies. Photo art will take care of itself, as it always has.

Vivan Sundaram
Recycling Photographs

I introduce myself as an artist living in Delhi to speak about the photographic medium via my practice—first as a "narrative" painter and, since the 1990s, as an artist working with found objects and photographs as well as architectural-scale installations and videos. Conscious that the introduction of the photograph to make an artwork implies a radical shift—"the privileged medium for the antiaesthetic moment in recent art history"—the moment of questioning included the fact that in India "painting was [and still is] celebrated" (Diarmuid Costello's phrase, with my addition) in the marketplace.

Theorists on photography propose a greater inclusiveness of voices, and they foreground an active relationship with art history with its new framing devices. How photographs acquire the status and scale of painting has been discussed (Jeff Wall, Gursky, Struth). But these star positions do not reflect the great diversity of positions, many of which would be opposed to photography as spectacle, as grand painting. How do we perceive the medium, the object, given this increasingly thin divide between photographers and artist-photographers?

As an artist I have mainly made photographs from existing photographs, and these have been figurative—the few that I have taken myself have been informal still lifes. Working on the image formally, the photograph can acquire an iconicity and enter the domain of art. But appropriation, when valorized in antiaesthetic terms, also implies critiquing notions of authorship, of a unified style. While a playful, or cynical, grabbing of images for surface effect characterizes a great deal of this genre, appropriation can

reinvest an existing photograph, a documentary shot, with meaning and recontextualize its references. The photographic medium has intrinsic properties that allow transformations of the original with greater facility than paintings and drawings. The copy of the copy of the copy makes it possible to shift register, to allow a dialectical reexamination, to propose new meanings.

The discussion among theorists often refers to the relationship between paintings and photographs as with Michael Fried ("because he can subsume them under a set of concerns derived from painting"). Just as "The Rhetoric of the Frame" has been theorized in complex formulations vis-à-vis painting, theorizing the frame of the photograph can yield a range of perceptions—both about its structure and the manner of looking.

Barthes commented a quarter of a century ago, "The only way I can transform the Photograph is into refuse: either the drawer or the wastebasket." The same could not have been said of paintings or drawings. This becomes all the more relevant since photography has now such a high premium with artists. This downgraded, throwaway aspect of the medium allows the artist to interrogate the image, the material on which it is printed, the manner in which it is presented and displayed. The innovative placement or repositioning of the photograph has bearing not only on the way we read and interpret the image; the dismantling of the traditional frame for photography—completely discarding the frame or introducing the possibility of new framing devices—allows a two-dimensional work on paper to acquire sculptural dimensions. The frame and the varieties of support can give the photographic artwork a new object status. Since the material support to which the image is fixed becomes an integral part of the artwork, an analysis of its totality must include both its pictorial and sculptural dimensions.

There is no denying that the changes that have taken place in modern sculpture—moving from the pedestal to the "expanded field"—are major in comparison to photography. But we must engage

with the displacements that have taken place. As Joel Snyder remarks, "[Y]ou don't instantiate everything you know about photography; you try to instantiate what, within this set of constraints, can be produced that is new—because novelty is the driving force."

So these opposite tendencies prompt James Elkins to say that "photography resists conceptualization in that it can be seen as not one but several practices or—to bring in the more charged word—several media." The theorizing needs to develop, to fine-tune, observations on the crossover whereby interpolations of the photograph create an expanded field across several media. The driving force of novelty has to engage in a critical discourse about the image and its politics of representation in order to get back to what the photograph has always dealt with: *reality*.

Since no images will be reproduced in relation to the discussion, I will describe my artwork with the hope that I can suggest connections being proposed in theory. I will first speak about two sets of works that involve a crossover from photography to sculpture to installation. In the first case the image was "appropriated" from a newspaper, the *Times of India*. Hoshi Jal's black and white photograph showed a riot victim, a man lying dead in the middle of the street in front of an upturned rubbish dump: two thousand Muslims had been killed by right-wing Hindu fundamentalists in the 1992–1993 Bombay riots that followed the demolition of the Babri Mosque in Ayodhya. This marked a tragedy in independent India as it challenged the modern and secular foundations of the Indian constitution. I "enshrined" this photograph in my 1993 installation titled *Memorial*.

Many artists had earlier worked on the concept of repetition; I used the copy negative of Hoshi Jal's photograph to make prints of different exposures and sizes. Going back to certain Surrealist devices of "assaulting" the image, of replicating an act of violence, a wounding/healing voodoo, I pierced the fragile photographic paper, *the dead body*, with small and big nails. Framed "reliefs" were displayed on the wall, enlargements were placed in vitrines and kept on the ground. Hundreds of small black cobbler nails or very large

handmade nails were placed on the body, to make a grid, a wreath, a burial mound, a funeral pyre, a shelter. The "low-relief images," overlaid with nails, forced the viewer to read the same photographic image simultaneously as an act of violence and redemption. The same photograph was mounted on the flank of a large metal box, minimalist in appearance; the enlarged head of the dead man was encased in a three-inch thick Perspex sheet, curved to make a protective shield. This was placed on a metal trolley with an attenuated handle to conduct the coffin, metaphorically speaking, through the street. I called the work *Gun Carriage*. Circumambulating the object, the photographic image is absent and present.

The photographic works in *Memorial* are part of a room-size installation. We know that the theatrical dimension and the phenomenological encounter in space that an installation stages alter the experience of the photographic component. The roundtable discussion constantly skirts the new antiaesthetic of art history, by referring only to painting. Does not the photograph as part of an installation force us to theorize it differently? I believe it is necessary to insist on the complete shift that installation art has brought about—consider the work of Kabakov, and the theorist Boris Groys.

My second photographic installation is made up of photographs displayed on the floor, to convert—in the manner of Carl Andre— three-dimensional objects into a two-dimensional experience. I took photographs from a secondhand market where the items are sold on the ground and composed them like a still life. Presented on the floor, these 300 images with five copies each made a pile: 1500 postcard-size photos encased in red metallic frames, scattered to make a circle with a 10-foot diameter. The viewers scrambled through the pile to look at the small photos, but also, responding to the cash-and-carry sign, to take them away. The look and meaning of this work I called *The Great Indian Bazaar* produced another kind of exchange-value, another way of looking at the poverty of items put up for sale. Quite obviously, a selection of the same photographs framed and displayed conventionally would be read differently.

More than one speaker in the roundtable mentioned that the digital has not been central to the discussion and that there is not a fully developed discourse around it. I would like to give an example from digital photographs I have made and link my attempts to some of the observations thrown up in the discussion about the digital. I have been engaged with my family album in a very different manner from Margaret Iversen's friend. I think the digital allows a much greater sophistication and complexity than Iversen's friend allows (she was "spending a lot of time perfecting them, so that her family history is now a complete simulacrum of what it was before she digitally 'improved' it.") Since 2001, my family photographs have gone through the scanner to make digital photomontages in a series I call *Retake of Amrita*.[121] The photographs taken by my grandfather, Umrao Singh Sher-Gil (1870–1954), belong to the period 1894–1948. My photographs bring in some elements of what Lev Manovich calls the 1920s montage; they also support the view that "digital photography is a radical shift, but in practice there are continuities" (William J. Mitchell). In the series I maintain the look of period pieces, even indulge "in Barthesian melancholy of the 'that-has-been.'" But my intention is "an experimental, open-ended way with the camera, I'm tempted to say future-oriented, as against Barthes's preoccupation with the past" (as Margaret Iversen says).

Rosalind Krauss writes, in "A Note on Photography and the Simulacral," that "if you are aware of what Bourdieu says (that photography serves a self-definitional function for the middle class), there are two things you can do: either give up photography, or identify yourself with a special kind of photographic practice, which is thought of as different." The photographic family album from the nineteenth century is the most practiced genre serving a definitional function for the middle class to find its self-image. One can engage with this "middlebrow art" digitally in a way as to make a different (*high art*) photograph.

The digital tool allows the image to be recontextualized and examined in a social or psycho-analytical manner. The colonial or orientalist representation can be recoded, replayed through critiques of those positions. The digital allows the possibility to take a photograph, a snapshot from a family album, and construct a narrative of relationships, engaging with the visual information to gain a greater depth of understanding of the social and personal than what the person who took the family pictures could foresee. You can shift to the playful, the provocative; you can lie to tell a truth. A sophisticated use of the digital works on the edge: the photograph is of a particular time and place, a real moment; you can make the viewer experience a slippage, a perceptual shift, so as to engage with its presentness.

There is a constant double-take or, in cinema terms, "a retake" of the shot. The photograph without a narrative content can acquire the quality of a film still, where a past, present, and future are proposed within a single frame. A conventional, realistic photograph scanned digitally can multiply points of entry and exit. A sensuous delight in the photograph is stepped up to demand from the viewer a reflection on "a certain aesthetics of depersonalization, chance, the encounter, and surrealist thinking and how all this reappears toward the end of the twentieth century" (Margaret Iversen).

The art historian Deepak Ananth, writing about my digital series, *Retake of Amrita,* shows how Amrita

> is foregrounded as the object of a gaze.... But now the subterfuge of digital manipulation allows her to be placed in company with, precisely, the bearer of the gaze for whom she originally posed.... The female narcissism that was disclosed in Umrao Singh's images of his daughter is now conjoined with the male narcissism evinced in the innumerable self-portraits that the photographer took of himself. This is a doubling that duplicates the structural condition of narcissism itself. These are spectral

doubles, related to the theme of the doppelgänger on one level, and to surrealist photography on the other.[122] The doubling procedure allows for the superimposition of a painted image and a photographic one, the seamless juxtaposition of images issuing from contrary visual contexts: a contrariness or opposition codified in familial, erotic, vestimentary, geographic, and class terms. The antinomies of the divided colonial subject are brought together in these… their pastness confronts the present in which we gaze at them. Benjamin might have described that confrontation as "dialectics at a standstill."[123]

I will close by using another art historian's words on my digital photographs. Marian Pastor Roces elicits extended tropes from the very technologies of digital montage. She suggests that I am "the artist whose manipulations are a kind of dreaming, and a curator who stages the context of interpretation." She says:

> He is the archivist who assembles and organizes the past; the photographer who understands that the medium is a kind of writing; the author of fictions who arrives at truth via contrivance; the director re-staging scenes; and the archeologist who breathes meaning into relics…. He renders the photographic "record" unstable (for it contains only the promise of truth), exposing it as malleable (for it contains germs of ideas that may be trained towards present and future concerns), recovering it as art's ready-made (for they contain a "readiness" for recycling).[124]

Rosalind Krauss
Notes on the Obtuse

1. In the panel's opening, a censorious and circular discussion about the status of the index as an adequate tool for the analysis of photography, only Margaret Iversen raises the relevant issue of the "work" the tool might be doing. It

is, indeed, my contention that whenever a critic or writer reaches into the vast possible literature for a theoretical term with which to deal with culture, it is to perform a task, making the question of the work the concept is doing the only one to apply.

2. As an active critic in the 1960s and 1970s, my irritation with the widespread use of the idea of "pluralism" was intense. The notion it expressed, that artists have a wide range of options open to them at a given point in history, conflicted with what I saw as Heinrich Wölfflin's correct position that "not everything is possible at any one time." The irritation led to the quest for a "unified field theory," the basis for which turned out to be the indexical sign.

 The field itself included many practices that depended on photographic documentation and reportage for their very existence, examples being Earthworks, Body Art, Performance, Dance Theater, and Conceptual Art. Aside from gallery exhibitions, the location for such documentation was most often art magazines, in either essays devoted to the work or articles written by the artists themselves. Thus these photographs almost never appeared without a caption. The theorist to whom I could turn for analysis of the relation between photograph and caption was Roland Barthes, specifically "The Photographic Message," where he produces the characterization of photography as "a message without a code." The next place to find an elaboration of this rather gnomic pronouncement turned out to be Peirce's "Logic as Semiotic" in which a taxonomy of the sign is divided into the possibilities icon, index, and symbol—the last (symbol) being conventional language (Barthes's idea of "code"), and the second (index) being the analogical "messages" of which Barthes speaks. In "The Third Meaning," Barthes pursues photography's resistance to language by making

a distinction between what he calls "obvious" meaning (at an informational, symbolic level) and "obtuse meaning" (the signifier without a signified or the "nothing to say"), which relates to Julia Kristeva's concept of *signifiance*, and which, in *Camera Lucida*, will develop into the concept of *punctum*—a traumatic suspension of language, hence a "blocking of meaning."

3. Barthes's "Rhetoric of the Image" develops this paradox more fully, by dividing the photograph into connotation and denotation. The former creates the combinations of textual effect that attract clichés of characterization to themselves (for example, connation links the colors red, green, and white to form a stereotype of Italy, which Barthes shortens to Italianicity) to produce sets of meaning. Denotation, on the other hand, is tied to the photograph as analogon, or as unbroken transfer of a real scene. It is here that Barthes cashes the check his analysis has written. As he speaks of the connotational text being "innocented" by the unanalyzable denotational fact, he concludes we are "thus confronted with a typical process of the naturalization of the cultural."

Barthes's language needs to be quoted word-for-word here: "the discontinuous connotators are connected, actualized, 'spoken' through the syntagm of the denotation, the discontinuous world of symbols plunges into the story of the denoted scene as though into a lustral bath of innocence."

4. Joel Snyder and I have been arguing about matters connected to the index for at least ten years now; his resistance related to a form of analysis that would deprive photography of its aesthetic possibilities of control over composition and internalized meaning. It is the camera lens's derivation from central-point perspective that opens, he argues, onto the conventions of (Renaissance) painting.

5. If I have descended into baby Barthes here, it is because I think the panel members should have been more familiar with the major theorist of the subject (and its medium specificity), especially when Snyder wonders about how photographs can be said to "point."

6. Photography plays a major role in Barthes's *Mythologies,* another study of the naturalization of the cultural or historical fact. Photography's role, he argues, is interpellation (as when a policeman hails—points at—one by yelling, "Hey, you!"). Photography's interpellant pointing takes the form of "You see!" as when the photograph on the cover of *Paris Match* shows a black Boy Scout making the French salute during the Algerian War and thus produces the "interpellation": "You see, France is all one nation, there are black subjects who also serve it." This is how the mythological signifier *points* to its consumer, creating depoliticized speech by plunging the connotated image into the syntagm's "lustral bath of innocence."

As the panel rightly observes, Barthes's idea of *punctum* is important here, since its traumatic or pricking effect is a form of address that would have to be seen as pointing. Barthes himself summons the Sanskrit term *tathata,* which he transliterates as *"Ta! Da! Ça!"* and the translator mangles as "That there it is! Lo!" (overlooking that in French, *ça* = id, so that *tathata* could be "Look! There id is!").

7. Barthes's work on photography cannot be ignored whether one is summoning Peirce or Benjamin. It remains magisterial and devoted to the index, to the "nothing to say."

Liz Wells
Navigating Theory Now

One of the great benefits of digital photography is that it fosters criticality. In viewing photographs we ask ourselves why the

photographer chose particular light conditions, a specific point of view, what might have been enhanced or eliminated, and so on. Of course we should always have done so, but, historically, critical thinking about photography to some extent stalled on the altar of facticity, on misguided ideas of photographic "truth." While photomontages were obviously constructs and fashion imagery accepted as fantastic, where the documentary idiom prevailed pictures were viewed as "speaking louder than words." Photographs were characterized as evidential. Theorists disagreed in terms of nuance as to whether pictures testified (Max Kosloff), represented (John Tagg), or appropriated (Susan Sontag), but there was a broad consensus that photography somehow animated and underpinned stories and information. Hence the debates about authenticity that raged in photojournalism a decade or so ago as the digital supplanted the chemical, resulting, in effect, in a shift of emphasis from the authority of the image to that of the maker. Our confidence now was to be placed in the reputation of the photographer, evidence of familiarity with subject matter, track record, indications of research underpinning a project—indeed, a range of factors. The optical unconscious, and fascination with content and detail notwithstanding, "truth" (whatever that might mean) no longer lay in superficialities of resemblance. It is not photography that has changed; rather, widespread ontological misconceptions have been challenged!

Given such shifts, indexicality, the relation between image and referent, seems an oddly antiquated place to start a discussion about photography theory now. First study your history! As E. H. Carr pointed out years ago, what the researcher catches depends very much on which waters are being searched.[125] As is suggested by one of the participants, the appropriation of photography within art historical discourses has not necessarily been helpful in interrogating photography in all its ubiquity. Here, in The Art Seminar, within the trinity of artist/context of production, text/object, and consumption/interpretation, object has been

prioritized. The corollary is that semiotics is centrally signposted; we journey toward Barthes, and away from more material interrogations of the social and political currencies of photography (Benjamin, Hall, Kuhn, Spence, Sekula, Tagg). It further follows that the discussion turns to personal photographs, and ploughs on via the *punctum* toward the mire of maternal recognition. That the digital might empower a viewer creatively through image adjustment—personal makeover—is an inviting path down which most participants hesitated to tread. It does not take a feminist to observe that, had the reference to creative empowerment cited political montage or, say, mobile phones and visual humor, perhaps more participants might have risked the detour!

Recent photography theory has tended to focus on portraits (public and personal) or on documentary/anthropology for examples. Discussions often get caught up with named players, or with particular details—strapped pumps, a hand on a door frame—and fail to question what game is being played. The subjective response of the viewer gets in the way of broader discussion, and, conversely, a more general level of inquiry becomes difficult because the emphasis is on the spectator's subjectivity. Some aspects of this can be further explored if we take the rather different genre of landscape. Of course, objects or people or contours depicted may attract attention; but there is something about the stilled scene, not animated by immediate narrative, which means that mood (*studium?*), rather than particularities of content, may have enhanced affect. In extreme (formalist) instances, geometry, rather than content, may be what is most remarked. Take Weston's *Dunes, Oceana:* pleasures of the imagination are triggered more by associative memory than by any literalness of the image. I feel warm and calm. Yet the picture is merely an image and the paper on which the image is printed is merely paper, albeit perhaps within a frame on the wall of a gallery. The warmth emanates from somewhere else! No detail distracts from solipsism—the viewer's or the artist's. This does not extend

arguments over the *punctum* very much at all, but it does remind us not to always focus on portraiture and documentary as a starting point for theorization, and it perhaps also reminds us that the right brain is also in play.

Many photographers view "theory" with disdain. This is hardly surprising. At minimum, you cannot declare the death of the author without offending artists! Terminology does not help. Photographs may "point to something that was in front of the camera," but it is photographers, not theorists or readers, who point their cameras! This is not to attribute the photographer a conscious epistemological agency, but to remind ourselves, nonetheless, that a role has been played that, at its best, implicates aesthetic experimentation and has clear social intentions, in other words, involves some degree of criticality.

I seem recently to have come across a number of references to photo-theory orthodoxies that characterize theory in terms that derive from the humanities rather than from arts practice or from media and cultural studies. Semiotics (Peirce, Barthes) is vintage; it can accelerate from one terrain to another, but the journey may be uphill and model limitations become apparent. Photography invites complex interrogation; with no expectation of uniform ontological outcomes as otherwise, they would certainly be reductive. The complexity is, of course, a part of the fascination. Critical analysis needs to be eclectic in method, carefully considered methodologically, and clear about research aims and precise problematics. At minimum we need to ask questions about purpose and sociohistorical contexts of production, and creative provenance; about content, aesthetics, and photographic coding; about readability and interpretation, context of engagement, and audience subjectivity.

A roundtable discussion develops its own dynamics. Starting points steer discussion, and certain themes (and personalities) inevitably dominate. Papers have been contributed, and fun may have been had! But theoretical orthodoxies seem to have emerged

intact. Rethinking photography now requires, at minimum, a more detailed route map!

<div align="right">

Beth E. Wilson

The Elephant in the Room

</div>

What exactly *is* a photograph? What constitutes a representation as being "photographic"? These questions hover throughout the roundtable discussion on photographic theory, yet we never find really satisfactory answers for them.

As the conversation makes plain, there is far from a common ground on which to meet this theoretical challenge. Discussion of prickly issues such as indexicality (and whether or not to consider Andreas Gursky's work as photographs) seems to lead us into more conflict than clarity in thinking through the matter. At the end of the transcript, I felt compelled to recall the old fable about the blind men attempting to describe an elephant: each laying hands on a separate part of the animal, they arrive at terrifically different conclusions (encountering the tusk, one decides it is like a spear; the trunk implies it is like a snake; the leg is read as a tree), with none of them ever comprehending the whole. The failure of photo theorists today to synthesize a broader, more flexible framework in which to work out the many interesting problems and issues raised by the medium should call us to reconsider the structure of our enquiries.

I have recently encountered an alternative approach to this theoretical divisiveness and disarray in the work of Brian Cantwell Smith.[126] His "successor metaphysics" is the product of his parallel activities as both a computer scientist and a philosopher. Confronted with the inability of traditional metaphysical models to help define key concepts like *objects, programs,* and *data structures* that are essential to fields such as artificial intelligence, Smith constructs a new approach to defining and understanding the dynamics of being and knowledge. His work has led him to suggest a new reading of "the computer" as a pivotal social/metaphysical figure,

not simply a certain sort of machine. By conjoining hardware (matter) with software (form), computers serve as a node at which the Cartesian subject/object divide is theoretically—and more importantly, *in practice*—imploded. Smith questions the artificial separation of the "external world" as "independent of the experiencing subject," advancing instead a realist position that interpolates the physical (matter) and the semantic (thought) realms as but two coexisting modes, or ways of framing the exceedingly complex, irreducible reality of the world.[127] (Smith's important principle of irreduction, which states that "no theoretical assumption—empirical premise, ontological framework, analytic device, investigative equipment, laboratory tool, mathematical technique, or other methodological paraphernalia—be given *a priori* pride of place," is one that seems quite prudent in the wake of the current roundtable discussion on photography theory.)[128]

It seems to me that photographs, with their troubling nineteenth-century pedigree as the bastard child of science and art, lend themselves to being understood in terms very similar to Smith's conception of the computer—they are a location for the radical interweaving of subject and object, of the material and the semantic realms. The whole notion of "indexicality" as a useful classification rests upon this relationship; or, to turn it on its head, the aptness of "the index" as a way of describing something that photographs do is inspired by this vital connection, reading as it does the physical trace (material) as a form of representation (meaning). Photographs, I contend, function as pivotal social figures in much the same way that computers do.

Another key notion in Smith's account is *registration,* or the processes by which we come to stabilize and use information from our world, thereby forming objects in a co-creative act of mind and matter. The putative "objects" thus formed have more to do with the particular nature and focus of our attention in response to the material conditions surrounding us, rather than some finite,

objective reality that imposes itself upon us. The significance of all this for comprehending what goes on in the photographic process is profound.

One could, for example, conceptualize the photograph as a particular screen in or on which we capture some part of the much larger, always overdetermined world. "Screen" is perhaps a particularly apt term, given its dual connotations both as a grid used to sift gravel, flour, or other physical materials to a particular size or consistency, and as the locus for the projection of images (and, in the Freudian mode, desire itself). An analogue photograph is a physical object that has been impressed with the photo-chemical trace of evanescent light, preserving in its emulsion a point of contact with the ineluctably concrete facts of the material world. Once produced, this image-object circulates in various contexts (lovingly encased in a locket or family album, on file in the police station, published in a magazine, framed and hung in a museum) that each project their own meanings onto the mute and semantically mutable image.

Photographs, like computers, are thus a sort of *mis-en-abyme,* a social construction that embodies on a microcosmic scale the structure and dynamics of the everyday encounter enacted by our consciousness as it is embedded in the material world at large. (Indeed, we should remember that modern science itself is the product of specific social practices arising from our encounter with the physical world, so declarations of "pure objectivity" or "pure subjectivity" should be equally suspect.) Along similar lines, Geoffrey Batchen has specifically called attention to a tantalizing early relationship between photography and computing, which started at the very dawn of both technologies, a relationship that has become particularly productive with contemporary digital technology.[129]

Of course, the new digital revolution has set in motion all sorts of reactions in recent years, both mournful for the loss of the once-upon-a-time believability of photographs (Fred Ritchin)

to the enthusiastic embrace of the aesthetic and epistemic shift enabled by the new technologies (W. J. T. Mitchell)—most of which somehow escaped commentary in the roundtable discussion. But the advent of the new digital era should serve to highlight the historicity of photography itself, as I have commented upon at greater length in the exhibition catalogue for my exhibition *The Material Image: Surface and Substance in Photography*.[130] We apply the term "photograph" to images generated by literally dozens of different processes, from the one-off daguerreotype to the reproducible gelatin silver print, from cyanotypes to calotypes to autochromes. When we use the exquisitely overdetermined term "photography," we are really referring to an ad hoc grab bag of technologies and techniques, thereby complicating even further any attempt to create a definitive theoretical model for it as a unique, autonomous medium, in time-honored modernist fashion.

Perhaps the focus should thus shift from the search for a priori principle to a more engaged look at how these images work or, more specifically, to ask ourselves what the hell is it that we recognize as being "photographic" about a photograph? In what (various!) ways is this quality used, expressed, and understood? The call to think beyond artistic practice, to embrace the full range of photography's applications, from the vernacular to the scientific to the purely aesthetic, requires that we not box ourselves in unnecessarily, and that we advance not only the usefulness of particular theoretical schemas (indexicality, the *punctum*, temporality), but also acknowledge the trade-offs incurred by committing ourselves to any one of these dimensions of the problem. As James Elkins rightly points out, "[W]e find photography hard to conceptualize [for the] immediate reason... that it is not one subject, but several." This is true at the level of photography's varied material manifestations, as well as in our theoretical modes of approaching it. In turn, we should find an appropriately

open structure for our theoretical approaches, lest we continue to mistakenly limit ourselves to describing this "elephant" by means of its trunk alone.

Martin Lister
Photography, Presence, and Pattern

In the first part of The Art Seminar, the talk moved from index, trace, pointing, impression, and imprint—"indexicality and its synonyms," as James Elkins remarks—to the *punctum*, giving each idea a (sometimes short) run for its money, before replacing it with an alternative, and laying aside the others with suspicion. As I followed the conversation, I became surprised at my response. I found myself, against the grain of the debate, actually thinking how serviceable these ways of talking about photography, or some kinds of photographs, are. On reflection, at least some among the panelists, for some of the time, thought so as well. The debate and the reservations and qualifications that abounded tended to mask this.

The profound difficulty of "conceptualizing" photography, something so socially and culturally ubiquitous, a technology harnessed to so many uses, is surely no surprise. A technology too, that has constantly been reinvented and extended, and of late in ways that begin (at least apparently) to challenge some of the very ideas that were entertained. And this is before we even begin to consider such questions as, At what historical moment is the conceptualising taking place? In respect of which photography? Within which disciplinary or theoretical frameworks? No roundtable discussion could ever begin to engage with all that, except at a level of generality and abstraction that would be of little interest anyway. The largely art historical and philosophical-aesthetic approach to the ideas entertained in The Art Seminar at least had the benefit of narrowing the field.

But, for all that, why was I nevertheless struck by the serviceability, the usefulness, of these ideas? I think this was for two main reasons. First, I agree with Jonathan Friday, or what I took

to be the spirit of his remark, when he says that he is not so much interested in what Peirce has to say about categories of signs but in "what can be said about them"—although I immediately wanted to change that to "what can be said *with* them." This is also the point I take Sabine Kriebel to be making, when after pages of checks and balances on the nature of the index, she finally makes her plea: "I'd like to know what does work… we are not going to find one set of words… to talk about all of photography…. I'd like to root our discussion back into language that we think is useful or productive." I am not sure her plea was heard. My point is that indexicality and its synonyms may be newly useful and productive right now, and I worried that in foregrounding their problematic dimensions, the panelists might find themselves responsible for throwing the baby out with the bathwater.

Why? This brings me to my second reason. There is a bigger contemporary picture to which the roundtable hardly alludes at all. The world in which photography continues to be practiced (and there is a very great deal of it, whether chemical, digital, or hybrid) is changing in a number of ways. Will the cluster of ideas that the panelists discuss and worry about, and which I find more serviceable than they do, continue to serve us as our media of material inscription, among which photography must be paramount, are transformed, displaced, or remediated by digital technologies and the practices built upon them? More importantly, how do they serve at a time when the actual, concrete, material stuff of the world comes to exist and jostle alongside so many virtual objects and spaces? While these too are the products of material technologies, and engage our physical senses in much the same way as other things, they have a kind of "existence which is less typical of the phenomenologically present-at hand and more typical of the non-existent and non-present."[131] They can be called "into action with the lightness of electrons," switched off and then "recalled back into existence, like a computer file redisplayed on a video screen." Such virtual objects and spaces are the product of

information; the kind that is invoked in terms such as "information society" or "information economy." This is information that is not best understood in terms of particular reports on the states of things (a typed memo or a table here, a photograph there) but as a new kind of abstract, generic, and intentional *substance* that is "at large" in the world.[132] It has been conceived and engineered (over a period of some fifty years) to be quantifiable, separable from any particular instantiation in a medium, traded, and moved around the world at high speed via electronic media and telecommunication technologies.

The oldest of modern media, photography (and radio and the telephone) now exists in a media ecology that was probably unthinkable even fifteen years ago. But these media do still exist, and we continue to make images that have the qualities that we try to describe in our talk of indexes, traces, and imprints. They continue to be carried by material substrates, and optical lenses are employed, which we take to physical vantage points and point at physical things. Mostly, we get the "indexical icons" we are seeking, and when occasionally we get a smushy one, or we fail to photograph gas, we know (more or less and depending on who we are) why. But photography also now coexists with the technologies of the virtual; it competes with, and is surrounded by, the almost tangible, time-and-space-warping buzz of information.

Most of my photographs now exist as electronic files and spring to luminous life, through layers upon layers of code, on my liquid crystal display screen. I can dismiss them at the stroke of key. If I am not careful, by a clumsy keystroke I might lose them entirely. A few have been realized as material objects: not photochemically, but by other codes, to an ink-jet printer. My computer also "contains" other images that I receive (and in some ways, may value and use) as photographic, as do my DVDs (they are images that have lens flare, depth of field, and all kinds of "photographic" noise). These have no relation to cameras except virtual (informational) ones, and nothing that I see in them, however

photo-realistic, ever had a material existence. All this coexistence of the material and the virtual is, of course, the tip of an iceberg. We know the story well enough from Katherine Hayles: money becomes information, not cash; genetic patterns override physical presence in determining parentage; physical work is replaced by flows of information through systems; DNA, not eyewitness accounts, convicts criminals; access to data, rather than the possession of data, can be a crime.[133] (Somewhere in the roundtable discussion, Joel Snyder is moved to assert that only his parents can reproduce him. True—but perhaps only for the time being.)

Hayles puts her finger on the situation: "as information becomes more important, the dialectic of pattern/randomness (with which information has deep ties) tends toward ascendancy over the dialectic of presence/absence."[134] She finds the twin concepts of "pattern" and "randomness" in her closely researched critical history of cybernetics and information engineering. They might have stayed safely in that domain, with its interests in maximizing channel utility and minimizing noise in telecommunications systems, if the development of information technologies had not come to permeate every corner of most of our lives.[135] The concepts with which they now compete for explanatory power, those of presence and absence, are of course those that underpin most modern Western theories of representation, signification, depiction, and indeed language. Crucially that also goes for the index, the trace, and the imprint. Photography is a medium that exemplifies the epistemological dialectic of presence and absence. Whatever misgivings deconstruction and semiotic theory (and some members of the roundtable) may have about this, we largely value and use photographs according to such a logic and the mediations that intervene between the terms.[136] This requires that we view matter—the stuff and things of the world—as having an ultimate presence in a realm before and beyond the symbol or sign. Photographs of several important kinds—documentary, archival, legal, medical, surveillance, personal—stand in for bodies, things, and events in

their absence. They are haunted by presence. They are compellingly underpinned by the notion of the trace, the sense that "objects have reached out and touched the surface of a photograph, leaving their own trace, as faithful to the contour of the original object as a death mask is to the face of the newly departed."[137] There is a sense that a photograph has literally been in touch with something that has existed but is no more, or exists but is spatially absent. They are also material objects themselves and can be as important to hold, touch, feel, and check for as they are to see. These are phenomenological qualities of photographs that foreground their materiality. As such observations on the photograph thicken and connect, it becomes clear that the photographic economy revolves around a dialectic of presence and absence: the presence of a material signifier that stands in for an absence, the absent presence of the signified, and a desired or predicated original existence. This is a dialectic that sees matter as the foundation, the underscoring, and the outside of representation.

But Hayles has a larger project, which is to trace the history of the divorce of information from material substance, a divorce that she understands as tragic and dangerous, a tendency that is to be resisted and is perhaps finally impossible, but is at least already partly realized. So, while seeing the importance of taking the virtual very seriously indeed, she also warns that it would "be a mistake to think that the presence/absence dialectic *no longer has explanatory power*… for it connects materiality and signification in ways not possible within the pattern/randomness dialectic."[138] It has of course long been the business of philosophers, and latterly cultural theorists, to question, test, and qualify theories of representation that are based on these terms, as in The Art Seminar's discussion of the picture of Snyder's mother. It is a fraught business, as the discussion revealed, but this should not blind us to the surprising way that not only the making of visual representations but also other activities rapidly cease to be readily comprehensible in its terms. Yet, at the same time as we strive to come to terms

with the characteristics of the virtual, where information can be thought of as prior to matter (information "writes" matter, is its code), we should not make the mistake of thinking that it somehow replaces or erases the material world.[139] At times we might be inclined to feel that it does. I imagine that is what Elkins is getting at in his concluding remark of the discussion, "For me at least, what's really going on with the index is some hope people have about the real world." Rather, we should remember that this is a perception, or worse an illusion, whatever the projects of artificial life scientists or bio-engineers. It is in this situation that the concepts that so worried the roundtable—the index, trace, impression, and imprint—become newly important to think with. They may be the very ideas that will be crucial in helping us gauge the transformations taking place, to see the continuities in our practices, and alert us to what we may lose.

The Art Seminar largely eschewed discussion of digital and/ or information technologies in its discussion, and that may be understandable. It can be tedious. Regrettably, but perhaps inevitably, a decade of arguing and sorting out millennial, utopian, and dystopian visions about what digital technology might mean *ontologically* for photography may have diverted us from studying some real processes of change. These are processes that are not simply about replacing film with CCDs, grain with pixels, and chemicals with software. They are more to do with the context for photography that I am proposing, with (if I may use a shorthand) the virtual, the informational, and, indeed, the global with which they are closely bound.

Since the mid-1990s "information," in the sense I am using it, has made various kinds of appearances in critical accounts of contemporary photography. In each case, the changes to photographic practices that are observed do not involve the direct application of new technologies to the photographic process. They are not thought of as technologically determined in that way. Let me conclude with some examples.

In his account of Paul Seawright's photographs of the 2001 war on Afghanistan waged by the United States and its allies, Mark Durden describes them as working through an "aesthetics of absence." They are photographs that "look away," draw us to the edges and fringes of things; the views they offer are occluded and blocked and have a "physical opacity." They are photographs that are made "too late," when the action is over. The journalists have moved on to new crises, and the "information technologies"—the military's cybernetic tele-presence technologies, and the media's digicams, laptops, mobile phones, and network connections—have been packed away.[140] Photography is displaced by these technologies yet struggles to continue to signify within the terms of presence/absence, to find ways of existing within the buzz and noise of pattern/randomness and the aftermath of the cyberspaces through which the wars were waged.[141]

Considering Joel Meyerowitz's official photographs of the destruction at Ground Zero, David Campany suggests that they represent "an investment in the idea that the relative primitivism of photography will somehow rescue the processes of memory that have been made so complicated by the sheer amount of information we assimilate from diverse technologies."[142] Here, as photography comes to exist and compete with electronic media in a densely networked and frenetic info-sphere (Ground Zero was one of the most "imaged and visible of places, the epicentre of a vast amount of state of the art news production"), it becomes a nostalgic symbol for an older kind of reflective attention to images.[143]

Finally, consider Paul Frosh's research into a very different area of photography: the commissioning, collection, and purveying of photographs to the advertising and marketing industry via the massive online image banks of Microsoft's Corbis and Getty Images. Here he finds an extension of the archival principle (collections of images to choose among and use for new purposes) "*into* the very material constitution of the photograph." The traditional stock photograph becomes a carefully arranged "code without a message," an ultimate

image commodity in the form of a multipurpose graphic quantity to be raided and changed.[144] At the same time, these image banks selectively digitize and rebrand the contents of older specialist photographic archives. It is an institutional, technologically facilitated exercise, which dismantles traditional boundaries between kinds of images (photographs, paintings, drawings, film, and video) and between kinds of photography (documentary, historical, fine art), to form a kind of generic "visual content." This "graphic substance" and "visual content" are concepts, he argues, that arise within a conceptual framework for which the paradigm, the master discourse, is "information."

There is of course much more to be said about these changes, but this is not the place. I want instead to note that such references to photography's active relationship to information—which I have briefly suggested, following others, concern its simultaneous displacement and entrenchment, its nostalgic compensatory role, and its entry into the flow of information—remain as a set of discrete, critical observations. To my knowledge, nowhere within photography scholarship are these kinds of change—these kinds of photographies—being conceptualized. Yet, as we saw briefly in the case of Frosh's research, it is suggested that Barthes's definition of the photograph as a message without a code (an idea not discussed at the roundtable) needs to be *inverted* to grasp what is happening. Frosh also argues that in the photography he studies, neither the index nor the *punctum* can have any useful place. Such contingencies have to be purposefully avoided by the photographers. This photography, he argues, outstrips our available theories. It is these kinds of change in which technology plays a part, but not in the old "death of photography by digital means" scenario, that I think we may be overlooking. Material signs for material things and the technologies that produce them now have complex relationships with digital media technologies and virtual things. As material signs are joined and interpenetrated by informational codes and their virtual products, we

need, in Hayles's terms, to continue to think about presence and absence (about indexes and their synonyms) because not all is "pattern and randomness."

Shepherd Steiner
Give Me Examples!

One way to frame my response to The Art Seminar would be to note a kind of fetishization of theoretical terms. While ably establishing the grounds for discussion as well as characterizing misuses over the past two decades, in the end these theoretical nodes only manage to reaffirm the terms of a fairly consistent set of problems that have plagued photographic criticism from at least the 1930s onward. Ever since Walter Benjamin's great essay "A Short History of Photography," criticism of photography has suffered in the shadow of what I would call the general theory of photography. Whether the terms of debate circle around the notion of aura, *punctum*, index, or sign, the question is the always same: a theoretical concept is abstracted from the experience of looking at a particular photograph, and applied across the board. Delexicalization is the problem here. The only way to stabilize the many uncertainties that we currently encounter as photography and photographic criticism is through close reading.

From my perspective as a critic, the time for general theoretical talk about photography is long over. There are just too many unique, careful, refined, let alone loose, wild, and irresponsible practices of photography now in circulation to warrant general terms or key words. This does not mean that the inherited terms of the ongoing debate around photography should be dismissed, but rather that terms like aura, *punctum*, index, and sign all need to be placed under acute and specific pressure. In other words, it is the responsibility of the viewer to mine these terms and an array of others, showing just how they are animated or put into motion in their interpretative contexts. These terms are highly unstable and variable, and they escape the apparent certainties

of the interpretative moment or meaning event; the face-to-face encounter is the point at which critical work begins. Given that understanding is only complete when understood as an act with its own history, this work will of necessity be dialectical. No more cutting and pasting of sutures that are spatially and temporally contingent, please!

Laying aside the huge problem of the circulation of images in the culture at large, one can take the panoply of very singular practices within contemporary photography as exemplary of larger interpretative problems. In face of contemporary photography, no single critical or theoretical approach suffices: one requires a variable practice of close reading. Why? Simply because contemporary photography is practiced by many different people, with many different ideas, and from many different localities, all with very different histories, all with very different concerns and hopes—some for the integrity of the medium, others for its unraveling, others still for its merging with cinema, sculpture, painting, the everyday, identity, emancipatory politics, and so on. And this is not even to mention the questions related to the recent explosion of imaging technologies, of photography becoming digital, or of the move to a cameraless practice by downloading images off the Web or by using a scanner.

In any case, one can further bracket this variable set of intentions by focusing on the question of large-format photography, the kind that usually comes under criticism (unfairly I would say) for its attempts to define a totalizing model of what photography should be. Confusing the grip these various practices have on our sense of the aesthetic with political machinations is a mistake. Aesthetic hegemony operates on all of us; it misses the point to hold up counterexamples either within the art world or outside it—whether in the popular media, scientific circles, or the Third World—in order to merely invert hierarchies already in place. The point is that even in the list of usual suspects, one comes a cropper of unique and absolutely singular models of photography, each

making its bid for what photography should be. If we take the examples of Thomas Ruff and Jeff Wall alone, we can still make further differentiations within the corpus of each. In fact, in the work of both of these photographers one confronts a family of heterogeneous photographic practices, all alive and well.

Both Ruff and Wall have developed bodies of work that plumb a number of photography's potentials: what Wall calls "the at least equal and simultaneous validity of different models." It matters little that Ruff mainly makes his way in photography by feeling out what is prohibited or taken to be inappropriate by the changeable, high-level global discourse around photography. Ruff's interest in generating a negative response to what photography is, or should be, is as rich a narrative line as Wall's apparent preference to move through photography as if in synch with the changeable and sublimated category of the aesthetic. I mean, how dare Ruff download pornography from the Net and present it as art! I like to look at it, but not only does the feminist in me shout out this is not right, but also the critic of photography in me yells that this goes against everything the medium stands for. Similarly, in Ruff's architectural photographs of Mies van der Rohe's projects, all one wants is a truthful document, and yet all one gets is a series of blurred, doubled, at times montaged, and troublingly artificially colored images. The narrative line that Ruff slices out of photography is unique and idiosyncratic. To be sensitive to his practice and the way it undermines expectations or gnaws away at our changeable aesthetic prejudices, it is necessary for a critic to attend to his or her responses to the images themselves.

If one is going to say anything about photography, it seems to me that one must not only talk the talk, but also walk the walk. Give me examples and tell me your responses, and I will be happy, not sullen—not left feeling inadequate about my lack of purchase on the terms of your debate, not lost, not wondering if I too should know about Peirce and study the theory of smudges; just left alone looking at the same image that you look at, learning

from your encounter and building on it in order to glimpse how to live differently. It is really that simple.

Take the frightening example of Wall's *Park Drive* (1994). One might easily mistake this work as championing perspective. I disliked it for a long time. It did not fit into my idea of photography. The seductive recession of the road opens up a clear entrance to the work. One is far removed from his earlier panoramic landscapes that typically move the viewer across the picture and not into depth. In fact, the tunnel vision and stop/go effect of *Park Drive* is a late development of Wall's earlier denial of perspective. One could detect a Baroque overconfidence, because the perspectival effect is raised to such a horrible fever pitch that the pleasant genre of landscape is transformed into something resembling the blood and thunder of Benjamin's *Trauerspiel*. This is barely a landscape, and it feeds solely on perspective! Flanked by trees that burn like funeral pyres along either side of the road, one has nowhere else to go but back and forth into what looks like the maw of a snake. Only death separates one from this horrible anthropomorphic illusion—an illusion that can also take the form of a tornado that is just touching down. And so one backs way out, takes stock of the four or five pictorial elements in this montage of paper-thin parts, and then bolts back in. As a source of anxiety, fragmentation is the equal of the unity provided by perspective. So much for thinking that Wall privileges the narrative space of large-format photography: close and attentive reading shows that Wall uses the fictive suture of perspective as a resource and temptation to be overcome.

Alan Trachtenberg
Response from an Adjacent Field

This is not exactly an assessment of value (taxable or otherwise), but a response from an adjacent field. I go with the project of wishing to examine how photographs have been "explained," though, like Michael Leja, I miss an effort to view the project in the eyes

of history, to ask and try to say where the stated need to explain comes from—whose need, and whose terms of articulation of such a need, in just this way at just this time. Leja suggests a link between discourse of the index and defense of minimal and process art in the 1970s, a rationale for the role of photo-imagery in such artworks. I think of the growing interest among historians (not just "art" historians) in "reading" photographs—any and all photographs—as texts: as residues of meanings piled on top of and under one another—meanings that might be traced on the face of the image or accumulated in recoverable uses of the image, resulting in a sense of the image as a certain kind of historical-cultural object that the honorific term "art" not only fails to explain but also positively obfuscates. Index or trace emerged in the late 1960s out of Pierce but also (not to forget this important context) out of a wider interest among cultural historians (a category then becoming conscious of itself as a distinct branch of academic history) in Mead and James and Dewey, the American Pragmatists. The notion of index worked itself into the lexicon of students for whom photographs were, in the first instance, experiences to be undergone, and only then objects to be understood—within as many overlapping or contiguous conceptual horizons as seemed cogent and plausible.

In spite of all the shouting and bullying, can there be any serious doubt that a photograph bears a different relation to what it shows (what is visible on its surface) than does any other version of reality made by any other means? How can denial of this difference itself be taken seriously? This is not to give the photograph any special privilege as a vehicle of "truth" or goodness. It is only to state an obvious given, from which real discussion must follow. How does one "explain" the photographic as a kind or a confluence of kinds of experience? Whose experience? Who asks that question, and why? To ask about explanations of the photograph is at the same time to ask why we want to know, what difference the answers might make in our behavior toward what we call

photographs, and what perspective we might gain on the world we call our discipline. One question leads to another. Do questions and answers (all provisional until we feel we have learned something and can move on) lead us back to the world or away from it? Do they take us back to that place and that time when someone put a camera down or merely pointed it, opened and closed a shutter in front of or behind or between the elements of a lens, and allowed an image to plant itself as a latency on a sheet or strip of film? What happens when the postcamera image takes shape as an image in someone's eyes?

Those questions are too important to be left to "art" or even "photo" historians alone. What is needed is a new emphasis on, and perhaps a new kind of, close reading—close reading of the act of close reading itself, allowing the image to read us as we read it, the analyst once again remembering to recover herself or himself within the field of reading. We might take the photograph itself, in its aspect not just as trace but also as temporal duration, as a model for the kind of historical criticism it elicits: the photograph both as discursive subject and as pedagogy.

Victor Burgin
"Medium" and "Specificity"

On the evidence of the transcript of The Art Seminar, I might now make much the same assessment of photography theory that Julia Kristeva made of Russian Formalism: "when it became a poetics [it] turned out and still turns out to be a discourse on nothing or on something which does not matter."[145] However, rather than pursue this melancholy reflection, I prefer to offer some thoughts on one of the two topics that receive most discussion: "medium specificity."

Rosalind Krauss has suggested the idea of "reinventing the medium." She develops it mainly through reference to photography, which she describes as ascendant in art from the 1960s but as "obsolescent" by the end of the twentieth century. For Krauss, this particular fate of photography exemplifies a more general condition

at the recent fin-de-siècle. She writes that "the late twentieth-century finds itself in the post-medium age. Surrounded everywhere by media, which is to say by the technologically relayed image, the aesthetic option of the medium has been declared outmoded."[146] Under such circumstances, she maintains, the exemplary artist is the one who can "reinvent" her or his chosen medium. She judges James Coleman to be such an artist. An examination of Coleman's work, she says, "can lay before us, with greater vividness than any general theory, what the stakes of this enterprise might be."[147] Although photography today "can only be viewed through the undeniable fact of its own obsolescence,"[148] Krauss finds "redemptive possibilities enfolded within the outmoded itself."[149] Coleman works with "slide-tape," a technology once widely used for business presentations and advertising, but now obsolete. The style and rhetoric of Coleman's images owe much to the photo-novel, now largely outmoded. Krauss therefore names a practice twice redeemed when she writes, "The two major ingredients for Coleman's medium—the slide-tape and the *photoromanza*."[150]

Krauss defines Coleman's "medium" as comprising both his choice of photographic technology and his choice of photographic genre. She is anxious that her use of the term "medium" should not be associated with that of Clement Greenberg. She notes that Greenberg's name has become attached to a definition of "medium" as "nothing more than an unworked physical support," a definition that has moreover become "common currency in the art world."[151] Krauss does not say whether she shares this common understanding of Greenberg's notion of medium. She does say she finds it reductive, and is at pains to emphasize her distance from it. But to be distant from this particular definition of "medium" is not necessarily to be distant from Greenberg. "Medium" is only one component in Greenberg's account of the program of modernist painting. In broad outline, Greenberg defines modernism as the tendency of an art practice toward self-reference, achieved through attention to the tradition of the practice, the difference of

the practice from other art practices, the "cardinal norms" of the practice, and the material substrate or "medium" of the practice. There are close parallels between Greenberg's program for modernist painting, when taken as a whole, and Krauss's program for "reinventing the medium." The two critics do not so much diverge as begin their arguments at different historical points on the same path. Greenberg writes, "Modernist art continues the past without gap or break, and wherever it may end up it will never cease being intelligible in terms of the past." Krauss agrees, but in the past tense, writing, "For centuries it was only within and against the tradition encoded by a medium that innovation could be measured."[152] It is to this loss of the compelling force of tradition, and of the shared values it transmitted, that Krauss responds with her idea of "reinventing the medium." Rather than representing a break with Greenbergian aesthetics, the idea serves to prolong a history of medium-centered independence, conserving what Edgar Wind had earlier described as "a proud art which is no-one's servant, posing all its problems from within." Greenberg emphasizes such self-referentiality when he writes that "the unique and proper area of competence of each art coincided with all that was unique in the nature of the medium," and that "each art had to determine through its own operations and works, the effects exclusive to itself."[153] Krauss accords an equivalent priority to what she terms the "recursivity" of an art practice—as when, for example, she writes, "Coleman's determination to mine his support for its own conventions is a way of asserting the redemptive possibilities of the newly adopted support itself."[154]

Krauss maintains that she differs substantively from Greenberg in her definition of "medium." But she merely applies the word "medium" more extensively than does Greenberg, to cover both Greenberg's "medium" and his "cardinal norms." Her extension of the reference of the term beyond "substance" follows unavoidably from the fact that she is talking about photography. If, according to Greenberg, the medium of painting is paint, applied to a flat

support (canvas or board), then it would most strictly follow that the medium of photography is photosensitive emulsion, applied to a flat support (glass or acetate). But such a definition would evict the camera itself from the scene, reducing photography to, literally, *photo-graphy:* drawing with light (as in, for example, Man Ray's "photograms"). Moreover, Greenberg insists on the materiality of the flat painted surface in the interests of anti-illusionism. "Content," he writes, "is to be avoided like a plague." To make a similar demand of photography would be to undermine what is historically its founding, and defining, attribute. It is understandable that Krauss should apply the word "medium" beyond the level of the material substrate of photography, but in doing so she gives no indication that there is any limit to its application. She recognizes that a medium rarely comprises one thing, but she does not say how many things it can be, nor what kind of things may count as belonging to a medium.[155] Nevertheless, the medium of photography is not difficult to specify. Historically, photography represents the confluence of two previously distinct bodies of technical knowledge: of the camera obscura, and photosensitive materials. Traditional photography begins with the chemistry of fixing an image, formed by a camera, in a light-sensitive substrate. These together yield a picture of the world beyond the aperture in the form of a positive or negative film.[156] This in turn is used to produce an opaque print, or a transparency that may either be backlit or projected. Digital photography offers some technical substitutions—for example, CCD in place of emulsion, memory storage device in place of film, and LCD or CRT screen or projector for display—but without fundamentally altering the basic conditions. Any individual who chooses to work with photography must choose among these material conditions. These and their technologically mutating variants constitute the "medium" of photography. This restricted definition of the "medium" fulfills our ordinary requirement that the definition of a medium be not bound to any individual use of it.

Krauss defines Coleman's "medium" as slide-tape plus photo-novel. In addition to these two, she identifies a third element in the "paradoxical collision between stillness and movement that the static slide provokes right at the interstice of its changes."[157] Krauss refuses consideration of the "Irish cultural and historical references" in Coleman's work because "the issue of the 'medium'... in relation to his art is not a matter restricted to one country or another, but is generalizable across the whole field of the avant-garde."[158] But why should a reference to the photo-novel (a genre particularly popular in Italy, where Coleman lived for many years) be considered any more universally "generalizable" than a refer-ence to Irish history? Krauss herself acknowledges the fundamen-tal contradiction inherent in her idea of a "medium" that can be defined only on an individual basis. That she is able to both recog-nize the contradiction and ignore it indicates that her argument is rhetorical rather than theoretical, and therefore stands or falls by its power to persuade rather than its internal coherence. There is nevertheless a way to resolve the contradiction in Krauss's argu-ment without leaving the Greenbergian discursive framework it inhabits. Greenberg emphasizes that an artistic practice progresses through the attention it gives to that which marks it as individual, that which differentiates it from other art practices: in a word, its "specificity." He was interested primarily in painting. For Green-berg, what most clearly distinguishes painting from the other arts is paint itself, applied to a flat surface. He consequently takes the material substrate of painting, its "medium," as the foundation for his critical judgments. As Krauss herself observes, others have since continued to maintain this "critical notion of medium." However, what has tended to be elided—whether missed, ignored, or forgot-ten—is that Greenberg's primary concern was with the specificity of a given practice. In the case of painting he found this specificity in the medium, but it does not necessarily follow that we might expect to find the specificity of any practice whatsoever in its medium. In the only article Greenberg wrote about photography,

he judged that the specificity of photography resides in its ability to tell a story.[159] In effect, Greenberg defines the specificity of photography as "technology plus narrative." This is not greatly different from Krauss's definition of Coleman's medium as "slide-tape and the *photoromanza*."[160] The apparent contradiction in her argument therefore may be simply resolved if we substitute the word "specificity" for "medium." Krauss is unable to do this because for her the two terms are indissolubly joined: the issue for her is one of medium specificity. Nevertheless, her arguments might gain in both coherence and fluidity if the ligature between the two words were broken. For example, Krauss commends Cindy Sherman's reference to film stills just as she approves Coleman's reference to the photo-novel. She finds that Jeff Wall also "offers something of a parallel with Coleman" in that he formulates his work in relation to "his 'own' medium, the back-lit photographic transparency."[161] However, she judges that Wall "has failed to engage that medium's specificity."[162] Why? Because he adopts the conventions of nineteenth-century history painting rather than those of a photographic genre (albeit this is to ignore the influence of photography on nineteenth-century painting). If we view Krauss's argument through Greenberg's idea that the specificity of photography lies in narration, then we might assess that what is at issue in her choice of Coleman and Sherman over Wall is not the "reinvention" of the medium of photography, but rather of those narrative forms specific to photography. These forms are not specific to the medium of photography but rather belong, to retain Greenberg's vocabulary, to the "cardinal norms" that, together with the medium, contribute to the specificity of photographic practice.

I suspect I have discussed "medium specificity" in order to avoid talking about the topic that receives most attention in The Art Seminar: indexicality. My response to this issue may be found reductive: the Abu Ghraib pictures are an example of the kinds of circumstances under which the question of the indexicality of a

photograph actually matters. In such circumstances, some person has to come forward and say, in effect, "I was there, I saw this."

And as for the rest, and vis-à-vis Barthes, I see no point in comparing answers deriving from phenomenology with those deriving from semiotics—these are distinct discursive formations that do different work (neither of them does the work of mourning), and their results are not comparable.

Joel Snyder
Pointless

The roundtable discussion in Cork began with a frustrating attempt to make sense of "indexicality" and to wonder why the term continues to function in critical discussions of photography. In person, face-to-face, we were civil and enjoyed a rather breezy if not terribly illuminating conversation that was brought to an end by Jim Elkins long after it had become clear that we were not finding any grounds for agreement. Regrettably, some of the statements in this volume are not presented in the spirit of the talks at Cork, and so I will be blunt in my response (*obtusus* in Latin means, among other things, *blunt*), but I want to emphasize to The Art Seminar participants that the following remarks are not responsive to them.

The problem with attempting to discuss photographs in terms of *the* index is that the notion is so thoroughly unspecified. As conversation proceeds, it becomes increasingly difficult to understand just what features of photography are supposed to be explained by the invocation of the word. There are still a few people who say that a photograph is indexical if it is a "mechanical analogue of reality," that is, if we take it to look like what it displays.[163] We see a half black, half white 78 rpm phonograph record in a photograph and are assured it is an index of that very platter. Likewise, a photograph made with a few-second exposure of the same platter while it spins rapidly on a turntable is an index of exactly the same black/white platter, even though the picture

shows the black and white as a middle grey. It is unclear to me what is gained by insisting that in each case the photographs show us what was there and show it irrespective of whether it looks like a "mechanical analogue" or not. Charles Marville took photographs of bustling, congested Parisian streets from the mid-1850s through the early 1870s, but most of his pictures show abandoned streets, robbed of the people and animals who paraded in front of the camera during the exposure of the sensitized plate. And yet photographs like these are said to be no more and no less indices of the Parisian streets than more modern photographs showing the same streets occupied by people, carts, horses, and so on. Some say that photographs (edge to edge and corner to corner) are traces, but what of the people who were present and at work on Marville's streets who, through no fault of their own, left no apparent trace on Marville's plates? Are the spaces in the photograph, which correspond to the cobblestones on which they scurried or trundled, bereft of traces? Where did their traces go? Do traces just disappear? Or were they never *there*—wherever *there* might be situated? (It won't do to insist that the absence of human figures in these pictures is explicable in terms of length of exposure. Of course it is, but that shifts the grounds of the explanation away from *the* index.)

I want to return briefly to the notion of mechanical analogue. One of the major shifts in scientific practice that occurred in the later part of the nineteenth century was a move away from the observation of phenomena and a turn to the use of highly sophisticated instruments for the production of graphs and pictures—which became the primary data of study. These instruments were designed to graph or depict movements (or sounds, pressures, etc.) that are imperceptible to human beings. What this did effectively was to remove certain kinds of scientific data from the realm of the phenomenal or apparent, and what that meant was both clear and vexing. The photographs produced by scientists could not be compared to or checked against anything but graphs or

pictures made by other instruments. In other words, these kinds of photographs are not analogues, because there is nothing with which to compare them.

For example, it is not correct to think of Étienne-Jules Marey's abstract chronophotographs (made on fixed plates in the 1880s) as copies that stand to their objects in the relation of a photographic portrait to its subject. Marey's photographs don't map against this kind of subject. They are cumulative and show the relation of forces in terms of distance/time relations. We can only see these data by looking at the chronophotographs. Apart from the pictures, there are no data.

Consider Marey's geometric chronophotographs of *l'homme squelette*. The pictures have no antecedent referent, if what we mean by that is something in the world that resembles what we see in the picture. They most assuredly do not work analogically. To insist that it is an index amounts to little more than saying that the picture has a cause, or causes. No one need deny this. These photographs are data, and understood properly they can be used to tell us the amount of force it took, say, for a human being to traverse a given distance (which can be read off the blocks at the bottom border of the picture), assuming that we also know the exact amount of time that light was allowed to reach the plate for each exposure, and the precise interval of time between exposures. Photographs like this, for all their meticulous accuracy and ability to reveal displacements that are beyond our capacity to resolve, correspond to no original. The photographs *establish* the data—none exist prior to the production of the picture, though there are most assuredly cameras, revolving shutters, sensitive plates, daylight, running animals, waves on the surface of water, and so on. Marey's photographs become devilishly difficult to understand when they combine (within one photograph) easily recognizable items like chairs or tables (that look like chairs and tables as shown in quite ordinary photographs), ghostlike clouds surrounding white overlapping lines, blurs, items that look like

372 PHOTOGRAPHY THEORY

serially related white dots against a black ground, together with diagrammatic data. How much does it improve our understanding of this kind of photograph to say that each sort of element it contains (diagrammatic, resembling, and nonresembling) is an index or a trace? It certainly is possible to insist on subsuming these disparate elements under the index label, but that amounts to stating the incontestable—the print is a photograph. But it does not begin to explain why some of the things it shows resemble items as they are generally portrayed in snapshots, while others look like data on a graph, and yet others don't look like anything at all.

Marey designed his photographic instruments to detect non-sensible displacements and simultaneously to visualize them. So his graphs and pictures give visual form to forces outside our experience. The way the data get visualized has everything to do with the thought and care put into the design and manufacture of the machinery and the particulars of the way the instruments are put to use. For Marey, the visualizations represent real displacements, but the only way we can study them, since they are beyond our ability to experience, is by means of his pictures. Again, using the index label to sort these complex and puzzling photographs fails to provide anything in the way of an explanation of why they look the way they do.

Let's say that I use a camera to copy the front page of the *New York Times* and do a careful job of it. The resulting print allows me to read the page and view the photographs. Shall we say that the copy print is an index of this thing—the front page of the newspaper? What is gained by doing so? If I take a photograph of a blank sheet of paper and fill the camera's frame with it and if I do everything else correctly (relative to the goal of making an exact copy of the paper), I get a blank, white print. Is this print an index of the white paper? Now, if I take an unexposed piece of film in a completely darkened room and place it on top of the white paper, flip on the lights and allow it to be exposed to light

reflecting off people, books, desks, curtains, floor, etc., and then process and print it, I will also get a blank, white print. Is it an index of the paper with which it was in intimate contact? Is it an index of all the things that reflected light onto the film? None of these candidates will work. If so, what then might it be an index of—disturbances caused by interactions of light in the crystals of silver bromide held in suspension in the film emulsion? Let me put this in a different way: don't all these photographs depend upon interactions between light and silver halide emulsions? Why should we say that some are indices of things and others are indices of light? If we put the two white prints next to each other, is there any chance we could distinguish each according to the object(s) it indexes?

Another example: I take two passport photographs of you, one with an exposure that produces a picture perfectly acceptable to immigration officials, but the second is made exactly the same way except that the exposure permits hundreds of times more light to expose the film than in the first case. The resulting print looks just like either of the two white prints discussed above. Is this failed portrait an index? Of what? You? Electromagnetic radiation?

Consider, finally, astronomical color photographs made prior to digital photography—pictures that show us the distant heavens as swirls of pink and purple clouds sprinkled with gold and silvery specks. I don't doubt that we are all tempted to understand these photographs as snapshots of the heavens, but they are not. An astronomer looking into a telescope aimed at a single place in the night sky might or might not see stars, but the picture, if properly made, will show the distant cosmos in a way that nobody can see it with a telescope or without. These photographs are exposed over many nighttime hours spread across many days. The telescope is situated on top of a clockwork mechanism that moves it slowly to keep it fixed on exactly the same point in space. Feeble light (far too feeble to affect the eye) from distant galaxies slowly accumulates on the color film. The hues of the clouds in the photographs

are not records of the colors "out there" but are due to what is called "reciprocity departure"—registration shifts internal to the various sensitive layers of the film, triggered by the very long exposures. Are these pictures perfect analogons, or imperfect ones, or are they comparable to anything? Do they look like what they represent? To respond to this question in the affirmative requires us to imagine that the universe answers to photographs—that what we see in a photograph is what was there to be seen in the universe, if anyone could have been stationed in the right place. We often speak this way—but in a precritical vein. I had thought that Roland Barthes's writing on photography was meant to help us think beyond this kind of talk.

Barthes's writing on photography, as most popularly interpreted for us, is not analytically or methodologically useful in trying to make sense of different kinds of photographs, or of photography as a whole. So it is wearying to find the same old aggressively tendentious, either/or reading of Barthes proffered as authorization for claims about photography *an sich*, claims that possess few of the virtues of commonsense intuitions, while husbanding all their vices.

For example, Barthes's delicate and frangible essay "The Photographic Message" is couched with qualifications, and while its mood in places can strike a reader as indicative, it tends primarily toward the tentative and subjunctive. The essay cannot be read profitably as if it were a manual of arms—it is hypothetical, conjectural, and speculative. It signals this repeatedly, as for example in this sentence: "In actual fact, there is a strong probability (and this will be *a working hypothesis*) that the photographic message too—at least in the press—is connoted."[164] Moreover, the range of the essay is restricted to what Barthes calls "the press photograph"—it does not expand to cover or explain photography as such, nor does it seem that it was meant to.[165] Barthes announces the tentative, first-step character of his essay this way: "What

follows will be limited to the definition of the initial difficulties in providing a structural analysis of the photographic message."[166]

Barthes gives the direction of the essay in this way: "This purely 'denotative' status of the photograph, the perfection and plenitude of its analogy, in short its 'objectivity,' has every chance of being mythical (these are the characteristics that common sense attributes to the photograph)."[167] He is careful to ground the essay with reference to common sense because it is, as he understands it, the source of the immense and unchallenged power of press photographs. We (or is it "they," the unwitting consumers of, say, *Paris Match* or *Life*?) take press photographs to show us "reality" as it is, without mediation. Barthes rests his analysis on an account of commonsense beliefs about the press photograph:

> In order to move from the reality to its photograph it is in no way necessary to divide up this reality into units and to consti-tute these units as signs, substantially different from the object they communicate; there is no necessity to set up a relay, that is to say a code, between the object and its image. Certainly the image is not the reality but at least it is its perfect *analogon* and it is exactly this analogical perfection which, *to common sense,* defines the photograph.[168]

It would be useful to know how Barthes divides the hunches of common sense from his own beliefs about photographs. Krauss, in her Assessment (which she calls her "descent into baby Barthes," but which unmistakably maintains all the subtlety of her adult disquisitions on Barthes), understands him to claim that there is, without qualification, a hard and fast denotation/conno-tation distinction that is not mythical and not merely conditional on common sense. So, we are to understand that when he says, "This purely 'denotative' status of the photograph, the perfection and plenitude of its analogy, in short its 'objectivity', has every chance of being mythical," he means to say that press photo-graphs, quite apart from common sense, really are denotative,

really do possess the perfection and plenitude of their analogies, but are only mythically "objective." The question here concerns the range of the "this" in "This purely 'denotative'..." Why bother to say that "it is exactly this analogical perfection which, *to common sense*, defines the photograph" unless he means to situate the entire essay between the fantasies of myth and the revelations of myth dismantling?

Let me offer another example. Barthes's essay closes in a remarkable manner that challenges Krauss's reading. He says,

> These few remarks sketch a kind of differential table of photographic connotations, showing if nothing else, that connotation extends a long way. Is this to say that a pure denotation, a this-side of language is impossible? *If* such a denotation exists, it is perhaps not at the level of what ordinary language calls the insignificant, the neutral the objective but, on the contrary, at the level of absolutely traumatic images. The trauma is a suspension of language, a blocking of meaning. Certainly situations which are normally traumatic can be seized in a process of photographic signification but then precisely they are indicated via a rhetorical code which distances, sublimates and pacifies them. Truly traumatic photographs are rare, for in photography the trauma is wholly dependent on the certainty that the scene 'really' happened: the photographer had to be there (the mythical definition of denotation).[169]

What happens to Krauss's version of Barthes's essay if there is no such thing as "pure denotation"? What if it turned out that there is only and at best an impure denotation (whatever that could possibly be), or, as Barthes is willing to wonder, what if there is nothing but connotation? Is denotation like extra virgin olive oil, or is it closer to Ivory soap (99 and 44/100ths percent pure), or is it yet more pure than that? As both Krauss and I read Barthes, the paradox is lost if photographs do not possess a "purely" denotative spine. Absent the claims about the rock-hard, either/or

denotation that Krauss maintains are authorized by Barthes, the entire enterprise of photographic signification teeters and inevitably falls. Krauss takes Barthes's essay and drains it of its greatest strength—its speculative and tentative character—which are themselves the signs of the complexity of its subject. She fashions a reading that insists on an in-principle analytic separation of denotation from connotation, but the "interpretation" violates both the spirit and content of Barthes's essay. If Krauss wants to insist on an absolute and fixed distinction between denotation and connotation, she will have to do so *sans* Barthes—because it isn't in residence in his essay. Absent the invocation of his authority, what is left of her "argument"?

There is an issue here about intellectual attitude that separates me from some of the writers in this volume. I don't believe in sacred texts, though I have my favorites, and arguments from authority in an academic context are not, as I see it, arguments at all—they are merely attempts at bullying, aimed at bringing questions to an end. But worse than arguments from authority are those that depend solely on the invocation of words borrowed from authorities. And so, I turn now to "*the* index."

Happily, Krauss provides us with a brief and revealing memoir of the development of her thought regarding "messages without codes":

> The theorist to whom I could turn for analysis of the relation between photograph and caption was Roland Barthes, specifically "The Photographic Message," where he produces the characterization of photography as "a message without a code." The next place to find an elaboration of this rather gnomic pronouncement turned out to be C.S. Peirce's "Logic as Semiotic" in which a taxonomy of the sign is divided into the possibilities icon, index, and symbol—the last (symbol) being conventional language (Barthes's idea of "code"), and the second (index) being the analogical "messages" of which Barthes speaks.[170]

What compelling reason does Krauss have that leads her to explicate her Barthes in terms of Peirce? Instead of providing the particular grounds for choosing Peirce, she gives us a generalized formula that guides her selection of critical terms. "It is, indeed, my contention that whenever a critic or writer reaches into the vast possible literature for a theoretical term with which to deal with culture, it is to perform a task, making the question of the work the concept is doing the only one to apply."

Indeed.

The choice of "index" was driven by "the work the concept is doing." Let us, for the moment, accept that report. Krauss identifies Peirce's index with "the analogical 'messages' of which Barthes speaks." This is an inauspicious starting point.

Peirce's writings are exceptionally complex, demanding, and often obscure. The tripartite division of signs is only the gateway to a mass of distinctions that lead quickly to further divisions. I will not descend into a Peirce quotation frenzy—this book is already well stocked with samples of his texts—nor would I claim that his terms are fixed and univocal—but it is possible to make some broad points about the tendency of Peirce's thought in respect to signs and what happens to that thought when his terms are used to "elaborate" what Krauss insists are Barthes's affirmations.

To begin: Peirce defines *all* signs in terms of denotation. As he offers them, icons, indices, and symbols are denoting *Representamen*—each determined sign is situated in relation to the object it signifies, stands for, represents. Accordingly, one sign cannot be distinguished from another in terms of its capacity to denote. But if that is the case, how can *the* index be expected to provide the kind of elaboration of "the analogical 'message'" that Krauss wants? It will not yield her a way of discriminating between the proposed universes of codified and uncodified messages in terms of a contrast between connotational and denotational content. In other words, Krauss needs to distinguish photographs from all other messages in terms of their denotative content if she really

means to make sense of analogical messages,[171] but Peirce's theory of signs cannot accommodate that division of signs.

There is an opportunity here to distinguish signs according to the kinds of objects they denote, but that would require explaining what Peirce means by "object," and Krauss is wise not to walk down that path. I cannot provide a rigorous and comprehensive explanation of Peirce's thoughts about objects, but I do know where and how to start one. For Peirce, the extension of the term "object" extends as far as significance itself.

My second point, alas, demands a quotation. Peirce offers this kind of formulation with great consistency:

> One very important triad is this: it has been found that there are three kinds of signs which are all indispensable in all reasoning; the first is the diagrammatic sign or icon, which exhibits a similarity or analogy to the subject of discourse; the second is the index, which like a pronoun demonstrative or relative, forces the attention to the particular object intended *without describing* it; the third is the general name or description which signifies its object by means of an association of ideas or habitual connection between the name and the character signified.[172]

How will this discrimination of different kinds of signs by way of their specific characteristics help Krauss explain *the* photograph? She claims to have elaborated "the analogical message" in terms of *the* index, but recall that Peirce explains *the icon* in terms of likeness, similarity, or analogy to the object denoted and explicitly says that an index forces attention to the particular signified object *without* describing it. An index indicates its objects. How can anyone, on Peirce's authority, argue that the "analogical message" is an index? The short answer is that it is not possible; the project will not work. If she wants the analogical message, it will have to be along the lines of Peirce's icon, or she can have

his index, but it cannot be an analogical message, no matter how perfect it may be.

Barthes's semiotics is dyadic and presupposes that connotation is everywhere while holding out the possibility that there may be denotation in a few places scattered here and there, while Peirce's semiotics is triadic and is built on the blunt supposition that the primary function of signs is to denote. To see how much at odds these two schemes are, note Krauss's assertion that in "Logic as Semiotic" Peirce provides "a taxonomy of the sign [which] is divided into the possibilities icon, index, and symbol—the last (symbol) being conventional language (Barthes's idea of 'code'), and the second (index) being the analogical 'messages' of which Barthes speaks." But this matching of Barthes and Peirce via the pairing of rubrics—analogical message/index and Barthes's code/ symbol—excludes the first of Peirce's signs. What happened to the icon? It gets lost or suppressed or simply assimilated into the realm of the codified. Peirce will not permit this reduction.

I want now to return briefly to the passage in Krauss's memoir in which she describes her method of choosing theoretical terms: "It is, indeed, my contention that whenever a critic or writer reaches into the vast possible literature for a theoretical term with which to deal with culture, it is to perform a task, making the question of the work the concept is doing the only one to apply." Judging by her performance, Krauss does not reach into a vast literature of *terms* or *concepts*. In the case at hand, she does something rather different—she selects a *word* from the work of a well- known theorist and then uses it in a way his theory could not possibly support. Theorists fashion and deploy concepts that take their functions and sense from their mutual relations. Extirpat- ing the word "index" out of its philosophic context and granting it analogical properties, while denying denotational capacity to symbols and icons, de-terminates (denatures) the term and ren- ders it incomprehensible in the context of Peirce's work on signs. In deauthorizing "index," Krauss simultaneously loses Peirce's

authority. It is hard to imagine why she would have sought his authority (such as it is) in the first place. The closer a reader gets to Peirce's work, the more difficult it becomes to understand.

It seems a reasonably sure guess that authors sharing Krauss's view of denotation/connotation would reject Peirce's contention that all signs function by denoting objects. But then the question is how do they choose which of his claims to use and which to ignore? Presumably, they do so by deciding which they think are correct and which they deem incorrect. For my part, I find Peirce intelligible and consistent in some places; in others, difficult to follow; and at times, simply wrong. In this, I take my lead from Peirce scholars who are forever accusing him of contradiction and/or a lack of clarity.

Read out of context from his magisterial work on signs, it is possible to conclude that Peirce sees an inevitable relation of resemblance ("analogical perfection"?) between photograph and the objects they represent. Bear in mind that for Peirce, "resemblance" has a wide range of meanings, including "likeness," "similarity," "similitude" (each in some qualitative respect), and so on. Take his famous attempt to explain what an index is by reference to photographs:

> Photographs, especially instantaneous photographs, are very instructive, because we note that they are in certain respects exactly like the objects they represent. But to these a resemblance is due to the photographs having been produced under such said that they were physically forced to correspond point by point to nature. In that aspect, then, they belong to the second class of signs, those by physical connection.[173]

Why does Peirce single out instantaneous photographs as especially instructive? Why would not a photograph of the Coliseum in Rome, taken with a 30-second exposure, be equally useful? I suspect he believes that the kinds of awkward positions of humans and animals that can be found in an instantaneous

photograph of the 1890s (when they were still novelties) display something important about how we understand these pictures to have been made. What Peirce is focused upon is the physical force it took to make the photograph come out the way it did. The point-by-point correspondence allows us to see that the things represented in the photograph "are in certain respects exactly like the objects they represent." The likeness here is not between the way the thing would have looked to the photographer when the shutter was snapped as compared to the way it is represented (recall my discussion of Marey's photographs), but between the object as it *was* for a fraction of a second and the way it is represented in the picture. We see this kind of picture and conclude that we could not have seen what the picture shows. It doesn't look like what could have been seen, though in his broad sense, it stands to what happened in front of the camera in a relation of qualitative similitude.

Whether or not my reading is persuasive, it does seem clear that Peirce is not providing a general theory of photography in the very few lines he takes to write the statement. He is trying to explain some one thing about a feature of an index and is not engaged in explaining everything about photography. He notices a single "aspect" of *certain* photographs—a feature that calls attention to force (and resistance), which are one mark of one kind of index. Photographs for Peirce are most generally both icons and indices. In a rather late manuscript, he writes, "A photograph, for example, not only excites an image, has an appearance, but, owing to its optical connexion with the object, is evidence that that appearance corresponds to a reality."[174] Note, he says "*a* reality"—which for Peirce is not delimited by the range of analogies between what was seen and what is shown.

One problem with the index project as conceived by Krauss is that it is set up around a notion of analogical perfection, which is then "elaborated" in such a way that the very idea of the "message without a code" gets obliterated.[175] We begin with the

hypothesis that a press photograph is a perfect analogon, a case of pure denotation, but by the time it is extruded through an emaciated understanding of Peirce's index, all sorts of marks are suddenly revealed as cases of pure denotation. But these new cases are not identifiable by way of their analogical plenitude, because they have none. So the elaboration via Peirce of Barthes's message without a code ends up showing us that many (all?) kinds of mechanical marks are purely denotative and do not require a code to be significant (in the way press photographs are significant).

To get some idea of how completely mismatched the index and its associated vocabulary, as developed by Krauss, are to the task of making sense of specific cases of mechanical markings, think of a seismographic printout made during a massive earthquake. Each of the swings of the inscriber is a *trace* of the release of massive quantities of energy. Absent the enormous telluric spasms, there would be no swings of the inscribing needle. But should the marks on the paper be conceived as pure denotata, as messages without a code? And should we conceive of the graph paper as providing the rudiments of connotation for the underlying message without a code? Why on earth should we? Imagine that the seismographic inscriber is allowed to run on ordinary white paper and the results are then shown outside the functional context of seismography to people who know nothing about it. Do they see indices of earthquakes denoted on the paper? If you want to go by the Peirce book, the marks retain their indexical relation to the quake, but only people who know seismography can comprehend them as indicia of anything. The marks must be returned to the iconic realm of graph paper (this, according to Peirce) and the symbolic realm of the rules of seismography to perform their function. Like photography, seismography isn't inert; it is plastic. If designers of seismographic equipment choose to, they can arbitrarily assign different profiles to the marks produced by their equipment. There is nothing inevitable about the outline of marks produced by a machine. But marks must have some shape.

The contours of marks produced by a machine are a function of pragmatic considerations embedded in the goals of a given study. Or do I mean Pragmaticist considerations? To be significant, the graph needs to be readable, and to read it a potential user needs to understand seismography—needs to know how curved spikes on a long sheet of graph paper relate to violent telluric convulsions. To repeat my question: is a seismographic printout best thought of as a message without a code that has a connotation imposed upon it?

A related matter: more than one of the assessors found it necessary to identify a motive behind my resistance to *the* index and found it in my concern that, as one assessor put it, *the* index "deprive[s] photography of its aesthetic possibilities of control over composition and internalized meanings."[176] I stand accused of having aesthetic, deviationist tendencies—the very worst kind. Next I will be accused of voting for Bush/Cheney, or perhaps that charge is already contained in the business about internalized meanings.

I know for a fact that some photographs are better than others. Among these are dental x-rays, astronomical photographs, passport pictures, and the like. I also know that photographs are not constrained by the world to look the way they do, and neither are seismographs or EKGs. None of this has anything to do with internalized meanings (not that I know what an externalized meaning might be). I remind the reader that my first publication attacked the very idea of photographic specificity, the idea that photographs were essentially this or that and that they could only be evaluated in terms of the nature of photography.[177] Back then, my view was held to be an attack on the foundational principles of modernist photography. The rule of the index is just one more attempt to stipulate a photographic essence. It is surprising to find so quaint a commitment to entelechies in the twenty-first century.

My opposition to *the* index has little to do with aesthetics and everything to do with the lack of intellectual rigor it represents, my sense of what it means to be responsible to texts (or, if

you prefer, to a community of intelligent readers of texts), and my desire to understand things that are complex and that cannot be understood by the application of a label. I have never believed that the rise or fall of *the* index could possibly effect anything very interesting or useful.

The index is beside the point and pointless.

Notes

1. W. G. Sebald, *Austerlitz* (London: Hamish Hamilton, 2001), 261.
2. I thank David Raskin for proposing I write an Assessment. For their willingness to discuss various aspects of the argument developed here, I thank Ellen Miles, Richard Shiff, Matt Witkovsky, and Frank Goodyear.
3. The literature on the photograph and the index is voluminous. See, for example, Charles Sanders Peirce, "Logic as Semiotic: The Theory of Signs," in *The Philosophical Writings of Peirce*, edited by Justus Buchler (New York: Dover, 1940), 119; Richard Shiff, "Phototropism (Figuring the Proper)," *Studies in the History of Art* 20 (1989): 169–71; and Rosalind Krauss, "Notes on the Index," parts 1 and 2, in her *The Originality of the Avant-Garde and Other Modernist Myths* (1985; reprint, Cambridge MA: MIT Press, 1993), 196–219.
4. The "truth claims" of photography have been widely analyzed; see Shiff, "Phototropism," 161–79, for a powerful analysis of the historical and cultural context from which photography's claim to represent the real derives.
5. After recounting this tale, Pliny goes on to praise the work of Lysistratus, who "first... obtained portraits by making a plaster mould on the actual features," noting he "also first rendered likeness with exactitude." On the myth of Dibutade and Butades, see Pliny, *Natural History*, 35.151–52; and Athenagoras, *Legatio pro Christianis*, 17; for the story of Lysistratus, see Pliny, *Natural History*, 35.153. Both legends are recounted by Antonio Corso, "The Position of Portraiture in Early Hellenistic Art Criticism," paper prepared for the colloquium "Praxiteles and Greek Portraiture in the 4th Century," at the Deutsches Archäologisches Institut, Phidiou 1, 9–10 November 2002. The paper is available at www.ascsa.edu.gr/conferences/Dit.htm. Ellen Miles discusses the link of the myth of the Corinthian Maid to the popularity of profiles in the neoclassical era of the late eighteenth and early nineteenth centuries; see Ellen G. Miles, *Saint-Memin and the Neoclassical Profile Portrait in America* (Washington DC: Smithsonian Institution Press and the National Portrait Gallery, 1994), 33–35.
6. A number of scholars have made this connection. On the figure of Narcissus as a means to get at self-portraiture and the construction of an alter ego, see Richard Brilliant, *Portraiture* (Cambridge MA: Harvard University Press, 1991), 45–46. For a succinct discussion of the emergence of self-portraiture and the concept of the modern self, see Joseph Leo Koerner, "Self-Portraiture: Direct and Oblique," in *Self Portrait: Renaissance to Con-*

temporary, edited by Anthony Bond and Joanna Woodall, exhibit cata-logue (London: National Portrait Gallery, 2005), 67–81. Woodall notes that in sixteenth-century Venice, the self-portrait was simply known as a "portrait made in the mirror." She addresses both the ideal and narcissistic associations conjured up by the mirror. Jean-Jacques Rousseau uses the figure of Narcissus to attack immature self-adulation, played out through a portrait, in "Narcissus, or the Self-Admirer, a Comedy," in *The Miscella-neous Works of Mr. J.J. Rousseau,* vol. II (London: Printed for T. Becket and P. A. de Hondt, 1767). Rousseau's work and treatment of Narcissus are discussed briefly in T. J. Clark, "The Look of Self-Portraiture," in Bond and Woodall, *Self Portrait,* 58.

7. Koerner, "Self-Portraiture," 70.

8. Robin Jaffee Frank notes that in addition to serving as an adornment or addition to miniatures in eighteenth- and nineteenth-century America, hair was actually "chopped up or dissolved to paint mourning miniatures, knotted in bracelets, plaited in lockets, or... displayed on the reverse of a portrait." See Robin Jaffee Frank, *Love and Loss: American Portrait and Mourning Miniatures* (New Haven: Yale University Press, 2000), 10. I thank Ellen Miles for her assistance with the question of hair ornamenta-tion and portrait miniatures.

9. The silhouette, named for Etienne de Silhouette, a mid-eighteenth-cen-tury French comptroller general of finances, was particularly popular in Europe and the United States from the mid-eighteenth through the mid-nineteenth centuries. A good overview of the history of the silhouette and its relationship to the physiognomic theories of Johann Kaspar Lavater is provided by A. Hyatt Mayor in his "Introduction" for *Auguste Edouart's Silhouettes of Eminent Americans, 1839–1844* (Charlottesville: University of Virginia Press, 1977, for the National Portrait Gallery, Smithsonian Institution), xi–xv. A detailed account of the history of the profile por-trait in Europe and the United States during the mid-eighteenth and early nineteenth centuries, describing its relationship to popularization of the myth of the Corinthian Maid and to Lavater's physiognomic theories, is provided by Miles, *Saint-Memin and the Neoclassical Profile Portrait in America,* 27–59.

10. On the relationship of the myth of the Corinthian Maid to the invention of photography, see Geoffrey Batchen, *Burning with Desire: The Concep-tion of Photography* (Cambridge MA: MIT Press, 1997), 112–20. Batchen provides an insightful discussion and an excellent review of the important literature devoted to this theme. For a detailed account of *The Corinthian Maid,* Joseph Wright of Derby's 1782–1784 painting of this myth, commis-sioned by Josiah Wedgwood, whose son Thomas conducted early research on photography, see John Hayes, *British Painting of the Sixteenth through Nineteenth Centuries,* The Collections of the National Gallery of Art Sys-tematic Catalogue (Cambridge: Cambridge University Press; National Gallery of Art, Washington DC, 1992), 344–50. Steven Z. Levine dis-cusses Baudelaire's recourse to the myth of Narcissus in his review of the Salon of 1859. See Steven Z. Levine, *Monet, Narcissus, and Self-Reflec-*

tion: The Modernist Myth of the Self (Chicago: University of Chicago Press, 1994), 1; and Charles Baudelaire, "Salon de 1859: Le Public Moderne et la Photographie," in *Curiosités esthétiques, L'Art romantique, et autres Oevres critiques,* edited by Henri Lemaitre (Paris: Bordas, 1990), 317.

11. William Henry Fox Talbot, "A Brief Historical Sketch of the Invention of the Art," in *Classic Essays on Photography,* edited by Alan Trachtenberg with notes by Amy Weinstein Meyers (New Haven CT: Leete's Island Books, 1981), 28–29.

12. Shiff, "Phototropism," 171.

13. This point is also made by Joel Snyder and Neil Walsh Allen in "Photography, Vision, and Representation," *Critical Inquiry* 2 (1975): 151.

14. Roland Barthes, *Camera Lucida: Reflections on Photography* (New York: Hill & Wang, 1981), 3. The power of the observation from Barthes's perspective is heightened by his preserving the original observation with quotation marks. Roland Barthes identifies the photography as "a message without a code" in his essay "The Photographic Message," in *Image, Music, Text,* essays translated and selected by Stephen Heath (New York: Hill & Wang, 1977), 17.

15. William Ivins identifies the photograph as a picture with "no linear syntax of its own" in *Prints and Visual Communication* (Cambridge MA: Harvard University Press, 1953), 180. While the technological relationship between the camera obscura and camera lucida is easily to establish, particularly given the language used to describe the invention of both the daguerreotype and the calotype in 1839, Jonathan Crary complicates the intellectual implications of this development, arguing that "the camera obscura model of vision... collapsed in the 1820s and 1830s, when it was displaced by radically different notions of what an observer was, and of what constituted vision." See Jonathan Crary, *Techniques of the Observer* (1990; reprint, Cambridge, MA: MIT Press, 1993), 27ff. On the announcement of the invention of the daguerreotype, describing its connection to the camera obscura, see H. Gaucheraud, "The Fine Arts: A New Discovery," *La Gazette de France (Paris),* January 6, 1839, translated by Beaumont Newhall, reprinted in *Photography: Essays and Images* (New York: Museum of Modern Art, 1980), 17; on Fox Talbot's description of his invention, linking it to the camera lucida and camera obscura, see Fox Talbot, "A Brief Historical Sketch of the Invention of the Art," 28–29.

16. Umberto Eco, *A Theory of Semiotics* (Bloomington: Indiana University Press, 1979), esp. 32–47.

17. Barthes, *Camera Lucida,* 6; and William J. Mitchell, *The Reconfigured Eye: Visual Truth in the Post-Photographic Era* (Cambridge MA: MIT Press, 1992), 26 and 31.

18. Germano Celant, "Interview with Marc Quinn," in Germano Celant, Darian Leader, and Marc Quinn, *Marc Quinn,* exhibition catalogue (Milan: Fondazione Prada, 2000).

19. Simon Hattenstone, "Marc Quinn: Blood Brother," *The Guardian,* October 25, 1999, 4.

20. Marc Sanders, "Invasion of the Body Sculptures: Interview with Marc Quinn," *Dazed and Confused* 13 (January 1995): 44.

21. Mirroring plays an important role in the work of Quinn; the artist's *Mirror Self-Portrait* consists of his shaving mirror, used on a daily basis; *Continuous Present* (2000), as Germano Celant has observed, "reflects time through the mirroring of the spectator's body"; Celant, "Interview with Marc Quinn." Numerous other works, such as *Spherical Morphology* (1997), engage reflective surfaces.

22. National Portrait Gallery, Press Release, "Genomic Portrait," Tuesday, 18 September 2001. Cited in Suzanne Anker and Dorothy Nelkin, *The Molecular Gaze: Art in the Genetic Age* (Cold Spring Harbor NY: Cold Spring Harbor Laboratory Press, 2004), 10.

23. The trustees of the London National Portrait Gallery agreed that *A Genomic Portrait: Sir John Sulston* could stand alone, independent of the photograph; Charles Saumarez Smith, "When Is a Portrait Not a Portrait?" *The Daily Telegraph*, 19 September 2001, 23.

24. Marc Quinn, quoted in Louisa Buck, "Away from His Body: Artist's Interview, London: Marc Quinn," *The Art Newspaper*, no. 108 (November 2000): 28.

25. Catherine De Lorenzo, "The Composite Enigma of Nadar," *History of Photography* 27, no. 3 (Autumn 2003): 205–21. The caption for this cover photograph reads, "Nadar [Félix Tournachon], *Portrait composite des frères Reclus A*, albumen print, 1885. Bibliothèque national de France, Paris. Estampes et Photographie, NA 238 Gd. Fol. Collection Nadar, 4566A P83678."

26. Gabrielle Esperdy, "A Taxing Photograph: The WPA Real Property Survey of New York City," *History of Photography* 28, no. 2 (Summer 2004): 123–36. The caption for this cover photograph reads, "*249-8-M. 277 South Street at Pike Slip*, New York City Tax Photographs, black and white print from duplicate of original 35mm negative, 1939–41. Courtesy New York City Municipal Archives."

27. Eric Sandeen, "The International Reception of *The Family of Man*," *History of Photography* 29, no. 4 (Winter 2005): 344–55. The caption for this cover photograph reads, "United States Information Agency (USIA) photograph, *A Khrushchev Look-alike Enjoying The Family of Man exhibition, Munich, West Germany, 1955*. USIA Collection, National Archives of the United States, Washington DC."

28. Much has been written about photography and indexicality, including Henri Van Lier's *Philosophie de la photographie* (Laplume: Les cahiers de la photographie, 1983); Philippe Dubois, *L'acte photographique* (Paris: Nathan/Labor, 1983); and Jean-Marie Schaeffer, *L'image précaire: Du Dispositif photographique* (Paris: Seuil, 1987).

29. Regarding Peirce's classification of signs, two important essays from the "Syllabus": "Sundry Logical Conceptions" and "Nomenclature and Divisions of Triadic Relations as Far as They Are Determined" can be found in *The Essential Peirce: Selected Philosophical Writings, Volume II (1893–1913)* (Bloomington: Indiana University Press, 1998).

30. See Charles Sanders Peirce, "On a New List of Categories," in *Writings of Charles S. Peirce: A Chronological Edition*, vol. 2, edited by Edward C. Moore (Bloomington: Indiana University Press, 1984), 49–59.

31. This is the case of the icon that, technically speaking, can only self-represent itself through connotation—which is to say that the icon can only represent through its own qualities. The consequence is that sign and object become indistinct with regard to the qualities in question. As for the symbol, its task is to represent a general object (a type) that it can only achieve by denoting, by way of an index, an actual occurrence that belongs to it. Without an index, the object of the symbol is purely abstract and thus unmoored from reality.

32. "Digital Editing and Montage: The Vanishing Celluloid and Beyond" (in collaboration with Marc Furstenau), *Cinémas* 13, nos. 1–2 (2002): 69–108.

33. In discussing iconic signs, Peirce mentions that they can be "divided according to the mode of Firstness which they partake. Those that partake of simple qualities, or First Firstnesses, are *images;* those which represent the relations, mainly dyadic, or so regarded, of the parts of one thing by analogous relations in their own parts, are *diagrams;* those which represent the representative character of a representamen by representing a parallelism in something else, are *metaphors.*" Charles Sanders Peirce, "Sundry Logical Conceptions," in *The Essential Peirce: Selected Philosophical Writings, Volume II,* 274.

34. See Martin Lefebvre, "De quelques airs de famille: remarques sur le langage et la ressemblance chez Peirce et Wittgenstein," in *Peirce, Wittgenstein et le pragmatisme,* edited by François Latraverse (Paris: l'Harmattan, forthcoming).

In a nondated fragment entitled "Notes on Topical Geometry," which was appended as a footnote by the editors of the *Collected Papers* to a letter Peirce addressed to British philosopher Victoria Lady Welby, he offers, roughly speaking, the same distinction. Peirce claims that there are two classes of indices, *designators* and *reagents,* which correspond to what I have called *indirect indexical relation* and *direct indexical relation:*

An index represents an object by virtue of its connection with it. It makes no difference whether the connection is natural, or artificial, or merely mental. There is, however, an important distinction between two classes of indices. Namely, some merely stand for things or individual quasi-things with which the interpreting mind is already acquainted, while others may be used to ascertain facts. Of the former class, which may be termed designations, personal, demonstrative, and relative pronouns, proper names, the letters attached to a geometrical figure, and the ordinary letters of algebra are examples. They act to force the attention to the thing intended. Designations are absolutely indispensable both to communication and to thought. No assertion has any meaning unless there is some designation to show whether the universe of reality or what universe of fiction is referred to. The other class of indices may be called reagents. Thus water placed in a vessel with a shaving of camphor thrown upon it will show whether the vessel is clean or not. If I say that I live two and a half miles from Milford, I mean that a rigid bar that would just reach from one line to another upon a certain bar in Westminster, might be successively laid down on the road from my house to Milford, 13200 times, and so laid down on my reader's road would give him a knowledge of the distance between my house and Milford. Thus, the expression "two

miles and a half" is, not exactly a reagent, but a description of a reagent. A scream for help is not only intended to force upon the mind the knowledge that help is wanted, but also to force the will to accord it. It is, therefore, a reagent used rhetorically. Just as a designation can denote nothing unless the interpreting mind is already acquainted with the thing it denotes, so a reagent can indicate nothing unless the mind is already acquainted with its connection with the phenomenon it indicates. (*Collected Papers of Charles Sanders Peirce*, 8. 368, n. 23)

In quoting from Peirce's *Collected Papers* I am using the standard reference practice, which consists in giving first the volume number followed, after the period, by the paragraph number. *Collected Papers of Charles Sanders Peirce*, 8 vols., vols. 1–6 edited by Charles Hartshorne and Paul Weiss; vols. 7 and 8 edited by Arthur Burks (Cambridge MA: Harvard University Press, 1931–1935 for vols. 1–6 and 1958 for vols. 7 and 8).

35. Charles Sanders Peirce, "New Elements," in *The Essential Peirce: Selected Philosophical Writings*, Volume II, 303.
36. Peirce, *Collected Papers of Charles Sanders Peirce*, 2.92.
37. Peirce is quite clear on the matter:

[A]lthough an index, like any other sign, only functions as a sign when it is interpreted, yet though it never happened to be interpreted, it remains equally fitted to be the very sign that would be if interpreted. A symbol, on the other hand, that should not be interpreted, would either not be a sign at all, or would only be a sign in an utterly different way. An inscription that nobody ever had interpreted or ever would interpret would be but a fanciful scrawl, an index that some being had been there, but not at all conveying or apt to convey its meaning. ("New Elements," in *The Essential Peirce: Selected Philosophical Writings, Volume II*, 318)

38. It goes without saying that such an interpretation may turn out to be false.
39. Peirce introduced the notion of legisign (along with those of sinsign and qualisign) into his classification of signs in 1903. A legisign is a sign that is such by sheer force of law or habit. Actual occurrences of such signs are called replicas. All linguistic signs are legisigns, as are all those signs that Peirce calls symbols—though indices and icons may also be legisigns. The case of linguistic indices is a somewhat complicated matter. From the perspective of the dictionary or from that of an English grammar, demonstrative pronouns or adjectives do not stand for a particular object to which they are existentially connected but for the very principle of linguistic indexicality (the act of denoting indexically) whose replication in language use requires each time an existential connection between sign and object. Thus when I say, "In English, the word 'that' is used as an index," the word "that" is the replica of a symbol—a linguistic symbol of linguistic indexicality. This is akin to saying that, in English, the purpose of the word "that" is to be interpreted as a sign of whatever object it may be existentially connected to in any given utterance. However, when standing in front of a table in a furniture store I say, "That table is too big," the word "that" is the replica of an indexical legisign. As Peirce scholar Thomas Short puts it, "A legisign is a legisign: something to be replicated. What its replicas signify depends on the rule of interpretation associated with the legisign. When the rule determines the significance, the legisign

is a symbol. When the rule only directs attention to certain aspects of the replica, then the legisign is either iconic or indexical. You know what 'there' [or 'that'] means if you know that, in any one use of that word, you have to look at what the speaker is looking at or pointing to or otherwise indicating. (Private communication)

40. *Collected Papers of Charles Sanders Peirce*, 2.320; 2.357; 5.569; 8.341; 8.352; 8.183.
41. Schaeffer, *L'image précaire*, 41.
42. Of course such "growth" must respect the architectonic of Peirce's phenomenological (or phaneroscopic) categories (Firstness, Secondness, Thirdness), as discussed briefly above.
43. All quotes from Barthes, *Camera Lucida*, 5.
44. Rosalind Krauss, "Notes on the Index: Seventies Art in America," *October* 3 (Spring 1977): 75.
45. Barthes, *Camera Lucida*, 5.
46. Barthes, *Camera Lucida*, 9.
47. Jonathan Crary's book, *Techniques of the Observer: On Vision and Modernity in the Nineteenth Century* (Cambridge MA: MIT Press, 1990), has notably expanded and greatly complicated this alignment by articulating points at which disjunction appeared between photographic technology and human vision.
48. Susan Sontag, *On Photography* (New York: Anchor Books, 1989), 20, emphasis added.
49. Barthes, *Camera Lucida*, 27.
50. Walter Benjamin, "Little History of Photography" (1931), in *Selected Writings Volume 2, Part 2, 1931–1934*, edited by Michael W. Jennings, Howard Eiland, and Gary Smith (Cambridge: Belknap Press, 2005), 510, emphasis added.
51. Charles Darwin, *The Expression of Emotion in Man and Animal*, 3rd ed. (New York: Oxford University Press, 1998), 168.
52. David Bate, *Photography and Surrealism: Sexuality, Colonialism and Social Dissent* (London: I. B. Taurus, 2004).
53. Roland Barthes, "Rhetoric of the Image," in *Image, Music, Text*; and Roland Barthes, "The Third Meaning: Research Notes on Several Eisenstein Stills" (1970), in *The Responsibility of Forms: Critical Essays on Music, Art, and Representation*, translated by Richard Howard (Berkeley: University of California Press, 1985).
54. Terry Eagleton, *After Theory* (London: Allen Lane, 2003).
55. Hence, the final term adopted for the medium, which signifies "light writing," notwithstanding the individual terms for specific technologies, such as daguerreotype, Talbottype, calotype, and so on. There are, of course, cameraless photographic images, as in the case of the photogram when objects are directly placed on a light-sensitive surface and exposed directly. This form of imagery is as old as photography itself, but can hardly be considered as a normative type of photography.
56. It should be said, however, that the question of indexicality is in certain ways related to this issue, inasmuch as the evidentiary status of photography (as in ID pictures, news photographs, and forensic or crime-scene photos) are all predicated on the presumption of indexicality.

57. Needless to say, there are several theorists who reject altogether the notion of a photographic ontology. Here, for example, is John Tagg's statement on the issue: "Photography as such has no identity. Its status as a technology varies with the power relations which invest it. Its nature as a practice depends on the institutions and agents which define it and set it to work. Its function as a mode of cultural production is tied to definite conditions of existence, and its products are meaningful and legible only within the particular currencies they have. Its history has no unity. It is a flickering across a field of institutional spaces. It is this field we must study, not photography as such." In John Tagg, "Evidence, Truth and Order," in Tagg, *The Burden of Representation: Essays on Photographies and Histories* (London: Macmillan, 1988), 63.

58. There is a suggestive exchange that occurs toward the end of the conversation, following an unresolved debate about medium, in the page that begins, "DC: Whenever we begin to talk about photography outside the art historical frame of reference, it's as if the conversation just dies. We talk about aerial photography, or PET scanning, all the uses that photography has, but when such examples come up, beyond acknowledging their existence, no one really seems to know what to do with them."

59. For example, *tone* might refer here to the political uses of manipulated photographs in the aftermath of French Commune, in Stalinist Russia, or in McCarthyite America.

60. Such a position is exemplified by the Museum of Modern Art's Photography Department for a great deal of its history. Especially in the exhibitions and catalogues produced under the aegis of the department's curator John Szarkowski and later, his institutional heir, Peter Galassi, photography has been positioned so as to be more readily aligned with other art histories.

61. "If the symbolic finds its way into pictorial art through the human consciousness operating behind the forms of representation, forming its connection between objects and their meaning, this is not the case for photography. Its power is as an index and its meaning resides in those modes of identification which are associated with the imaginary." Krauss, "Notes on the Index," 203.

62. Krauss, "Reinventing the Medium," *Critical Inquiry* (Winter 1999): 294.

63. In the guild system as it developed in the Middle Ages and continued for several centuries, the ascent from apprentice, to journeyman, and then finally to master was based on the production of a work, subject to the standards applied by the guild, and thus designated as the masterpiece.

64. The term is Bernard Edelman's.

65. In my own earlier work on photography and postmodernism (and quoting some remarks by Peter Bunnell on Cindy Sherman that are quite close to Snyder's in this recent conversation), I made the point, still clearly valid, that one needs to distinguish art photography in its modernist lineage from the postmodernist context in which one would rather refer to artists using photography. In this respect, I mentioned that when MoMA purchased its first work by Barbara Kruger, it was through the Department of Painting, not that of Photography. *Mutatis mutandis,* however, artists like Kruger, Louise Lawler, Richard Prince, and Sherman are now routinely included in books on photography, his-

tories of twentieth-century photography, and journals consecrated to photography (for example *Aperture*). All of which is evidence, did we require any, that contemporary art is almost uniformly considered as "postmedium." See Abigail Solomon-Godeau, "Photography after Art Photography," in her *Photography at the Dock: Essays on Photographic History, Institutions, Practices* (Minneapolis: University of Minnesota Press, 1991).

66. For example, Rosalind Krauss, *"A Voyage on the North Sea": Art in the Age of the Post-Medium Condition* (London: Thames & Hudson, 1999).

67. "Notes on the Index," and even more influentially, her "Sculpture in the Expanded Field" are both briefs for, and analyses of, the eclipse of medium specificity and the advent of the kinds of art making now wholly identified with postmodernism. Both essays are reproduced in Rosalind Krauss, *The Originality of the Avant-Garde.*

68. Alex Potts, "Tactility: The Interrogation of Medium in Art of the 1960s," *Art History* 27 no. 2 (April 2004).

69. In French, the title of the book of Krauss's essays is *Le photographique: Pour une théorie des écarts,* but this is deceptive because photography's difference is not defined; the index does not suffice.

70. Here I refer readers to my text, Michel Frizot, "La modernité instrumentale. Note sur Walter Benjamin," *Études photographiques* 8 (November 2000): 111–23.

71. The French title, *La chambre claire,* is a transformation of the term *chambre obscure:* dark becomes light. But this play on words is not always understood because few people know what the device named *chambre claire* (camera lucida) really is.

72. Barthes, *Camera Lucida,* sec. 30.

73. On this subject, I recommend Raymond Bellour's interview of the art historian Pierre Francastel in 1968, in Raymond Bellour, *Le livre des autres* (Paris: Union Générale d'Éditions 1978), 75–96, quotation on 86: "images have positive qualities that never perfectly correspond with the information that is defined by language."

74. I also think that there is a lot of misunderstanding in France regarding Crary. Although I do not share his ideas, he appeared innovative here because he seemed to take "technology" into account more than other authors.

75. I am thinking of Jonathan Friday's remark: "I don't by any means want to go to photons."

76. It may be useful to specify that this quantity is such that $E = h\nu$ (h being Planck's constant, E being energy, and ν the frequency of the light wave) and is the basis of the quantum theory of light. It is this determined quantity of energy that moves electrons and ultimately brings about the darkening (or another type of reaction) with which we are familiar.

77. When digital photography appeared, I thought about whether it was strictly "photographic," and came to the conclusion that the fundamentals of photography were still present in digital photography: a sensitive surface and the action of light. See Michel Frizot, "Qui a peur de la lumière?" *Art / photographie numérique, l'image réinventée* (Cyprès: École d'art d'Aix en Provence, 1995), 18–35.

78. Barthes, *Camera Lucida,* 115.

79. Barthes, *Camera Lucida,* 3.

80. Barthes, *Camera Lucida*, 55.
81. Barthes, *Camera Lucida*, 96.
82. Michel Tournier, *La Goutte d'Or* (Paris: Gallimard, 1986); the title refers to the quarter behind the Gare du Nord in Paris, populated by Arabs. But *the golden drop* is also a necklace, a talisman that a young Berber takes with him when he leaves for France to get hold of a photograph featuring a representation of him: an ominous accident, since, according to tradition, a parcel of the soul of the sitter moves into the representation. The young man is determined to restore the unity of his personality, of which "the golden drop" has become a symbol. Tournier attempts to arrest the attention of the reader by putting him under the spell of *the sign, the antidote to the image.*
83. An interesting overview of the theory of photography may be found in Hubertus von Amelunxen, *Theorie der Fotografie IV 1980–1995* (München: Schirmer/Mosel, 2000).
84. Philippe Dubois, *L'Acte Photographique* (Bruxelles: Editions Labor, 1983). He analyzes three putative definitions of photography departing from the tripartite scheme of the semiologist Peirce. In the first instance, photography can be considered as a mirror of reality. In this case, one conceives of it as an iconic sign, and more precisely a sign in which the similarity with the referent (reality) is of essential importance. Second, photography can be seen as a transformation of reality. This is a reaction to the realists. In this case, one focuses on the potential of photography to change or distort reality, inspired by inner motives and stirrings. In this case, photography is understood as a symbolical sign. Third, photography has an optical chemical relation with the world. In this sense photography is an index, a sign based on a natural relation with its referent.
85. F. Ripoll and D. Roux, *La photogaphie* (Toulouse: Milan, 1995).
86. *Attack! Photography on the Edge*, edited by Johan Swinnen (Antwerp and Baarn: Houtekiet/De Prom, 1999); see especially Willem Elias's essay, "Profiles of Paroxysm."
87. N. Zurbrugg, "The Ecstasy of Photography," in Jean Baudrillard, *Art and Artefact*, vol. 37, interview of 1993 (London: Sage, 1997).
88. Jean Baudrillard, *Car l'illusion ne s'oppose pas à la réalité* (Paris: Descartes & Cie, 1998).
89. See the exhibition in the hall "Arti & Amicitiae," at the Holland Festival, Amsterdam, 5–26 June 1999, with original work of Abdu'Allah, Nobuyioshi Araki, Amy Arbus, Pia Arke, Shimon Attie, Jean Baudrillard, Charif Benhelima, Jo Brunenberg, Theo Derksen, Joan Fontcuberta, Ben Hansen, Steve Hart, Duane Michals, Bart Michielsen, Ryuji Miyamoto, Andreas Müller-Pohle, Hans Neleman, Sakiko Nomura, Pentti Sammallahti, Toshio Shibata, Sterk & Rozo, and Masao Yamamoto, and a collection of photographs of male nudes (a private collection), as illustrations of the idea paroxysm.
90. Zurbrugg, "The Ecstasy of Photography," 32.
91. Baudrillard, *Le paroxyste indifférent. Entretiens avec Philippe Petit* (Paris: Grasset, 1997), 161.
92. English edition: Jean Baudrillard, *Paroxysm* (London: Verso, 1998).
93. Baudrillard, *Paroxysm*, 68.
94. Baudrillard, *Paroxysm*, 70.

95. Baudrillard, *Simulacres et simulation* (Paris: Galilée, 1981). The nihilism that he discerns assumes a new form, namely, that of transparency, of the complete transparency of values. The world is increasingly a virtual display in hyperreality. All things are simulated in transparency. The fatal strategy that Baudrillard prescribes to escape the capitalist system is that capitalism must destroy itself. Baudrillard, *Les stratégies fatales* (Paris: Grasset, 1986).
96. Baudrillard, *La Transparence du Mal* (Paris: Galilée, 1990), 158–61.
97. Jean Baudrillard, *Paroxysm*, 164.
98. "Voici une bonne nouvelle pour l'avenir de la peinture…. Il nous est né, depuis peu d'années, une machine, l'honneur de notre époque, qui, chaque jour, étonne notre pensée et effraie nos yeux. Cette machine, avant un siècle, sera le pinceau, la palette, les couleurs, l'adresse, l'habitude, la patience, le coup d'œil, la touche, la pâte, le glacis, la *ficelle*, le modelé, le fini, le rendu. Avant un siècle, il n'y aura plus de maçons en peinture : il n'y aura plus que des architectes, des peintres dans toute l'acception du mot." Wiertz, "La photographie," *Le National* (June 1855), reprinted in Wiertz, *Œuvres littéraires* (Brussels: Parent et Fils Editeurs, 1869), 309–10. My translation. I thank Virginie Devillez for pointing my attention to this essay.
99. The term *absorptive* cannot but bring to mind Michael Fried's employment of it regarding questions of spectatorship and the way pictorial images address their viewers. My intermingling with this terminology is determined by the simple fact that I have so far been unable to find a better English word than absorption to describe the phenomenon I am trying to grasp here. Absorption in this essay has to do with an attempt to understand the way artistic disciplines evolve over time and what kind of images can be seen as belonging to a certain discipline at a given point in time. Yet, this said, it is fascinating to find that nowadays, Fried himself is applying his own phenomenological theory of absorption to some of the very same images I range under the "absorptive model," See Fried, "Barthes's *Punctum*," *Critical Inquiry* 31 no. 3 (Spring 2005): especially 569, where Fried discusses the work of—among others—Bernd and Hilla Becher, Thomas Ruff, and Thomas Struth.
100. See Hilde Van Gelder, "De artistieke grenzen op het spel. Picturale aspecten van de actuele fotografie," *Obscuur* 6 no. 17 (October 2000): 23–32; and Hilde Van Gelder, "Disturbance as Art: Tracing Realism in the Photographic and Video Tableaux of Philippe Terrier-Hermann," in *Internationales*, edited by P. Terrier-Hermann (Amsterdam: Artimo Foundation, 2001), 52–55 and 65–71.
101. See in this respect Hilde Van Gelder, "Photography: From Modus to Picture," in *The Photographic Paradigm*, L & B, Series of Philosophy of Art and Art Theory, vol. 12, edited by A. Balkema and H. Slager (Amsterdam, Atlanta: Rodopi, 1997), 148–62.
102. I have also worked out a distinction between pictorial and pictural in the above-mentioned contribution in Balkema and Slager, *The Photographic Paradigm*, 149.

103. "Photography cannot find alternatives to depiction, as could the other fine arts": Wall, "Marks of Indifference: Aspects of Photography in, or as, Conceptual Art," in Ann Goldstein and Anne Rorimer, *Reconsidering the Object of Art*, exhibition catalogue (Los Angeles: Museum of Contemporary Art, 1995), 247. See especially 247, 260, and 266 for a description of what Wall understands by photography's "depiction."

104. To mention just two out of numerous examples: Dominic van den Boogerd defines Wall's images as "tableaux vivants" in his "Digitale allegorieën. Over de fotobeelden van Jeff Wall," *Metropolis M*, 5 (October 1994): 32–38. James Lingwood, in a detailed analysis of Wall's 1993 *A Sudden Gust of Wind (after Hokusai)*, defines it as "a picture of a moment elevated to the scale of a history painting": J. Lingwood, "Different Times," in *The Epic and the Everyday*, exhibition catalogue (London: South Bank Centre, 1994), 9.

105. Wall, "Marks of Indifference," 248 and 266.

106. See in this respect the discussion of Wall's work by Joanna Lowry in her "History, Allegory, Technologies of Vision," in *History painting reassessed. The representation of History in contemporary Art*, edited by D. Green and P. Seddon (Manchester: Manchester University Press, 2000), 97–111, and especially 101, where she addresses the question of the "tableau" in relation to Wall's oeuvre and Manet's painting.

107. Probably this is also at what Sabine Kriebel is pointing at in the roundtable when she states that to her, Gursky's work "pushes certain boundaries."

108. Krauss states, "[A]lthough Wall may have 'invented a medium' he has, by producing 'talking pictures,' failed to engage that medium's specificity. It is this failure, I think, that consigns his reworkings of old master art to nothing more ambitious than pastiche." Krauss, "... And Then Turn Away?" An Essay on James Coleman," *October* 81 (Summer 1997): 29. The "concealment" I allude to also has to do with the censorship Krauss's essay was subjected to. Initially written as a catalogue essay for an exhibition of the work of James Coleman, the Belgian publisher of the book asked Krauss to withdraw the passages overtly criticizing Wall, which she subsequently did, even though her criticism is amply justified on 32–33 of the (integral) *October* version of the essay. For a comparison with the heavily cut-down catalogue text, see *James Coleman*, exhibition catalog (Vienna: Wiener Secession, 1997), 27.

109. See Hilde Van Gelder, "Een kritische boodschap over de dagelijkse realiteit: fotografie tussen poëzie en politiek/A Critical Message on Everyday Reality: Photography between Poetry and Politics." *A-Prior* 5–6 (Spring–Summer 2001): 170–89.

110. For a plea for the inferiority of photography's iconicity in favor of its indexicality in the contemporary photography that can be situated into this intervening model, see Hilde Van Gelder, "Social Realism Then and Now: Constantin Meunier and Allan Sekula," in *Constantin Meunier: A Dialogue with Allan Sekula*, edited by Hilde Van Gelder (Leuven: Leuven University Press, 2005), 81.

111. This is also the argument Jean-Marie Schaeffer develops in the chapter "l'Icône indicielle," in *L'image précaire: Du dispositif photographique* (Paris: Seuil, 1987), 59–140. I thank Jan Baetens for reminding me of this text.



112. James Elkins has by now amply and more than convincingly pointed out that "the work indexicality has been made to do" in recent photography theory "could often have been done without any reference to Peirce": see James Elkins, "Critical Response: What Do We Want Photography to Be? A Response to Michael Fried," *Critical Inquiry* 31 no. 4 (Summer 2005): 938 n. 1.

113. Thierry de Duve's suggestive essay "Time Exposure and Snapshot: The Photograph as Paradox," reprinted in this book, came up in the roundtable and in some ways his distinction between the snapshot and the time exposure works along the same lines as my thinking here, although his conclusions are somewhat different. What de Duve calls the traumatic effect of "snapshot"—I have referred to it as "ecstatic"—comes about through photography's arresting of things: a stilled image of a moving world. The "time exposure" (it is a misleading term since they do not actually demand different lengths of exposure) is a still image of a still world, and is aligned not with trauma but with mourning or melancholy (I have referred to it as "stoic").

114. A good exception to this is Bernard Steigler's discussion of digital cameras in Bernard Steigler and Jacques Derrida, *Echographies of Television: Filmed Interviews* (Cambridge: Polity, 2002).

115. Baudrillard, "For illusion is not the opposite of reality." *Jean Baudrillard, Photographies 1985–1998* (Ostfildern-Ruit: Hatje Cantz, 1999).

116. Albert Renger-Patzsch, "Joy before the Object" / "Die Freude am Gegenstand" (1928). The year before, he had also spoken of magic: "We still don't sufficiently appreciate the opportunity to capture the magic of material things" ("Aims / Ziele," 1927). Both statements appear in English in *Photography in the Modern Era: European Documents and Critical Writings, 1913–1940*, edited by Christopher Phillips (New York: Aperture / The Metropolitan Museum of Art 1989).

117. Edwin Smith, "The Photography of Paintings, Drawings and Print," in John Lewis and Edwin Smith, *The Graphic Reproduction and Photography of Works of Art* (London: Cowell and Faber, 1969).

118. See, for example, Ed Ruscha's photo books such as *Twenty-six Gasoline Stations* (1963), Joseph Kosuth's proto-investigations such as *One and Three Chairs* (1965), and Victor Burgin's *Photopath* (1967–1969).

119. Lee Friedlander in *Lee Friedlander,* edited by Peter Galassi (New York: Museum of Modern Art, 2005).

120. I am restating a point I made in a little essay called "Still Standing, Still," *Contemporary Magazine* 67 (2004).

121. These may be seen at www.walshgallery.com.

122. See Rosalind Krauss, "The Photographic Conditions of Surrealism," in her *The Originality of the Avant-Garde and Other Modernist Myths* (Cambridge, MA: MIT Press, 1985), 106–10.

123. Deepak Ananth, *Unpacking Europe,* exhibition catalogue, 2001.

124. Marian Pastor Roces, *Science-Fictions,* exhibition catalogue, 2003.

125. E. H. Carr, *What Is History?* (London: Macmillan, 1961).

126. Brian Cantwell Smith, *On the Origin of Objects* (Cambridge MA: MIT Press, 1996).

127. Smith, *On the Origin of Objects,* 77.

128. Smith, *On the Origin of Objects,* 97.

129. Geoffrey Batchen, "Obedient Numbers, Soft Delight," in his *Each Wild Idea: Writing Photography History* (Cambridge MA: MIT Press, 2001), 164–74. Batchen draws attention to the close personal and professional links between William Henry Fox Talbot, who was working on what became the first successful negative/positive photographic process in the 1830s, and Charles Babbage, the English philosopher and mathematician who pioneered the first mechanical computer in 1833.

130. Beth E. Wilson, *The Material Image: Surface and Substance in Photography* (New Paltz: Samuel Dorsky Museum of Art at the State University of New York [SUNY] at New Paltz, 2005).

131. Rob Shields, "Performing Virtuality," http://virtualsociety.sbs.ox.ac.uk/ events/pvshields.htm (accessed January 2006).

132. G. Nunberg, "Farewell to the Information Age," in *The Future of the Book,* edited by G. Nunberg (Berkeley: University of California Press, 1996), 110–11.

133. Katherine Hayles, *How We Became Posthuman: Virtual Bodies in Cybernetics, Literature, and Informatics* (Chicago: University of Chicago Press, 199), 27–28.

134. Hayles, *How We Became Posthuman,* 247.

135. Hayles, *How We Became Posthuman,* 25.

136. S. Kenber, *Virtual Anxiety: Photography, New Technologies and Subjectivity* (Manchester: Manchester University Press, 1998), 17–36.

137. Geoffrey Batchen, "Ectoplasm," in his *Each Wild Idea,* 139.

138. Hayles, *How We Became Posthuman,* 247.

139. Hayles, *How We Became Posthuman,* 28.

140. M. Durden, "The Poetics of Absence: Photography in the 'Aftermath of War,'" in *Paul Seawright: Hidden,* exhibition catalogue (London: The Imperial War Museum, 2003), unpaginated.

141. See also Ian Walker, "Desert Stories or Faith in Facts," in *The Photographic Image in Digital Culture,* edited by M. Lister (London: Routledge, 1995). on Sophie Ristelhueber's photographs of the first Gulf War.

142. David Campany, "Safety in Numbness: Some Remarks on the Problems of 'Late Photography,'" in *Where Is the Photograph?* edited by D. Green (Maidstone UK: Photoworks and Brighton UK: Photoforum, 2003), 126.

143. Campany, "Safety in Numbness," 121.

144. Paul Frosh, *The Image Factory: Consumer Culture, Photography and the Visual Content Industry* (Oxford: Berg, 2003), 186.

145. Julia Kristeva, "The Ruin of a Poetics," *20th Century Studies* (December 1972): 104.

146. Rosalind Krauss, "'And Then Turn Away?' An Essay on James Coleman," *October* 81 (Summer 1997): 29.

147. Krauss, "Reinventing the Medium," *Critical Inquiry* 25 (Winter 1999): 296.

148. Krauss, "Reinventing the Medium," 289.

149. Krauss, "Reinventing the Medium," 290.

150. Krauss, "'And Then Turn Away?'" 9.

151. Krauss, *"A Voyage on the North Sea,"* 6.

152. Krauss, "'And Then Turn Away?'" 29.

153. Greenberg, "Modernist Painting," *Arts Year Book* 4 (1961).

154. Krauss, "Reinventing the Medium," 302.
155. Greenberg, we should note, is no more systematic. He counts "paint" and a "flat surface" as comprising the modernist painter's medium, but does not count the vehicle by which the former reaches the latter—determining whether, for example, the paint is brushed, poured, or sprayed.
156. For reasons that I hope will be obvious, I leave the daguerreotype out of consideration.
157. Krauss, "Reinventing the Medium," 297.
158. Krauss, "'And Then Turn Away?'" 9.
159. Greenberg, "Four Photographers," *New York Review of Books*, 23 January 1964.
160. Krauss, "'And Then Turn Away?'" 9.
161. Krauss, "'And Then Turn Away?'" 8.
162. Krauss, "'And Then Turn Away?'," 29.
163. These days, most believers in the index do not talk about "mechanical analogues." I begin with this notion for historical reasons that will soon become apparent.
164. Roland Barthes, "The Photographic Message," in *Music Image Text*, 19, my emphasis (hereafter, PM). (Originally published as "Le message photographique," *Communications* 1 [1961].)
165. Barthes takes some pains to stipulate the range of his denotative/connotative hypothesis. He says, for example, "When we come to the photograph, however, we find in principle nothing of the kind [a code of connotation] at any rate as regards the press photograph (which is never an 'artistic' photograph)." PM, 18.
166. PM, 16. It is hard to imagine a more restrictive statement of the goals of the essay.
167. PM, 19. Barthes's use of quotation marks here may be telling, but then, it may not be. Why are "denotative" and "objective" in quotation marks? Does common sense typically contain a notion of denotation, or "denotation"? My point here is not that Barthes is hedging his bets or being, for example, inconsistent, but that an interpreter needs to take a position on matters like this and give reasons for taking the position. Condescension is an unattractive posture, to be sure, and it hardly amounts to an intellectual position.
168. PM, 17, Barthes italicizes "analogon"; my emphasis on "to common sense."
169. PM, 30.
170. Rosalind Krauss, "Notes on the Obtuse," in this volume.
171. I give the expression without quotation marks and leave it to the reader to use them or not, or to distribute them as he or she sees fit.
172. Charles Sanders Peirce, "One, Two, Three: Fundamental Categories of Thought and of Nature" (1885), in *The Writings of Charles S. Peirce*, 6 vols. to date, vols. 3–5, edited by Christian Kloesel et al. (Bloomington: Indiana University Press, 1980–2000), 5:243.
173. "What Is a Sign?" (ca. 1894), in *Collected Papers of Charles Sanders Peirce*, 8 vols., vols. 1–6, edited by Charles Hartshorne and Paul Weiss (Cambridge MA: Harvard University Press, 1931–1958), vol. 2, para. 281 (hereafter, *CP*).
174. "Logical Tracts, No. 2" (ca. 1903), in *CP*, vol. 4, para. 4447.

175. Recall that I am adhering strictly to Krauss's account of how and why she turned to *the* index.
176. This is a puerile "argument" ad hominem and has no place in an exchange of this kind. Even a cursory reading of this essay will demonstrate that I never mention, address, or suggest "composition or internalized meanings," nor do I invoke "creativity," "genius," or "eternal value." I have kept my examples clear, simple, brief, and as workaday as possible. When I imagine the names I might have tossed (with better reason than those lobbed in my direction) at some of the contributors to this volume, I consider myself fortunate to be called nothing more than a "modernist."
177. Joel Snyder, "Photography, Vision and Representation," *Critical Inquiry* 2, no. 1 (Fall 1975).

5
AFTERWORDS

THE TROUBLE WITH PHOTOGRAPHY

Anne McCauley

> Going to a gallery and finding "only" photographs is a little like going to a whorehouse and finding only pornography. You feel gypped.
>
> —Jean-Louis Bourgeois, 1969[1]

Why do we care about photographs? What is it that puzzles us about them, that, as James Elkins states in his opening remarks, drives us (or at least a few of us who make our livings talking about pictures) to want to "conceptualize" them? Why is there such a sense of urgency and personal investment in defining the ontological condition of the photographic, when other media, such as watercolors, printmaking, or plaster casting, provoke only an intellectual yawn? Obviously, one could answer that photographs are ubiquitous and have a seemingly healthy life today outside the realm of the aesthetic that makes them more visible. Or that photographs' necessary link with what common sense continues to tell us is "the real" gives them a stronger and more troubling psychological presence than other types of pictures. Or

that photographs seem to have replaced, or given us a model for, a reality that has dissolved, as the postmodernist mantra claims, into spectacle and virtuality.

I start with these questions because, even though I would include myself within those who care in some way about photographs, I do not share the panelists' drive to draft a neat, theoretical framework that allows me to pigeonhole where photography stands within all human concepts, to tame its anarchic unruliness. This is undoubtedly in large part because I am more a historian intrigued by individual objects created at specific moments than a philosopher (although one cannot separate the two). But it is also related to my belief that the current sense of the photograph as a conceptual "problem" is in fact inspired by anxieties that I do not share (or perhaps do not feel to the same degree)—anxieties that are at once political and psychological. The first of these is the broad malaise about the growth of the "image society" and fear that the matrix/apparatus/postindustrial complex will use the mass media to control our minds and destroy our humanity. The second, which in fact necessarily determines the first, is a kind of photophobia induced by the mimetic image's doubling of perceived reality, its magical power to replace the animate with an inanimate likeness and induce what Freud termed the "effect of the uncanny."

There are many reasons why I am skeptical of the claims that more, and more "accurate," pictures circulating in the world will transform who we are and how we think. Mimetic images have been dismissed as politically suspect and as seducers of the masses ever since Plato, and every generation in the modern period has complained of their proliferation.[2] However, it has yet to be proven that pictures (including photographs) play a substantial role in either modifying behavior or fragmenting an individual's sense of self.[3] Although I am naturally concerned about the willful distortion of the news and the manipulation of visual and electronic information to suit the ends of the parties in power that

have become more conspicuous in the past few years, and, as a parent, I pay attention to the latest studies about the impact of video games and Internet porn, I find the jeremiads against the explosion of mass electronic media (of which photography is seen as the progenitor) to be misplaced and as much of a problem as the ills that they propose to reveal. Just as post-9/11 hyperbolic claims of imminent terrorist attacks created the atmosphere of fear that justified the violation of First Amendment rights and the Geneva Convention, cries of the collapse of the ability to distinguish media images from the real thing can rebound in the imposition of further controls on copyright, ownership, and authentication (such as the latest attempts to imprint a digital print with an image of the iris captured during the shot to ensure its lack of manipulation).[4] The handwringers claiming that all that is solid is melting into an undifferentiated, pixilated field uncannily echo the rapturous advertisers of the Macworld conference or the Consumer Electronics Show celebrating the integrated gadget home of tomorrow. Like most utopian fiction writers, both critics and boosters of an image-saturated future vastly overestimate the speed of change, underestimate the resistance of nature, and ignore the historical evidence that humans have consistently been able to distinguish between the catharsis of entertainment and the experiences of daily life that underwrite any appreciation of its artistic imitations.

The second anxiety about photography's uneasy status as a double of the real and its role in debates on indexicality was in fact noted by Elkins but not pursued by the panelists. He proposed that the intellectual fascination with conceptualizing the index derived from "a certain anxiety about the real, or even the Lacanian Real," or was "a symptom of unease about what is real, or Real in the Lacanian sense." The awareness of the photograph as psychologically disturbing permeates texts ranging from Barthes's sense of the *punctum* or piercing and excising of time to the Surrealists' reading of Atget's and found commercial

images as uncanny, to say nothing of the fetishistic uses of pho-
tographs as substitutes for persons we love or hate. While the
confusion of an inanimate image with a living referent occurs
in the perception of (and is the justification for) many tradi-
tional, handmade objects (portraits that stare, voodoo dolls that
are stabbed), that animistic belief is stronger in photography
because of the viewer's knowledge of how the image is made
and its closer homology to optical experience. Joel Snyder's off-
hand dismissal of the Epicurean account of representation as
the shedding of physical skins ("we don't believe that any lon-
ger") is just one instance of the panelists' general failure to admit
the peculiar psychological grip that photographs have on many
viewers. Whereas they allow Barthes's very personal responses
to diverse types of historical and family photographs to become
the subject of inquiry, the panelists rarely interrogate their own
feelings in front of photographs, which undoubtedly impact the
way that they frame questions about the medium.[5]

 Members of the panel might have also reflected upon why
they repeatedly took writings about photography published since
1970 and ideas "since the 1970s" as their frame of reference.[6] A
glance backwards would reveal not an absence of earlier discus-
sions, but very different issues that prompted what might in ret-
rospect be termed theoretical statements about the nature of the
medium, its audience, its social functioning, and its relation to
the fine arts. Like early writing about film, nineteenth-century
literature on photography was defensive in nature. Established
artists, aristocrats, and intellectuals attacked the new technology
as mechanical, mindless, inferior, vulgar, and servile, while the
new practitioners, equipment manufacturers, scientists, progres-
sives, populists, and positivists had to defend it as contributing to
knowledge, amazingly detailed, better than the handmade, effi-
cient, true, real, and possibly even beautiful, artistic, and immor-
tal. The battle for photography, which François Arago in 1839
promised would help fulfill his utilitarian dream of the greatest

good for the greatest number, had become the battle for art pho-
tography by the late nineteenth century, since its acceptance as
a general recording device had already been assured. Today, by
all accounts (prices for new and historical images; institutional
acceptance by museums, galleries, collectors, and cultural arbi-
ters), some photographs have achieved their place of honor next to
Van Goghs and Rembrandts, which means that the defensive pos-
turing directed to proving that photographs could share modes
of making and aesthetic responses with the fine arts seems bor-
ing and outmoded. Among people who count (certainly not the
yahoos in the provinces whom Bourdieu surveyed in the 1950s
who persisted in seeing the medium only as the real), the war is
over.

Or is it? The early 1970s saw the takeoff of the traffic in vin-
tage photographs as well as the use of purportedly documentary
photographic records accompanied by maps, maquettes, and
designs by conceptual and environmental artists claiming to
eschew the object and its commodification but nonetheless feel-
ing obliged to prove that the event, performance, or geographical
transformation had occurred. At the time, the prices for fine arts
photographs were undoubtedly higher than they had been before
(the press marveled in 1974 over the $35,000 paid for a daguerre-
otype of Edgar Allan Poe), but in fact remained pittances in
comparison with the amounts regularly charged for paintings
and even for the new earthworks, which in 1970 could run up to
$130,000 for a Christo piece, or a norm of $50,000, one-third of
which went into the pockets of the anti-art artists.[7] Furthermore,
the photographic records of the scored desert sands and wrapped
buildings that found their way into galleries, which were often
not even taken by the artists themselves, became collectibles:
as Roy Bongartz reported in 1970, "collectors may also content
themselves for paying $500 to $1000 for documentation—maps,
photographs, and models."[8] In 1979, when Winogrand and Fried-
lander photographs were selling at auction for $200–300,[9] the

deadpan, serialized black-and-white prints by Smithson, Oppen-
heim, de Maria, and Heizer were acquired at comparable prices
by museums eager to ride the new wave. Anticipating the phe-
nomenon that Joel Snyder decries in Gursky and Sherman, peo-
ple who knew nothing about the history of photography and did
not do their own printing were incidentally selling photographs
that, by their appropriation into museum Solander cases, became
as valuable as those produced by persons who had apprenticed for
decades in a darkroom. The status difference between people who
made "Art" from big ideas and people who made "Art" from tiny
negatives was, in effect, unchallenged.

The current situation is in fact not very different, despite the
astronomical prices for blown-up, digital prints by the likes of
Richard Prince, Cindy Sherman, and the Düsseldorf school. The
record $1.2 million paid for Prince's *Cowboy* at Christie's in 2005
now surpasses the $720,000 for a Weston *Breast* from the same
year, despite the fact that Prince's work is an ektacolor photograph
reproducing a commercial Marlboro advertisement enlarged to 50
× 70 inches. It is not surprising that these contemporary artists,
formed in art schools during the very decade that conceptual art-
ists turned to photography, do not consider themselves photog-
raphers, do not do their own printing, and have appropriated the
large scale of the heroic abstract expressionist generation. Richard
Prince's assertion, "When you don't have any training in a par-
ticular medium you can bring something to it that hasn't been
brung. I 'brung' the sheriff and I shot him. I killed photography,"
flaunts his outsider (and superior) status to a photographic prac-
tice mired in convention and technical finickiness.[10]

Photography still suffers from a prestige problem (both finan-
cial and intellectual), largely for the same reasons it did in the
nineteenth century, and anyone talking about photographic theory
needs to admit that. (The same taint can be extended to "photo-
graphic historians," as one can see in some of the personal inter-
actions that occurred among members of the panel.)[11] As long as

camera work remains identified as mindless, popular, democratic, functional, and reproductive, it is not particularly interesting to the liberal arts segments of the academy (thus the panelists' failure to engage with the scientific images that Elkins invoked). Arago's 1839 prediction that photographs would be servile handmaidens to artists seems to have come full circle, as a new generation of CEO artists busily commandeering commercial printers, managing fabricators, and appropriating imagery justifies their high salaries as the idea men (and women) behind their slick, laminated, machine-made prints. Far from proving that photography is now an accepted art, the enthusiastic embrace of supersized photographs issued in limited editions (inspired by a strategy developed by late nineteenth-century printmakers who at least had the excuse that their plates did in fact change through repeated printing) confirms that the medium is not an art unless its defining characteristics are ignored. Therefore, the very existence of this panel discussion and book project is contingent upon the contemporary fashionableness not of photography as a medium, but of a market for artists "working in photography" that has risen, according to investment advisors, some 88 percent since 2001.

Do We Know What We Are Talking About?

It would have taken an unusual degree of self-examination and frankness for the participants in this panel to have begun by revealing why they found photography amazing, annoying, threatening, or banal and therefore worth dissecting in the abstract at this particular moment. But it would have been natural if they had chosen to begin by discussing what exactly they meant by the term itself. Several commentators (Wilson, Lowry, Frizot) complained of this critical absence, which resulted in a confusion between the physical manifestations of the image and its mode of production. If the task is to define the specificity of the medium, then it is crucial to consider what people were thinking of when the neologism

was invented and how actual practice has shaped the ways we use the term today.

· Everyone has heard the story of how the word "photography" was coined by John Herschel in 1839 and won out slowly over competing terms that were more egotistical (*daguerreotype, Talbotype*) or less descriptive of the unique properties of the medium (*calotype, photogenic drawing, heliotype*). "Light" plus "writing or scratching" had the advantage of harking back to a whole series of technological inventions associated with improvements in reproduction, such as "telegraph" (far writing, already an electronic machine by 1797), "pantograph" (a way of reproducing drawings dating from 1630), "polygraph" (a mechanical device for making multiple copies from 1794), "eidograph" (a variation of the previous machine invented in 1831), to say nothing of "lithograph," the 1790s technique that launched Nicéphore Niépce on his photographic experiments. The term *photograph* could also stand in opposition to the much older, medieval term *chirograph* (handwriting), which was a legal document on which two copies of the same text were separated by a horizontal inscription (either the word "cirographium" or the alphabet), which was subsequently cut in a wavy pattern so that each party would have a copy. The authentication of the copy was proven when the two pieces could be fitted together. The double sense of authentication and the hand were encoded in another English word, "autograph," writing with one's own hand, which was only used after 1791 in the sense of a signature in which the personality of the writer was literally embedded in the marks (it apparently was only used as a verb after 1837).

Collecting autographs (and chirographs) were activities that Talbot indulged in,[12] as was the study of etymology, so his and Herschel's agreement over the term "photograph" was not entered into casually. Its substitution of "light" for "hand" or "self" was the critical point, and the generation of a fixed image created by light has remained the sine qua non for a photograph ever since. A photograph does not have to be a multiple, it does not have to

be on paper, it does not have to be flat, it does not have to be made with a camera, it does not inherently have to be fixed or permanent (although that is nice if you want anyone else to ever *see* it), it does not have to be iconic (or "resemble" the image formed by the projection of light through a lens onto the retina): it has to be generated by light. One might qualify that further (considering the "-graph" part of the equation) by saying that the action of light must result in a change in a physical substance that is visible to the eye (the latent image that Talbot discovered and that exists on photographic paper exposed in an enlarger prior to development would not, I think, be accepted as a "photograph" since it remains invisible). A further limit might be to require that the visible change effected by light on a substance serve to constitute a "picture." (This, of course, begs the issue of what a picture is, but is necessary to exclude phenomena such as paint fading on a wall from the action of sunlight, other chemical changes or bleaching activated by light, or photosynthesis. On the other hand, historically these natural processes have been linked to the concept of photography and its invention, and have also been exploited by conceptual artists.)

Photons, as Michel Frizot remarked in his comments, are indeed at the heart of what delimits the definition of a photograph, in a way that the hand or the artist's body does not define "painting."[13] The words that we use in English to label "mediums" themselves have evolved in different ways, often starting as verbs ("to paint," first used as "color with paint" in the thirteenth century) before referring to more particular objects resulting from those actions ("painting," in its modern sense of a noun referring to an aesthetic object, appearing in print in 1602). A painting is today an object materially constituted out of paint that Clement Greenberg would have us believe is normatively flat and bounded, but the sense of it as a generic medium, "painting," is still defined by the presence of a certain mixture of pigments and binders that is variously viscous and applied to a flat support. The category

of "painting" does not in and of itself say anything about what caused the paint to be there or to be configured in a certain way (thus, it is irrelevant definitionally whether a monkey, a human, or a tire driven across a canvas put the paint there). In contrast, the term "photograph," which within twenty years had subsumed within its purview images made on paper, glass, and metal,[14] came to define a category based solely on an object's mode of production rather than its physical composition. Inherent in the term is a shift in emphasis toward methods of manufacture, which reflects concerns about the advent of machinism and its threats to human labor that marked the moment of the medium's invention during the Industrial Revolution. However, one can note that the manufacture of cloth by Jacquard and Cartwright looms did not result in a new name given to the cloth. In other words, there was something else behind the coining of a new word than the fact that a photograph made by the sun was produced mechanically without human effort, and that something was the understanding that the image was magical, perhaps created with the help of a manmade machine (a camera, analogous to an iron loom or steam engine) but driven not by coal or wood combustion but by light itself, a free substance given to man by God. At the beginning, it was not that the picture made with silver salts looked radically different from a drawing, because at least in Talbot's case it did not (one could perhaps say that images made with cameras may have looked slightly more regular and even, the way machine-made cloth looked more even and consistent than cloth made by hand-driven looms, but the earliest cameraless pictures were distinctly inferior in detail and color to drawn renderings). The startling quality of photographs hinged on their erasure of the labor that defined man's fall from grace, their promise of a return to a harmonious, unified universe in which our consciousness and God's grace were linked in a ray of light.[15]

If unmediated light striking a support that is thereby physically transformed is a necessary condition for the creation of

a photograph as it was originally defined, then the question becomes, how do we deal with subsequent changes in the process in which an object's relationship to the light is mediated? By our first definition, all negatives are photographs (including moving picture negatives), as are all positives made by the action of light passing through those negatives onto a light-sensitive surface. But what about certain types of Polaroid prints? The light directly hits a surface (thus altering its chemistry), but that chemical change effects a second chemical change through contact (not through a second action of light) and makes a positive image. Most people call the final image a photograph, even though there has been an intermediary process that is not light-generated. This problem anticipates the issue of digital photography, where in fact there remains a light-sensitive array of photo cells whose output is electronic rather than a visible trace. The translation of light into binary information that is later recoded back into visible tones and colors involves a similar mediation process that demands that the definition of the "photographic" be expanded to accommodate that process if we want to still think of the output inkjet or laser-printed images as "photographs."

Most of the debate about whether or not a digital image can be subsumed within the traditional definition of the photograph centers around the possibility of human interventions in the mechanically generated electronic code of signals to cause manipulations (now commonplace, thanks to PhotoShop and other software programs). However, the fundamental issue is whether or not we will enlarge the definition of photography to include that intermediary step in which the visible is translated into a different code and the final output is generated with no use of light (in other words, if the digitized bits of information were translated into a projection of light that was directed onto light-sensitive paper, then perhaps we would have to call the resulting object a photograph, since it would, by our definition of "light drawing," be no different from any conventional print made from a negative). By

moving directly from electronic codes to printed output, we have technically erased our defining statement that the resulting image be directly, physically caused through the action of light.

If we accept the paper print ultimately generated from a digital camera as a photograph, we then have opened up the definition to include any visible objects in which light was involved *at some stage* in the generative process. That would mean that all of what we now call photomechanically printed images, where the results were ink on paper transferred from a matrix generated from a photograph, would have to be considered photographs. The status of halftone prints, Woodburytypes, collotypes, photo silkscreens, photogravures, and so forth would be no different from that of what we now call gelatin silver prints or Type-C prints or cyanotypes in which light was projected onto paper to create the image. This change in the definition of a photograph has nothing to do with hand- or human-generated, keystroke-instructed manipulation or interference in some sort of pristine "matrix," but calls into question the importance of the idea of "unmediated light" in the formulation of our definition. We may choose to accept the displacement of the "light writing" to any position within the chain of steps in the making of an image that we define as "photographic," but we need to be aware of the ramifications of so doing.

Talbot's and Herschel's neologism, while emphasizing the miraculous way an image was generated, also contained implicitly within it the idea that "nature" not only was doing the writing but also was the thing that was being written. Even though both men had explored the physical properties of light long before Talbot succeeded in making a photograph, they would have not thought that dark stains on a sheet of paper made by light would be very noteworthy if they did not tell us something about the actual world. Whether making his negative imprints of leaves or camera images of Lacock Abbey, Talbot appreciated the medium's ability to record *things*—the presumed message of the light writing—but had some difficulty describing the relationship between the forms

that nature drew and the ones that he constructed with his own eyes. He used terms like "impressed" or "stamped" to describe the process (as Graham Smith noted in the panel discussion) and called a contact print of a drawing a "facsimile," but introduced "trace" only to refer to the inadequate pencil marks that his hand made on the paper while using a camera lucida at Lake Como in 1833. A trace implied a lack, a failure to translate enough of a scene experienced by a human observer for another (or the same) person later to reconstruct the originary vision. Far from wanting his drawings to be obsessively detailed and shaded tonal reconstructions of what he had seen (it is our postphotographic projection back onto the early nineteenth century that constructs this teleology of "realism"), Talbot was enough of a romantic to want his pictures to be stimuli for memories where imagination continued to play a role.[16] At the same time, he recognized that his new photographic prints were a type of *acheiropoietai*, literal embodiments of a divine presence that permeated all of nature's creations like the orchids and wildflowers that he dried and brought back with him from his continental travels.[17]

Talbot, echoing early French critics of the daguerreotype, realized immediately that the images that he was able to fix, despite being automatically registered by light, did not look the way that scenes and objects appeared to a human observer.[18] But far from rupturing the vital link between luminous object and recording emulsion, which would have transformed the photograph from a presentation to a representation, Talbot and his contemporaries explained the peculiarities of the photograph—its stasis, revelation of details, and overall clarity of focus—as shortcomings of the human sensorium rather than active properties of what could be seen as a medium. Undoubtedly more accustomed to accepting the theological notion of human fallibility, these earliest nineteenth-century viewers privileged the truth of the photograph over the truth of corporeal vision. Instead of worrying about how the photograph differed from the real, as our panelists and many

recent theorists did, they considered how their vision fell short of what the camera saw.

In that sense, the recent obsession over the "indexicality" of the photograph reflects not only a disillusionment with mechanization but also an elevation of the human. Even though the semiological division of signs into the categories of icons, indices, and symbols is a way of expressing relational differences between signifiers and their meanings, in the practical application of these terms to photographs there has been an unacknowledged idealism whereby the signifier (in this case, a material object) is inferior to its signified. The photograph is perceived as less complete, less full of meaning, less "real" than another thing/experience that, if it is known to the viewer at all, can only be registered through a more sensitive and successful perceptual system, which has to be defined as the nexus of eye and brain. The only way to know that which the photograph is an index of (in the narrow sense of indexicality as referring to the relationship between the photograph and objects that previously existed in space and were hit by light) is to be able to perceive it in another way than the photographic (or else the signifier and its signified would be identical, and there would be no sign).

James Elkins's decision to start the panel by considering the indexicality of the photograph was unfortunate, in part because it bogged down the discussion in quibbling over terminology and in part because it was an act of bad faith on Elkins's part. He had just published in 2003 a critique of the usefulness of Peirce's categories for art historians and the ways that the complexity of Peirce's thought (and the changes that his semiological categories underwent throughout his life) had been flattened and ignored.[19] Martin Lefebvre's lengthy response aptly argues that indexicality should not be limited to the relationship between the depicted content of photography and its "cause" in the form of objects in the "real world," and traces the many ways that all pictures (and even "every worldly object") can be seen as indexical. What has

happened is that most people are not particularly interested in how, say, all paintings done by hand are indices of the actual motion of the arm and the brush as it stroked the canvas in the same way that they are interested in how photographs relate to the people and objects that formerly moved around in front of a camera. Indexicality as a conceptual way of describing the relationship between a photograph and its mode of creation tells us little about the meaning of the photograph to its viewers. As Lefebvre, Leja, and Solomon-Godeau among others complain, the very goal of semiology for Peirce and his followers was to understand how we acquire knowledge and to determine the nature of truth, and attempts to weigh to what extent a photograph is an icon, an index, or a symbol often lose sight of the reasons why those categories were devised.

Joel Snyder's and Rosalind Krauss's arguments about the importance of indexicality for an understanding of the photograph's meaning contain misunderstandings and repressions on both sides. Snyder, in his comments during the panel, justly attacks the fashionable invocations of Pierce in photo theory, but reveals an acceptance of the narrow reading of indexicality as suggesting resemblance between the sign and the thing indexed: "A photograph that looks like a grey smudge isn't an index of whatever object or objects may have been in front of the camera during the exposure of the film. If it were, we could name the objects." However, there is nothing within the concept of indexicality that claims that the thing/event indexed has to resemble the index and that we should be able to "name the objects" (to take one of Peirce's examples, the weathercock does not resemble the wind). Snyder's true complaint, and it is one with which I am sympathetic, is that photographs are much more than indices of past events and that the focus on causality (defined as light traveling out from a source) neglects the transformations that occur on its long path to the actual print (or object) that we call a photograph and, more importantly, the uses that viewers subsequently make

of the object. Speaking as a practitioner, a historian, and some-one who actually likes photographs, Snyder recoils from efforts to reduce the richness of photographic meanings to abstract catego-ries that inevitably fail when confronted by actual historical cases. Whether it is the blind adulation of Peirce, Barthes, or Benjamin, Snyder objects implicitly to the setting up of these authors as in any way definitive and transcendent of their particular historical positions and personal agendas in discussing photographs. Fun-damentally, just as Elkins has on other occasions wanted to com-plicate the study of visual culture to make it more difficult and thus more thoughtful, Snyder defends the difficulty of studying photographs (and, in turn, of making them—thus his defensive-ness about Jeff Wall and recent "artists using photography").

Krauss, on the other hand, realizes that Snyder's unwilling-ness to accept the application of the term *index* to a photograph is all about his need to preserve it as a potential art in its own right, but she obfuscates her own motivations in defending indexical-ity. She claims in her "Notes on the Obtuse" that she is primarily interested in the work that the use of the term "index" does for the criticism of photography. Yet, in her concluding remarks defend-ing Barthes, she identifies his "magisterial" texts as "devoted to the index, to the 'nothing to say.'" This evocation of the "nothing to say," the phrase Barthes introduces in quotes in *La Chambre claire* to refer to the photograph as a measure and testimony of death, but also to allude to its blockage of meaning, its failure to reveal the life of its referent, does not seem to be directly related to any working of indexicality per se. But it becomes one of many instances in which Barthes (and subsequently Krauss) defines the photographic negatively, as the loss of something rather than its presence. For Barthes, the photograph repeats "mechanically that which can no longer be existentially repeated," carries "with it its referent," and is "always invisible," something to be seen *through* and not seen.[20] But within his moving responses to specific pho-tographs, we can perceive his growing awareness of the medium

as such, as a bizarre "form of hallucination." He takes the strangeness of photography and its difference from the quotidian experience of events to be a function of its arresting of time, a quality that becomes an attribute of the medium as a whole.

What Barthes does not admit, and Krauss similarly rejects in articles such as her "A Note on Photography and the Simulacral,"[21] is that the features that make photographs interesting or captivating to many people are not necessarily accidental effects of automatic recording. They are more often the results of conscious (or at times intuitive) manipulations of posing, focus, or exposure by the photographer (or others in the production process) and of the equally intentional designs of cameras, lenses, film, printing paper, and so forth (as David Campany chronicles). Where do we locate the "inherently" photographic? Every physical feature that draws Barthes to particular photographs (from the *studium* to the *punctum* to the "that which has been") is one that has been made visible through the labors of a chain of human engineers, chemists, and camera operators who worked to get it there. The jumps between tones that we read as focus, the rectangular frame, the gaze of the sitters at the camera, the momentary opening of the shutter, the glossiness of the paper—all are elements that result from human intervention and are historically determined. Within the complex unfolding of thoughts triggered by the study of a photograph that at some point become its "meaning" must be reckoned those that are inspired by its particular configuration of tones and colors on a planar surface (and not just its "pointing" to the last brother of Napoleon, soldiers and nuns in Nicaragua, or a blind gypsy).

Absences

Despite efforts to move the panelists toward discussions of the importance of time to the conception of photography, the difficulty of determining who gets to speak for the medium, and the

status of contemporary digital work, Elkins ended on a note of failure that was inevitable from the outset. By focusing initially on how photographs were made and their problematic relationship to reality, the panelists jumped onto a treadmill that kept them rushing to find the elusive source for the photograph's mimetic power yet returning always to the same place. Oddly, at a moment when the "author" as a determinant of texts has been securely buried, the shadow of the author in the form of technology (camera plus light-sensitive medium) haunts this and other discussions of photography where a single agent is invoked to explain or define the nature, style, and meaning of a cultural product (the so-called photographer already having largely been erased in this instance from the debate).

One useful strategy to counter this insistence on "how the photograph is made" would be to apply Foucault's idea of the "author-function" to the technologies of photographic production. Foucault writes of the author-function as a psychological projection, "tied to the legal and institutional systems that circumscribe, determine and articulate the realm of discourses; it does not operate in a uniform manner in all discourses, at all times, and in any given culture."[22] In the almost literal substitution of light and machine for "hand," we can see that within photographic discourse "technology" functions as an author and thus can be similarly interrogated for the institutional freight that it carries; its workings as a locus where fears over dehumanization and mechanization are displaced; its promise of effortlessness, transparency, objectivity, naturalness, and instantaneity. Rather than trying to prove that "a photograph is x" or "a photograph reveals y" because of the way it is made or its relationship to its referent, one might more productively consider the photograph as an idea as much as a thing, in which repressed human concerns about making, keeping, and losing resurface.[23]

The importance of defining photography more as a social praxis than an object emerged in many critiques of the panel,

from Frizot's cataloguing of the medium's powers to attest to and define an event to Solomon-Godeau's insistence on its "profound imbrication with the social, ideological, or political" to Lowry's invocation of Wittgenstein as a model for looking at what we *do* with photographic technology.[24] This has been the work of photographic history during the past generation (if not before, going back to Gisèle Freund's sociological investigation in the 1930s), although more often than not it has been limited to narrowly defined case studies or monographs. However, the absence of any references to specific instances of the political or psychological impact of photographs (and the concomitant failure to engage directly with actual photographs present to the panelists, as Frizot, Kusnerz, and Maynard complained) suggests that what The Art Seminar accomplished was more meta-theory, theory about other people's theories, than actual rethinking based on new ways of looking at a broad array of historically different moments. The split between history and theory evident here, which tends to inflate the contemporary experience of photography to the normative, leads to errors such as speaking of all paintings as "aesthetic" (thus forgetting the centuries in which handmade art was the only functional and documentary visual medium), seeing the assimilation of photography into artistic discourses as an event of the last twenty-five or thirty years (whereas it was part of those discourses since its invention), and wishing that photographic history could accommodate the vernacular (which it generally did prior to the 1940s). Any attempt to "theorize photography" must be able to accommodate all genres within the medium as well as all historical manifestations, and, if that task proves too difficult, then it would be more honest to begin by bracketing off "fine arts photography since 1970," which comes closer to what the panelists finally seized upon.

If, as I have suggested, we need to shift discussions of photography away from issues surrounding its mode of manufacture and toward its reception and circulation in the world, then we would

be well advised to revisit Barthes's technique of examining our
personal responses to images. Whereas Barthes observed him-
self seeing through the image to its referent, I think it is possible
(through an effort of defamiliarization) to consider a photograph
as a pattern of tiny, multicolored shapes on paper. I can imagine
being confronted with one sheet of glossy, coated paper covered
with a dense array of tiny dots of color that coalesce into a shape
(what I recognize as the face of a girl) next to a second image
on paper painted with careful gouache strokes, and yet a third
image on paper where the darks are dense color, the whites are
the blank paper, and there are irregular, thicker areas of pigment
to form the halftones. If given no additional information, I could
compare the faces that emerge with differing degrees of clarity
from these surfaces and would perhaps pay more attention to the
first image, since there were more details to be read in the picture.
However, after being told that the first image is a color photo-
graph, the second is a miniature painting, and the third is a gum
print (from a photographic negative), I would immediately think
about these works differently and begin to ask other questions of
them. In other words, the knowledge of how the image is made,
rather than anything inherent in the image, changes the way the
viewer thinks of the image. Provided I have at some point learned
that a photograph is a type of picture generated (normally with a
camera) by physically standing in front of an object, I will become
more interested in what I presume to be the reality of the original
photogenic situation.

The importance of this externally generated belief about "how
a photograph is made and what it normally looks like" has been
raised in recent speculations that the advent of digital imagery
will collapse the meaning of the medium so that, in the future,
photographs will return to the state of drawing (or our popular
conception of drawing in a postphotographic world) and have no
claims to reality. But for any theory of photography, it seems to
me vital to return to the contingency of its truth claims and to

displace them onto the viewer rather than onto the representation. Digital photography only makes clear what was present in all photography, which was that what we see is to a large extent what we want to see and what we have been taught to see. Shown photographs by our parents as a child, we are told, "There's mommy and there's you as a baby." We can imagine a well-to-do urban toddler in 1800 being shown a miniature painting on ivory and being told the same thing, and that child would similarly think that the picture in some sense *was* his parent and his earlier incarnation at a moment that he could no longer remember. It is not that photographs necessarily *are* the "that which has been," but that we have concentrated within them all the documentary weight that was formerly contained within an array of mimetic drawings, life casts, icon paintings, relics, and any sort of pictures that claimed to be in some way "authentic."

Changes in the technologies of image making and in our understanding of brain neurophysiology will eventually make apparent the constructedness of our use of the photograph as a paradigm for the memory of the real. Or, contrarily, our seemingly insatiable, post-Renaissance appetite for mimesis and simulation may dissolve into a new "dark ages" where we turn away again from the evanescent here and now. Either way, the photograph will emerge as a peculiar, dated artifact that says more about the modern industrial age's narcissistic privileging of its own mastery of nature (its attempt to rapidly contain and exploit the material world with little regard for long-term consequences) than about what may have existed. In anticipation of this transformation, what we may need now is less a focus on the ontology of the photograph and more a consideration of its ethics and politics.

Notes

1. Jean-Louis Bourgeois, "Dennis Oppenheim: A Presence in the Countryside," *Artforum* (October 1969): 35. Bourgeois was presenting this statement as evidence of popular reactions to photographs in art galleries before proceeding to defend Oppenheim's work, which challenged the

conventional definitions of commercialized fine art. Bourgeois's statement
was recycled in a more sarcastic review of recent conceptual art by Roy
Bongartz, "It's Called Earth Art—and Boulderdash," *New York Times*, 1
February 1970, Sunday Magazine, 9. Bourgeois, the son of Louise Bour-
geois and Robert Goldwater and an architectural historian, was identified
by Bongartz as an "Artforum critic" in the *New York Times* article.

2. For a brief overview of antimimetic attitudes specifically directed to the
tradition of trompe l'oeil painting and photography, see my "Le réalisme et
ses détracteurs," in *Paris en 3D: de la stéréoscopie à la réalité virtuelle, 1850–
2000* (Paris: Musée Carnavalet, 2000), 3–29.

3. As Christian Metz noted many years ago, "we always know that what the
photograph shows us is not really *here.*" Christian Metz, *Film Language: A
Semiotics of the Cinema* (Chicago: University of Chicago Press, 1974), 6. The
issue is, of course, the extent to which the viewing of what are recognized
as "fictive" representations permanently changes the psyche (consciously
or unconsciously) and (of more concern to public policy) behavior. Recent
research in this area, largely directed to determining the effects of Internet
pornography and violence, has suggested that a number of mental health
problems (addictive behavior, sex exploitation and abuse, gaming, infidel-
ity, isolative-avoidant behavior, and so forth) are exacerbated with extreme
Internet use. For a recent summary of the findings of clinical psycholo-
gists, within a huge literature on the subject, see Kimberly J. Mitchell,
Kathryn A. Becker-Blease, and David Finkelhor, "Inventory of Problem-
atic Internet Experiences Encountered in Clinical Practice," *Professional
Psychology: Research and Practice* (October 2005): 498–509. Although the
Internet clearly facilitates the delivery of visual information that was for-
merly restricted or difficult for the general public to access, the styles of the
still photographs transmitted are not clearly different from those already
available to more restricted audiences. From the point of view of the his-
tory of photography, the Internet continues the transformation effected by
photomechanical printing in disseminating imagery, popularizing niche
or underground markets, and collapsing the borders between the private
and the public. It is the erasure of those social borders, rather than the
existence of newly conceived photographic subjects and styles, that seems
to upset much of the public.

4. This technique was reported in *Popular Photography* and is based on tech-
nologies developed by Paul Blythe and Jessica Fridrich of the Department
of Electrical and Computer Engineering at the State University of New
York (SUNY) at Binghamton. See their paper, "Secure Digital Camera,"
at www.dfrws.org/2004/bios/day3/D3.Blyth_Secure_Digital_Camera.
pdf. Commercial digital watermarking is now a common technology for
certifying copyright and allowing copyright owners to locate violations
within the Internet.

5. Margaret Iversen at one point considered her investment in the medium,
but saw it in a limited way as a continuation of her interest in other con-
temporary art forms.

6. Elkins: "in the 1970s, indexicality was a way to say that photography was
a legitimate medium"; Elkins: "But I really do want to continue the task
of the first part of this conversation, which is the provisional inventory
of ways that photography has been explained in the last three decades";

Elkins: "all the methods that have been applied since the 1970s"; Costello: "It is impossible to discuss this question of professionalization without discussing the change in *status* of photography as a medium—or at least resource—for artists since conceptual art, and especially over the last twenty-five or thirty years."

7. Bongartz, "It's Called Earth Art," 9.

8. To be fair, few photographs seem to have been acquired by museums at the time. For example, the photographs and slides that Robert Smithson shot of his earthworks and installations are still predominantly maintained by his estate. For more information on Smithson's complex attitudes toward photography, see Robert A. Sobieszek, *Robert Smithson: Photo Works* (Los Angeles: Los Angeles County Museum of Art, 1993). More work needs to be done on the involvement of earthworks artists with photography in the 1970s and the history of fine arts museum purchases of photographic records during that decade.

9. According to data in *The Artronix Index: Photographs at Auction, 1952–1984*, edited by Bhupendra Karia (New York: Artronix Data Company, 1986), Winogrand's prints sold in 1978–1979 for between $100 and $308, and Friedlander prints sold in 1979 for $200–300. Arbus's photographs sold at auction for up to $1,000 in the late 1970s, reflecting the escalation in prices for vintage prints after her suicide in 1971 and the inclusion of her photographs in the 1972 Venice Biennale (the first photographer to be shown).

10. Brian Appel, e-mail interview with Richard Prince, September 25, 2005, cited in *Artcritical.com*, edited by David Cohen (December 2005): www.artcritical.com/appel/BAPrinceRecord.htm. Prince's boast that a lack of training in a discipline allows one to recreate the medium echoes 150 years of avant-gardist rhetoric (dating at least to Courbet) in which the artist touted his lack of a master. Smithson, who was much more astute about the representational transformations of photography, nonetheless expressed his consternation about the technical mystique surrounding the medium: "Who knows the right camera to choose? Actually, when I walk into a camera store, I am overcome by consternation. The sight of rows of equipment fills me with lassitude and longing. Lenses, light meters, filters, screens, boxes of film, projectors, tripods, and all the rest of it makes me feel faint. A camera store seems a perfect setting for a horror movie." Robert Smithson, "Art through the Camera's Eye" (ca. 1971, unpublished essay), in *Robert Smithson: The Collected Writings*, edited by Jack Flam (Berkeley: University of California Press, 1996), 372.

11. For example, in the discussion about who gets to speak for photography, Margaret Olin observed, "I think the history of photography has changed. At one time it was more of a field than it is now, which reflects changes in what counts as a photograph. At one time, I think that photography history covered a set, canonical group of photographs, and you could pretty much count the photo historians, and tell them easily apart from the art historians; they did not tend to write about painting and installation." The implication is that this movement from specialization to other media is both new and desirable. What this statement reveals, however, is an incredible historical narrowness regarding the people who have actually written about photography and their training. The "pure" photographic

historian is an anomaly (of the people writing at least occasionally about photography who actually had graduate degrees, from Alfred Lichtwark to Heinrich Schwarz to Beaumont Newhall to almost every contemporary curator, most were trained as general art historians and maintained interests in other media). The fact that persons writing about photography are viewed as somehow being "different" or "apart from the art historians" is itself a result of the ongoing inferior status of the photograph (and, to be fair, also the flip side of the belief by some persons who write about photography that special technical knowledge is required to discuss the medium). It is worth considering why this division by medium was (if it has indeed disappeared) so much stronger in photographic studies than in, say, printmaking or sculpture.

12. Talbot, like many of his contemporaries, indulged in the practice of autograph collecting. For example, in a September 14, 1839, letter, the French physicist Biot remarked that he was going to send Talbot autographs by Napoleon, Lagrange, Humboldt, Seebeck, and Laplace (all references to Talbot letters are from "The Correspondence of William Henry Fox Talbot," Glasgow University, www.foxtalbot.arts.gla.ac.uk). Talbot was at once interested in the material connection with famous men who a signed document provided (perhaps his first involvement with "indexicality") and in the nature of writing as a way of encoding meaning (thus his endless etymological publications and obsessive interest in translating Assyrian texts that preoccupied him increasingly in the 1850–1860s). Some of Talbot's earliest photographs were in fact reproductions of original and printed documents in his collection, such as an autograph by Byron, a copy of the Domesday book, cuneiform Assyrian seals, and Egyptian hieroglyphs. He also owned a manuscript of the Magna Carta, and in 1846 published *Talbotypes Applied to Hieroglyphs.*

13. The term *photon* long postdated "photograph." According to the *Oxford English Dictionary,* the only English terms using the combining form "photo" that predated photography were *photometer* (or *photometrum,* an instrument for measuring the intensity of light noted as early as 1760), *photophobia* (the medical condition of the eye's "shrinking from light," observed in 1799 by Hooper), and *photology* (the science of light or optics, recorded in *Webster's Dictionary* by 1828). From their early researches on the nature of light, Herschel and Talbot were familiar with the terms photology and photometer. In fact, at the time of his earliest "photographic" experiments in 1833–1834, Talbot writes of using a "photometer" (letter of 3 March 1833).

14. In France, there was nationalistic resistance to giving up Daguerre's name, so that the earliest paper prints were sometimes referred to as "daguerréotypes sur papier" before the acceptance of "photographies." The term *daguerréotype* itself initially referred to the process (as a verb, *daguerréotyper*) and to the cameras used to make images (as a noun). When Daguerre's plates were first shown to the Académie des Sciences, they were described in the press as "dessins" (drawings, designs), an unusual adaptation given that to us today they look little like works on paper, and "épreuves" (prints, tests), again a strange word for a unique image but borrowed from printmaking and having an industrial association. In England, Talbot's works on paper were more easily associated with drawings (or "sun pictures").

15. The identification of the sun as the source of light dominates early photographic rhetoric, even though Herschel and Talbot were interested in the properties of artificial light as generated by burning various substances, and Talbot, like Humphrey Davy and Thomas Wedgwood before him, was fascinated by the properties of moonlight and in November 1839 even tried nocturnal photography. Practically speaking, artificial light photography was not possible until the 1850s. The insensitivity of early processes to candlelight, which was used during the sensitization process, certainly reinforced the metaphorical identification of the medium with "divine light" as embodied in the sun. In his book *The Antiquity of the Book of Genesis*, Talbot wrote, "And what could be a more natural error of the uninstructed mind than to adore the beneficent luminary, the source of all the earth's fertility, and the fountain of perennial light?" William Henry Fox Talbot, *The Antiquity of the Book of Genesis* (London: Longman, Orme, Green, & Brown, 1839), 9. Here he is of course distinguishing himself from the sun-worshipping pagans, but he was conversant with the archetypal association of the sun with "the Great Father" (9) and of nature as the "Great Mother." His goal in this book was to identify links between classical myths and the book of Genesis in order to push its dating to a pre-Mosaic period.

16. This idea, never clearly and consistently articulated, crops up throughout Talbot's writings. For example, in the discussion accompanying "The Open Door" in *The Pencil of Nature,* he notes how "a casual gleam of sunshine, or a shadow thrown across his path, a time-withered oak, or a moss-covered stone may awaken a train of thoughts and feelings and picturesque imaginings" in the artist. The photographic image could in turn inspire the same sort of imaginative musings through its capture of fragments of nature. For Talbot, pictures, far from having to be exact reproductions of natural forms, can exist as summarial stimuli for feelings. This way of thinking links him to eighteenth-century theories of the picturesque and the widespread appreciation for the sketch among British elites, but is contradicted by other texts in which he likens the camera to the eye and emphasizes the scientific, descriptive potential of the medium. What emerges is not a single way of categorizing the new medium, but multiple potentialities consistent with those satisfied by different types of drawings (from the topographical portraits to Alexander Cozens's blots that could be shaped into landscapes).

17. Barthes famously made this connection with *acheiropoietos* in Roland Barthes, *La Chambre claire* (Paris: Gallimard Seuil, 1980), 129. How photography's invention and reception are inflected by theological beliefs about handmade versus divine images needs to be investigated more fully. William Paley's *Natural Theology; or, evidences of the existence and attributes of the deity, collected from the appearances of nature* (1802), with its likening of the eye and the telescope and its questioning of why God did not give man the faculty of instantaneous vision, ponders some of the same challenges to representation that will later occupy Talbot. Similarly, the Bridgewater Treatises published in the 1830s (that tried to reconcile science and the belief in God) certainly form one of the intellectual backdrops for Talbot's experiments.

18. The differences between the photographic and retinal images inspired Biot (who had been sent Talbot's prints) to question whether in fact visible light was causing the image. In a 7 March 1839 letter to Talbot, he complained that the terms "héliogenie" or "photogenie" might be inadequate to describe the process, and proposed "actigenie." Talbot himself noted in *The Pencil of Nature* the ways his photographs surpassed common eyeball vision. In the text for Plate 3, "Articles of China," he anthropomorphized the camera by describing how it made a picture of what *it* saw (like the eye, but not identical to it), and in the text for Plate 4, he noted how it had a different sensitivity to color. Writing about Plate 8, he imagined a camera in a darkroom recording invisible rays and a figure unseen by the eye. In the text accompanying Plate 13, "Queen's College, Oxford," Talbot further remarked how a viewer studying a photograph could discover inscriptions, dates, printed placards, and clock faces that had not been originally noticed at the site.

19. James Elkins, "What Does Peirce's Sign Theory Have to Say to Art History?" *Culture, Theory & Critique* 44 (2003): 5–22.

20. Barthes, *La Chambre claire*, 15, 17, 18.

21. Krauss's arguments against the possibility of constructing an aesthetic discourse around photography in "A Note on Photography and the Simulacral" seem to me to depend on very weak evidence. She uses the case of responses to "Une minute pour une image" to suggest that all that viewers see in photographs are their subjects. This is, of course, no different from the way that the general public responds to paintings (listen to museum conversations in front of "abstract art" where people try desperately to find figures, landscape elements, etc.). Then Krauss introduces Bourdieu's similar findings about the uses of cameras as a social praxis favored by families (a practice Krauss describes as "narrow," with its subjects characterized as "extremely limited and repetitive") and his conclusion that "photographic discourse borrows the concepts of the high arts in vain." Throughout this report on mass responses to mass photographs, Krauss's position is clearly elitist and outside that of her witnesses and their images (thus her dubbing of Bourdieu's subjects as "hicks with their Instamatics" and her statement that "[t]o all of those who are interested in serious or art photography [i.e., Krauss and her readers] … Bourdieu's analysis of the photographic activity of the common man must seem extremely remote"). But, in an odd twist, it is exactly these mass opinions about photography's transparency and the contemptible repetition and lack of originality of mass photographs that in Krauss's text define photography's inherent incapacity to be included in the "aesthetic universe of differentiation." Most people today would not agree with Martine Frank that hundreds of Japanese men shooting the same model would make the same image, but Krauss reads Frank's observation as potentially exploding "the grounds on which there might be constructed a concept of photographic originality" (by the way, this "explosive" observation of the ways that multiple people placed before the same natural scene produce similar or different images is a trope in discussions of originality that appears as far back as Quatremère de Quincy's 1825 *Essai sur la nature, le but et les moyens de l'imitation dans les beaux-arts* and is revived in many defenses of photography in the 1850s).

Borrowing the notion that photography's status as a multiple changes the condition of earlier handmade art from Benjamin (without citing him here), Krauss then turns to concrete examples of ways that "contemporary painting and sculpture has experienced photography's travesty of the ideas of originality." The violence of the word "travesty" suggests her antipathy to the medium, onto which the burden of shattering originality is placed with no regard to the roles played by the entirety of the print culture that predated it and the self-conscious gestures of Marcel Duchamp. By turning to the work of Cindy Sherman, Krauss effects a curious rhetorical jump where photographs, already damned for collapsing the aesthetic universe of original/copy and good/bad, become not just copies but also false copies, simulacra. Good copies, according to Platonic definitions, copy "the inner idea of form and not just its empty shell"; photographs, in contrast, resemble "only by mechanical circumstance and not by internal, essential connection to the model." One wonders how any medium could maintain "internal, essential connection to the model"; if anything, photography in its recording of emitted light has a more "essential" connection with its model than any other medium. Clearly, by rejecting empty shells and aspiring for essences, Krauss alludes to the most fundamental academic concept of art as embodying the true, the beautiful, and the good.

The last section of the essay, setting up the straw man of Irving Penn's patently commercialized, blown-up still life photographs of 1980, makes explicit what really bothers Krauss about photographs. Penn's indebtedness to the values of advertising and his professional moves between art and commercial culture (apparent in his recent show at the Metropolitan Museum of Art) are well-known, so Krauss's revelation of his work as "debauched by commerce" is anticlimactic to critics on the left. What is a single case, however, becomes an indictment of a medium, and Krauss neglects the fact that most contemporary art that achieves any level of visibility can be seen as "debauched by commerce" often as much in its forms of address as its circulation within the art market. Krauss, like a good Frankfurt school follower, seizes upon photography, a medium that remains largely popular and functional, as a representative of all that she dislikes in capitalism—its false consciousness, its emphasis on endless production and consumption, its superficiality. While I am totally sympathetic to her antipathy to American-bred, consumerist values, I am not willing to assume that a medium contains its message. Krauss herself, in a later essay on medium specificity, admits to being attracted to Stanley Cavell's "insistence on the internal plurality of any given medium," and she admits for film and video a "Hydra-headed" status "existing in endlessly diverse forms, spaces, and temporalities for which no single instance seems to provide a formal unity for the whole." Why she does not grant a comparable status to photography is unclear to me. See Rosalind Krauss, "A Note on Photography and the Simulacral," *October* (Winter 1984): 49–68; and Rosalind Krauss, *A Voyage on the North Sea: Art in the Age of the Post-Medium Condition* (London: Thames & Hudson, 1999), 31.

22. Michel Foucault, "What is an Author?," in Language, Counter-Memory, Practice; Selected Essays and Interviews, edited by Donald F. Bouchard (Ithaca NY: Cornell University Press, 1977), 115, 130.

23. One attempt at a psychoanalytic examination not only of the needs of photographic viewers but also of photographic snapshooters is Serge Tisseron, *Le Mystère de la chamber claire: photographie et inconscient* (Paris: Les Belles Lettres, 1996). Tisseron's approach needs to be expanded to accommodate the possibility of historical variations in responses to and readings of photographic images.

24. Costello in fact proposed that the panel consider photographs as performative and address "the simple point that different uses of photography, in different situations, and for different purposes, achieve very different things." Even though this seems to be supported by Iversen, Elkins, and Olin, the panel drifts away from actually developing such an analysis in order to reflect upon why they (apart from Elkins) could not muster sustained interest in nonart photographs. This admission reflects the composition of the panelists, who are university faculty trained or teaching in English, comparative literature, philosophy, and art history departments, and the greater prestige given within the humanities to the artistic rather than the popular. The inclusion of panelists from schools of journalism or communication, the sciences, psychology, anthropology, or outside the university (practitioners, photo editors, manufacturers of equipment and supplies, etc.) who have certainly written a great deal about photography would have resulted in a totally different discussion more reflective of the fact that only a small percentage of the public is involved with (or cares about) fine arts photography. Similarly, the respondents come from the same academic disciplines as the panelists, with the exception of Vivan Sundaram and Alan Cohen, who are fine arts photographers. Van Gelder, Maynard, and Kusnerz, among others, remark on this skewed distribution of panelists.

PHOTOGRAPHS AND FOSSILS

Walter Benn Michaels

Hiroshi Sugimoto's *History of History* show (Japan Society, 2005–
2006) centers on five of Sugimoto's own photographs but includes
several other kinds of artifacts (like wood sculptures and hang-
ing scrolls) and begins with objects that are neither photographs
nor artifacts (at least not artifacts in the way that sculptures and
hanging scrolls are)—a set of fossils of trilobites, ammonites, and
sea lilies. What sets these objects apart from the others in the
show is that, as Sugimoto says, they "date to a time well before the
rise of humanity" and thus before the creation of "the concept of
'art.'"[1] For precisely this reason, it might seem that, made by nature
rather than humans, they not only predate art but also have noth-
ing to do with it. The fossils Sugimoto has chosen are, it's true,
very beautiful, but then some sunsets are very beautiful and some
rocks are and some mountains are. We do not think of sunsets
as belonging to the history of art. But Sugimoto says that fossils
do; in fact, he says, they are "the oldest form of art." And they are
particularly relevant to his show, he thinks, because they provide
a kind of genealogy for his own art, photography: fossils, he says,
are a kind of "pre-photography." So even though photography "is a
novel medium of artistic expression, far newer than painting and

sculpture, which date back to the early days of humanity," it is also far older than painting and sculpture and older even than "humanity." Photography is the first art, prehistoric, prehuman.

There is an obvious sense in which this view is a little implausible—how can there be art without people to make it? How can there be photographs without photographers? But there is an even more obvious sense in which—at least to the readers of this volume—it will not seem at all implausible. For fossils—like footprints, like shadows, like reflections—are a standard example of indexicality, a topic with which the contributors to this volume are deeply (and, in my view, appropriately) obsessed. Indeed, insofar as the other main subjects both of The Art Seminar and of the Assessments to it are medium specificity and Roland Barthes's idea of the *punctum*, there is an interesting sense in which this volume is all indexicality all the time since, as we'll see, the *punctum* is just another way of talking about indexicality, and indexicality—if only in the form of a problem—is central both to the medium specificity of the photograph and, at least in the last twenty years, to what Abigail Solomon-Godeau calls the other topic of interest and controversy in this volume, "photography's relation to art historical discourse."[2]

So Sugimoto's fossils make sense both as an emblem of the photograph and, as the readers of The Art Seminar will already have noticed, as a problem for photography. They make sense as an emblem of the photograph because if you have the fossil of a sea lily colony, then you know that the colony played the same causal role in the making of the fossil that the fossil itself would play in the making of a photograph of the fossil. The thing the photograph is of is causally indispensable to the photograph in a way that the thing a painting is of need not be. That's why Sugimoto thinks of his photographs of fossils as "another set of fossils," as, in effect, fossils of fossils. And that's why although there are paintings of unicorns, there are no fossils of unicorns and there are no photographs of them either. But the fossils also make sense as a problem for photography, and for the same reason. The painting of a sea lily

colony is a representation of it, a picture of it. The fossil of a sea lily colony is neither. The footprint is not a representation of the foot that made it; the smoke may be a sign of fire but it isn't a picture of it. So when Joel Snyder says that what he "fears" about the "causal stuff" (that is, indexicality) is that "it stops you from seeing the photographs as pictures," his fear isn't entirely misplaced. In fact, both as fear and as hope, the idea that the photograph is not a picture is central to the history of recent photography and to the history of recent art more generally.

That idea is most frequently associated in this discussion with Barthes and with the opening sentences of *Camera Lucida:* "One day, quite some time ago, I happened on a photograph of Napoleon's youngest brother, Jérôme Bonaparte, taken in 1852. And I realized then, with an amazement I have not been able to lessen since: 'I am looking at eyes that looked at the Emperor.'"[3] The point of the remark depends, of course, on the implicit comparison with painting. And the distinctive character of the amazement is a function of the fact that it has nothing to do with the kinds of amazement—at the skill of the artist, the brilliance of her conception, and so on—that might plausibly be produced by a painting. If paintings could show you the eyes of the emperor, then Barthes himself could have looked at him. But paintings cannot. That's why Kendall Walton, coming from a different theoretical tradition, nevertheless makes the same point: "We do not see Henry VIII when we look at his portrait; we see only a representation of him."[4] To say that you are seeing eyes that looked at the emperor is thus to say that you are not seeing a representation of eyes that looked at the emperor. This is what Walton calls the "sharp break... between painting and photography" (253). The break is sharp because it is a break not between two different technologies of representation but between something that is a technology of representation and something that is not. The photograph, for both Barthes and Walton, is not.

For some writers, this represents what James Elkins calls a "hope" and what Geoffrey Batchen calls a "desire"; the hope is "about the real world" and the desire is for some kind of access to it, "a real outside of representation." Elkins himself doesn't think this hope has much to do with photography, and Batchen is hardly endorsing the desire; indeed, insofar as Abigail Solomon-Godeau is right and we are supposedly all poststructuralists now, almost no one in this volume shares it. But it's not hard to see (or at least remember) what it is. Barthes reminds us when he distinguishes between "the *optionally* real thing to which an image or a sign refers" and the "*necessarily* real thing" that is "the 'photographic referent'" (76). It is this distinction that makes it possible for photographs to count as evidence in ways that paintings don't. I can hardly, say, accuse you of stealing my wallet and then offer as proof a little watercolor I have just made of you sneaking into my room. The watercolor would count more as a repetition of the accusation than as evidence of its truth, precisely because the reality of the referent—you entering my room—would be optional rather than necessary. And this would be true even if the drawing were remarkably realistic—entirely accurate in its depiction of your features, my room, and so on. The photograph necessarily shows what was in front of the camera; the painting only shows what was in front of the canvas optionally—and the option is the painter's.[5]

Barthes makes this point by saying, "Painting can feign reality without having seen it" (76); Kendall Walton makes it by saying, "Photographs are counterfactually dependent on the photographed scene even if the beliefs (and other intentional attitudes) of the photographer are held fixed" (264).[6] His point is that paintings are "based on the beliefs" (again, or other intentional attitudes) "of their maker"; photographs are not. So my photograph of you stealing my wallet is evidence of you stealing my wallet whether or not I believe that you stole my wallet. My watercolor is evidence not that you stole it but evidence of my intentional attitudes about

your stealing it—perhaps that I believe you stole it or perhaps that I want others (feigning, other intentional attitudes) to believe that you stole it.

To say the photograph is not a representation, in other words, is to say that it doesn't represent either the thing it is a photograph of or the intentional attitudes of the person who made it. The fossil is neither a likeness of the trilobite nor an expression of the trilobite's beliefs. But it is good evidence of the existence of trilobites, and the photograph of an event is good evidence that the event took place. It's not, however, definitive evidence. Even leaving digitality out of it for the moment, we all know that the realism of the photograph—its ability to show us what really happened, its ability to tell us the truth—is problematic. Photographs, as Margaret Olin puts it, "distort." And even photographs that don't seem to us distortions may nonetheless not help us in determining what really happened. For while our account of what the photograph shows us may not depend on the beliefs and desires of the photographer, it does (as Solomon-Godeau invokes the Rodney King story to suggest) depend on *our* beliefs and desires, the beliefs and desires of the interpreter.

It's not really that question, however (not really the question of whether photographs can tell the truth), that makes indexicality controversial in this volume and that produces both what David Green calls "indexophobia" in writers like Snyder and a corresponding indexophilia in writers like Krauss. What's at stake instead is, first, the photograph's status as art and, second, the status of art itself. The first question, in other words, is about photography as an art—can the photograph be a work of art? The second question is about art, irrespective of the photograph. The issue here is not what a photograph must be in order for it to count as art but what art must be if the photograph does count as art. And if the first question emerged as a kind of challenge to the photograph, contesting its claim to be a work of art, the second

has emerged as a challenge not to photography but to art and to the very idea of a work of art.

Skepticism about photography as an art started early and was based from the start on Barthesian doubts about the causal contribution of the photographer. As Patrick Maynard summarizes them, the issues have centered on whether the photograph "sufficiently expresses or manifests intentional states of people, rather than other formative factors" like the "photochemical/electronic marking process."[7] Thus, as he puts it, "there will be effects in successful photos that one does not know how to attribute" (305), by which he means one doesn't know whether or not they're there on purpose. The standard example here is the profusion of detail in the photograph, the way in which the photograph shows things the eye did not see. And it is such details, Maynard says, that raise "the question of the kinds and proportion of controlled features relative to uncontrolled ones, as compared with drawing and painting" (305). On this account, the difference between the painting and the photograph that Barthes understands as the difference between a representation and what he will call an "emanation" is at the same time a difference between the kind of control available (and necessary) to the maker of representations and the kind of control neither available nor necessary to the maker of emanations—which is why Barthes calls photography "a *magic* not an art" (88). What this actually means is that it is a technology, not an art, and so what is described in the seminar as the "automaticity" of the photograph is its indexicality approached from another angle: the more you see the photograph as made by the world, the less you see it as made by the photographer.

For Barthes, of course, that's the attraction—both the guarantee of "reality" (88) that counts as indexicality with respect to the referent and the limitations on the photographer's control that derive from that reality and that therefore count as indexicality with respect to the agent. If Kertész wants, as Barthes imagines, to take a picture of a violinist, he must also—whether he wants

to or not—take a picture of the dirt road the violinist is walking on. The point here is that the indexicality of the photograph—its status as a trace of what was there—is identified with the critique of the photographer's intentionality—his inability to control what the photograph shows. In a painting, the road would be dusty because the painter made it dusty; in the photograph, it's dusty because it was dusty in the world. And if the "detail" that interests Barthes in the photograph turns out precisely to be the dirt road, it does so not despite the fact that it was unintended by the photographer but rather *because* it was unintended, because Kertész could not help but include it. The "inevitable and delightful" detail "does not necessarily attest to the photographer's art; it says only that the photographer was there, or else, still more simply, that he could not *not* photograph the partial object at the same time as the total object (how could Kertész have 'separated' the dirt road from the violinist walking on it?)" (47). It is, in other words, delightful only because it is inevitable. The details that "prick" do so only because they are not supposed to; they are not even supposed to be there. And if they don't prick, "it is doubtless because the photographer has put them there intentionally."

The *punctum* is thus essentially (not merely in practice but also in principle) the unintentional. And it is this principled unintentionality that Michael Fried has insisted on in his recent essay on Barthes,[8] where the commitment to the *punctum* is read as the mark of Barthes's antitheatricality and where the fact that the *punctum* is (indeed, must be) unintended appears as the essential guarantee of the photograph's absorptive status. To the extent that it has not been produced on purpose, it cannot count as a performance. For Fried, Barthes thus emerges as a champion of absorption; more importantly, photography itself (as both the essay on Barthes and an even more recent piece on Thomas Demand argue) emerges in the last thirty years as the site of the response to what Fried attacked in "Art and Objecthood"—what he called literalism, or what we might more generally call postmodernism.

What identifies the unintentional with the antitheatrical is in a certain sense pretty straightforward: if you don't (consciously or unconsciously) mean to be doing something, you cannot possibly be doing it for someone. The idea here is not just that the subject of the photograph is not posing, that the person in the photograph isn't seeking to produce an effect on the beholder of the photograph. Indeed, part of what Fried calls Barthes's originality is that photographs of absorbed subjects—photographs taken, say, when the subject not only is not posing but also is completely unaware of being photographed—seem, to him, "quintessentially theatrical" (552). Why? Because in these photographs, it is the photographer who is performing. So what Barthes requires is a radicalization of absorption; he transforms the insistence that the subject of the photograph not be seen as seeking to produce an effect, into the insistence that the photographer not be seen as seeking to produce an effect. Actually, this is too weak a way to put it. The effects Barthes is interested in are not merely ones that seem to be unintended; they are ones that really are unintended. And while this insistence on the unintended makes Barthes, as we have seen, a crucial figure for Fried and the critique of the postmodern, it also makes him a crucial figure for writers like Krauss and Solomon-Godeau, who are committed to defending the postmodern. Indeed, what I have just described as the radicalization of absorption (the radicalization of the refusal of performance) turns out in Barthes to be dialectical: it turns the antitheatrical into pure theatricality; it turns what Fried called absorption into what was supposed to be its opposite, literalism.

The reason for this is obvious and is already suggested by Fried when he notes that the *punctum* exists only "through a particular viewer's subjective experience" and that the theatricality of literalist work consists above all in its dependence on "the experiencing subject" (56). The intended effect of a photograph does not depend on the beholder's experience—it is what it is whether or not any viewer actually experiences it. But once the effect the photograph

is supposed to have on the beholder (what the photographer intended) gets relegated to the studium, the only thing that can matter (the only thing left) is the effect the photograph actually has on the beholder. And this effect must of necessity be entirely a function of who the beholder is. No *punctum* for us in the photo of Barthes's mother; "at most," only "*studium*" (73). And, of course, no *punctum* for Barthes in the photograph of somebody else's mother. The repudiation of the photographer's intentions is in itself the appeal to the beholder's experience. Once the structural (or theoretical) indifference to the beholder that Fried identified as absorption appears as indifference, not just to the performance of the person being photographed but also to the performance of the photographer, its meaning is completely inverted. Instead of being irrelevant, the beholder is the only one who matters.

It is for this reason that the *punctum* seems to produce the problem of subjectivity described by Elkins in The Art Seminar; it is, "by definition, private" because it is by definition dependent on the response of the individual beholder. At the same time, however, it is important to see that privacy is not really the central issue here. What about the photograph of Jérôme and the eyes that looked at the emperor? You do not have to be Barthes, you do not even have to be French, to feel the prick of Napoleon's mortality. The *punctum*, in other words, is not intrinsically private; it can be shared with millions of others. What is intrinsic to it is not its subjectivity but its independence of the intention of the photographer; it's the thing that produces an effect even though it's not supposed to produce an effect. Margaret Iversen makes this point when she refers to Benjamin's discussion of the "double portrait of Dauthendey and his wife," where Benjamin says you "search the picture to find a flaw" that, as Iversen points out, "you can only do retrospectively, after the tragedy." The point is that the photographer did not know that the wife would commit suicide, and thus the effect the photograph has on you after the tragedy could not have been intended by the photographer (and if it somehow

was intended by the photographer, it would belong to the *studium* rather than the *punctum*). But you do not have to be related to the Dauthendeys to feel the effect, you don't even have to know them—you just have to know about them.

The real point of the *punctum* is thus that it turns the photograph from a representation—something made by someone to produce a certain effect—into an object—something that may well produce any number of effects, or none at all, depending on the beholder. We may find fossils beautiful, or we may not; we may find the painting of a fossil beautiful, or not. The difference between them is that the painting is meant to be beautiful and we do not (whether or not we find it beautiful) understand it as a work of art unless we recognize the intention, whereas the fossil is not intended to be anything and there is nothing about it as a work of art to understand—it is not a representation. Insisting on the *punctum,* Barthes insists that the photograph is more like the fossil than it is like the painting of the fossil. Thus, the photograph's *punctum* does (by way of its relation to the beholder) what its indexicality does (by way of its relation to the referent). In suspending the question (or denying the relevance) of the photographer's intentionality, they both make the photograph as a work of art—or as what Snyder calls a picture—invisible.

But if the disappearance of the work of art makes Snyder sad, it makes some of his colleagues happy. When, in "Photography's Discursive Spaces," Rosalind Krauss criticized efforts to treat the photographs of Timothy O'Sullivan as works of "Art," displaying "aesthetic values" and belonging to "aesthetic discourse," the object of her critique was Art, not O'Sullivan.[9] Her point, made also in "Notes on the Index,"[10] was that the indexicality of the photograph was indeed an obstacle to seeing it as a picture and that indexicality more generally was an obstacle to seeing things as representations, and that this was a good thing. It was precisely because there was an important sense in which photographs were not pictures that they could play such a central role in the critique

of modernism, here understood as crucially the critique of representation, of the picture and of the categories associated with it: "aesthetic intention," "work of art," "authorship," and so on (4). So if Snyder's claim that the photograph is not indexical is an effort to hang on to it as a work of art, Krauss's claim that it is indexical is an effort not to criticize the photograph but to criticize the very category of the work of art.

In this way, the medium specificity of the photograph was always crucial even when what it was crucial to an attack on medium specificity. For inasmuch as the idea of the medium is a fundamentally art historical one, what defines the medium specificity of the photograph—its indexicality, its automaticity, the *punctum*, in short, the bypassing of the artist's intentionality—is what calls into question its capacity to count as an art. Fried, in "Art and Objecthood," argued that theatricality (of the kind that I have identified here with the *punctum*) was not merely a wrong turn in the history of art, not merely a threat to good art but also a threat to "art as such,"[11] and, especially if we bracket the advocacy that is otherwise so central to the essay (if, in other words, we stop trying to keep art from coming to an end and just focus on the difference between art and nonart), we can see how right he is. For the whole idea of the *punctum* is that it undoes the opposition between good art and bad art by treating all photographs as if they were not art and so assessing them instead in terms of their effect. Again, the point is not that evaluation is rendered subjective; it is not that the Winter Garden photograph is from Barthes's point of view a great photograph but not so great from yours or mine. The point is rather that for Barthes, it is deeply moving (because it's his mother), and for the rest of us, it is not. The difference here is not, in other words, in our beliefs about which photographs are great; it is instead in the kinds of affect produced in us by photographs of people we know and care about as opposed to the kinds of affect produced by photos of people we do not know or care about. Indeed, we could have the same kind of difference without

the photographs; if (before her death) Barthes's mother herself had walked into the room, he might have been thrilled, whereas I might have been merely pleased. What is being registered here is not the subjectivity of aesthetic judgment but its irrelevance. The fact that I respond to your mother differently from the way that you respond to your mother has nothing to do with the aesthetic.

If, then, the conflict in painting of the late 1960s was "whether the paintings or objects in question are experienced as paintings or objects" (151),[12] the point of the photograph in the years since 1967 is that it has become the site on which this conflict takes place. As long as we are concerned about the *punctum,* the question about any photograph must be not whether it is good art or bad but whether it can be art at all.

And it is this replacement of the opposition between good art and bad art with the opposition between art and not-art that places photography at the center of art history in the last half century. For the imbrication of photography's specificity as a medium for art and of the ontological doubts about whether photography can be an art produces a situation in which the effort to answer the modernist questions—what is distinctive about photography as an art? What is it that makes it different from, say, painting?— produces as one possible answer the critique of modernism itself. There is an important sense, in other words, in which the question about the painting—is it a painting or an object?—has become the question about the photograph, not so much because the photograph can somehow be taken as the object it is a photograph of (even if we think of the image of Barthes's mother as an "emanation" of her body, we do not exactly think that the photograph *is* her body), but because it cannot simply be taken as a picture of the object it is a photograph of. That is the point, again, of the fossil. We do not experience the fossil of the trilobite as a trilobite, but we do not experience it as the picture of a trilobite either. And if we understand photographs on the model of fossils, we cannot take for granted their status as works of art.

To put it that way, however (to say that we cannot take for granted their status as works of art), is to refuse both the indexophobic and the indexophilic, to refuse the idea that because indexicality is a false issue photographs can of course be works of art and to refuse also the idea that because photographs are essentially indexical they cannot be works of art (or "Art"). Indeed, the fact that Fried is now writing a book on recent photography gets noticed several times in this volume precisely because the mid-twentieth-century obligation of the painter to secure or assert the status of the painting as art and not (only) object has, for all the reasons suggested above, devolved upon the photographer. Hence, as Fried himself says in the piece on Demand, the importance of photographers like Gursky, Struth, Hofer, and Wall (not to mention Sugimoto, Welling, and Demand himself) can only be understood in terms of their more or less implicit (in Wall, it is pretty explicit) commitment to *establishing* (since it cannot be taken for granted) the photograph as a representation.

Fried's own reading of Demand as committed above all to providing in his photographs "images of *sheer authorial intention*"[13] makes this clear. Why, if Fried is right, does Demand not only build his models to guarantee that the referent of his photographs is itself a product of his own intentions but also strip them of the details they would in reality inevitably have (the titles on the book bindings, the names on the ballots) in order to guarantee that they bear *only* the marks of his own intentions? Diarmuid Costello's observation that the conversation in The Art Seminar "just dies" "[w]henever we begin to talk about photography outside the art historical frame of reference" is helpful here, especially if it is juxtaposed with Snyder's doubt about whether people (either the photographers themselves or their audience) are interested in the post-Becher photographers *as photographers*. For Demand's insistence on intentionality—or, more precisely, his desire to thematize his own authorial intentionality—would not make much sense if he were, say, a figurative painter from the Leipzig school.

That is the difference between the photograph of Barthes's mother and a painting of her. No one doubts the relevance of the portrait painter's intentionality to the portrait—everything on that canvas has been put there by him. But, as the Kertész example in Barthes insists and as David Campany's entirely on-target citation of Friedlander on the "generosity" of photography makes clear, that is obviously and importantly not true of the photographer. "I only wanted Uncle Vern standing by his new car (a Hudson) on a clear day," Friedlander says, "I got him and the car. I also got a bit of Aunt Mary's laundry, and Beau Jack, the dog, peeing on a fence, and a row of potted tuberous begonias on the porch and 78 trees and a million pebbles in the driveway and more. It is a generous medium, photography."

And the generosity of photography is not only that you get more than you want but also that you can sometimes get what you want just by wanting it. What Friedlander had to do to get those 78 trees into the picture is radically unlike what a painter would have to do—the painter has to place them there, whereas the photographer has only to decide to include them. The painter has represented 78 trees; the photographer has allowed them to appear. And it is only in the context of this difference that one can explain why Demand photographs an artificial lawn about which the salient fact is that every blade of fake grass captured in the photograph has been put there by the photographer. The point here is to overcome the generosity of the medium, a point that cannot be understood (that is actually inconceivable) except by reference to the medium. So Demand's insistence on the photographer's intentionality—his effort, as Fried calls it, to make photographs that are "manifestly the bearers of no intentions other than the artist's own" (203)—is an effort that makes sense only as part of the history of art photography and of art. The conversation dies when it gets outside art history because the meaning of the photograph's indexicality is constituted within art history. Outside that history, as several participants remark, indexicality is cheap. And the fact that Demand,

Gursky, and so on are making photographs is central because the fact that the photographs *are* photographs is part of their meaning.

The centrality of the photograph thus emerges out of a certain crisis of the picture because it is understood already to embody that crisis. So while Snyder is right to insist that what is at stake is our ability to see photographs as pictures, it obviously will not work just to insist that they are pictures and to urge people to stop talking in ways that might distract us from this fact, any more than it works to say that photographs just are not pictures and that we have gotten beyond pictures. (The only thing more regressive than the insistence on the photograph as just another form of representation is the insistence that, as the photograph has shown us, we can achieve an art without representation.) It is precisely because there are ways in which photographs *are not* just representations that photography and the theory of photography have been so important. Indeed, we might say that it is precisely the photograph's complicated status as a theoretical object that has made it so important in art. And it is precisely the efforts of photographers to establish them as pictures that have made photography so crucial.

Another way to put this would be to say that the theory of photography is, at this moment, of particular interest because it is playing a crucial role in the history not just of art photography but also of art. The question of whether or in what sense photographs are representations is a question in the theory of photography; but it mattered in one way (not so much and only to photographers) when it was asked at the end of the nineteenth century, and it matters in a different way (more and to more people) when it is asked at the beginning of the twenty-first.

(Periodically in this volume, people talk about the difficulty or impossibility of theorizing photography; I am not quite sure what that means. I take the theory of photography to be a set of questions involving the different processes by which photographs are made and hence their relations both to the things

they are of and to the people who make them, as well as their relations to the people who look at them or otherwise use them, and so on. It seems pretty clear that there isn't now and never has been some definitive list of these questions, much less some definitive set of answers to them. So if that is what is meant by the difficulty of theorizing photography, then I agree that it is difficult. But inasmuch as the same could be said of the theory of literature, or of painting or music or any art, it is hard to see why the point seems to be worth making as if it were a point about the distinctive nature of photography. Perhaps, as some think, the real problem is with the notion of theory. I myself doubt this, but that is a different topic.)

The question raised by the ontology of the photograph—what did it take for something to count as a work of art?—is a question that may always have mattered to photographers but that only mattered to the history of art when modernism made it matter. Perhaps we could describe this as the moment when a theoretical question also became an important art historical question. And we can turn the process around by noting the way in which what had been (as it were, merely) art historical questions got redescribed as theoretical ones. Thus, for example, we could describe the conflict between the absorptive and the theatrical as Jeff Wall does when he says that they are both "modes of performance."[14] The point here is that absorption, as Fried deploys it, involves the effort to produce certain kinds of effects as opposed to certain other kinds of effects, and by calling absorption an art historical concept, I mean to emphasize that it involves understanding a certain set of acts—it involves understanding what certain artists were doing, or trying to do. But it is one thing to value the effect of unintendedness, and it is a different thing to value unintendedness itself; (paraphrasing Wall) it is one thing to value absorption as a mode of performance, and it is another thing to value it as the refusal or rather the absence of performance. And this, of course, is what

happens when Barthes requires that the photographer as well as (or instead of) the subject not be seeking to produce an effect, when he transfers the burden of absorption from the subject to the artist.

Absorption here becomes a theoretical concept. The historical question of which intentions any given photographer had becomes the theoretical question of whether photographers have any intentions that matter, and, more generally, of what relation there is between the meaning of a work of art and the causal account of how it was produced.

And this question now becomes crucial to the making of photographs. The project of establishing the intentionality of the photograph—a project made both possible and necessary only by the recognition that it needs to be established, that it is not just there—becomes crucial to the making of it. Sugimoto's invocation of the fossil is emblematic here. On the one hand, it signifies the impossibility (and the undesirability) of simply denying the indexicality of the photograph. On the other hand, insisting on the photographic fossil as an intentional object ("By photographing these fossils... I was making another set of fossils"), it marks the transformation of the natural object into the intentional one, of the trace into the representation, not exactly a representation of the referent but rather of the making of the photograph. You do not need a fossil to make a painting of a fossil; you do need one to make a photograph of it. That reminder of the indexicality of the photograph and of the irrelevance of the photographer's intentionality is here turned into an assertion of his intentionality. Just as the painter uses paint, the photographer uses the fossil. And with the referent redescribed as the medium, the causal stuff that gets in the way of seeing the photograph as a picture is here deployed to make it possible for the photograph to be a picture.

Notes

1. Hiroshi Sugimoto, *History of History* (New York, 2005). This brochure accompanied the exhibition at the Japan Society Gallery (September 23, 2005, though February 19, 2006). Its pages are unnumbered.

2. Indexicality is, but Peirce probably is not. We ought to disconnect the claim that the distinctive causal connection between the referent of a photograph and the photograph itself is important to the theory of photography from the claim that Peirce's semiotics is similarly important. The latter claim might be true, but it does not follow from the former.

3. Roland Barthes, *Camera Lucida* (New York: Hill & Wang, 1981), 3.

4. Kendall Walton, "Transparent Pictures: On the Nature of Photographic Realism." *Critical Inquiry* 11 (December 1984): 253. In this context, it might also be worth noting that Sugimoto has produced photographs of portraits (including one of Henry VIII) and that part of the point of them is no doubt that you are *not* looking at the eyes of the historical figure in question, or at eyes that did look at him.

5. It is important to acknowledge here that this distinction is one that can be troubled in lots of ways. Most obviously, the photograph can be doctored, or can in various ways be misleading. Almost as obviously, there are contexts in which the watercolor might also count as evidence. Suppose you had purchased special clothes in which to perform the theft and had disposed of them immediately afterwards—the fact that I was able to depict them accurately would count as evidence that I had been there and seen you, for how else would I know about them? It is this kind of point that Snyder is making when he reminds us that his mother would have a causal relation to a portrait of her. Her causal connection to her portrait does not make us worry at all about whether the portrait is a representation of her—obviously it is. So why should the causal connection of a photograph to the thing it is a photograph of make us worry about whether it is a picture? On the other hand, we wouldn't think for a minute that a reflection in the pond of Snyder's mother was a picture of her. So what is the difference between the reflection and the portrait? The answer is that the portrait requires a painter, and the reflection does not. Hence, there are all kinds of questions we can ask about the portrait—is it meant to bring out the specificity of her personality, or to allude to a general maternal function, or perhaps a distinctively middle-class maternity?—that we cannot ask about the reflection. And the reason we can ask these questions about the portrait is that they are about what the painter was trying to do, whereas in the case of the reflection there is no painter, no one to ask them about. What makes the photograph interesting, of course, is that there is a photographer, and yet there are important things about the photograph that are like the reflection—it shows things that the photographer need not have intended, that have no connection to what the photographer was trying to show. In Barthes, in fact, the things the photographer was trying to show get relegated to the *studium*. More generally, as we will see below, the question of the artist's intentions and of their relation to the meaning of the work of art is at the center of the current debate.

6. Walton's point is made in Gricean rather than Peircean terms: it involves the distinction between "natural" and "nonnatural" meaning: "Spots mean N (mean naturally) measles... and the ringing of a bell on a bus means NN (means nonnaturally) that the bus is full" (265). The point again is that the photograph is more like the spots than like the ringing bell, and the way of making the point is to say that our sense of what the photograph shows is not dependent on our sense of what the photographer meant it to show. Diagnosing the patient with spots is not a matter of figuring out what he means by them (he does not have measles because he intends to). Of course, the questions of the reliability of the evidence, of which is better evidence, and so on are irrelevant here. The point is only that the painting is routed through the painter in a way that the photograph is not routed through the photographer.

7. Patrick Maynard, *The Engine of Visualization* (Ithaca NY: Cornell University Press, 1997), 284.

8. Michael Fried's essay, "Barthes's Punctum," appeared in *Critical Inquiry* 31 (Spring 2005): www.uchicago.edu/research/jnl-crit-inq/issues/date/v31/31n3fried.html, and was subsequently responded to by James Elkins, the editor of this volume. Furthermore, the book on photography that Fried is now writing (and of which the essay will be a chapter) is referred to several times in both The Art Seminar and the Assessments. One way to characterize my own work in this essay would be as an effort to explain exactly why this is so—why, in other words, the continuing debate about the photograph's indexicality is a version of the debate about the ontology of the work of art decisively inaugurated in Fried's 1967 "Art and Objecthood"; Michael Fried, "Art and Objecthood," *Artforum* 5 (June 1967): 12–23. One could put this point more generally by saying that it is in photography rather than painting (and rather than—for somewhat different reasons—video) that the most fundamental questions about the limits of representation and the limits of the critique of representation have been raised. And, of course, all the issues that in this volume get mobilized around indexicality (the photograph's relation to the real, the automaticity of the photographic process, the problematic status of the photographer's intentionality, the relevance of the beholder's subjectivity) are artifacts of positions taken on the critique of representation. (On the connection between these positions in literary as well as art theory, and for an account of the politics produced by that connection, see Walter Benn Michaels, *The Shape of the Signifier: 1967 to the End of History* [Princeton NJ: Princeton University Press, 2004].)

9. Rosalind Krauss, *The Originality of the Avant-Garde and Other Modernist Myths* (Cambridge MA: MIT Press, 1986), 133–34.

10. Rosalind Krauss, "Notes on the Index," pts. 1 and 2, in her *The Originality of the Avant-Garde*, 196–219.

11. Michael Fried, *Art and Objecthood* (Chicago: University of Chicago Press, 1998), 163.

12. We might just as easily say, in connection with Barthes, as works of art or as persons, a way of putting it that reminds us of the relevance of the debate over anthropomorphism also at work in Fried, "Art and Objecthood."

13. Michael Fried, "Without a Trace," *Artforum* (March 2005): 202.

14. Jeff Wall, "Restoration: Interview with Martin Schwander," cited in Fried, "Barthes's Punctum," 551. Wall is discussing his photograph *Adrian Walker* and its relation to Fried's *Absorption and Theatricality* (Chicago: University of Chicago Press, 1980).

NOTES ON CONTRIBUTORS

Jan Baetens is professor at the Institute for Cultural Studies of the University of Leuven and codirector, with Hilde Van Gelder, of the Lieven Gevaert Centrum for Photography and Visual Studies. He has published or (co)edited some thirty volumes, including *Du roman-photo* (Paris, 1994); *Close reading New Media. Analyzing electronic literature*, edited by Jan Baetens and Jan van Looy (Leuven, 2003); and *Romans à contraintes* (Amsterdam, 2005). As a poet, he has published eight books (all in French), among which is *Vivre sa vie. Une novellisation en vers du film de Jean-Luc Godard* (Paris and Brussels, 2005).

Geoffrey Batchen is currently a professor in art history at the Graduate Center of the City University of New York. He previously taught at the University of New Mexico and the University of California, San Diego. In 1997 he published *Burning with Desire: The Conception of Photography* with MIT Press, and in 2001 the same press issued an anthology of his essays under the title *Each Wild Idea: Writing, Photography, History.* His most recent book is *Forget Me Not: Photography and Remembrance* (Princeton Architectural Press, 2004). (gbatchen@gc.cuny.edu)

David Bate works in the School of Media Art and Design at the University of Westminster, London. His publications include "Notes on Beauty and Landscape," in *Shifting Horizons,* edited by Liz Wells (2000); "Fotografie und der koloniale Blick," in *Diskurse der Fotografie Volume II,* edited by Herta Wolf (2003); "Voyeurism and Portraiture," in *Geometry of the Face,* edited by Mette Mortensen (National Museum of Photography, Denmark, 2003); "Space of the Other," in *Surrealism/Frontiers,* edited by E. Adamowicz (London: Peter Lang, 2006); and the book *Photography and Surrealism: Sexuality, Colonialism and Social Dissent* (2004). His photographic work is represented in London by Danielle Arnaud Contemporary Art.

Victor Burgin is professor emeritus of history of consciousness at the University of California, Santa Cruz, and professor emeritus of fine art at the University of London. His theoretical publications include *The Remembered Film* (London, 2004), *Ensayos* (Barcelona, 2004), *In/Different Spaces* (Berkeley, 1996), *The End of Art Theory* (London, 1986), and *Thinking Photography* (London, 1982). Monographs of his visual work include *Relocating* (Arnolfini, 2001), *Victor Burgin* (Barcelona, 2001), *Shadowed* (London, 2000), *Some Cities* (London, 1996), and *Between* (London, 1986). (v.burgin@gold.ac.uk)

David Campany is a writer, an artist, and a reader in photography at the University of Westminster. He is the author of *Art and Photography* (London, 2003). He has contributed essays to many books, including *Cruel and Tender: The Real in the Twentieth Century Photograph,* edited by Emma Dexter and Thomas Weski (London, 2003); *Rewriting Conceptual Art,* edited by Jon Bird and Michael Newman (London, 1999); *Where Is the Photograph?* edited by David Green and Joanna Lowry (Brighton UK, 2003); and *John Divola: Three Acts* (New York, 2006). He is currently writing a book on photography and cinema for Reaktion Press,

London. His photographic project *Adventures in the Valley,* made in collaboration with Polly Braden, was shown at the Institute of Contemporary Arts, London, in the summer of 2005.

Alan Cohen is a photographer who teaches at the School of Art Institute, Chicago. His publications include *On European Ground* (2001), with essays by Sander Gilman and Jonathan Bardo, and an interview by Roberta Smith. (www.alancohen.com)

Diarmuid Costello lectures in aesthetics in the Department of Philosophy at the University of Warwick. He has published a number of articles at the intersection of aesthetics and art theory, including papers on Benjamin, Lyotard, Heidegger, Wittgenstein, Danto, de Duve, Greenberg, Fried, Kant, and conceptual art. He is coeditor, with Jonathan Vickery, of *Art: Key Contemporary Thinkers* (Oxford, 2007); and, with Dominic Willsdon, of *After Beauty: Exchanges on Art and Culture* (London and New York, 2007). He is presently completing a monograph, *Aesthetics after Modernism.* (Diarmuid.Costello@warwick.ac.uk)

James Elkins teaches at the University College Cork, Ireland, and at the School of the Art Institute of Chicago. His most recent books include *Visual Studies: A Skeptical Introduction* (New York, 2003); *On the Strange Place of Religion in Contemporary Art* (New York, 2004); and *Master Narratives and Their Discontents* (New York, 2005).

Jonathan Friday is head of the History and Philosophy of Art at the University of Kent. His publications include *Aesthetics and Photography* (Ashgate, 2002), *Art and Enlightenment* (Imprint Academic, 2004), and a number of articles on photographic aesthetics to be found primarily in the *Journal of Aesthetics and Art Criticism* and the *British Journal of Aesthetics.*

Michel Frizot is a Senior Researcher at the Centre de recherche sur les arts et le langage (CRAL), École des Hautes Études en Sciences Sociales (EHESS); he has been teaching History of Photography since 1977 and is currently at the Ecole du Louvre. He edited *Nouvelle Histoire de la Photographie* (Paris, 1994; published in English as *A New History of Photography*, Könemann, 1998). His other publications include *Histoire de Voir* (Paris, 1989); *E. J. Marey Chronophotographe* (Paris, 2001); *Photomontages, E. J. Marey, A. L. Coburn* and *Dieter Appelt* (in the Photo Poche series) and numerous articles.

Anne Collins Goodyear is assistant curator of prints and drawings at the National Portrait Gallery, Smithsonian Institution. Her publications include "NASA and the Political Economy of Art, 1962–1974," for *The Political Economy of Art: Creating the Modern Nation of Culture*, edited by Julie Codell (Newark: University of Delaware Press, forthcoming); "Technophilia, Vietnam, and the Rise and Fall of 'Art and Technology' in the United States, 1965–1971" (forthcoming June 2006); and "György Kepes, Billy Klüver, and American Art of the 1960s: Defining Attitudes toward Science and Technology," *Science in Context* 17, no. 4 (December 2004): 611–35.

David Green is senior lecturer in the History and Theory of Contemporary Art at the University of Brighton. He has written widely on various aspects of contemporary art and photography. He is editor and contributor to *History Painting Reassessed* (2000), *Where Is the Photograph?* (2003) and *Stillness and Time: Photography and the Moving Image* (2005). Other recent publications include "Painting as Aporia," in *Critical Perspectives on Contemporary Painting*, edited by Jonathan Harris (2003); and two essays for *David Claerbout*, edited by Susanne Gaensheimer and published to coincide with a major retrospective touring exhibition of the artist's work that began at the Lenbachhaus, Munich, in 2004.

Margaret Iversen is professor in the Department of Art History and Theory, University of Essex, England. Her published books include *Alois Riegl: Art History and Theory* (Cambridge MA, and London, 1993); *Mary Kelly,* coauthored with Douglas Crimp and Homi Bhabha (London, 1997); and *Art and Thought,* edited and introduced with Dana Arnold (Oxford, 2003). Important articles include "What Is a Photograph?" *Art History,* 17 no. 3 (September 1994): 450–63; "Retrieving Warburg's Tradition," in *The Art of Art History: A Critical Anthology,* edited by Donald Preziosi (Oxford, 1998); "Readymade, Found Object, Photograph," *Art Journal* (Summer 2004): 44–57; and "Hopper's Melancholy Gaze," in *Edward Hopper,* edited by Sheena Wagstaff, catalogue essay for exhibition at Tate Modern, London, 2004. *Beyond Pleasure: Freud, Lacan, Barthes,* is forthcoming from Penn State Press. (miversen@essex.ac.uk)

Rosalind Krauss is university professor at Columbia University, New York. A founder and editor of *October Magazine,* she has curated exhibitions focused on twentieth-century art: *Joan Miro: Magnetic Fields,* The Guggenheim Museum, 1971; *L'amour fou: Photography and Surrealism,* The Corcoran Gallery of Art, Washington, DC, 1976; *Richard Serra: Sculpture,* The Museum of Modern Art, 1976; and *L'informe, mode d'emploi,* Centre Georges Pompidou, 1996. Her books include *David Smith: Terminal Iron Works, Passages in Modern Sculpture, The Originality of the Avant-Garde and Other Modernist Myths,* and *The Picasso Papers.*

Sabine Kriebel currently is a lecturer in modern and contemporary art at University College Cork, Ireland. She is writing a book about John Heartfield's radical political photomontages and their critical interventions in photojournalism and propaganda during the 1930s. Before coming to Cork, she worked at the National Gallery of Art, Washington DC, assisting with exhibitions in the Department of Photographs and collaborating on the groundbreaking Dada exhibition that traveled to Paris, Washington

DC, and New York in 2005–2006. Her essay "What Is Dada and What Does It Want in Cologne?" was published in the accompanying catalogue *Dada: Zurich, Berlin, Hannover, Cologne, New York, Paris,* edited by Leah Dickerman (2005). She is also at work on a study of photography in the German Democratic Republic and on commodity fetishism in Rosemarie Trockel's 1980s sculptural objects.

Peggy Ann Kusnerz is associate editor of the international journal *History of Photography.* She received her doctorate in American Studies from the University of Michigan. (Lily@umich.edu)

Michael Leja teaches in the History of Art Department at the University of Pennsylvania. His publications include *Looking Askance: Skepticism and American Art from Eakins to Duchamp* (Berkeley and Los Angeles, 2004); "Peirce, Visuality, and Art," in *Representations* 72 (Fall 2000): 97–122; and *Reframing Abstract Expressionism: Subjectivity and Painting in the 1940s* (New Haven, 1993). (Jaffe History of Art Building, Philadelphia 19104-6208; mleja@sas.upenn.edu)

Martin Lister is professor of visual culture in the School of Cultural Studies at University of the West of England, Bristol. His publications include *New Media: A Critical Introduction* (London and New York, 2003); "Photography in the Age of Electronic Imaging," in *Photography: A Critical Introduction,* edited by Liz Wells (London and New York, 2003), 295–336; and *The Photographic Image in Digital Culture* (London and New York, 1995).

Joanna Lowry is reader in visual theory and media arts at the University College of the Creative Arts at Canterbury Epsom Farnham Maidstone and Rochester. She has written widely in the art press on photography and contemporary art practice. Her academic publications include "Allegory, History, Technologies of Vision: The Work of Jeff Wall," in *History Painting Reassessed,*

edited by David Green and Peter Seddon (Manchester University Press, 2000); "Photography Video and the Everyday," in *Creative Camera: Thirty Years of Writing*, edited by David Brittain (Manchester University Press 2002); "Documents of History, Allegories of Time," in *Afterglow—Ori Gersht* (Tel Aviv Museum of Modern Art, 2002), 153–67; and (with David Green) "From Presence to the Performative: Rethinking Photographic Indexicality," in *Where Is the Photograph?* edited by David Green (Photoworks, 2003). (j.lowry@brisys.demon.co.uk)

Patrick Maynard, professor emeritus, Department of Philosophy, University of Western Ontario, is author of *The Engine of Visualization: Thinking through Photography* (1997), and *Drawing Distinctions: The Varieties of Graphic Expression* (2005) with Cornell University Press; and coeditor of the Oxford *Aesthetics* reader (1997). He has also taught philosophical classics and philosophy of art at the University of California, Berkeley; the University of Michigan, Ann Arbor; and Simon Fraser University. His publications include "'What Will Surprise You Most': Self-regulating Systems and Problems of Correct Use in Plato's *Republic*," *Journal of the History of Philosophy* 38 (2000): 1–26; as well as pieces in *Current Anthropology, The Times Literary Supplement,* and many other journals; and he has mostly recently written on portraits in painting and photography. (pmaynard@uwo.ca)

Margaret Olin is professor of art history and visual critical studies at the School of the Art Institute in Chicago. She is the author most recently of *The Nation without Art: Examining Modern Discourses on Jewish Art* (2001); and the editor, with Robert Nelson, of *Monuments and Memory Made and Unmade* (2003). Her book *Touching Photographs* is forthcoming from University of Chicago Press. (Department of Art History, Theory and Criticism, School of the Art Institute of Chicago, 112 S. Michigan, Chicago, IL, USA; molin@artic.edu)

Nancy Shawcross works at the Department of English, University of Pennsylvania. Her publications include *Roland Barthes on Photography* (Gainesville, 1997); "The Filter of Culture and the Culture of Death," in *Writing the Image after Roland Barthes*, edited by Jean-Michel Rabate (Philadelphia, 1997), 59–70; "Counterpoints of View: The American Photo-text, 1935–1948," in *Literary Modernism and Photography*, edited by Paul Hansom (Westport, 2002), 71–89; "Image-Memory-Text," in *Phototextualities*, edited by Alex Hughes (Albuquerque, 2003), 89–102; and "Barthes, Roland" and "Morris, Wright," in the *Encyclopedia of Twentieth-Century Photography*, edited by Lynne Warren (New York, 2005). (shawcros@english.upenn.edu)

Sharon Sliwinski works at the Department of English and Cultural Studies at McMaster University. Her publications include "'A Painful Labour': Photography and Responsibility," *Visual Studies* 19, no. 2 (October 2004): 150–62; "Camera War, Again," *Journal of Visual Culture* 5, no. 1 (April 2006): 111–15; and "The Kodak in the Congo: The Childhood of Human Rights," *Journal of Visual Culture* 5, no. 3. (sliwin@mcmaster.ca)

Abigail Solomon-Godeau teaches in the Department of the History of Art and Architecture, University of California, Santa Barbara. Her books are *Photography at the Dock: Essays on Photographic History, Institutions and Practices* (Minneapolis, 1992); *Male Trouble: A Crisis in Representation* (London and New York, 1997); and *The Face of Difference: Race, Gender and the Politics of Self-Representation* (Durham, 2007). Her numerous articles have appeared in journals such as *Afterimage, Art in America, Artforum*, and *October*, and she is the author of numerous exhibition catalogue essays.

Carol Squiers is a writer, editor and curator who lives in New York City. She received a B.A. in Art History from the University

NOTES ON CONTRIBUTORS 459

of Illinois in Chicago and did graduate study in art history at Hunter College at the City University of New York. As Curator at the International Center of Photography, New York (2000-present), she has organized the exhibitions for the five-part series "Imaging the Future: The Intersection of Science, Technology, and Photography," including "Perfecting Mankind: Eugenics and Photography" (2001) and "Foreign Body: Photography and the Prelude to Genetic Modification" (2002). She was curator of the exhibition, "The Body at Risk: Photography of Disorder, Illness, and Healing," and author of its fully illustrated catalogue (University of California Press, 2005). Edited the collection *Overexposed: Essays on Contemporary Photography* (The New Press, 2000). She has written essays for a wide variety of publications, including *Artforum*, *The New York Times*, *Vogue*, *Vanity Fair*, *Parkett*, *Art in America*, and *Aperture*.

Shepherd Steiner lives in Los Angeles. His publications on photography include "In Another Orbit Altogether: Jeff Wall in 1996 and 1997," in *Vancouver Art and Economies*, edited by Melanie O'Brian (Vancouver, 2006); "v.s. a beginning of sorts," in *Intertidal* (Antwerp, 2006); "The Los Angeles Spring, May, 1968, 2005," *Parachute* 120 (2005); "William Eggleston's *Los Alamos*," *X-tra* 7, no. 1 (2004); "Candida Höfer," *Contemporary* 67 (2004); "*l'autobiographie dans l'oeuvre de Rodney Graham*," *art press* 295 (2003): 29–37; "Le Corbusier as Subject in the Photography of Arni Haraldsson," in Shepherd Steiner, Arni Haraldsson, and Christina Ritchie, *Arni Haraldsson: Firminy* (Vancouver, 2001); "The Old Mole: Photography Neighboring on Materialism," in *Roy Arden: 1986–2001* (Oakville, 2001); "Wondering about Struth," *Afterall* 4 (2001); and "A Plot Unfolding: The Work of Stephen Waddell," in *Solitude im Museum / Solitude au Musée* (Stuttgart, 2000).

Johan Swinnen works at the Faculty of Arts and Philosophy at the Free University of Brussels, Belgium. His publications include essays in *The Cinema of The Low Countries*, edited by Ernest Mathijs (Wallflower, 2004); *Photography: Crisis of History*, edited by Joan Fontcuberta (Actar, 2004); *Encyclopedia of 20th-Century Photography*, edited by Lynne Warren (Routledge, 2005); and *Encyclopedia of 19th-Century Photography*, edited by John Hannavy (Routledge, 2006). He is vice president of the European Society of the History of Photography (ESHPh), is in the staff of the Editorial Network of *European Photography and New Media* (Berlin), and has made contributions to various symposia. (johan.swinnen@vub.ac.be)

Hilde Van Gelder is professor of modern and contemporary art at the University of Leuven. She is director of the Lieven Gevaert Research Centre for Photography and Visual Studies (LGC). She is editor of the e-journal *Image [&] Narrative* (www.imageand-narrative.be) and of the LGC-Series (www.lievengevaertcentre. be). She regularly publishes on postwar abstract art and photography, with a strong focus on Belgian artists; she is coediting a special issue of *History of Photography*, guest-edited by Jan Baetens and Hilde Van Gelder. (KULeuven, Faculty of Arts, Art History, Blijde-Inkomststraat 21, 3000 Leuven, Belgium; hilde.vangelder@arts.kuleuven.be)

Liz Wells writes and lectures on photographic practices. She teaches in the School of Media and Photography, University of Plymouth, and is director of the Faculty of Arts research group for Land/Water and the Visual Arts. She is curating *Uneasy Spaces*, an exhibition of work by nineteen British-based artists working in photography and photo-video (New York, 2006); and she curated *Facing East: Contemporary Landscape Photography from Baltic Areas* (2004–2006). Her publications include Liz Wells, Kate Newton, and Catherine Fehily, *Shifting Horizons: Women's Landscape Photography Now* (2000). She is working on a book whose tentative

title is *Land Matters;* it concerns critical currencies in contemporary landscape photography. She is editor of *The Photography Reader* (2003), and *Photography: A Critical Introduction,* third edition (2004).

Beth E. Wilson is an art/photo historian and critic, currently serving as the interim curator of the Samuel Dorsky Museum of Art at the State University of New York (SUNY) at New Paltz, where she recently curated *The Material Image: Surface and Substance in Photography.* Her publications include the short story "The Charlatans," in the catalogue for the exhibition *Vik Muniz: Ver Para Creer* (Museu de Arte Moderna, São Paulo, Brazil, 2001); and she is writing a doctoral dissertation on Surrealist photographer Lee Miller's World War II documentary work. (wilsonb@newpaltz.edu)

INDEX